NATIONAL GEOGRAPHIC
ON ASSIGNMENT USA

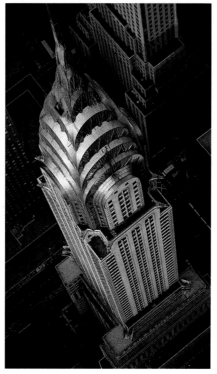

"You always leave something behind on assignment, and something always clings to you..."

—PRIIT VESILIND

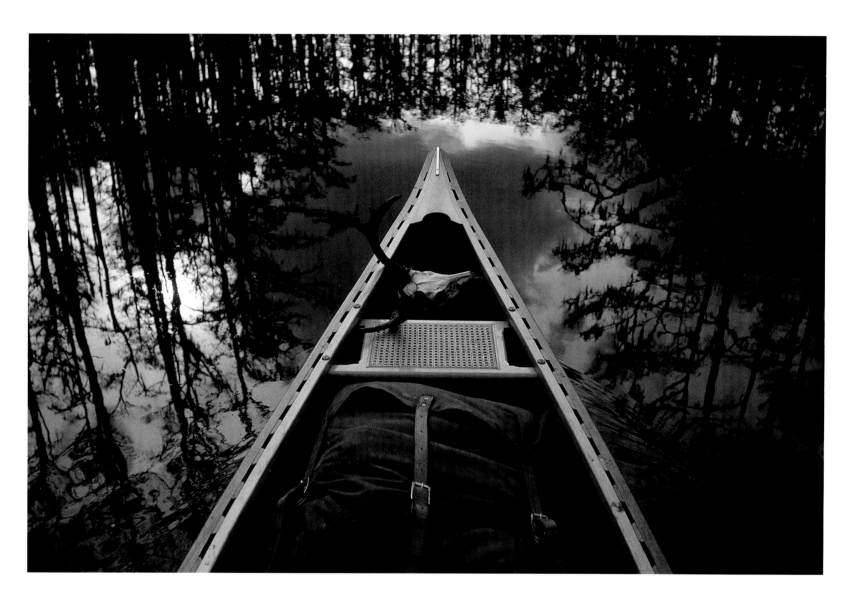

PHOTOGRAPH BY SAM ABELL

ON ASSIGNMENT
STILL WATERS, WHITE WATERS 1977

Okefenokee Swamp, Georgia

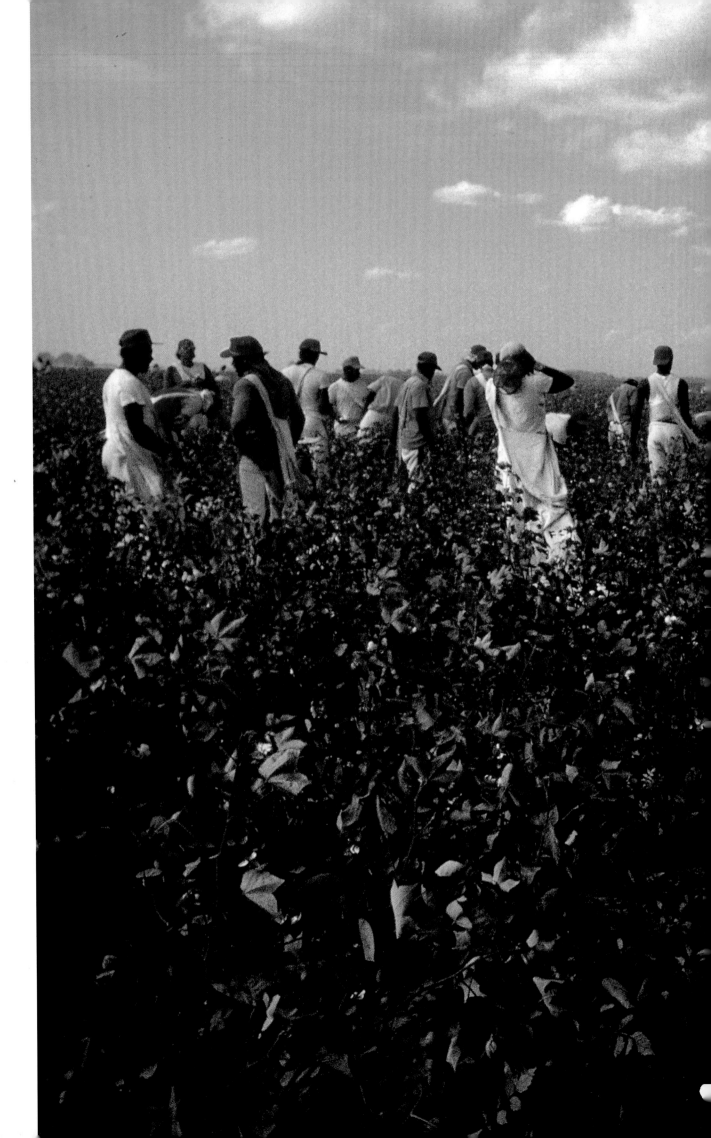

PHOTOGRAPH BY
WILLIAM ALBERT ALLARD

ON ASSIGNMENT
"FAULKNER'S MISSISSIPPI"
MARCH 1989

Prisoners work cotton field
at state penitentiary
in Parchman

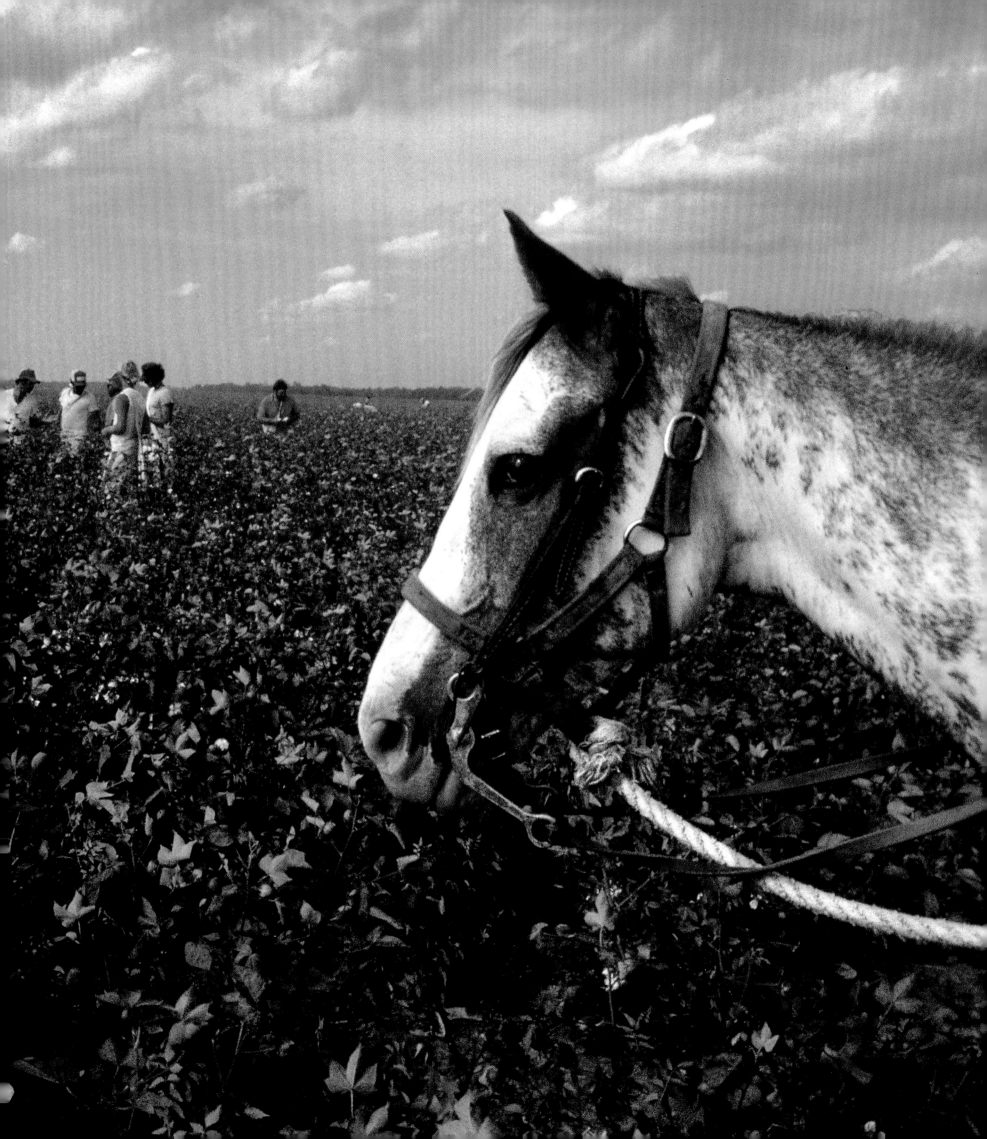

PHOTOGRAPH BY
DAVID ALAN HARVEY

ON ASSIGNMENT
"POWWOW"
JUNE 1994

"Comanche John" Keel
dances at Red Earth
Festival, Oklahoma City

8

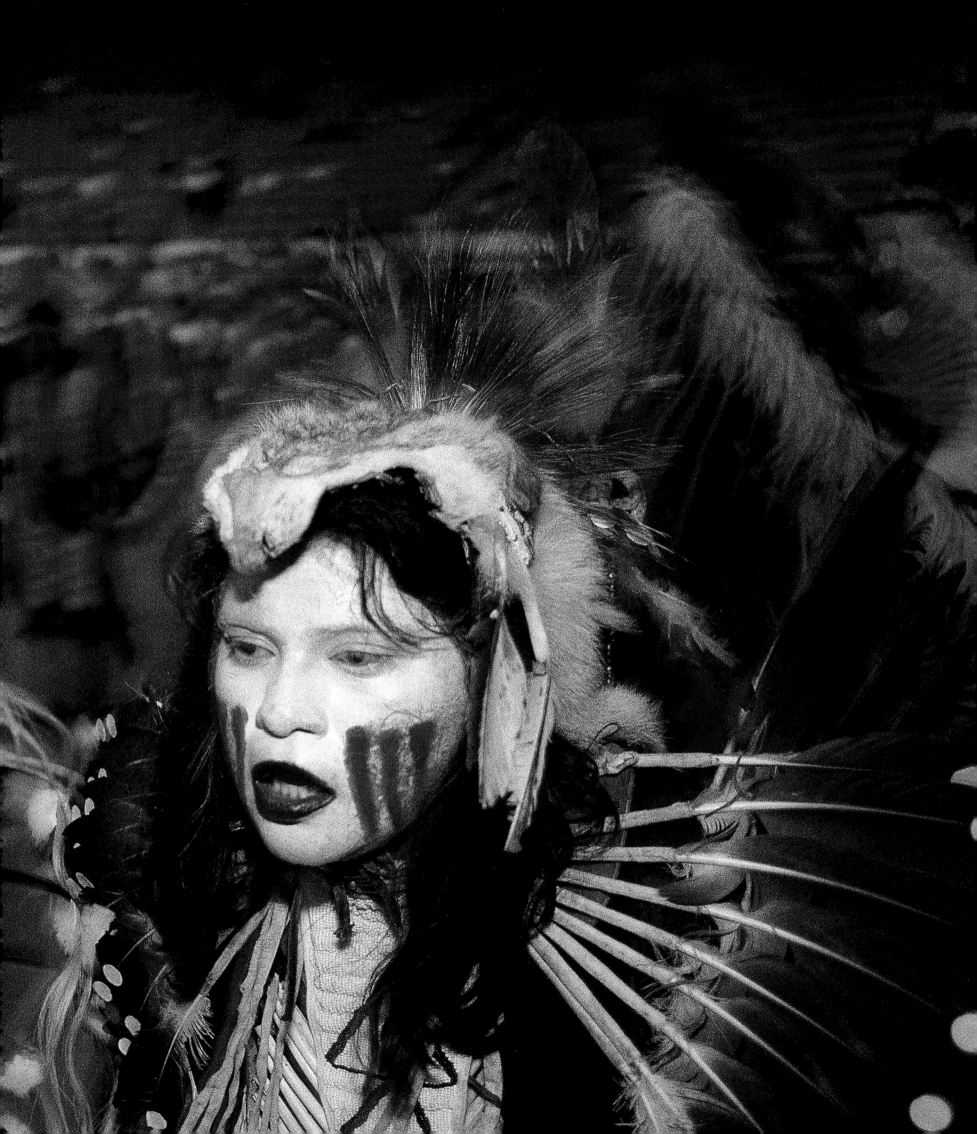

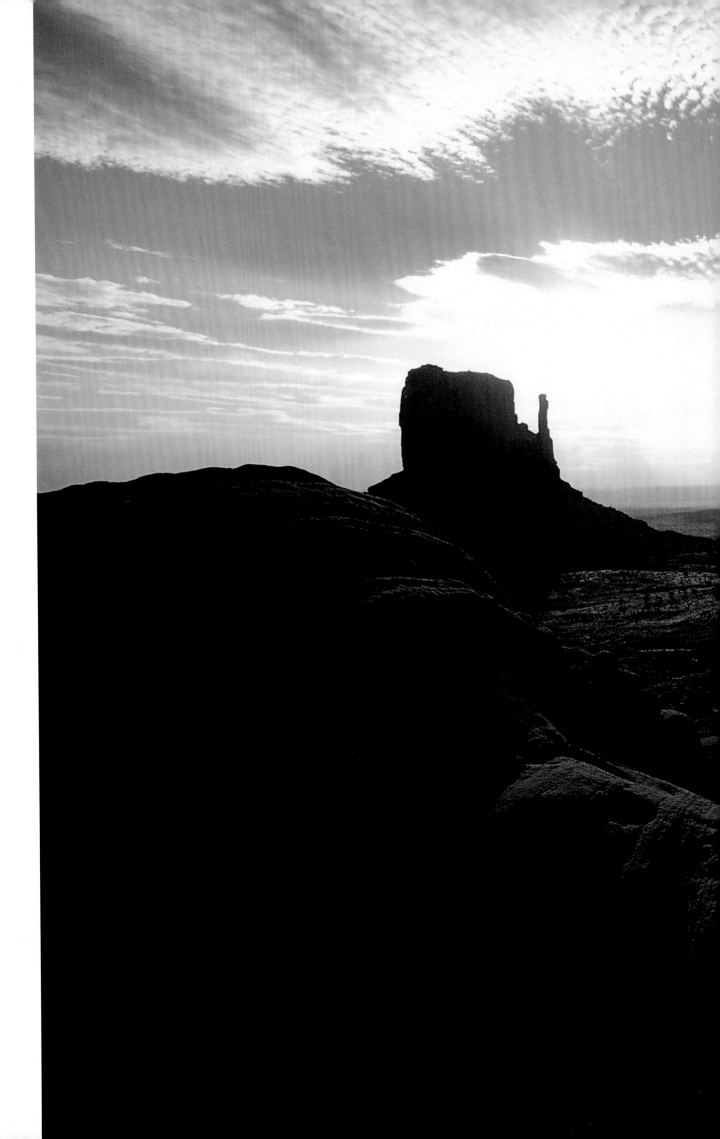

PHOTOGRAPH BY
BRUCE DALE

ON ASSIGNMENT
"THE NAVAJOS"
DECEMBER 1972

Monument Valley,
Utah-Arizona border

10

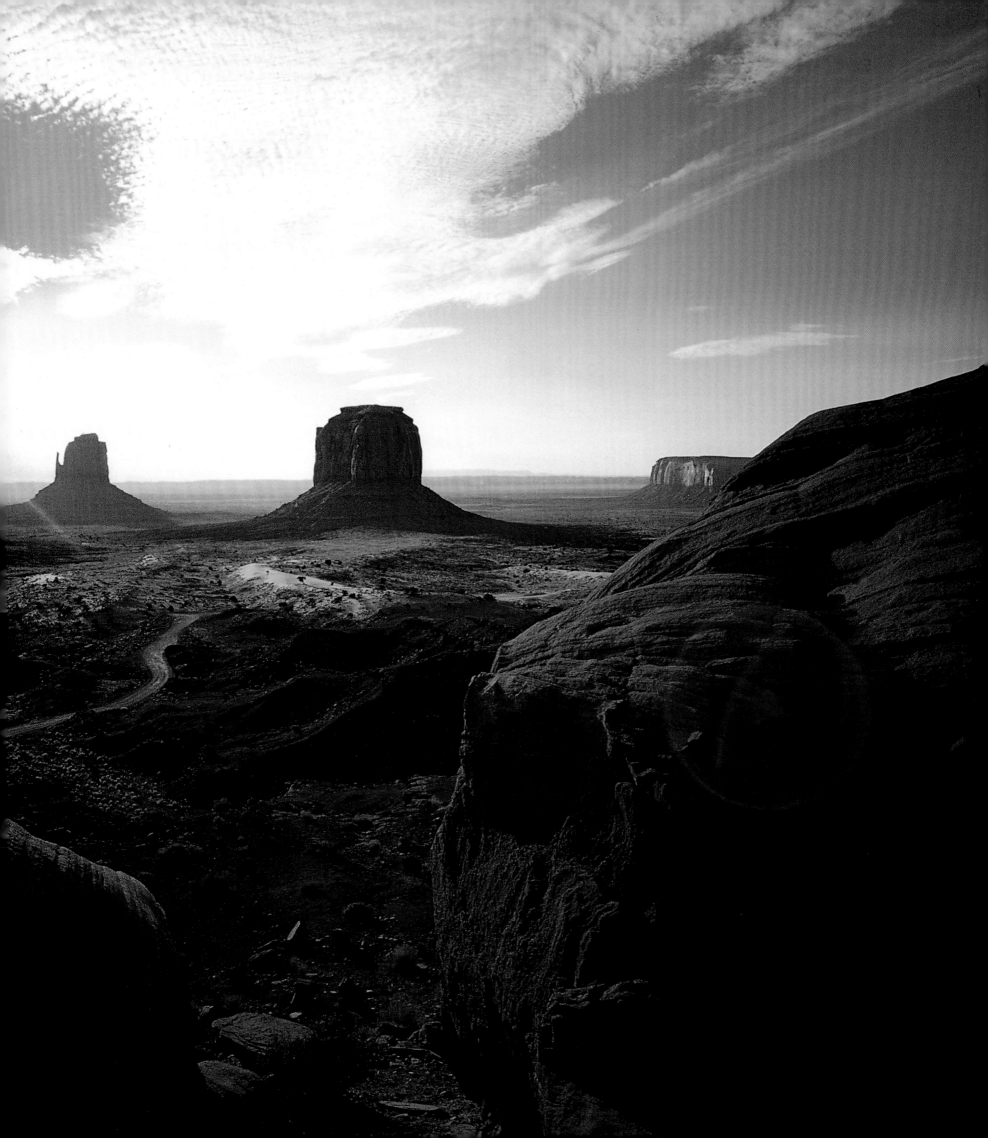

PHOTOGRAPH BY
NATHAN BENN

ON ASSIGNMENT
"PITTSBURGH"
DECEMBER 1991

Homeowner Robert Kenney
in Duquesne Heights

PHOTOGRAPH BY
CHRIS JOHNS

ON ASSIGNMENT
"ROUTE 93"
DECEMBER 1992

Gas station, garage
in Nothing, Arizona

14

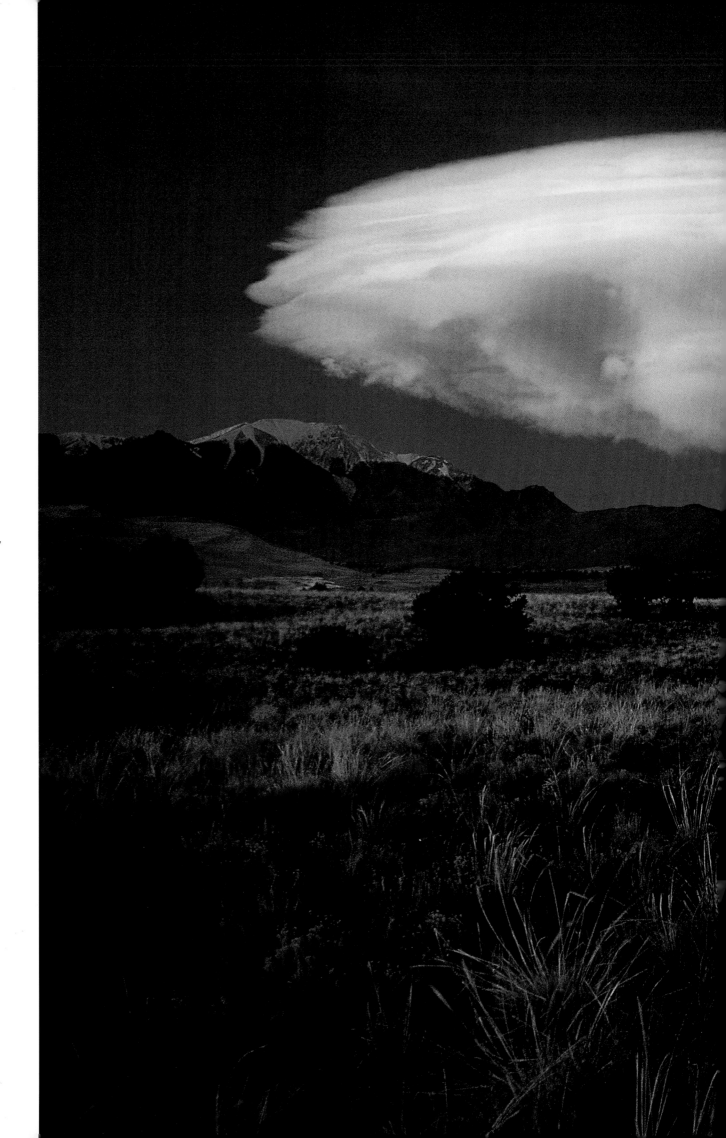

PHOTOGRAPH BY
JIM BRANDENBURG

ON ASSIGNMENT
"THE LAND THEY KNEW"
OCTOBER 1991

Great Sand Dunes
National Monument,
Colorado

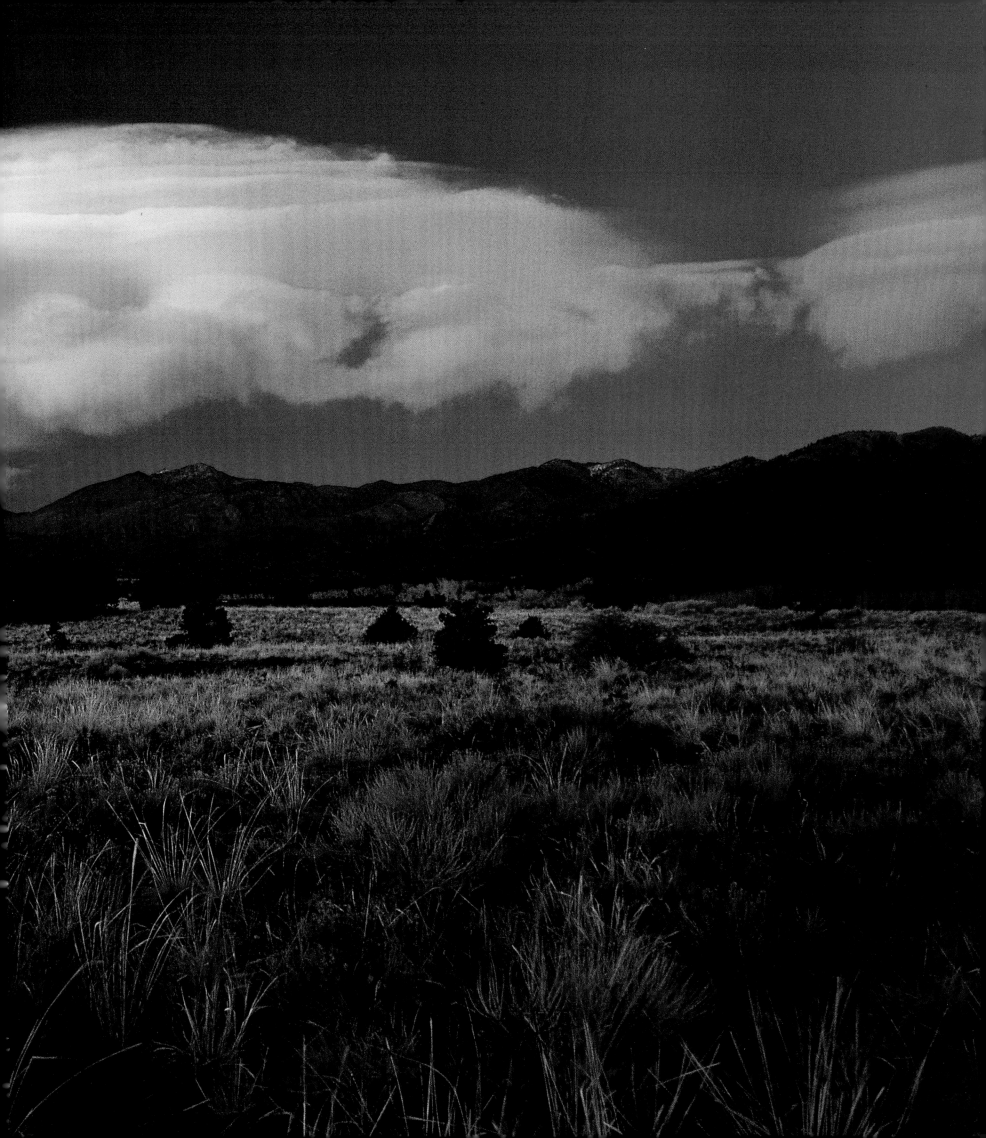

PHOTOGRAPHER PETER ESSICK on assignment
"CALIFORNIA DESERT LANDS" PHOTO BY PETER ESSICK

PHOTOGRAPHER JODI COBB on assignment
"BROADWAY, STREET OF DREAMS" PHOTO BY JODI COBB

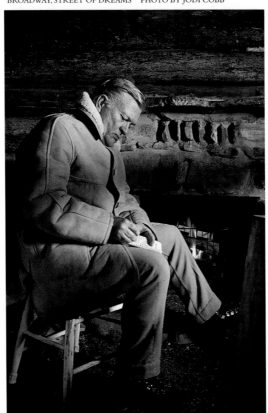

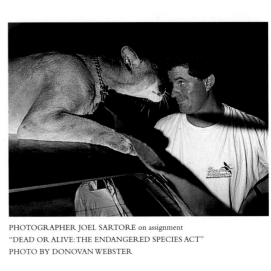

PHOTOGRAPHER JOEL SARTORE on assignment
"DEAD OR ALIVE: THE ENDANGERED SPECIES ACT"
PHOTO BY DONOVAN WEBSTER

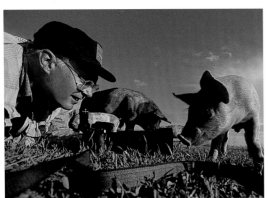

PHOTOGRAPHER JIM RICHARDSON on assignment
"A FARMING REVOLUTION: SUSTAINABLE AGRICULTURE"
PHOTO BY JIM RICHARDSON

WRITER BART MCDOWELL on assignment
"C. M. RUSSELL, COWBOY ARTIST" PHOTO BY SAM ABELL

WRITER DOUGLAS H. CHADWICK on assignment
"DEAD OR ALIVE: THE ENDANGERED SPECIES ACT"
PHOTO BY JOEL SARTORE

WRITER CATHY NEWMAN on assignment
"THE PECOS—RIVER OF HARD-WON DREAMS"
PHOTO BY BRUCE DALE

☐ NATIONAL GEOGRAPHIC
ON ASSIGNMENT USA

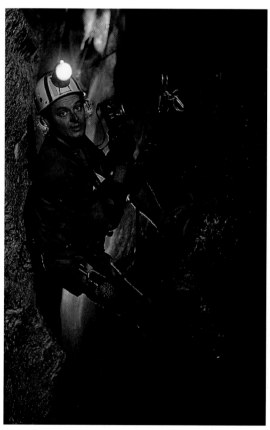

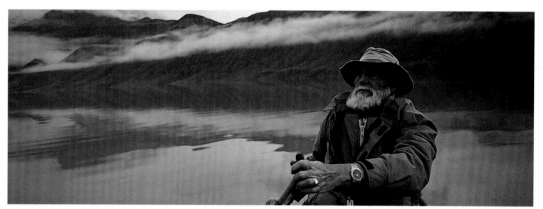

PHOTOGRAPHER GEORGE F. MOBLEY on assignment
AMERICA'S HIDDEN WILDERNESS: LANDS OF SECLUSION PHOTO BY GEORGE F. MOBLEY

PHOTOGRAPHER MICHAEL NICHOLS on assignment
"CHARTING THE SPLENDORS OF LECHUGUILLA CAVE"
PHOTO BY MICHAEL NICHOLS

PHOTOGRAPH BY JAY DICKMAN, MATRIX
"YELLOWSTONE: THE GREAT FIRES OF 1988"

PHOTOGRAPHER WILLIAM ALBERT ALLARD on assignment
"TWO WHEELS ALONG THE MEXICAN BORDER"
PHOTO BY WILLIAM ALBERT ALLARD

PHOTOGRAPHER ANNIE GRIFFITHS BELT on assignment
EXPLORING AMERICA'S BACKCOUNTRY
PHOTO BY ANNIE GRIFFITHS BELT

NATIONAL GEOGRAPHIC
ON ASSIGNMENT USA

BY *Priit Vesilind*

PROJECT DIRECTOR *Leah Bendavid-Val*

THE NATIONAL GEOGRAPHIC SOCIETY

PRESIDENT AND CHIEF EXECUTIVE OFFICER *Reg Murphy*

CHAIRMAN OF THE BOARD *Gilbert M. Grosvenor*

SENIOR VICE PRESIDENT *Nina D. Hoffman*

PREPARED BY THE BOOK DIVISION

VICE PRESIDENT AND DIRECTOR *William R. Gray*

ASSISTANT DIRECTOR *Charles Kogod*

EDITORIAL DIRECTOR *Barbara A. Payne*

STAFF FOR THIS BOOK

EDITOR *Leah Bendavid-Val*

ART DIRECTOR *Kate Glassner Brainerd*

DESIGN CONSULTANT *Constance H. Phelps*

TEXT EDITOR *John J. Putman*

EDITORIAL ASSISTANT *Kevin G. Craig*

ILLUSTRATIONS RESEARCHERS *Jennifer L. Burke*

Vickie M. Donovan

TEXT RESEARCHERS *James B. Enzinna*

Christina Perry

LEGENDS WRITER *Demetra Aposporos*

PRODUCTION ASSISTANT *Sadie Quarrier*

RESEARCH ASSISTANT *Steven Branton*

ILLUSTRATIONS ASSISTANT *Jennifer L. Burke*

PRODUCTION PROJECT MANAGER *Richard S. Wain*

STAFF ASSISTANT *Peggy J. Candore*

CONSULTING EDITOR *Joyce B. Marshall*

INDEXER *Susan Fels*

MANUFACTURING AND
QUALITY MANAGEMENT

DIRECTOR *George V. White*

ASSOCIATE DIRECTOR *John T. Dunn*

MANAGER *Vincent P. Ryan*

Library of Congress CIP data
Vesilind, Priit.
 National Geographic on assignment USA / by Priit Vesilind.
 p. cm.
 Includes index.
 ISBN 0-7922-7010-X. — ISBN 0-7922-7011-8
 1. Travel photography—United States. 2. Nature photography—United States.
 3. Photojournalism—United States. 4. Photographers—United States—Biography.
 5. News photographers—United States—Biography. 6. National Geographic Society (U.S.)
I. National Geographic Society (U.S.) II. Title.
TR790.V47 1997
910'.5—dc21 97-29891
 CIP

ON ASSIGNMENT USA

INTRODUCTION 22

LAND 34

PEOPLE 78

JOURNEYS 122

DISASTERS 156

PLACES 188

PROGRESS 222

CITIES 252

HEROES 288

INDEX 332
ACKNOWLEDGMENTS 334
ABOUT THE AUTHOR 335

PHOTOGRAPH BY BRUCE DAVIDSON
on assignment "NEW YORK HARBOR—
THE GOLDEN DOOR" JULY 1986

"The greatest job" on earth"

By Priit Vesilind

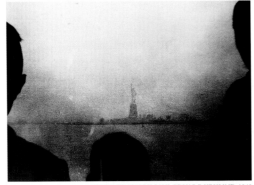

WHEN I LOOK UP FROM MY DESK in the marble-covered headquarters building of the National Geographic Society in Washington, D.C., I see myself on the wall. I am six years old in the black-and-white photograph that hangs there, and I'm flanked by my mother and my big brother, Aarne. You can see only the backs of our heads. We're on the deck of a ship, looking out through the fog at the Statue of Liberty in New York harbor.

We are refugees from Estonia, coming to America from a resettlement camp in Europe. The year is 1949. My father, with his old box camera, captures the moment. We are on our way to Beaver, Pennsylvania, a small town northwest of Pittsburgh on the Ohio River. The Ohio was once the way west for settlers in flatboats; when we reached the river valley it was a great, smoking, industrial corridor. Here, my father told us, we would be just Americans.

Twenty-six years later, as a new staff member of NATIONAL GEOGRAPHIC, my first assignment was to return to the Ohio: "The Ohio—River With a Job to Do," February 1977, with photographs by freelancer Martin Rogers. I wrote with affection and with memories:

"As kids we often sat on the bluff overlooking the river and watched the powerful towboats. They seemed endless—the barges of oil and chemicals, coal and gravel that passed and disappeared into the river haze. Late at night we heard the shift whistles of the mills and the faraway rumbling of hopper cars. And we heard the towboat horns lamenting the fog...."

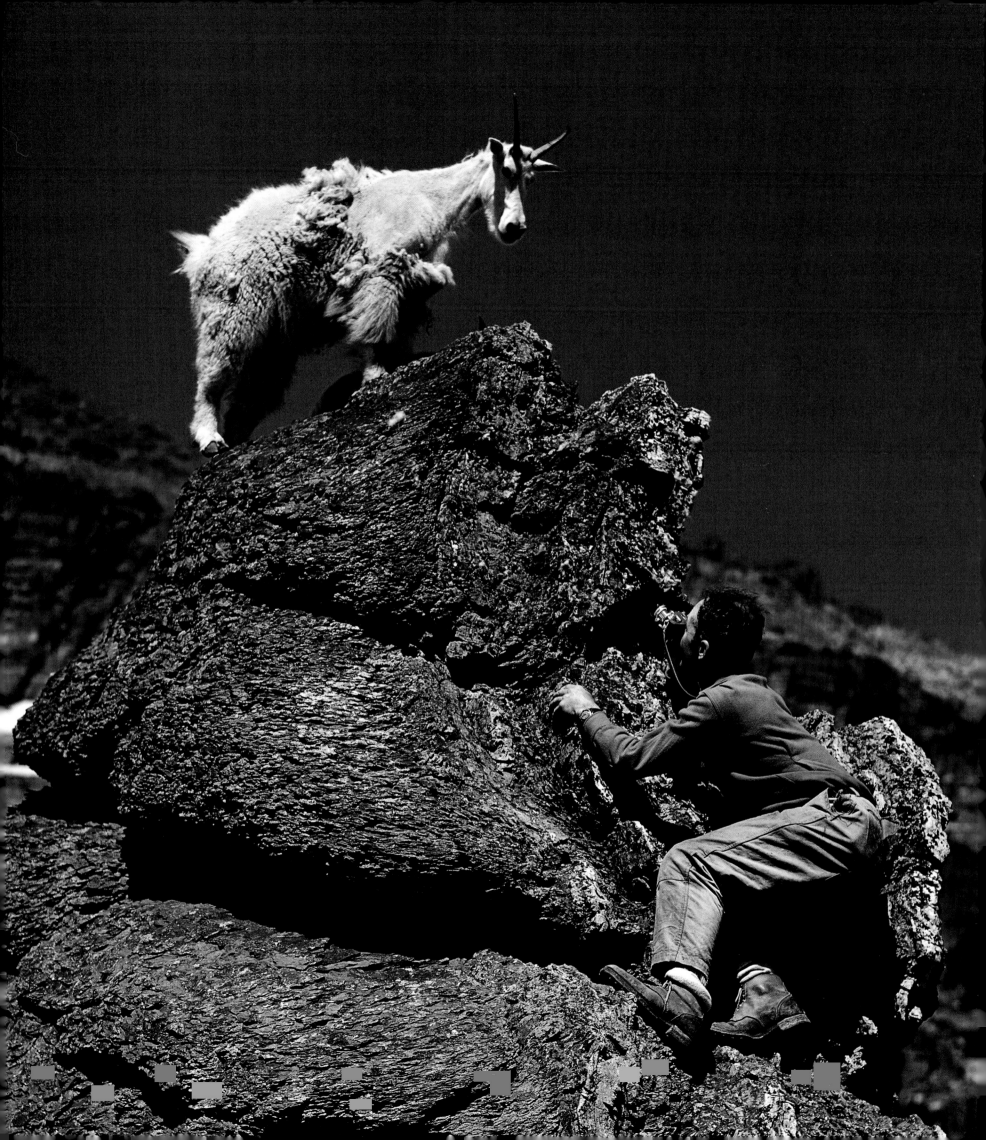

You will understand, then, why family, America, and the GEOGRAPHIC are things I treasure. And why writing this book has seemed a personal pilgrimage—a pilgrimage shared by all the colleagues who work or have worked in the field on assignment in the U.S.A. for NATIONAL GEOGRAPHIC.

You should not be surprised when emotion breaks through; it is part of the journalist's kit, along with professionalism, the ability to work hard and long, and a passion to get things right. On the Ohio story, I worked at various jobs along the river: tobacco picker, peanut vendor, sledgehammer man at a coal terminal, deckhand on a towboat. I fished for catfish, sang in a Christmas choir at a Serbian church. I got to see where the towboats go.

You always leave something behind on assignment, and something always clings to you. A year after the Ohio River article appeared, I drove back through Vevay, Indiana, where I had worked with a farmer named Joe Lamson, helping pick his tobacco crop. As I walked up to his house, I heard a voice call, "Here, Priit! Here, Priit!" And a small beagle scurried around the corner. My namesake. May it snuffle in rich hunting grounds.

IN ITS 110 YEARS the NATIONAL GEOGRAPHIC has published hundreds of articles on life, nature, and science in the United States. It has dispatched artists, writers, and photographers to record the nation's progress and changes through time. In so doing, NATIONAL GEOGRAPHIC has become our nation's journal of record. Or to put it another way, our nation's family album.

At any given time, some 25 articles are underway in the United States, with about 50 people in the field. The resources behind them are impressive: illustrations editors, text editors, legends writers, researchers, cartographers, designers, consultants, travel and medical offices. But only two souls sally forth—one writer, one photographer.

"So how was it?" friends and neighbors ask. "What's it like to be out there?" I usually relate some funny stories, but I can't fully explain the experience of living another life. I tell them that in the field I'm the eternal stranger, and at home I'm considered temporary help, and sometimes I feel like an intruder in both places. But they don't want that answer: no griping allowed when you have the greatest job on earth. They want to know about the romance and mystery—how you *feel* about it.

That's when I draw on the words of Maynard Owen Williams, one of the GEOGRAPHIC's truly great field men. In the 1940s a colleague asked him what it was out there that pulled him back time and again. His answer: "If I knew, I wouldn't go. The world is always full of surprises; that's why I go. The only reason I'm in this game is zest for my work; it's not a job to me; it's a pleasure."

The National Geographic Society and its magazine, the NATIONAL GEOGRAPHIC, were established on a chilly Victorian evening, January 13, 1888, at the Cosmos Club in Washington, D.C. A group of uncommon men—scientists, explorers, geographers, inventors, men of intellect and action—met and agreed on "the advisability of organizing a society for the increase and diffusion of geographical knowledge."

It would cast its net broadly. As the Society's first president, Gardiner Greene Hubbard, elected two weeks later, stated: "the membership of our Society will not be confined to professional geographers, but will include that large number who, like myself, desire to promote special researches by others, and to diffuse the knowledge so gained, among men, so that we may all know more of the world upon which we live."

PHOTOGRAPHER SAM ABELL on assignment
THE PACIFIC CREST TRAIL 1975

PHOTOGRAPH BY SAM ABELL

The new magazine would prove the key to accomplishing that goal. In October of that year, the first slim copies of the NATIONAL GEOGRAPHIC trickled off the press. The membership was then about 200 (today it is slightly over nine million).

The magazine early recognized the exceptionalism of America and was unabashed in its praise. Editor Gilbert Hovey Grosvenor (whose son and grandson followed in his footsteps as Editor) laid out this view in a spirited magazine-length opus, "The Land of the Best," April 1916:

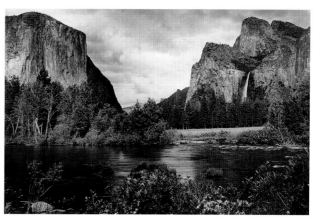

YOSEMITE NATIONAL PARK
"THE LAND OF THE BEST" APRIL 1916
PHOTOGRAPH BY PILLSBURY

"It is true that one finds a more ancient culture in Europe... more splendid architecture...better art; for before America was born into the family of nations Europe had castles and cathedrals and masterpieces of art and sculpture.

"But in that architecture which is voiced in the glorious temples of the sequoia grove and in the castles of the Grand Canyon, in that art which is mirrored in American lakes, which is painted in geyser basins and frescoed upon the side walls of the mightiest canyons, there is a majesty and an appeal that the mere handiwork of man, splendid though it may be, can never rival."

Gilbert Hovey Grosvenor also laid down a precept that the magazine would publish only material "of a kindly nature." Today, although the magazine deals with such unkindly subjects as the cocaine trade, illegal wildlife harvest, pollution, and urban decay, it still recalls that injunction. Its enduring philosophy is that the magazine will highlight the positive, while airing both sides of an issue. Says Thomas R. Kennedy, a lanky Floridian who became director of photography in 1987:

"Sometimes we're perceived as quaint or absurdly optimistic, but this world would be a hard place to live in if life were only cynical. Cynicism has its place, but we don't run roughshod over our subjects or put our own journalistic agendas above accurate chronicling of the lives of people that we are trying to portray. The strength of the magazine is that we make pictures that ring true—resonate to a certain place in the heart of Americans where there's that shock of recognition, and laughter in the next breath."

And the founders' aim to diffuse knowledge remains a key. Said freelance photographer Karen Kasmauski, who has covered highly technical subjects: "Americans don't see the GEOGRAPHIC as just another magazine. They see it as an educational tool. They use it as a reference to an area or a subject, and you want to make sure that what you're doing is not just the superficial pop culture, but a deeper definition of America."

It is no surprise then that when you go into the field for NATIONAL GEOGRAPHIC, you may encounter what some call the magazine's "halo effect." As staff writer Alan Mairson told me: "When you arrive in a place and people know you are from the GEOGRAPHIC, they get a warm, fuzzy feeling—and you get all the goodwill this organization has built up over the years. People welcome you into their homes in circumstances and in ways that you would never get otherwise."

YOU PACK YOUR BAGS with the usual mix of guilt and anticipation—guilt at leaving your family, anticipation at the work ahead. You toss in small spiral notebooks, ballpoint pens, scissors (to clip newspapers), camera, lenses, tape recorder, tapes, batteries, flashlight, duct tape, laptop, coffee bags, paperback books, peanut butter, radio, binoculars, Swiss army knife, sunglasses.

An assignment in the United States can be a relief from difficult overseas assignments. The phones

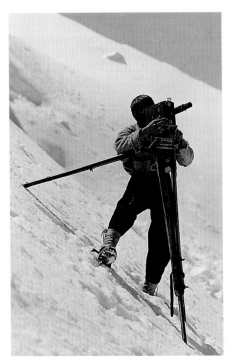

EXPLORER-CARTOGRAPHER BRADFORD
WASHBURN on Mount Crillon, Alaska, 1935

*Often hailed as America's fore-
most living exploratory cartographer,
Bradford Washburn led expeditions to
photograph and map many uncharted
places in North America. Much of
Washburn's work was in Alaska,
where his wife, Barbara, a constant
professional colleague, became the first
woman to climb the continent's high-
est peak, Mount McKinley. He began
in the 1920s, at a time when radio
communications between mountain
climbers, equipment airdrops, and long
airplane flights at high altitudes were
still in their infancy. During these
early, hazardous years, Washburn's
work helped set new standards for
such scientific exploration.*

*Washburn devoted seven years
to creating a precise large-scale map of
the Grand Canyon, which was published as a supplement in the July
1978* GEOGRAPHIC. *For this achievement and others, he was hon-
ored with the Alexander Graham Bell Medal for "unique and notable
contributions to geography and cartography" in 1980.*

*Bradford Washburn, now 87, continues to be among the premier
aerial photographers in the world.*

EXPEDITION NEARS SUMMIT of Mount Hayes, Alaska, 1941

PHOTOGRAPHS BY BRADFORD WASHBURN

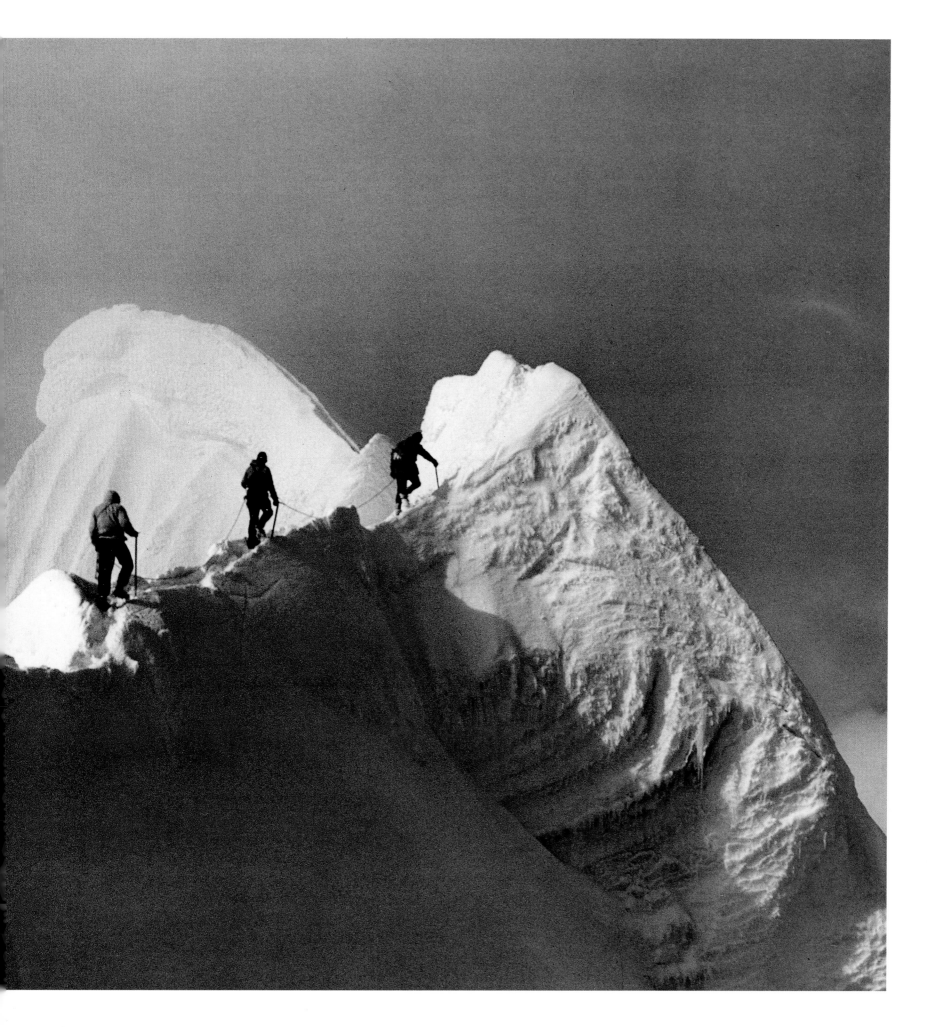

work, no translators are needed, and the reputation of the magazine opens doors. But a U.S. subject can make work more difficult for photographers.

Said Kent Kobersteen, associate director of photography: "It's really tough to go down the same kind of streets you go down day after day and see them in a fresh way. It's a challenge to work in your own backyard and in your own culture."

In the field the photographer's task is to find images that reveal or symbolize the subject; the writer's challenge is to find the people, the situations, the words that achieve the same goal. If the assignment is, say, "Pittsburgh," and the guiding premise is "the collapse of the steel industry," the sub-themes may include: breakdown of the neighborhoods, erosion of union influence, new high-tech industries, change of curriculum in local universities, homeless people on the streets.

Not every lead pans out. Out of four union halls he visits, for example, the writer may find in only one the mixture of people, information, and quotes he needs. And only one woman out of three in a homeless shelter may be able to describe fully and clearly her situation. The writer also records personal observations: the intense heat of a coke oven, the industrial smell of the Monongahela River on a warm night, the taste of a kielbasa at the home of a Polish priest.

One guideline for a GEOGRAPHIC story is that the writer should use the first-person narrative: *I* went there; *I* felt this. "But you have to earn the right to put yourself in the story," said retired senior writer Bryan Hodgson. "You have to do something, be involved somewhere. One way or another you have to get your feet and hands dirty, get wet."

And all the time, the writer knows that out of 60 interviews he may be able to use perhaps ten, and from each of these he may pull only eight or ten lines from a conversation that lasted several hours. The photographer, meanwhile, may shoot 1,000 rolls of film on this single story—36,000 separate images—to arrive at the 30 that will be published. These are the pearls extracted on each assignment.

PHOTOGRAPHERS SOMETIMES struggle to the airport with 20 bags of gear and anxiety in their hearts. "You step off the plane," said longtime photographer David Alan Harvey, "and you have a lot of film that has not been exposed. And a roll of film with no pictures on it is absolutely frightening."

"For the first day you're too scared to leave the hotel," said Jodi Cobb, a staff photographer who has completed some 20 NATIONAL GEOGRAPHIC assignments. "It's all a big mistake, you think. Every story for the past 20 years was a fluke. You order room service and go to bed. The next day you go out and start slaying dragons."

Photographers have varied approaches to their work. Freelancer Annie Griffiths Belt told me: "I'm always looking for something that will reveal the place and the subject. I talk to everybody. I read every bulletin board in every cafe. I talk to the maid in the hotel. I talk to the guy who fills my car with gas. The entire assignment, I'm searching, searching. And when I finally see it, it's like a camera's flash going off in my head."

David Alan Harvey said: "I sit and listen. I go back to the same street corner day after day. Pretty soon you're invited to dinner by the owner of the shop on the corner, and then the daughter is having a birthday, or a wedding, and you're invited."

"The reality is that photography is a lot of work," freelancer Steve McCurry told me. "It takes all your concentration. I must focus 100 percent; otherwise, I lose my way. The assignment is a football game: There is a definite amount of time to do a story, and you have to do it. There is no alternative to doing a great job."

Photographers' work is physically demanding. Said Karen Kasmauski: "I'm not a real outdoors person. I don't rock climb; I don't bungee jump. But sometimes your mind just stops, and the fear of not

getting the picture kicks in. So here I am in Alaska, climbing a sheer rock cliff, with ropes and a 40-pound backpack, handling fragile photo gear at the same time. It's pouring rain; it's 30 degrees; and I have to get to these bird rookeries ["Oil on Ice," April 1997]. After it was over and I got back to my hotel, I realized that every bone in my body was aching, and there was a tingling sensation in all my muscles."

When a photographer sees a great photo within his grasp, he may feel a sudden sense of isolation. Staffer Sam Abell said: "Your concentration is so honed on doing the picture, and part of you thinks: Lord, don't desert me now. Just let me do what I need to do mechanically. Let me load the film, put the right lens on; let me not blow it right now. You scarcely breathe. Time stands still, stretches, curiously speeds up, gets misshapen."

Obsession is not too strong a word for some photographers. "Sometimes you get on a roll," said staff photographer Chris Johns, "and once you're on a roll, you don't want to stop. So you don't sleep much. Then you go too far, and you crash. My left eye starts to twitch uncontrollably. That means I'd better rein myself in a little bit."

The abiding fear for both photographer and writer is missing the story, missing the point in a given situation. Freelance photographer Jim Richardson told me of a recurring dream. "When I am awake, working, I may go into a small town and find it pretty dead, dried up, hard to make something interesting out of it. Then that night I may dream that I am back in the Midwest, and I go to the town I knew as a boy. And gee, there are interesting shops, a jazz band playing at the pub, nice brick houses, interesting people, things going on. It's a fascinating place, this town of my dream.

"And somewhere along the line I wake up. What the dream tells me is that in real life I've gone to some place—like the town I found dead and dried up—and I haven't seen what was there, and it was my fault. *My* fault for not being open to it. I passed it by."

LONELINESS IS A CONSTANT companion. "Everybody assumes that you're drinking champagne out of a lady's slipper every night," said Bart McDowell, a dapper retired staff writer. "But there aren't that many ladies or that much champagne. What you're really doing is trying to find a restaurant that won't give you indigestion and that has enough light so you can read your paperback."

"Many times you wake up in a motel," reflected Boyd Gibbons, a staff writer for 15 years, "and don't know where you are. You get up thinking you're supposed to walk the dog. And then you go in the bathroom and there's that band across the toilet that says 'sanitized for your protection,' and you remember where you are."

A few women have succeeded in integrating family with assignments. Annie Griffiths Belt is married to assistant editor Don Belt, and they sometimes do assignments together. They have Lily, seven, and Charlie, four. "When I was pregnant with Lily and on assignment," Griffiths told me, "I had a dream: In this dream there was a monster child in my hotel room, eating a room service meal and watching MTV. It scared me. So when the kids come along with me, I get a nanny, and we don't stay in hotels, but in a beach cottage or such, in a neighborhood, and the kids' lives go on.

"We do home schooling on the road, and when I am in town, I volunteer in their classroom once a week, so I know the drill. And I'm not lonely. Never lonely. Usually the kids are in the same bed with me."

Life seems to move by with swift feet. Said Joel Sartore, "In the eight years

WRITER PRIIT VESILIND on assignment
"HUNTERS OF THE LOST SPIRIT"
FEBRUARY 1983

PHOTOGRAPH BY DAVID ALAN HARVEY

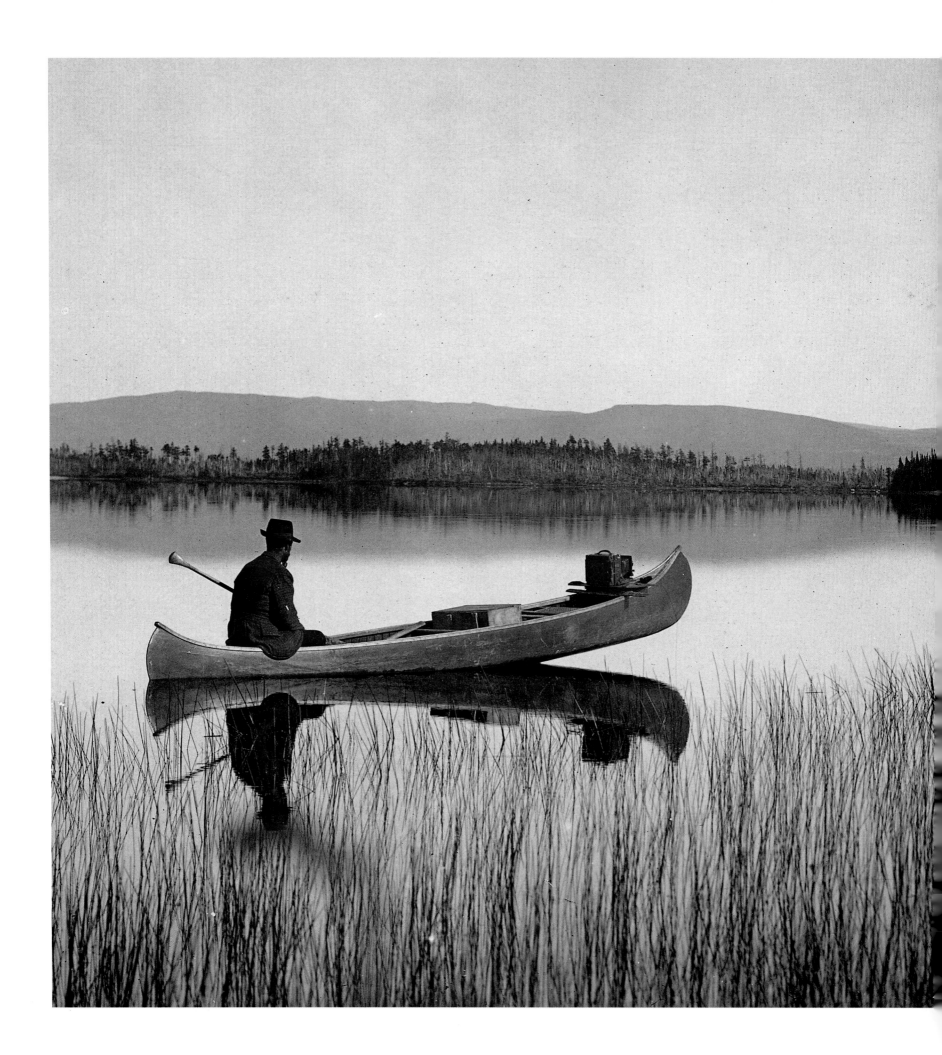

An early pioneer in wildlife photography, George Shiras 3d brought the first real glimpse of animals at night to GEOGRAPHIC readers, traveling by canoe in search of deer, raccoon, or bobcats grazing along the shore. Shiras experimented with magnesium-powder flashes before finding one quick enough to capture images of fast-moving animals on the slow-to-register film plates of the day. He would later invent a system of trip wires that triggered shutter and flash mechanisms, enabling animals to snap their own photographs in their natural habitat. Among the animals he bagged: a large caribou stag (below) photographed on a dark day for "One Season's Game-Bag with the Camera," June 1908.

Shiras was also ahead of his time in the field of conservation. While serving as a congressman from Pennsylvania, he introduced the Migratory Bird Act of 1904. It contained unprecedented legislation to help protect wilderness areas for generations to come.

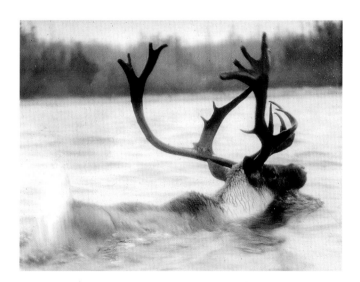

PHOTOGRAPHER GEORGE SHIRAS 3D at left in canoe in Deer Lake, Newfoundland
PHOTOGRAPHS BY GEORGE SHIRAS 3D

PHOTOGRAPHER KAREN KASMAUSKI with son Will
on assignment "JAPAN'S SUN RISES OVER THE PACIFIC" NOVEMBER 1991

PHOTOGRAPH BY BILL DOUTHITT

I've been shooting for the GEOGRAPHIC, I've been away so much that my wife has purchased two cars and a house without me first seeing them. I don't think about my life in terms of what happened in 1994 and 1995. I think, for example, that my son was born between the 'Federal Lands' and 'Endangered Species' assignments, and I know that my second child will be born just before layout on the 'Nebraska' story."

In the novel *The Bridges of Madison County,* the fictional hero Robert Kincaid is portrayed as a NATIONAL GEOGRAPHIC photographer, a self-contained man but one who has spent a large part of his life struggling with personal involvements. At least that last part is true. "Your ability to be a good citizen, have children, remain married, be a faithful friend, are all put into jeopardy by the job," said Sam Abell.

"You're out there doing something totally apart from your life back home," said staff photographer William Albert Allard. "The juices are going; it's both great and there's an element of danger. You've gotta somehow keep it together, keep yourself together."

I am not the only father to carry photographs of my kids with me on assignment, little collections that used to get dog-eared from wistful thumbing. In my 24 years at the magazine I have seen too many friends and colleagues floundering through divorce.

With children, pets, a house, automobiles, sometimes a career of their own to manage, spouses end up carrying an immense load. Resentments can build. Keeping in touch is paramount. Some writers and photographers in the field call home every night. E-mail has made a tremendous difference. Photographer George Mobley writes letters home on paper place mats or napkins from restaurants. "They bring out the menu, and you look at the menu, order, then flip the mat and start writing. Then you fold it up, put it in an envelope, and mail it home." His daughter Tammy calls such letters "napkin art."

Freelance writer Michael Parfit used to arrange to read to his kids while in the field. "I read them the entire *The Lord of the Rings* trilogy twice," he told me. "The first time on tape, and the second time I read it to them in bits over the phone."

I told my wife Rima that I would try to send a postcard every day. At breakfast, when possible, I write a few words on a card and draw a picture of a cartoon duck (Vesilind means "waterbird" in Estonian) doing whatever I had done the day before: the duck struggling with luggage, lost in the rain, climbing a mountain, running a fever....

No one wants to hear the well-known words that one photographer's girlfriend spoke to him: "If you think your pictures are that important, let me know now so I can bring them to you on your deathbed, and you can hug them."

AND THEN YOU COME HOME, sunburnt, shaggy, jet-lagged. One day you're interviewing a governor; the next day you're taking out the garbage. Karen Kasmauski remembered: "My daughter was born while I was working on the virus story ["Viruses: On the Edge of Life, On the Edge of Death," July 1994]. I weaned her at three months, and three days later I'm on a plane to Puerto Rico to photograph heroin addicts. With Wilmer, my streetwise guide who had grown up in the housing projects, I walked over syringes and bullet casings to get from one 'shooting gallery' to another.

"After that harrowing week, I come home, and before I can get to the door, my son runs out and

asks me to make him macaroni and cheese. I don't have time to decompress. I have to immediately get into a housewife mentality. People ask, 'What do you do?' I laugh. I tell them I'm Martha Stewart and Indiana Jones."

Rituals can ease the homecomings. My wife and I usually conduct a "transfer of loads" in the car coming from the airport. Rima blurts out all the troubling things that have happened in the past six weeks, then breathes a big sigh. She is immensely relieved, wanting to go out to a restaurant for dinner. And I am suddenly depressed and want only a home-cooked meal and my old saggy chair.

PHOTOGRAPHER JOEL SARTORE at home editing after assignment "SANCTUARY: U.S. NATIONAL WILDLIFE REFUGES" OCTOBER 1996
PHOTOGRAPH BY KATHY SARTORE

At the end of an assignment differences between writer and photographer are highlighted. The photographer's work is essentially done; his photos are "in the can." He has only to work with the illustrations editor to select the very best of his images (bickering a bit over the choices, of course).

For the writer, there are more weeks of work ahead—building the story from the piles of notebooks and tapes and from the memories he has collected in the field. There is often frustration. As veteran writer Charles E. Cobb, Jr., told me: "We cover so much ground that we have enough material for a book, but we must compress it into an article of 25 to 39 pages. There's never enough room."

And it will be usually six or more months before the article appears in NATIONAL GEOGRAPHIC. "It's disconcerting at times," said Associate Editor Robert M. Poole, "when you're sitting on a story for six months, and you see pieces of it showing up in the *New York Times* and other publications. But our publishing rhythm forces us to take a long view of a place or a subject, to dig deep, to get to what really matters, to the things that will be true five years from now. That's the kind of reporting that makes our stories different."

IT SEEMS SELFISH in this business to expect both halves of your life to be in tune, but many of us have been lucky enough to keep loving families intact and to experience the kind of moments in the field that photographer Richard Olsenius described to me:

"Sometimes when I was doing the Wyoming story ["Wide Open Wyoming," January 1993], I would leave a ranch or a farmhouse, and my eyes would be wet. I wouldn't be crying out of sorrow, but because maybe I had caught a glimpse of life that was so moving—an old Basque shepherd on a ranch, a family sitting around a kitchen table. And I'd drive back to my hotel room in the blue light, and music would be playing on the car radio, and I'd get an overwhelming sense of our common humanity, and how fragile we are as human beings, and how beautiful and how vulnerable. And I'd get these emotional waves hitting me, and it's something I rarely get any other time.

"It gives me the tiniest microgram of—if there is a God—what He must feel in any given day if He's able to look into people's minds across the universe and process that information. How do you keep from burning out? It gives you a deeper respect for a God who can absorb the whole human story."

So I have interviewed my colleagues, listened to their tapes, pored over bound volumes of the GEOGRAPHIC so old the covers crumbled in my lap. I found that my colleagues have covered this nation with affection and respect and with a glad and open heart. And I am thankful, each time I look up from my desk at the old photograph of myself and see the fog of New York harbor billowing around Liberty, that in this nation of infinite possibilities I can count myself among such men and women.

The chapters that follow take you backstage and tell the stories behind the stories—on assignment for NATIONAL GEOGRAPHIC. ■

CHAPTER ONE LAND

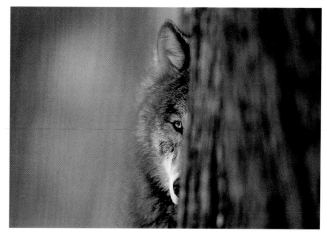

"This was the assignment I was born to do... It's been an obsession of mine, and continues to this day...

—JIM BRANDENBURG

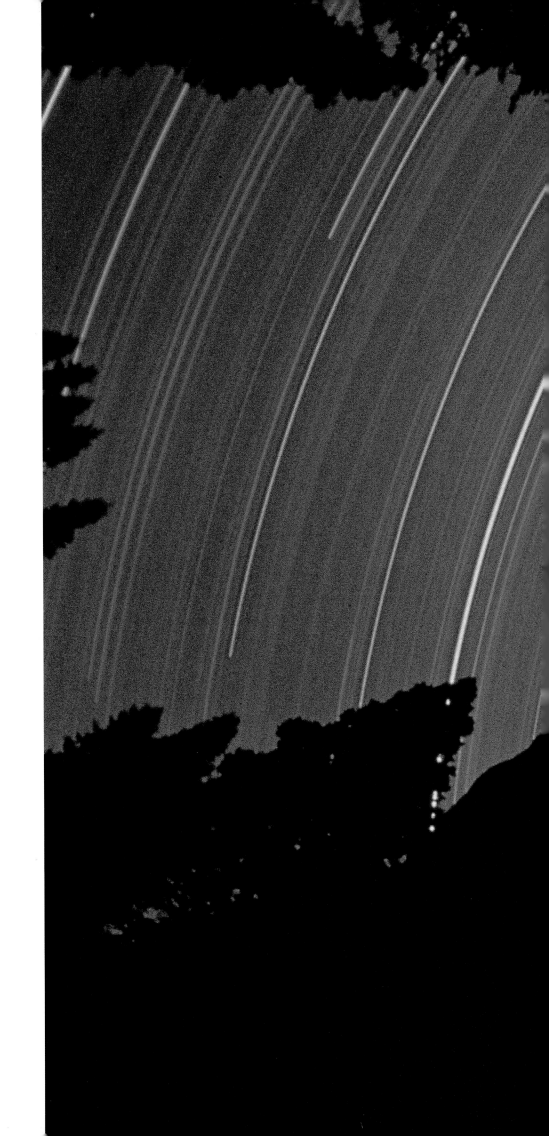

1491 AMERICA BEFORE COLUMBUS
"THE LAND THEY KNEW"

October 1991

photographs by
JIM BRANDENBURG

> " The winds are dark passages among the stars, leading to whirling void pockets, encircled by seeds of thought, life force of the Creation. "

—PETER BLUE CLOUD
TURTLE CLAN MOHAWK

STARS SWIRL ABOVE sequoias
in a time-lapse photograph, Kings
Canyon National Park, California.

preceding page:
CAPTIVE-BORN wolf roams
in Superior National Forest, Minnesota.

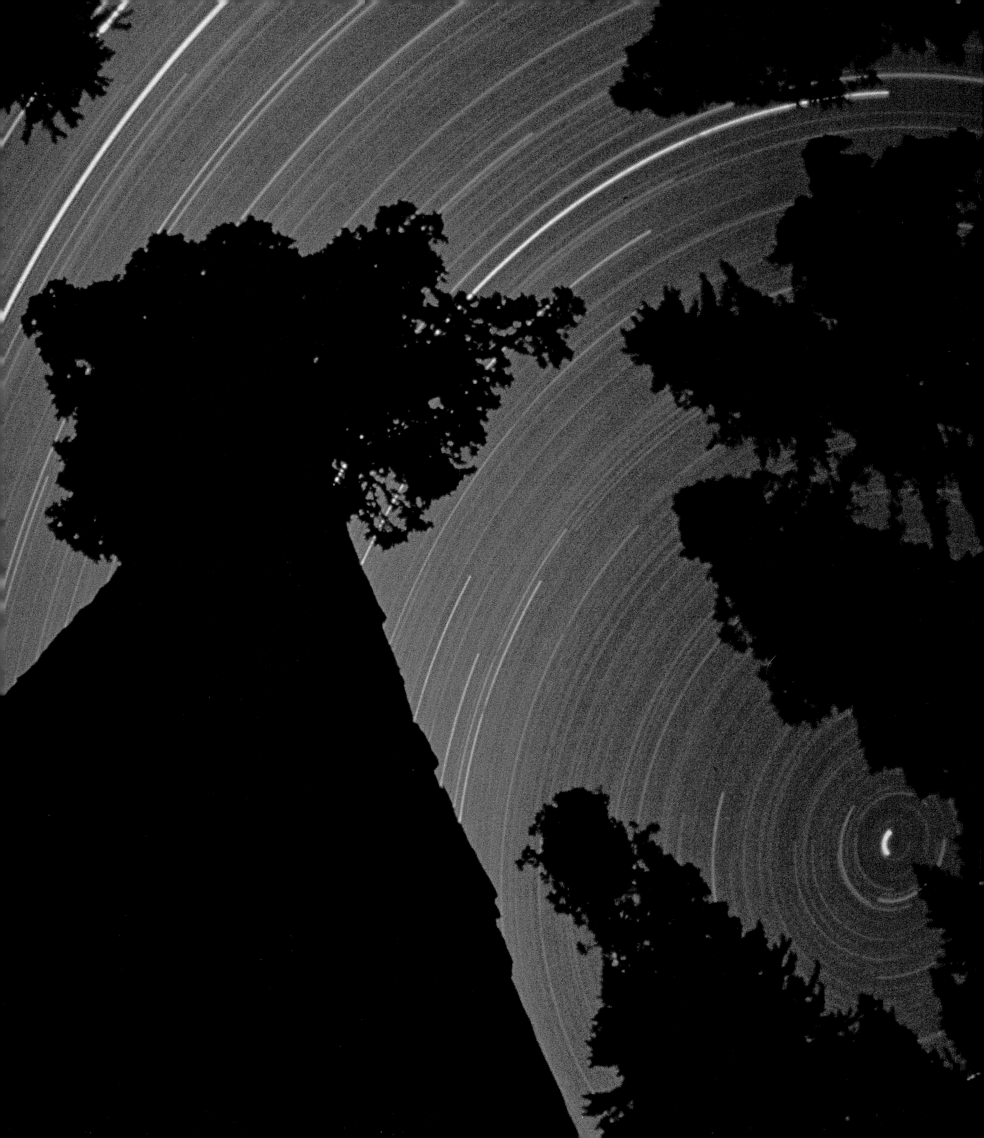

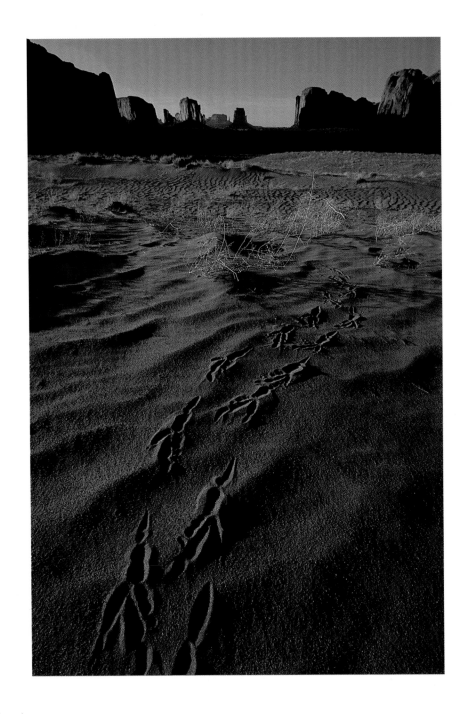

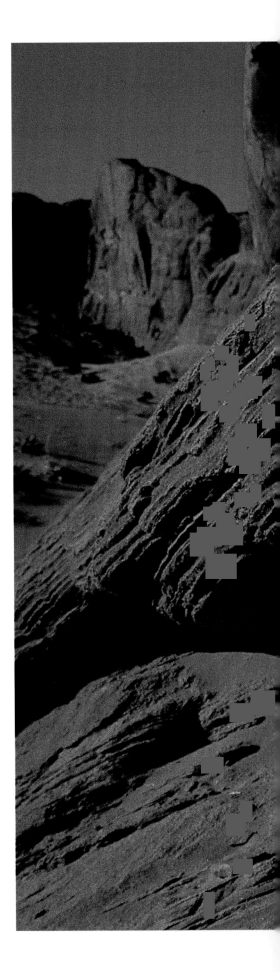

❝❝The animal in me crouches, poised immobile, eyes trained on the distance, waiting for motion again. The sky is wide; blue is depthless; and the animal and I wait for breaks in the horizon.❞❞

—SIMON J. ORTIZ
ACOMA PUEBLO

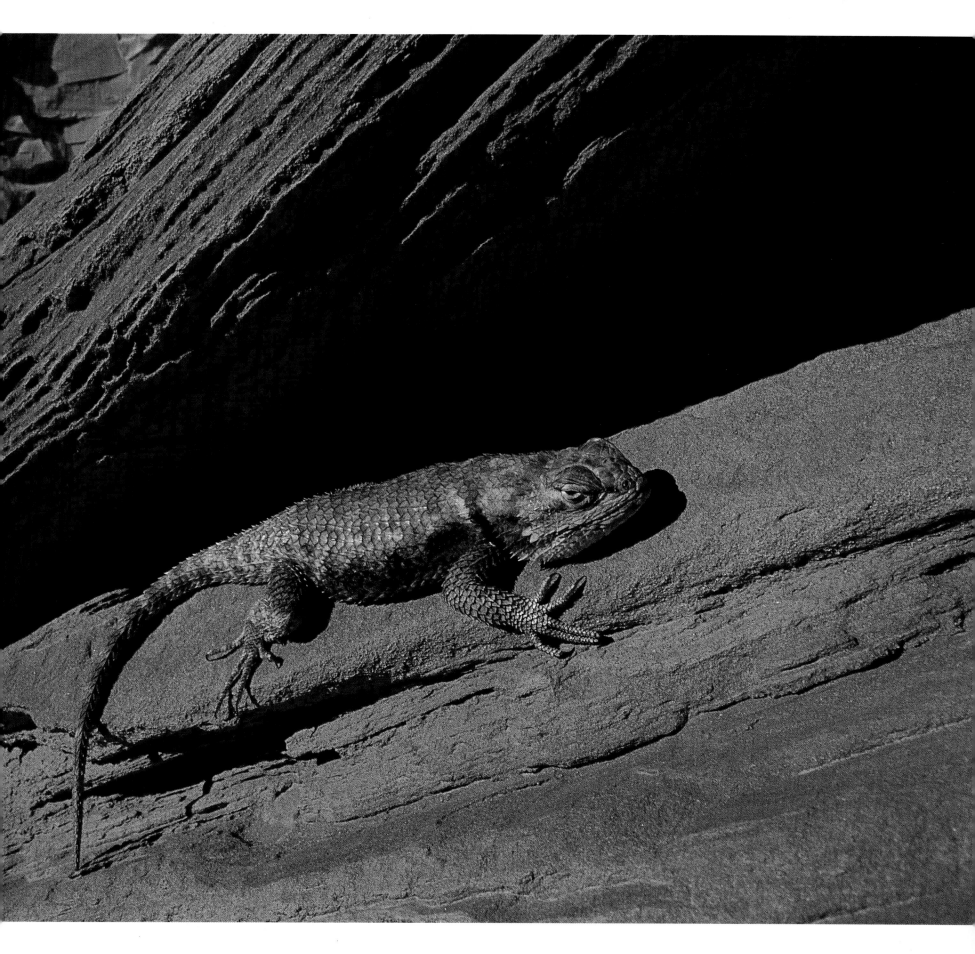

TRACKS MARK A RAVEN'S PATH (opposite), and a lizard bakes
in the Arizona sun on the Navajo Reservation in Monument Valley.

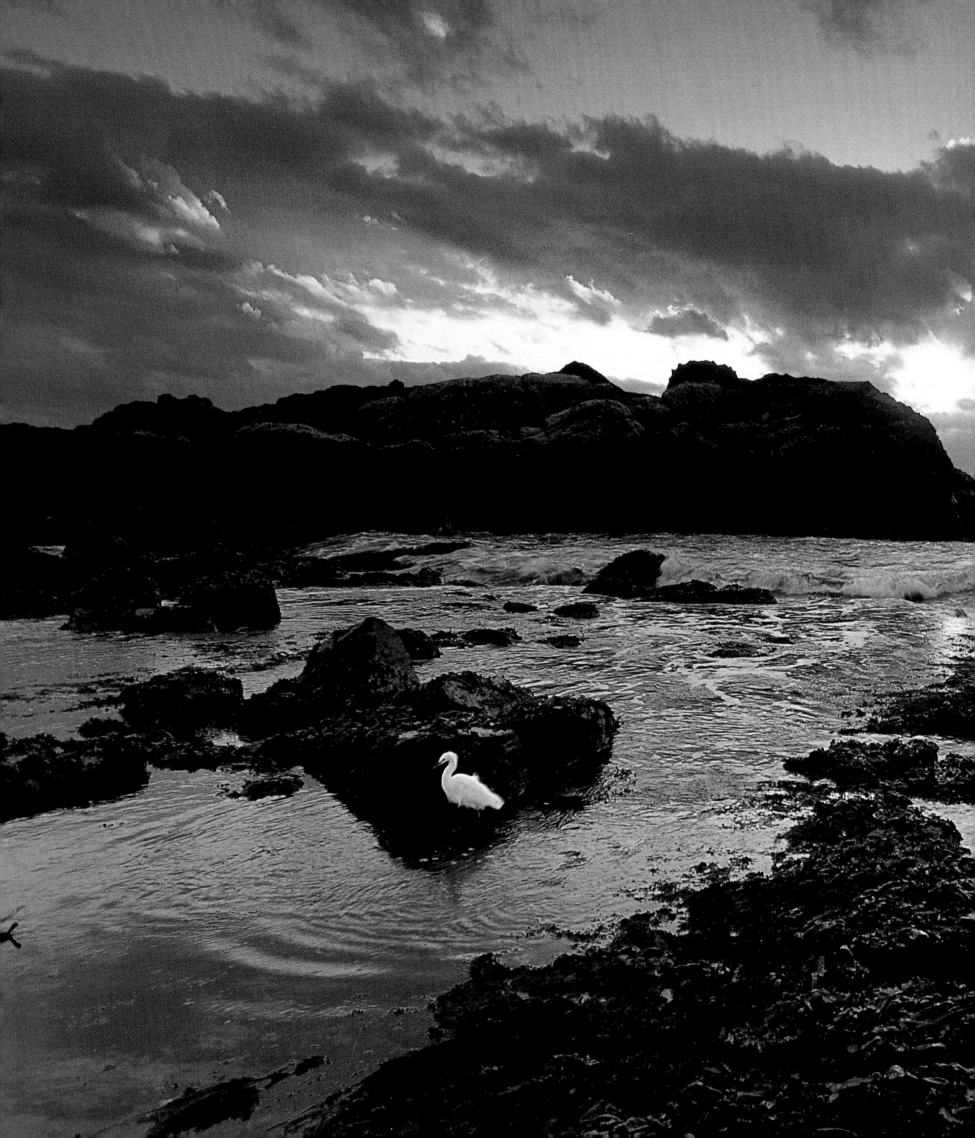

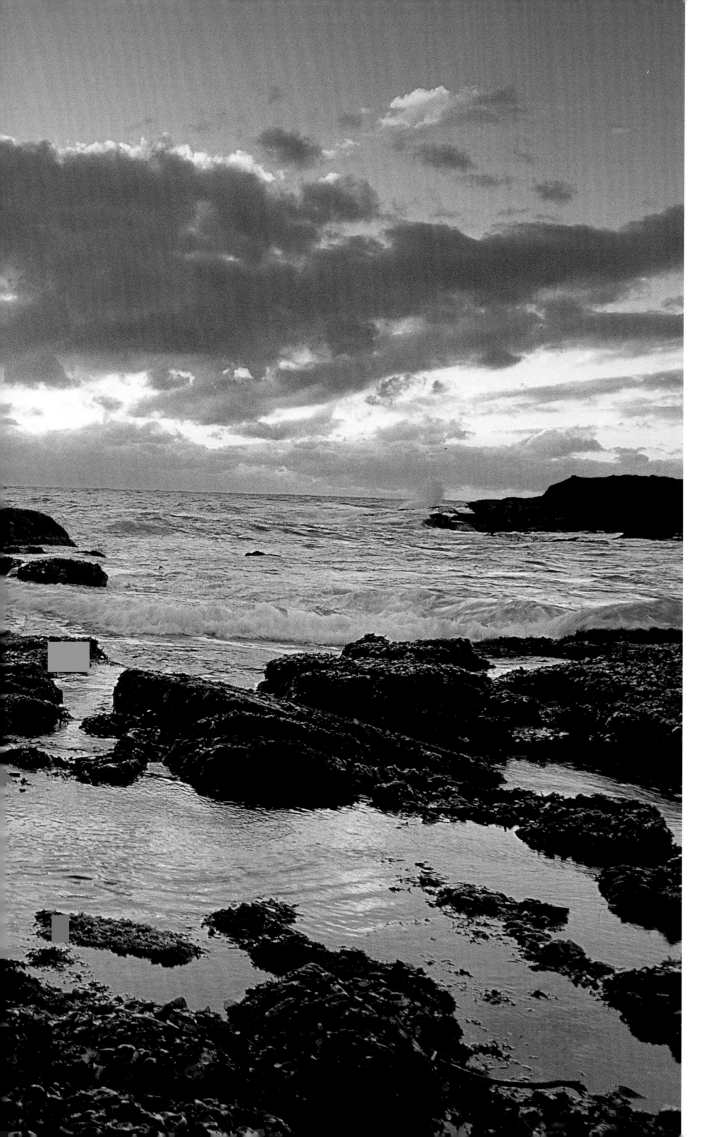

PACIFIC OCEAN tide pools
fill outside Monterey, California.

"I can never own a forest, even though the deed be in my name, and I think that is the Indian in me. But that forests own me, I have no doubt, for I have been making pilgrimages to them, summoned by every change of season, as far back as my memory goes.

"So when I write of national forests, I confess that in any tug of loyalties, I am for the trees."

ROWE FINDLEY, assistant editor,
in "Our National Forests: Problems in Paradise"
September 1982

IMAGINE THE LAND—just the land—the wilderness of the New World. Imagine the land as Native Americans knew it—unspoiled, unruly, electric with spiritual energy. Imagine it before Christopher Columbus made his historic voyage of discovery in 1492. What did the land look like, feel like?

That was the assignment given freelance photographer Jim Brandenburg in 1990, as NATIONAL GEOGRAPHIC made plans to mark the 500th anniversary of the Columbus voyage: Make photographs of America as it was.

"This was the assignment I was born to do," said Brandenburg, whose pictures of white arctic wolves remain among the most astonishing natural history photographs ever published. "This was something that I had thought about since I began shooting pictures: How do you portray the land without any vestiges of man's footprints? It's been an obsession of mine, and continues to this day."

The Columbus celebration was controversial: Many critics protested that it was wrong to celebrate an event that led in time to the destruction of Native American cultures and the despoilment of wilderness. Environmental purists complained that the magazine's concept could be harmful. "They said that we would be depicting the land as a lie," said Brandenburg, "that there's nowhere you can go where you can't see a jet trail or a telephone pole." But he was not discouraged.

Brandenburg set out from his home in Ely, Minnesota, with his 21-year-old son, Anthony, and drove west. "We wanted to go to western South Dakota, where the prairie is a little less torn up. We had barely made it to the Badlands, near Wounded Knee, and we pulled up to this

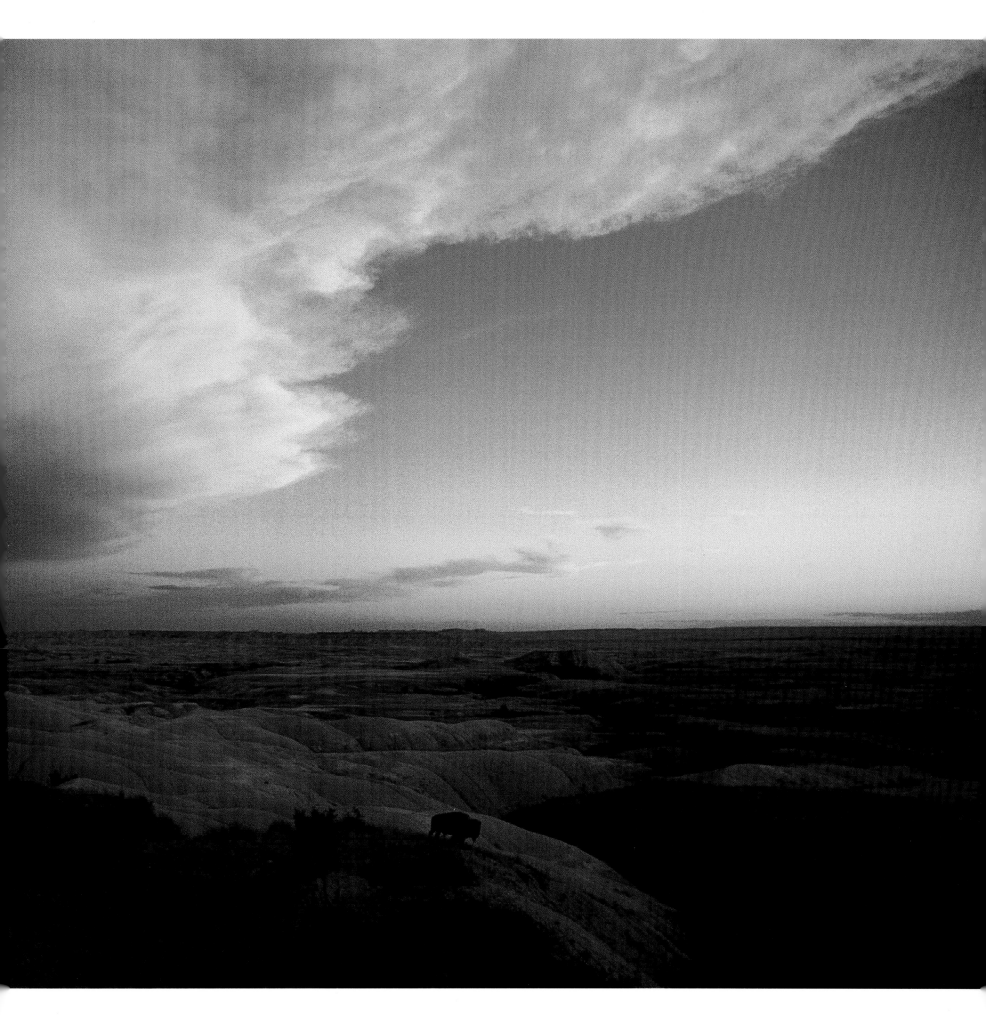

LONE BISON WANDERS near the Oglala Sioux Pine Ridge Reservation, Badlands, South Dakota.

vista just as the sun was setting. And there was a lone bison. Often the old bulls will go off by themselves. You find them far from the herd—they can be very dangerous.

"I saw this bull standing, and I knew what lens I needed—an extreme wide-angle. I grabbed a camera body and a lens, jumped over a fence, and started shooting. The exposure was a little too slow for the camera to be handheld, and I remember crouching down, planting my elbows into my knees, holding my breath like a target shooter, and squeezing off these images." The first picture became the lead photograph of the portfolio. "That was incredible," Brandenburg said. "That had never happened before.

"That image spoke volumes to me. The prairie is mainly about sky, and I got a remnant of the old prairie, and that old bull was the sentinel. To me, that is an ultimate—to have an image that works visually, and one you can wrap a story around, based on truth, pain, joy, and romance."

Brandenburg was frustrated only in the Northeast, in states like Vermont, where old-growth forest long ago had been plowed into fields and new forest had taken its place. But he found heaven among the sequoias, some as old as 3,500 years, of California's Sequoia and Kings Canyon National Parks. "It was the most exhilarating, religious experience I've had," he said. "I'd never been to the big old men, the old trees, and I was just absolutely blown away."

He did not know then that many of the sequoias owed their existence to the National Geographic Society. In 1916 the Society contributed $20,000 to help the government buy acreage and preserve the trees. In the early 1920s the Society donated $76,330 more. These gifts preserved 1,916 acres.

To capture the stars swirling above the trees in the photograph that opens this chapter, Brandenburg spent five nights in a sequoia grove, setting three or four cameras on tripods underneath the trees. "I used different lenses, with different kinds of film and different camera angles," he said. "Just at dark I tripped all the shutters and left them open for ten hours, hoping that people wouldn't come by at night with flashlights and spoil the exposure, or steal the cameras."

As the clear mountain nights passed, starlight painted brilliant arcs across the film, while the trees remained black silhouettes. Brandenburg returned just before dawn each day to close the shutters again, and on some mornings the cameras would be covered with snow.

"I really always wanted to be a painter or a writer," he said, "to create something done by a person rather than by an electronic box. But here's a case where technology created an illustration that was evocative of time and universe and perception. Only a camera could do that—only a camera."

Brandenburg's evocative portfolio, "The Land They Knew," accompanied by words from Native Americans, was published in October 1991. The issue included five articles, illustrated with paintings and photographs, portraying Native American cultures on the eve of cataclysmic change. Columbus himself got his due in a two-part historical treatment in January 1992.

THE NATIONAL GEOGRAPHIC SOCIETY early embraced the principle of wise and prudent use of natural resources and was a sturdy advocate of environmental responsibility. In May 1908, in "An American Fable," Gifford Pinchot, Chief of the United States Forest Service, warned in the magazine:

"We have been so busy getting rich, developing, and growing, so proud of our growth, that we have let things go on until some intolerable abuse has compelled immediate action to cut it off. It is time that we put an end to this kind of opportunism...."

The magazine had already noted in December 1897 increasing pollution in the Potomac River. It had cautioned that "the self-purification of rivers is a phrase which has been made the excuse for much carelessness or indifference...."

In July 1906 an entire issue was devoted to wildlife: "Photographing Wild Game with Flashlight and Camera," by the Honorable George Shiras 3d, a former U.S. congressman who hunted with a camera. Seventy-four candid photographs captured animals—deer, porcupines, a wildcat—as they tripped across triggers in the darkness.

Shiras's photographs, which had won prizes at the Paris International Exposition in 1900 and the

Louisiana Purchase Exposition at St. Louis in 1904, but which had not been published before, caused a sensation. He would contribute eight more articles to the magazine and a book for the Society.

In the 1906 issue he wrote:

"One purpose of this article is to show that the time has come when it is not necessary to convert the wilderness into an untenanted and silent waste in order to enjoy the sport of successfully hunting wild birds and animals."

But Shiras did not disparage hunters: "…they have done much in keeping up the virility of the race, and in leavening those debasing influences of over-civilization." Indeed, the magazine itself, in those more sanguine years, published several articles on hunting.

GEORGE SHIRAS 3D on assignment in 1909
HUNTING WILD LIFE WITH CAMERA AND FLASHLIGHT
PHOTOGRAPH BY GEORGE SHIRAS 3D

In addressing natural history, early GEOGRAPHIC editors often catalogued subjects like 19th-century English botanists, producing elegant and precise articles remindful of encyclopedia chapters. Among the first was "Fifty Common Birds of Farm and Orchard," June 1913, a reprint of U.S. Department of Agriculture Bulletin 513, prepared under the direction of Henry Wetherbee Henshaw, Chief of the Bureau of the Biological Survey, with paintings by Louis Agassiz Fuertes.

The colorful illustrations and text blocks were aimed to "serve the very practical purpose of enabling our farmers and their boys and girls to identify the birds that frequent" the countryside. Other such articles followed, including "Our State Flowers: The Floral Emblems Chosen by the Commonwealths," June 1917, and "Common Mushrooms of the United States," May 1920.

Covering the sweep of nature in the United States was a daunting undertaking, but few mountain ranges, beaches, forests, or deserts escaped the scrutiny of the GEOGRAPHIC through the years. And most creatures, great and small, got their moment—from Gilbert H. Grosvenor's "Reindeer in Alaska" in 1903 to "Into the Land of the Chipmunk" in 1931 to "Br'er Possum, Hermit of the Lowlands" in 1953.

From the beginning, articles were upbeat and celebrated the scenic beauties of the wilderness, the growth of the national parks, and the wondrous variety and ways of wildlife.

Readers came to know twins Frank, Jr. and John Craighead, tireless outdoorsmen, who contributed 13 articles over 40 years. In one they sought to study the habits and biology of bears in Yellowstone National Park: "We followed this grizzly day and night and slept wherever darkness overtook us."

Paul A. Zahl, a devoted scientist who spent much of his life in the field, contributed an astounding 54 articles over 33 years. In "Mystery of the Monarch Butterfly," April 1963, readers discovered with Zahl where the lovely creature goes on migration.

BY THE LATE 1960s a powerful new force had swept across the nation: the environmental movement. Events such as the publication of biologist Rachel Carson's book *Silent Spring* in 1962 had alerted millions of Americans to the dangers in the indiscriminate use of pesticides. Progress, it seemed, had a cost.

The GEOGRAPHIC confronted this issue in "Pollution, Threat to Man's Only Home," December 1970, by staff writer Gordon Young, illustrated by staff photographer James P. Blair. The article, a landmark for the magazine, was accompanied by a supplement, "How Man Pollutes His World," and a photo-essay, "The Fragile Beauty All About Us," by Harry S.C. Yen. The portfolio depicted plants and animals. Frederick G. Vosburgh, in his last year as Editor, wrote the foreword for the coverage:

"Today, with eighty million more Americans and also eighty million more cars, trucks, and buses than 40 years ago, we see smoking stacks and acrid exhaust fumes as poisoners of the air we breathe, as examples and symbols of man's befoulment of the only home he has.

"Full realization of this sober truth has come since Christmastime 1968, when—through the eyes and cameras of

moon-orbiting Astronauts Frank Borman, James A. Lovell, Jr., and William A. Anders—we first saw our earth as a planet, and saw ourselves, in the words of poet Archibald MacLeish, 'as riders on the earth together, brothers on that bright loveliness in the eternal cold—brothers who know now they are truly brothers.'"

At a planning meeting before fieldwork began, some editors suggested an international approach—Mexico City for air pollution, the Rhine River for water pollution. But photographer Blair suggested a U.S. focus—Los Angeles for air pollution, the Cuyahoga River in Cleveland for water pollution. Blair remembered: "By the end of the meeting, my dream trip around the world was history, and Herb Wilburn [the illustrations editor] turned to me and said, 'Have a good trip to Cleveland.'"

Nevertheless, Blair set out with a missionary's zest. Blair's fire had been stoked some weeks before by the legendary David Brower, a leader of the Sierra Club and a relentless crusader for the environment. At an Earth Day gathering at the University of Michigan, Blair had been photographing a session during which Brower was speaking. "And in the middle of his discussion," Blair said, "Brower turned and pointed to me: 'This is a photographer from the NATIONAL GEOGRAPHIC,' he said. 'The NATIONAL GEOGRAPHIC does wonderful things, but it is so far behind what is happening in the area of the environment that it's totally out of touch.'

"Well, it made me mad," said Blair, "and I stuck my hand up and said, 'Mr. Brower, just you wait.'"

Blair crisscrossed the nation to photograph sites of land, air, and water pollution and took quick trips to Italy, Germany, and England in search of solutions to environmental problems. But his tour-de-force in the gritty coverage was a three-page, foldout panorama of the Cuyahoga River, which, in July 1969, was so befouled by oil and debris that it literally caught fire. "It was a different game for us," he said, "to not look for something beautiful, but for something awful."

On a dark winter day, Blair and a man from a local environmental group took a small rowboat and pushed into the Cuyahoga where it had burned worst, between the ruins of an abandoned steel mill and a charred pier. Like riding with Charon across the River Styx to the Underworld, Blair remembered: "It was bitter cold and the water was ugly, malevolent—black and brown and iridescent with oil slick; it was very toxic, and it stunk. To have fallen in at that point would have been dangerous indeed. If you'd swallowed that water, I think you would have been a long time recovering."

It was a powerful and memorable coverage. Writer Gordon Young, who had followed the same grimy trail of pollution, ended his text with a quote from Russell E. Train, then Chairman of the Council on Environmental Quality:

"'We're all responsible. We all owe, and we're all going to have to pay. Nineteen seventy may go down in history as the year in which we began to settle our account with our environment, the year in which we made our first down payment on our debt to our world.'"

THE ENVIRONMENTAL GENIE was well out of the bottle when staff photographer Steve Raymer and senior writer Bryan Hodgson were assigned to cover "The Pipeline: Alaska's Troubled Colossus," November 1976. They were about to document one of the world's most costly and most controversial private construction projects—the attempt to bring oil by pipeline across 800 miles of rugged arctic landscape, from Alaska's Prudhoe Bay in the north to the southern port of Valdez. Environmentalists feared the pipeline, which ran both above- and belowground, under rivers and over mountains, would be broken by earthquakes or shifts in the earth as it thawed and froze—and vast oil spills would occur.

"We were supposed to cover social and economic themes," said Raymer, now a professor of journalism at Indiana University, "and how the pipeline was going to affect the environment, and we thought that the good name of the GEOGRAPHIC would open the doors. But we had the doors slammed in our face by the people—a consortium of oil companies—who were building the pipeline.

"It turned out to be like doing a story inside the old Soviet Union. It was partly due to the large number of journalists there, but their policy was: 'We'll give you a couple of escorted tours under a tight itinerary, and we don't want to hear from you again.'"

Raymer and Hodgson could not do the thorough coverage the GEOGRAPHIC expects under those rules.

They decided to find ways to get around a system that tried to deny them access to the story. "I rented a four-wheel-drive Chevy Blazer that looked like one of the cars that the pipeline honchos drove," said Raymer, "and smeared mud over the part of the cab that would have had the company insignia, and I drove along the pipeline as if I belonged there."

Another technique was to ride with the long-haul truck drivers on the road that paralleled the pipeline. "We just got ourselves listed on the manifests as guys who were accompanying the drivers," said Raymer. "We had to keep ourselves inconspicuous at some security points."

But most of the construction was inaccessible by road, and Raymer said he ended up having to hire helicopters like some people rent cars: "We had favorite pilots positioned along the pipeline. It was like running our own little Vietnam operation, with a fleet of choppers. When the bills started coming in back at the office, people wanted to know what we were doing up there: Wouldn't it be cheaper to just *buy* a helicopter? But the only way we had access was to fly in. We did our business in the shadow of the state inspectors and choppered back out before the other guys knew what had happened."

Raymer and Hodgson got the story—a powerful and informative one.

Other strong environmental stories followed, among them: "The Pesticide Dilemma," February 1980, by staff writer Allen A. Boraiko and freelance photographer Fred Ward; "Acid Rain—How Great a Menace?" November 1981, by freelance writer Anne LaBastille and freelance photographer Ted Spiegel; and "Storing Up Trouble…Hazardous Waste," March 1985, by Allen A. Boraiko and photographer Fred Ward. Industry reaction was sometimes strong and emotional. Although he had painstakingly sought in his 1980 article to present fairly both the pros and cons of pesticide use, Boraiko told me, "I got potshotted from every direction."

SPECIAL ISSUE: "WATER: THE POWER, PROMISE, AND TURMOIL" NOVEMBER 1993

PHOTOGRAPH BY PETER ESSICK

IN NOVEMBER 1993 came a special extra issue of the magazine to address the growing concern over one of our most precious natural resources: "Water: The Power, Promise, and Turmoil of North America's Fresh Water." It was a monumental, staff-wide effort coordinated by Associate Editor William L. Allen, who would succeed William Graves as Editor one year later. The issue drew on teams of illustrators, artists, cartographers, researchers, and five photographers: freelancers Peter Essick, Stuart Franklin, Jim Richardson, Rick Rickman, and George Steinmetz.

Assigned as the principal writer was freelancer Michael Parfit, who was uniquely equipped for the far-ranging coverage. He flies his own plane, a Cessna 210, on most U.S. assignments. "You get a real good look at the way the landscape shapes itself," he told me, "not just in the original shape of the land but also in the way people are living on it. And if you fly yourself, you get to know the way the wind shapes itself, because it really kicks you around; you know the way the fog tends to lie up against a certain valley, because you had to land there. And so you have that intimate connection with the landscape, about the same way the sailor has an intimate connection with the sea."

The plane was essential, said Parfit, not only because it helped whisk him over vast stretches of the continent, but also because the patterns of water use were laid out so vividly in front of him. "In eastern Washington, if you look back into the sun," he said, "all you can see on the face of the land are these shining threads, like molten gold being poured into troughs—zigzagging across the landscape. These are the canals that move water from one place to the other, a big irrigation project." After his travels, Parfit wrote:

"Like good health, we ignore water when we have it.

"But, like health, when water is threatened, it's the only thing that matters. Fresh water is the blood of our land, the nourishment of our forests and crops, the blue and shining beauty at the heart of our landscape."

The issue made clear that change was coming, and all of us would have to help shape that change, like so many patients suddenly cautioned by their doctors.

FOR SOME JOURNALISTS, protecting the environment is seen as a personal responsibility. Chris Johns is one such journalist, an energetic, boyish-looking staff photographer. "I grew up in Oregon, right next to the Cascade mountains," he told me, "where there was clean water and clean air. Now I could get terribly melancholic and depressed about our environment, but I don't see any point in that."

In 1992 the Society's book division sent Johns on assignment to Hawaii. "I thought I would take my wife, my oldest daughter, and my new little baby girl," Johns said, "and we would go over and I'd take pictures and it would be relaxing. And of course I got over there and became obsessed with what I learned about the Hawaiian environment."

What he learned was that more than a third of the 526 plants and the 88 birds then on the U.S. endangered and threatened species list came from those islands. Agriculture, development, and the introduction of foreign species were ravishing a rich and unique natural heritage.

When Johns returned to the GEOGRAPHIC, he lobbied magazine editors to do a piece about the dilemma. The result was "On the Brink: Hawaii's Vanishing Species," September 1995, with text by Elizabeth Royte, a freelancer from New York.

Both focused on damage done by introduced species. Royte went hunting for feral pigs with federal conservation workers and dogs. The pigs have destroyed much of the native ecosystem.

Johns decided to attempt a difficult photograph—to catch a *Culex* mosquito injecting its needle-like stinger into the rim around the eye of an *'i'iwi*, a colorful bird with a long, curved bill that draws nectar from native lobelias. As the mosquito draws blood from the bird, it injects into it a lethal dose of avian malaria. The mosquitoes probably arrived in Hawaii in the water casks of whaling ships. Their effect has been devastating. During recent outbreaks of avian malaria, a biologist said, "birds literally dropped out of the trees."

Johns got the shot, which was published as a double spread. "I worked with a biologist for two years to get it," he said. The effort was worth it. "It's important to do a story so that when somebody picks it up, he says, 'Gee, I didn't know that about Hawaii. I thought there were just beaches and resorts. I didn't know that these lush, endemic rain forests are packed with species that live no place else in the world. I didn't know that you could stand near the top of Mauna Kea and see almost every ecological system in the world, from coral reefs to alpine.'

"There's a lot of satisfaction in doing a story like that. You can surprise people and alarm people, but you also have to balance that with a sense of hope—so they don't throw up their hands and say, There's not anything I can do. You've got to inspire people. All I am is a messenger."

PERHAPS NO ONE has written more passionately or lyrically on nature in the GEOGRAPHIC than freelancer Douglas H. Chadwick, a wildlife biologist with ten magazine stories to his credit. He did not start out as a journalist but as a scientist cranking out papers for his colleagues.

"But my call on it was that we were not keeping up with the pace with which animals were falling into ruin," he told me, "and I lacked the patience and diplomacy to publish scientific papers, back away, and hope somebody would do something."

He decided to write for a broader audience and accepted an assignment from the GEOGRAPHIC: "Our Wild and Scenic Rivers: The Flathead," July 1977, with photographs by Lowell Georgia. "When I started writing for the GEOGRAPHIC," Chadwick said, "it took me a while to stop writing as if I was still writing for my science colleagues. I felt like I was pandering to the public; there are great fears among scientists that you'll fall out of the priesthood when you talk to the masses." But Chadwick managed the change. Colleagues believe his masterpiece, both lyrical and scientifically correct, to be "Grizz—Of Men and the Great Bear," February 1986.

Chadwick, his wife, and two children spend a lot of time near Glacier National Park, Montana, in a log cabin, which they have yet to outfit with a telephone or running water. They lived there for 11 years, and it was during that period that Chadwick's interest in grizzlies deepened.

"I used to go out every morning, get up before dawn, and hike into these meadows and glaciers," he told me. "Barefoot to keep the noise down. In the spring there was still snow under the trees, and all the

wildlife was there in the few meadows that had opened up. It was like the peaceable kingdom—coyotes feeding next to the deer, bear next to the elk—and everybody padding around on the new grasses, the first green. I would sneak in before the wind came up and watch bears, and I watched bears for reasons of the heart."

Chadwick captured that feeling in the article:

"When a grizzly moves, its silver-tipped fur shimmers and changes color, as if arcs of power were rippling off it. This is the one the Blackfoot Indians called Real Bear—omnivorous, dexterous, highly adaptable, highly intelligent, huge, aggressive, smashingly strong, capable of sprinting at a deerlike 35 miles an hour and living as long as 30 years, and once codominant with man across the western half of North America."

Chadwick has never really learned to deal with the city. When he shows up at GEOGRAPHIC headquarters in Washington, D.C., face ruddy and glowing, he moves through the offices with the befuddled look of a beached salmon.

People puzzle him, too. When he followed the trail of disappearing critters for "Dead or Alive: The Endangered Species Act," March 1995, with then-contract photographer Joel Sartore, he was startled by the elasticity of people. "We can adapt to anything," he said. "Everything dear and stable in nature is almost gone, and people are still thriving, still not concerned. I'm amazed. I always thought there was a point at which people would rise up and say, 'No more.'"

THERE REMAIN, EVEN TODAY, hidden pristine corners of the American land. In March 1991 the GEOGRAPHIC reported on the exploration of a vast cavern system in New Mexico. The enormously complex, dangerous, and stunningly alien system proved to be the deepest in the United States—reaching some 1,565 feet below the surface.

WRITER DOUGLAS H. CHADWICK on assignment
"DEAD OR ALIVE: THE ENDANGERED SPECIES ACT" MARCH 1995
PHOTOGRAPH BY JOEL SARTORE

Assigned to "Charting the Splendors of Lechuguilla Cave" were freelance photographer Michael "Nick" Nichols, now a staff photographer, and Tim Cahill, a freelance writer who was a founding editor of *Outside* magazine. Cahill wrote evocatively of life underground:

"I sit on my air mattress and wait to stop sweating. Fifty miles of caverns plunge and snake and twist away from me in every direction, passages of impenetrable darkness, like damp black velvet pressing against my face. The disk of light from my helmet lamp sweeps across the walls of the tunnel as I turn my head. The surface is white, glittering with gypsum crystals, and crystals loosened by my body heat snow gently onto my hands. The air smells clean and wet, like fresh laundry, and the silence is absolute. It must be like this in outer space, I think, but I am a thousand feet underground."

Nichols's monumental task was to light the cavern; merely bringing the equipment into the cave was a challenge. "The trick with Lechuguilla," said Nichols, "is that it's literally the most beautiful cave in the world, and so fragile. How do we even look at it without destroying it? Every time we go anywhere in there, we leave footprints that we can never erase."

Nichols and his assistants spent several months photographing in the cave, descending on Mondays, emerging on Saturdays. "We all sort of went a little nuts during that time," said Nichols. "On Mondays, as you'd hike back to the cave entrance, you'd just be saying, No, no, no, not again. I'm not going back in there. And then you go, and as you get down in there, you say, OK, we're here. Let's get to work. And you do it. It's a very friendly cave, but it's still pitch black. When you wake up in the night, you can wave your hand in front of your face and nothing's there. And they all say, whatever you do, even when you go to sleep, make sure you know where your little flashlight is.

"We ate freeze-dried food, noodles, and horrible sweet stuff...a little bit of sugar would help you get out of this cave. We were drinking all kinds of sports drinks. It was pretty physical." But the job was done.

When the article was published, more than 50 miles of the great cave, which lies within Carlsbad Caverns National Park, had been explored and mapped, and the end was nowhere in sight.

JIM RICHARDSON IS AN INTENSE, scholarly-looking freelance photographer with an extraordinary sensitivity to the land. He has contributed to the magazine a sense that there should be a binding of the two attitudes that have shaped our view of the land—the European urge to manage, the Native American urge to leave it whole, little touched.

Richardson grew up on a farm in Belleville, Kansas, studied in a one-room school, and attended a high school where he was considered the country boy. In his career he has covered much of the great heartland of America. Richardson photographed, along with freelancer Raymond Gehman, "Our Disappearing Wetlands," October 1992, with text by John G. Mitchell, now senior assistant editor for the environment. He also photographed "Ogallala Aquifer: Wellspring of the High Plains," March 1993, by assistant editor Erla Zwingle and "A Farming Revolution: Sustainable Agriculture," December 1995, by Verlyn Klinkenborg.

"People think these are boring stories," he said. "I always joked with my wife that I was heading off in search of the great chicken-fried steak. But I got a great pleasure out of getting into complex stories that took understanding to reveal their content.

"The Ogallala aquifer was probably the extreme challenge: You're photographing something that's basically buried underground." The great water-bearing stratum of sand and gravel spreads for some 140,000 square miles under eight western states.

"But one day I saw kids playing out in a stock tank on a hot summer day, and I thought, You know, we're in a land where every little spot of water is a big treat for these kids, and playing in a stock tank is going to be in their psyche for the rest of their lives. They're going to remember the coolness and refreshment of splashing around in the hot summer day, with the horses coming up in the middle of them, wanting a drink. And that frame, that picture, suddenly becomes a story about growing up in the plains.

"When I was doing the sustainable agriculture story, I photographed this couple out in the evening, walking across a wheat field, having dreams together about what they would do with their land and how they would farm it. It was no big event, unless you look at what's going to happen to that land over the next 40 years. And then it becomes a very big event, because those dreams that are spawned out of this loving walk are going to have a very big effect on the land and the wildlife upon it.

"Our mission is the same as it was a hundred years ago—geography—and in the kind of stories I do, geography matters. What encourages me is that finally voices are emerging that say we humans are a part of nature also, a part of the ecosystem, and that both those who use the land and those dedicated to its protection can't continue to look on each other as adversaries.

"Simply leaving the land alone is not the answer, because there is not enough of it. And there is no such thing as walking away, because somebody else is going to walk in. You have to have people out there who care for the land. They could care for it with a hundred small kindnesses, as writer Wendell Berry says, and that means that you need more farmers, not fewer. You need people who have the time and the love and the concern to pay attention to this place and to use it wisely."

RICHARDSON'S WORDS TOOK ME back to another set of words—a set that appeared in the Columbus quincentennial issue "1491 America Before Columbus," October 1991. In "Otstungo: A Mohawk Village in 1491," writer Joseph Bruchac, of Abenaki ancestry, told of the Native Americans' balance with the land, "[b]alance and the giving of thanks…a balance that our modern world desperately needs to remember." He gave the Mohawk words of thanksgiving:

"Our Grandparents of old, they are saying, 'Listen to her, all, to the Earth our Mother, to what she is saying.' People, listen all." ■

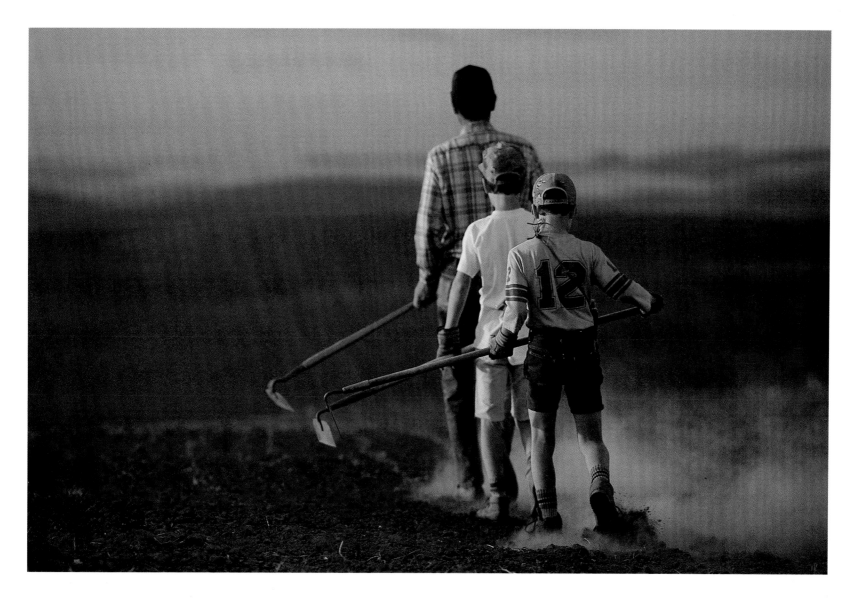

"A FARMING REVOLUTION: SUSTAINABLE AGRICULTURE"

December 1995

photographs by
JIM RICHARDSON

text by
VERLYN KLINKENBORG

ARMED WITH HOES instead of chemicals, Rod Repp and sons Kevin and Nathan battle weeds on the family farm in the Palouse country of eastern Washington State.

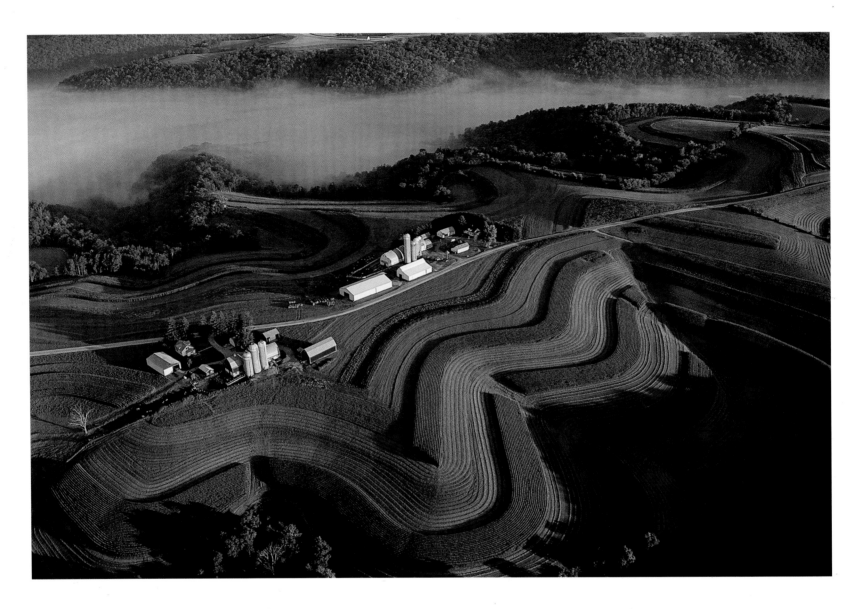

MARRIAGE OF LANDS and sustainable farming methods followed the wedding of Nick Ogle and Mary Jane Butters of Moscow, Idaho (opposite); in Wisconsin, artfully efficient contours catch rainwater and limit erosion on the neighboring farms of cousins Arlin and Myron Manske.

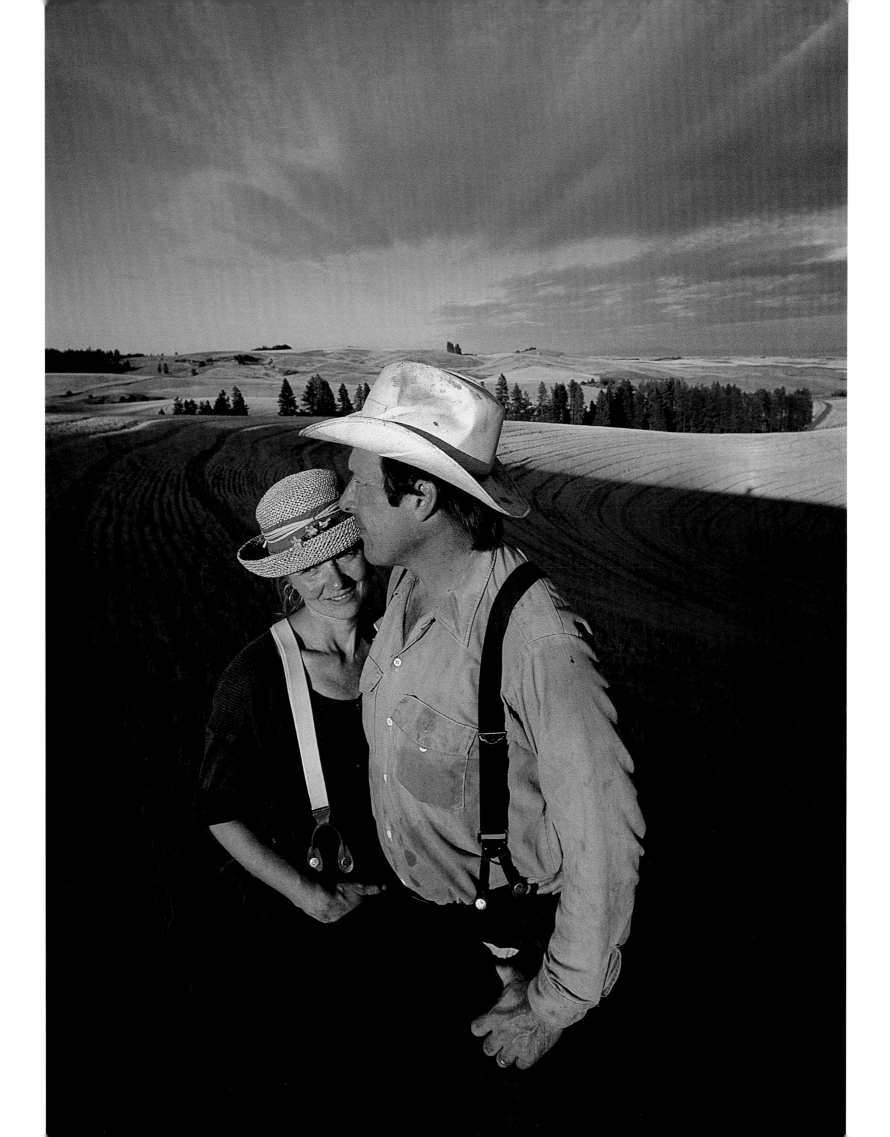

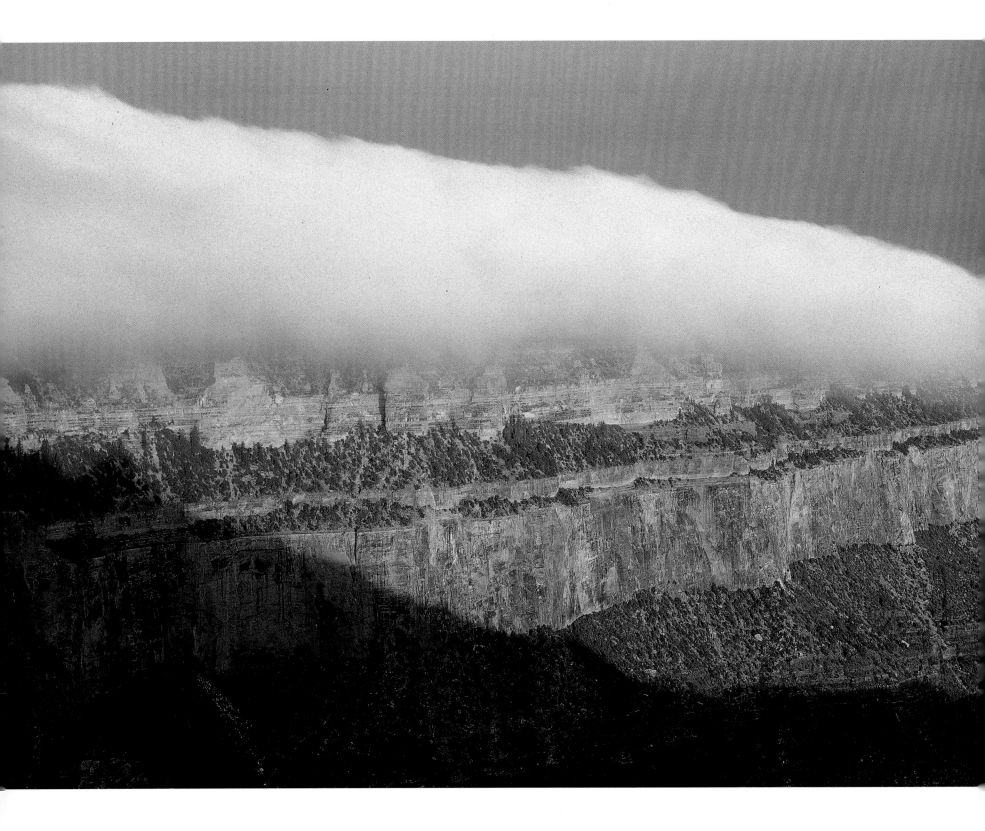

"OUR NATIONAL PARKS"

October 1994

photographs by
MELISSA FARLOW AND RANDY OLSON

text by
JOHN G. MITCHELL

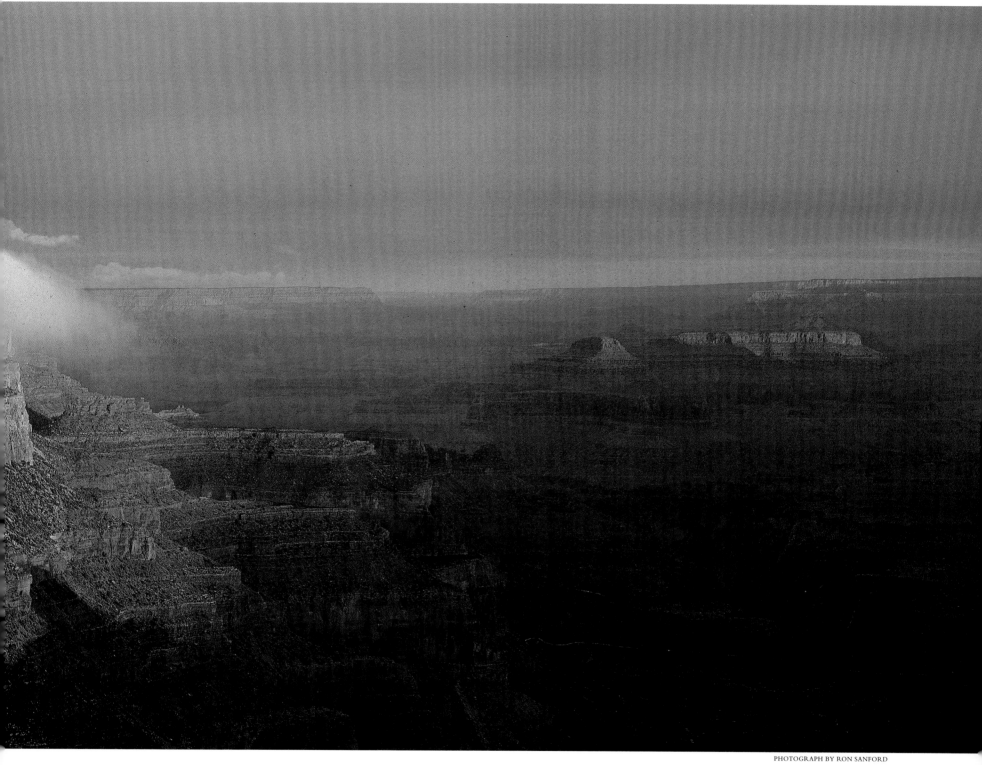

SUNRISE GILDS the south rim of Arizona's Grand Canyon.

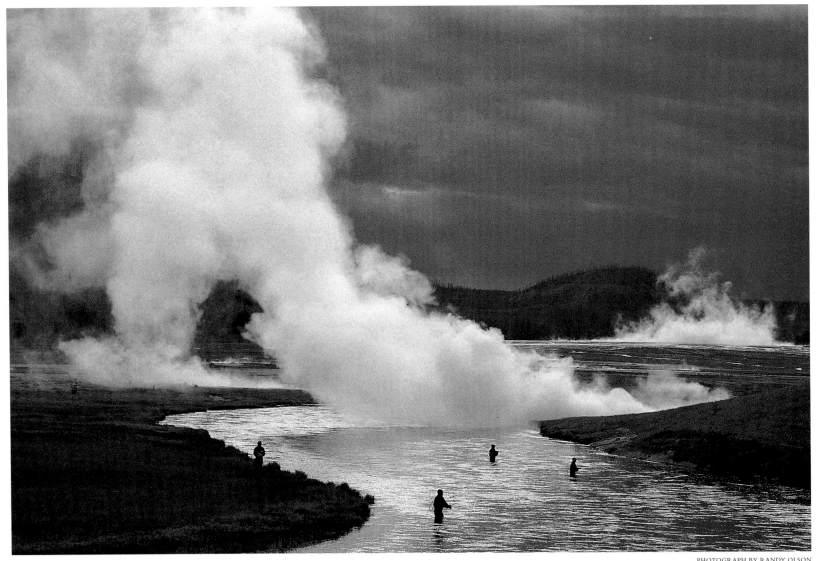

ANGLERS AT FIREHOLE RIVER test the waters for trout,
Yellowstone National Park, Wyoming.

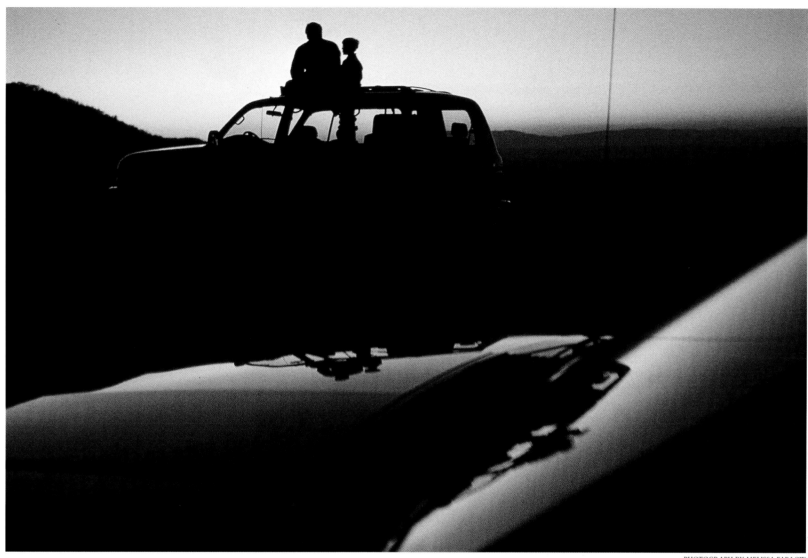

VISITORS ENJOY the view along Skyline Drive
in Shenandoah National Park, Virginia.

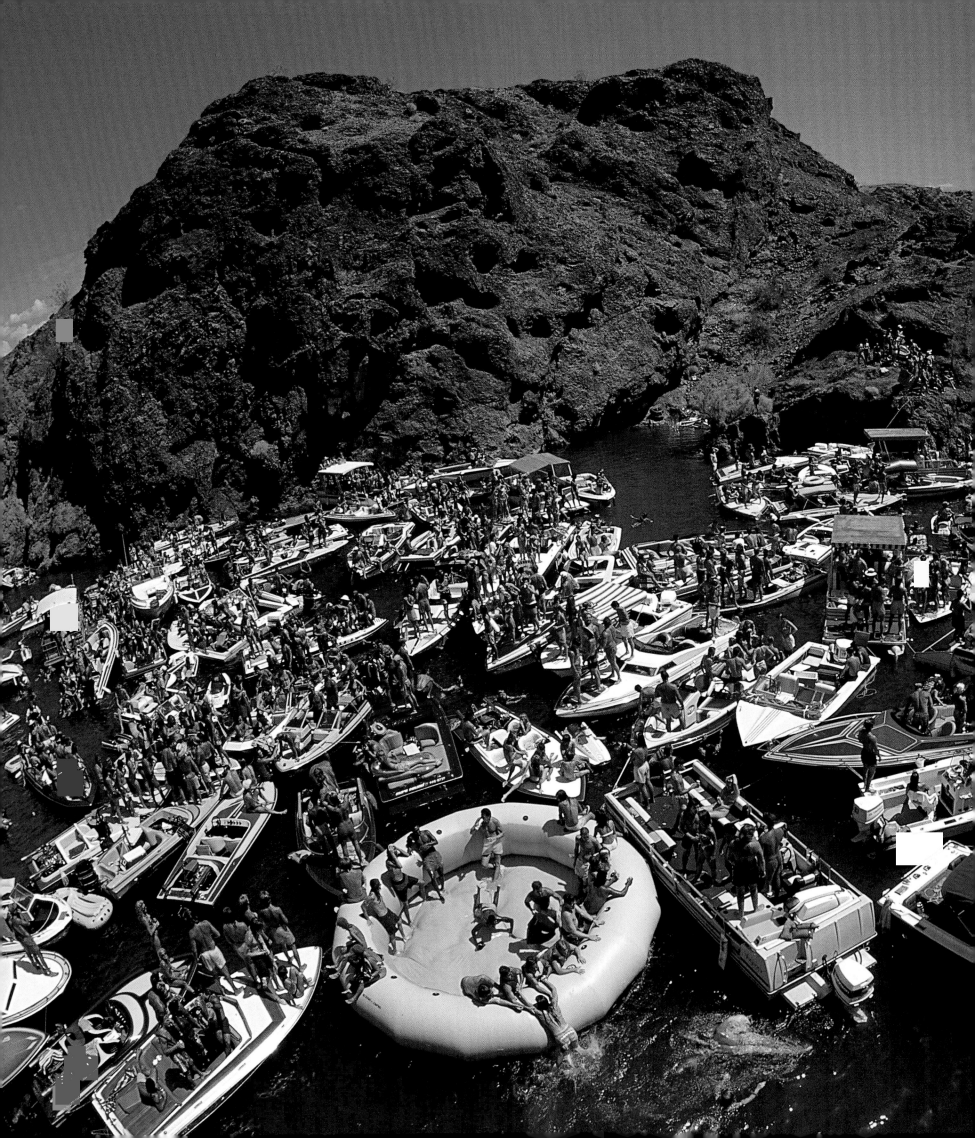

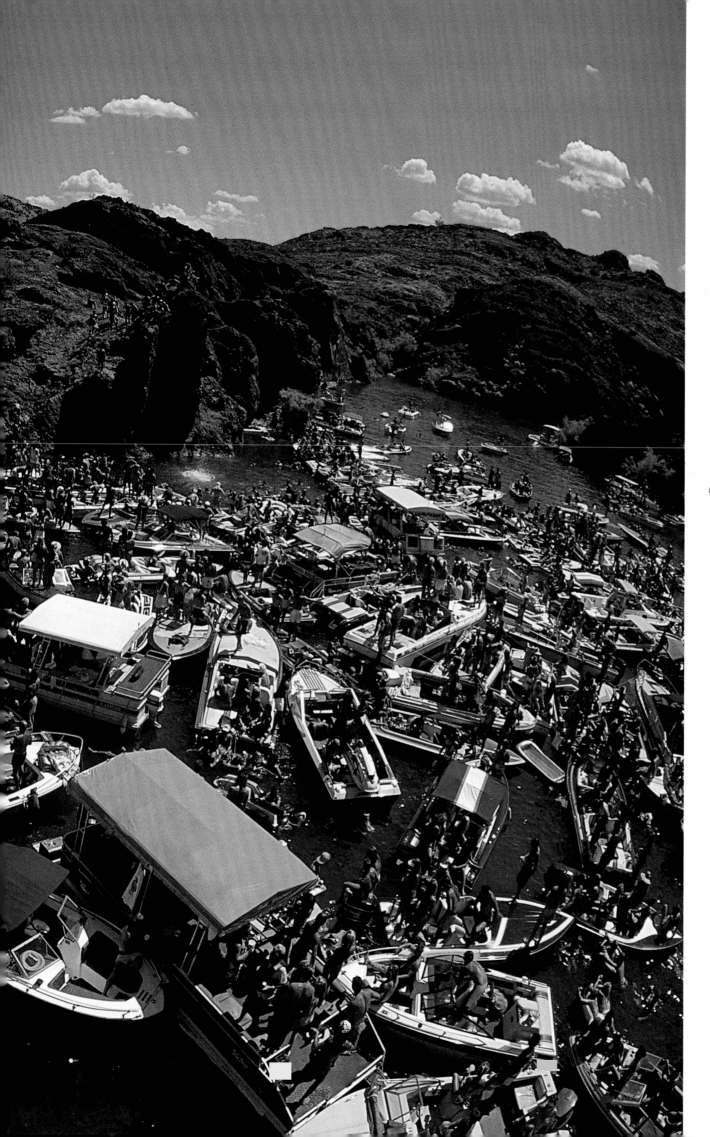

"THE COLORADO:
A RIVER DRAINED DRY"

June 1991

photographs by
JIM RICHARDSON

text by
JIM CARRIER

LABOR DAY FLOTILLA jams
Copper Canyon in Lake Havasu
on the Arizona-California border.

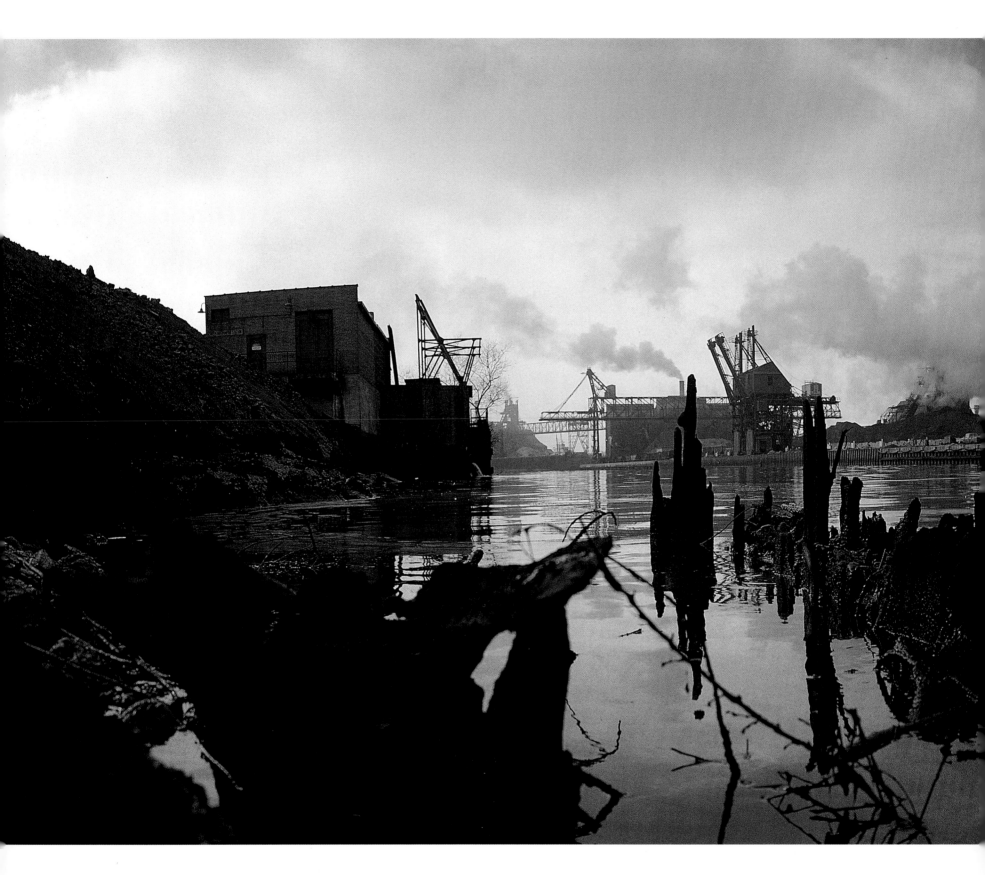

"POLLUTION: THREAT TO MAN'S ONLY HOME"

December 1970

photographs by
JAMES P. BLAIR

text by
GORDON YOUNG

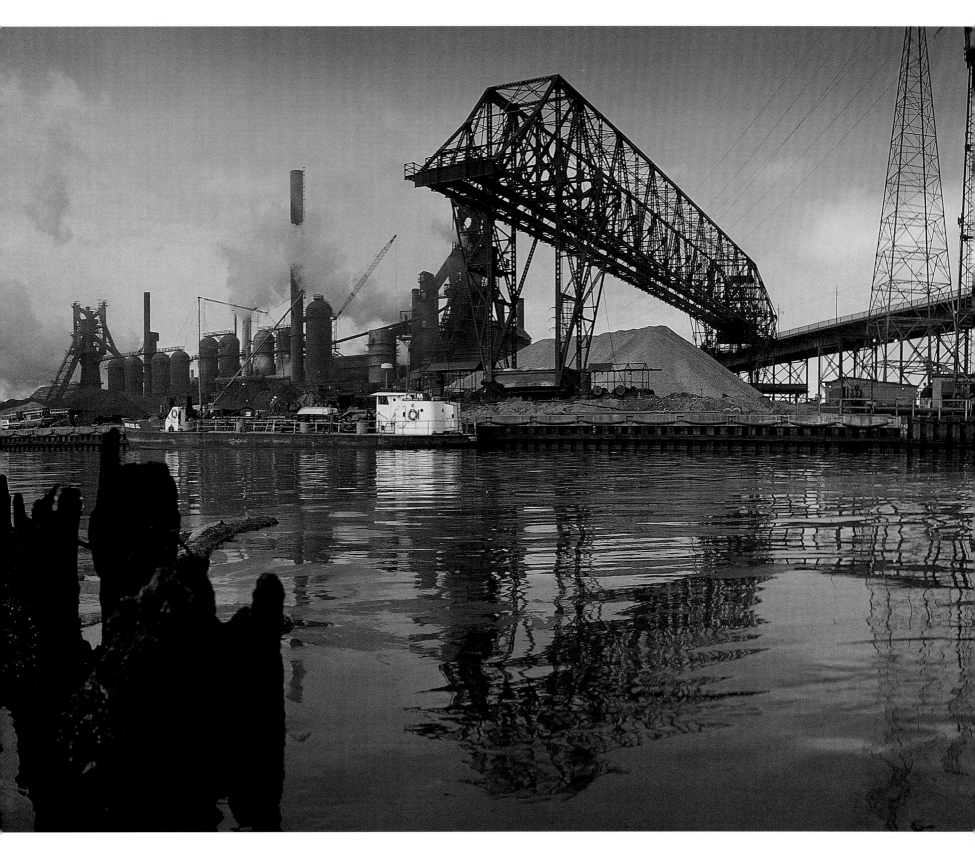

EFFLUENT-FILLED WATER of the Cuyahoga River, Cleveland, Ohio, which caught fire in July 1969.

"DEAD OR ALIVE:
THE ENDANGERED SPECIES ACT"

March 1995

photographs by
JOEL SARTORE

text by
DOUGLAS H. CHADWICK

A WHOOPING CRANE, killed by avian cholera, floats on a lake in New Mexico. One of the original species protected under the Endangered Species Act of 1973, the whooper remains perilously close to extinction.

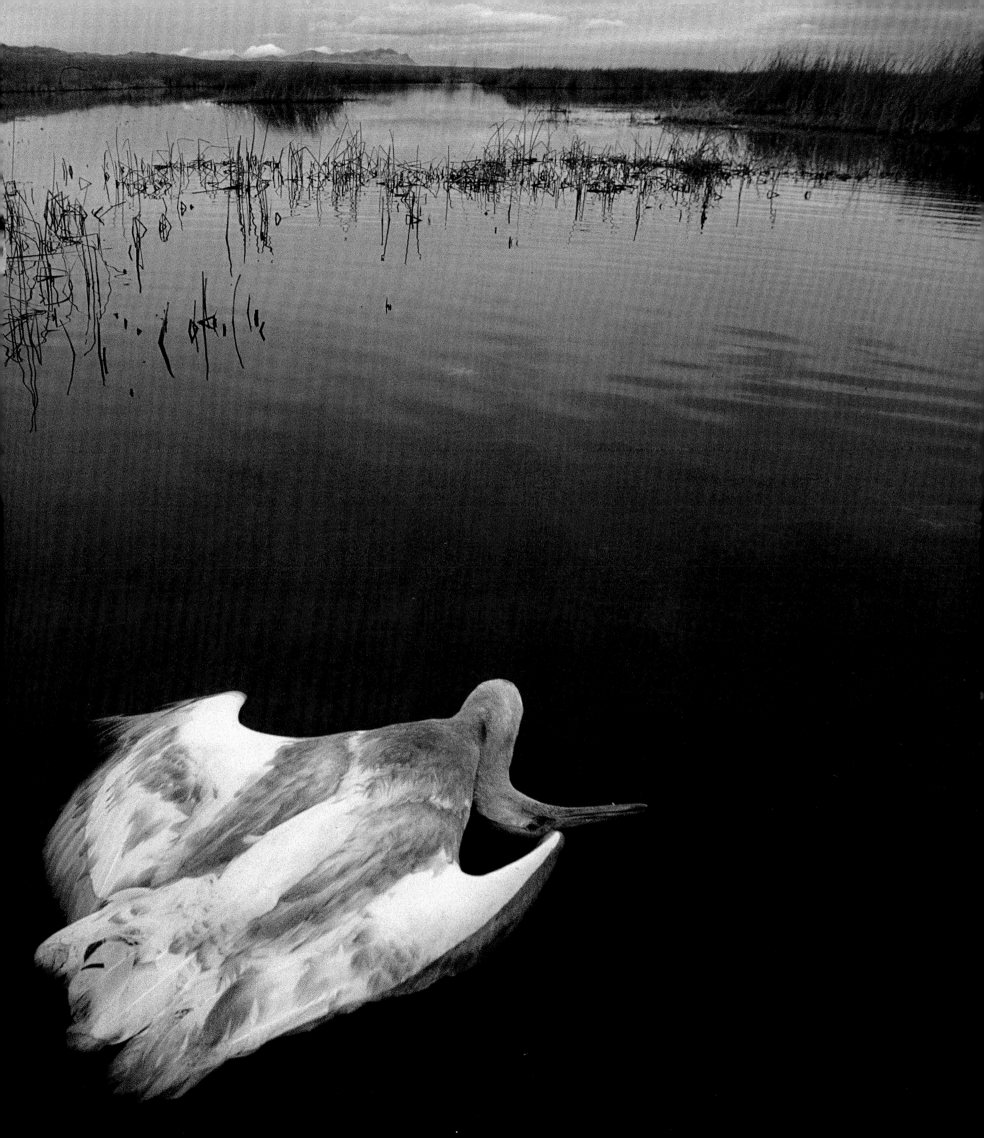

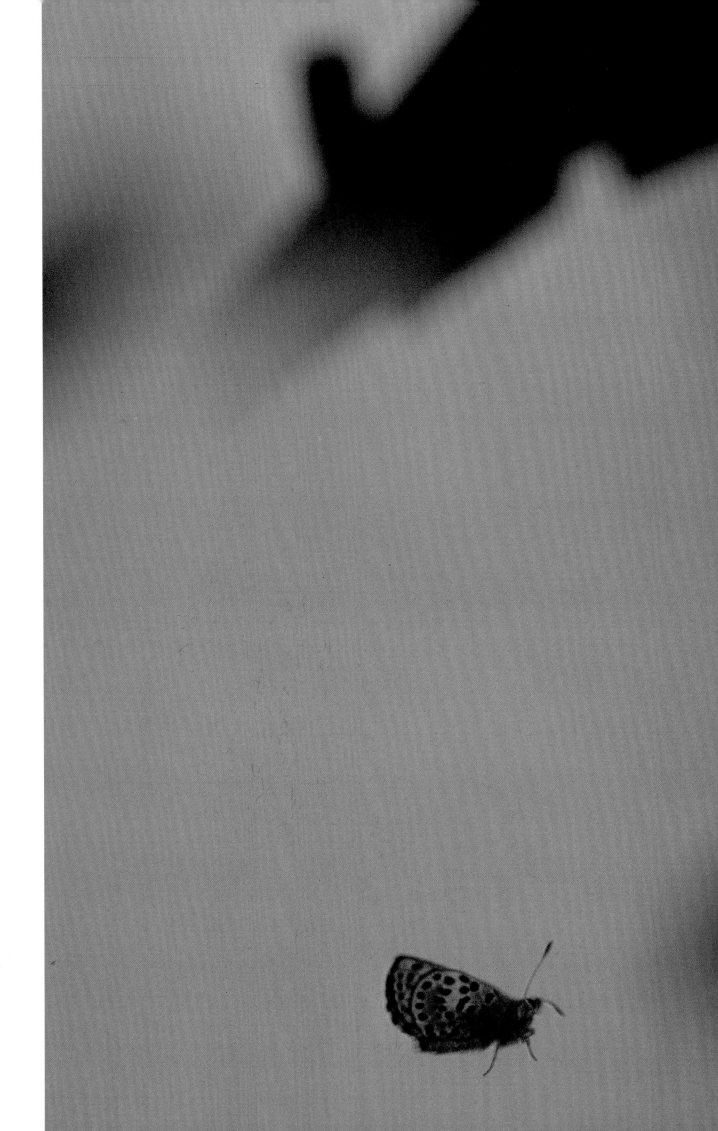

ENDANGERED EL SEGUNDO blue butterfly finds sanctuary in dunes located near the runways of Los Angeles International Airport. Because butterflies lack ears, the species can coexist painlessly with roaring jets.

"OUR DISAPPEARING WETLANDS"

October 1992

photographs by
RAYMOND GEHMAN
AND JIM RICHARDSON

text by
JOHN G. MITCHELL

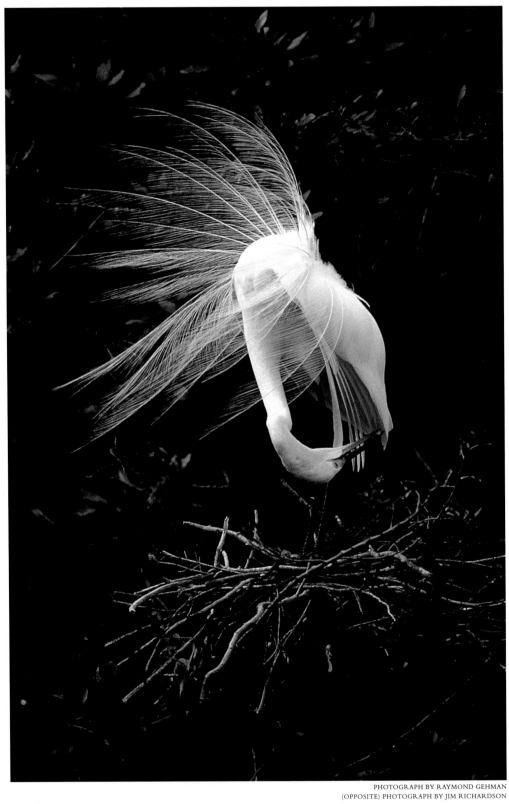

GREAT EGRET PREENS its feathers
at a park in Venice, Florida (right);
cypress trees at sundown in Heron Pond
(opposite), Cache River State Natural
Area, southern Illinois.

PHOTOGRAPH BY RAYMOND GEHMAN
(OPPOSITE) PHOTOGRAPH BY JIM RICHARDSON

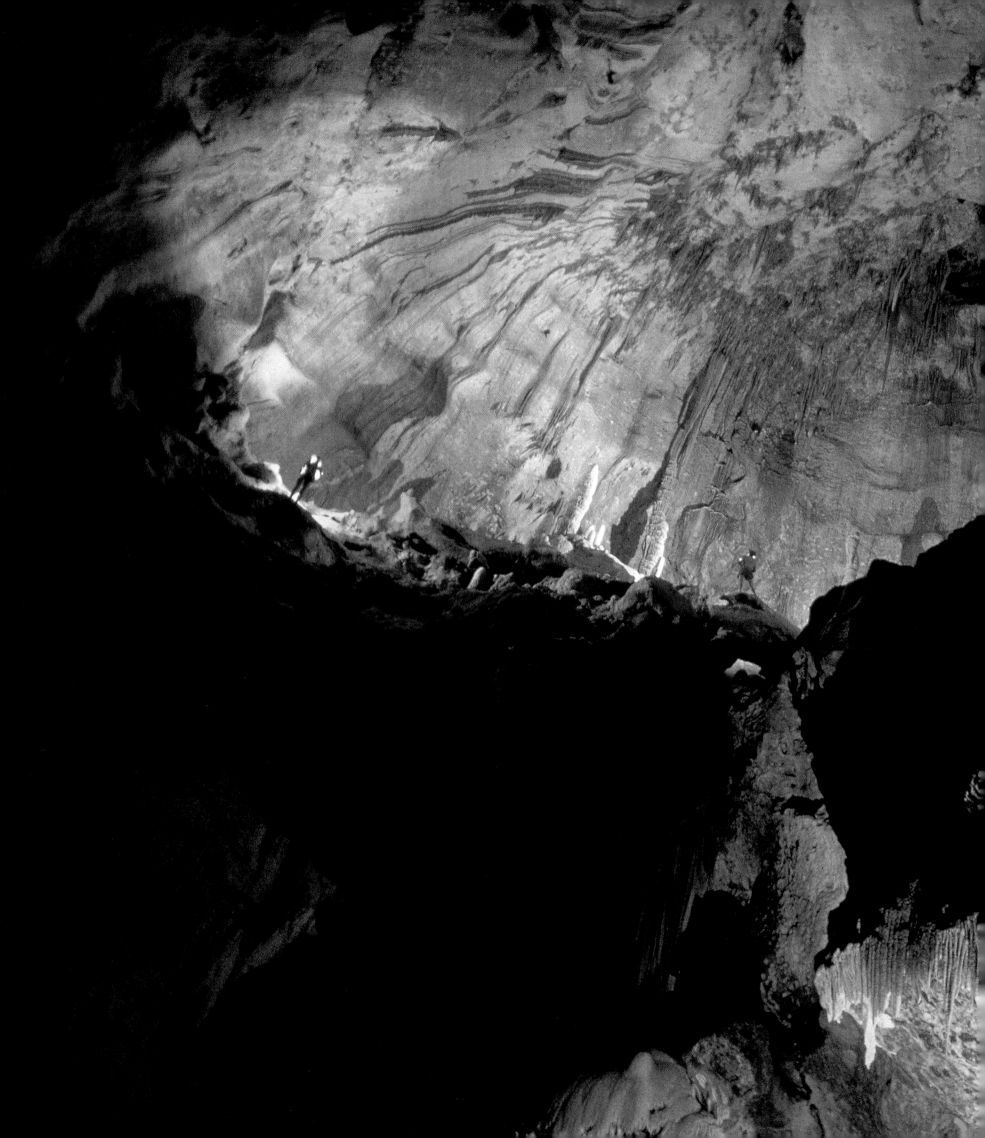

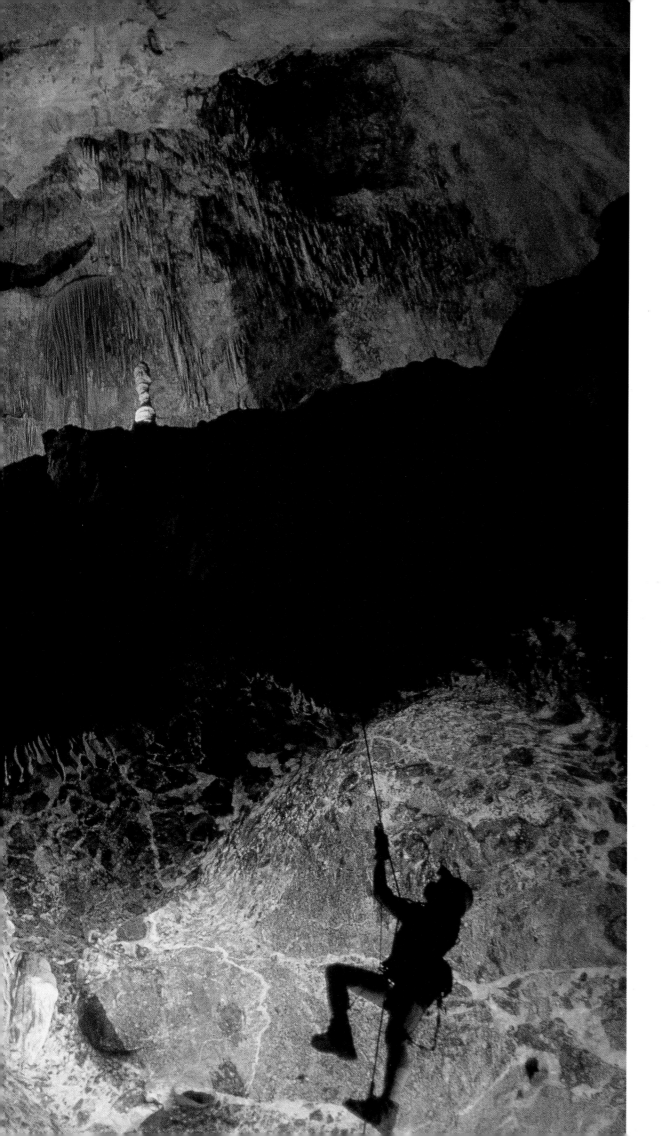

"CHARTING THE SPLENDORS OF LECHUGUILLA CAVE"

March 1991

photographs by
MICHAEL NICHOLS

text by
TIM CAHILL

CAVER ASCENDS to join exploration team members probing Lechuguilla, a sprawling expanse beneath the desert in southern New Mexico.

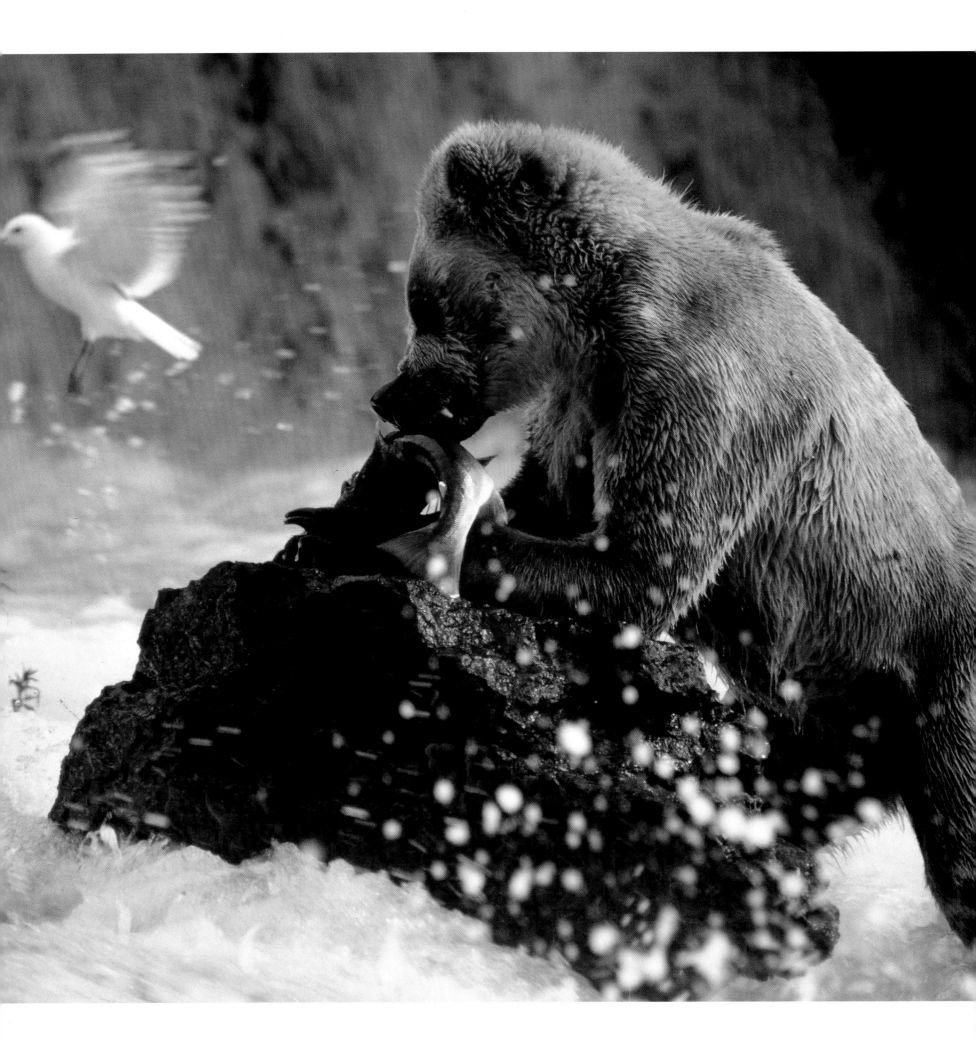

"'GRIZZ'—OF MEN AND THE GREAT BEAR"

February 1986

photographs by
JOHNNY JOHNSON

text by
DOUGLAS H. CHADWICK

GRIZZLY DEVOURS a sockeye salmon
in Alaska's Katmai National Park.

"BUFFALO: BACK HOME ON THE RANGE"

November 1994

photographs by
SARAH LEEN

text by
BRYAN HODGSON

AMERICAN BISON RUMBLE across Colorado's Rocky
Mountain Bison Ranch (below); the Bison Bar in Miles City,
Montana, has attracted ranchers for 50 years.

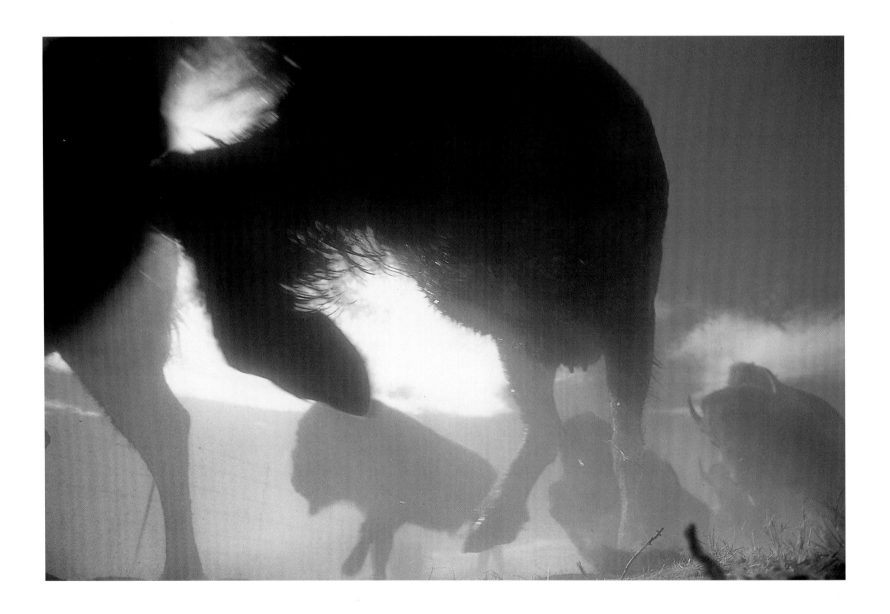

PULL

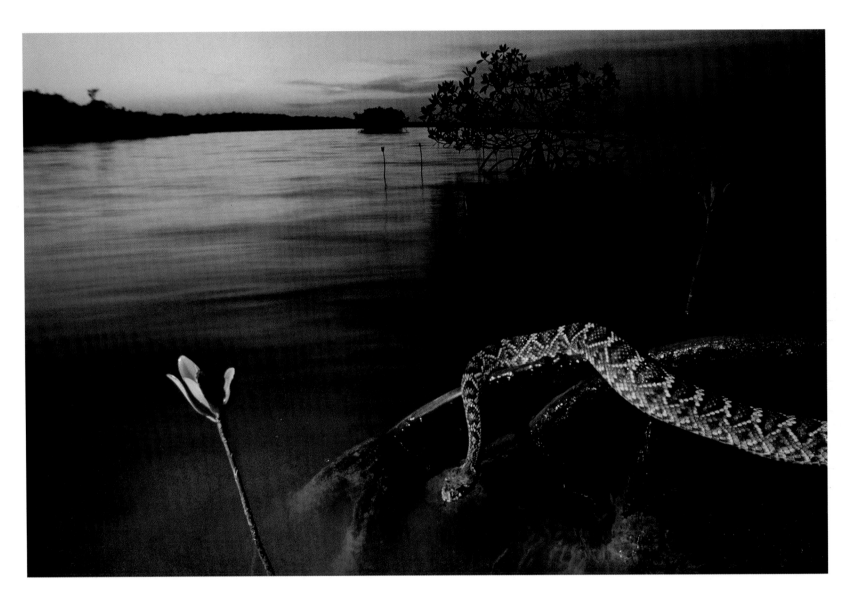

"THE EVERGLADES: DYING FOR HELP"

April 1994

photographs by
CHRIS JOHNS

text by
ALAN MAIRSON

RATTLESNAKE SLIDES through the endangered Everglades National Park, Florida.

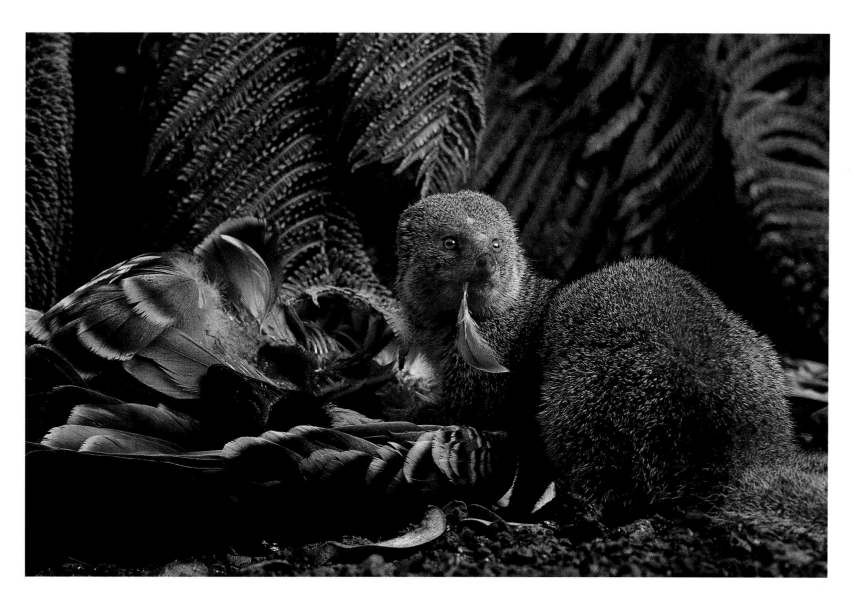

"ON THE BRINK: HAWAII'S VANISHING SPECIES"

September 1995

photographs by
CHRIS JOHNS

text by
ELIZABETH ROYTE

MONGOOSE PREYS upon a nēnē, Hawaii's threatened state bird.

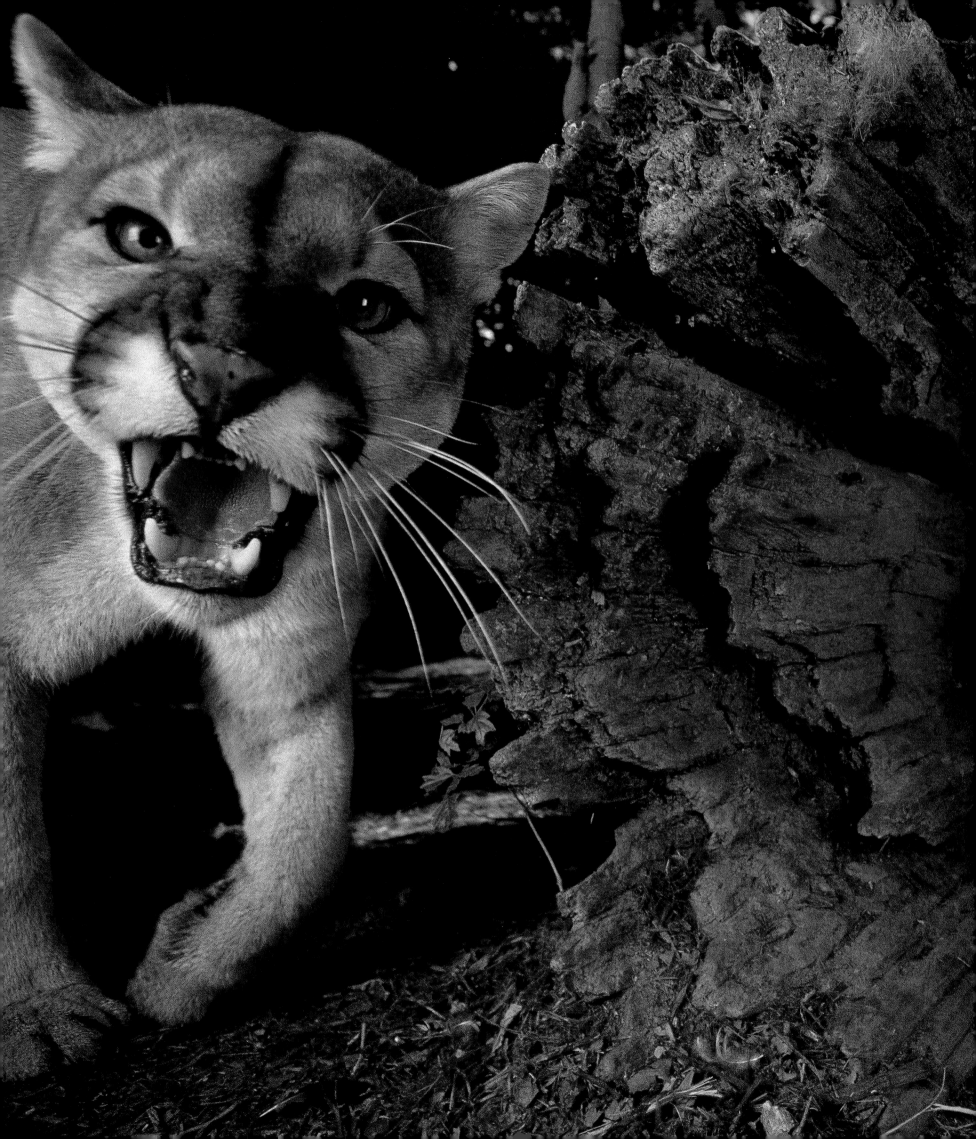

"NEW ZOOS—TAKING DOWN THE BARS"

July 1993

photographs by
MICHAEL NICHOLS

text by
CLIFF TARPY

HISSING COUGAR, of Rocky Mountain origin, prowls the "Louisiana Swamp" exhibit at New Orleans' Audubon Park.

CHAPTER TWO PEOPLE

"Somehow you have to project... you're trustworthy, because you're asking...to be a witness, to be present..."

—WILLIAM ALBERT ALLARD

"A SEASON IN THE MINORS"

April 1991

photographs by
WILLIAM ALBERT ALLARD

text by
DAVID LAMB

66 You want to know why players can't let go of the game, why you don't worry about odds like that? I'll tell you why. There's no ecstasy like winning. Nothing feels that good. 99

—DAN SNOVER
ROOKIE INFIELDER

BATTER JOHN JAHA of the Stockton
Ports prepares to step up to the plate.

preceding page:
A FAN MAKES QUICK WORK of
a corn dog at a Bakersfield, California,
doubleheader.

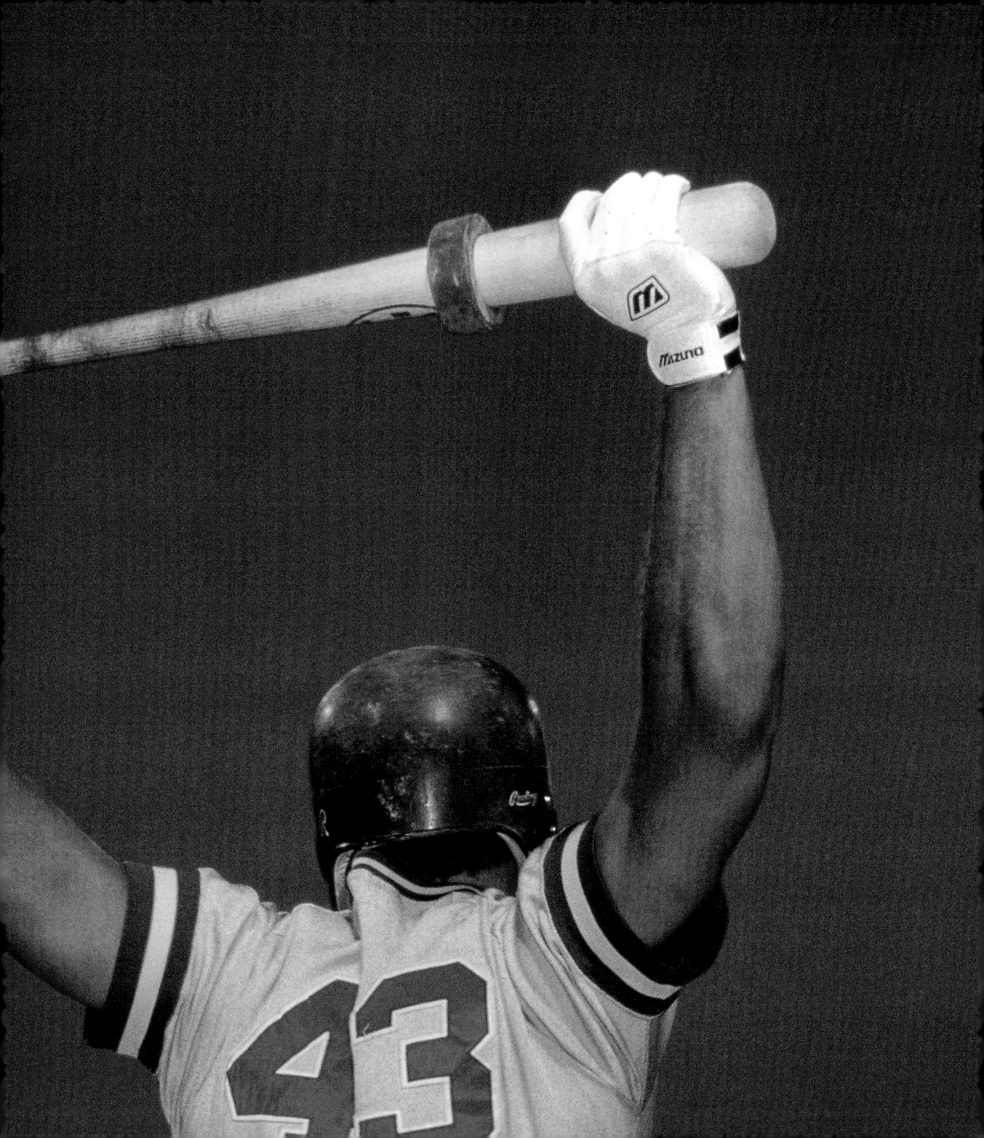

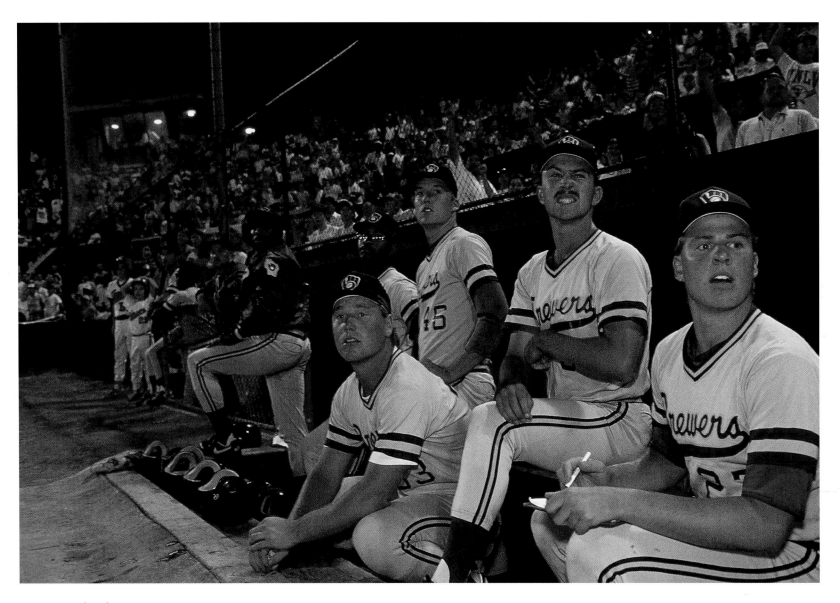

66 What their lives were really about, I decided, was the acceptance of defeat, because in baseball failure is the norm. Even the best teams lose one of every three games, the finest hitters fail seven times in ten. 99

—DAVID LAMB

PLAYERS FOR THE HELENA BREWERS react to a hit by the opposition
during a game with the Salt Lake Trappers (opposite); a Billings Mustang says
good-bye to his wife before getting on the team bus in Great Falls, Montana.

T_{HE BEAUTIFUL THING} about minor-league baseball," staff photographer William Albert Allard told me, "is that you can touch it. It's accessible. Most of the players don't have their lives out of proportion. You can get the best seat in the park for five or six bucks, and if you hang on to your stub, you might win a free Coke and fries, or a lube job in Eddie's Garage. There's no dome over the place, the field might be a little ratty, but you can look up and see the stars…you can breathe the air."

A NATIONAL GEOGRAPHIC article about baseball? Why not? Along with art, literature, and music, games are integral to understanding a culture and a people.

"A Season in the Minors," April 1991, photographed by Allard, was written by David Lamb, a correspondent for the *Los Angeles Times,* whose book, *Stolen Season: A Journey Through America and Baseball's Minor Leagues,* inspired the assignment. Lamb's idea was to revisit his childhood memories of the Boston Braves, a major-league team that moved to Milwaukee in 1953. At age 15, upset with the move, Lamb had written to a Milwaukee newspaper and persuaded the editor to let him write a series of columns about the Braves, from the standpoint of a teenage fan whose team had deserted him.

In 1989 Lamb approached Harry Dalton, general manager of the Brewers (the Braves' successors in Milwaukee), and was given access to the Brewers' five minor-league teams. Lamb took a leave of absence from the *Los Angeles Times.* He bought a used recreational vehicle (RV) for $17,000 and set out to rediscover the magic. He spent five months following the season for the book and one summer later made refresher loops around the league for NATIONAL GEOGRAPHIC. As he wrote in the article:

"Ahead of me on that April evening lay a sport I had loved as a child and a country I had lost touch with during eight years as a foreign correspondent…I feared that perhaps professional baseball had changed more than the nation had. Salary disputes—the average major-league salary was now about $600,000, with .250 hitters routinely earning a million dollars or more—and labor strikes and lockouts had disillusioned me. In the minors I hoped I would find the people and values that had not yet been corrupted by fame or fortune."

Sometimes Lamb would pull his RV into the ballpark grounds and camp there: "That became my home; I was there when people arrived and when they went away at night. And more than once I sat and had a drink with baseball people in my little RV. I became part of the scene."

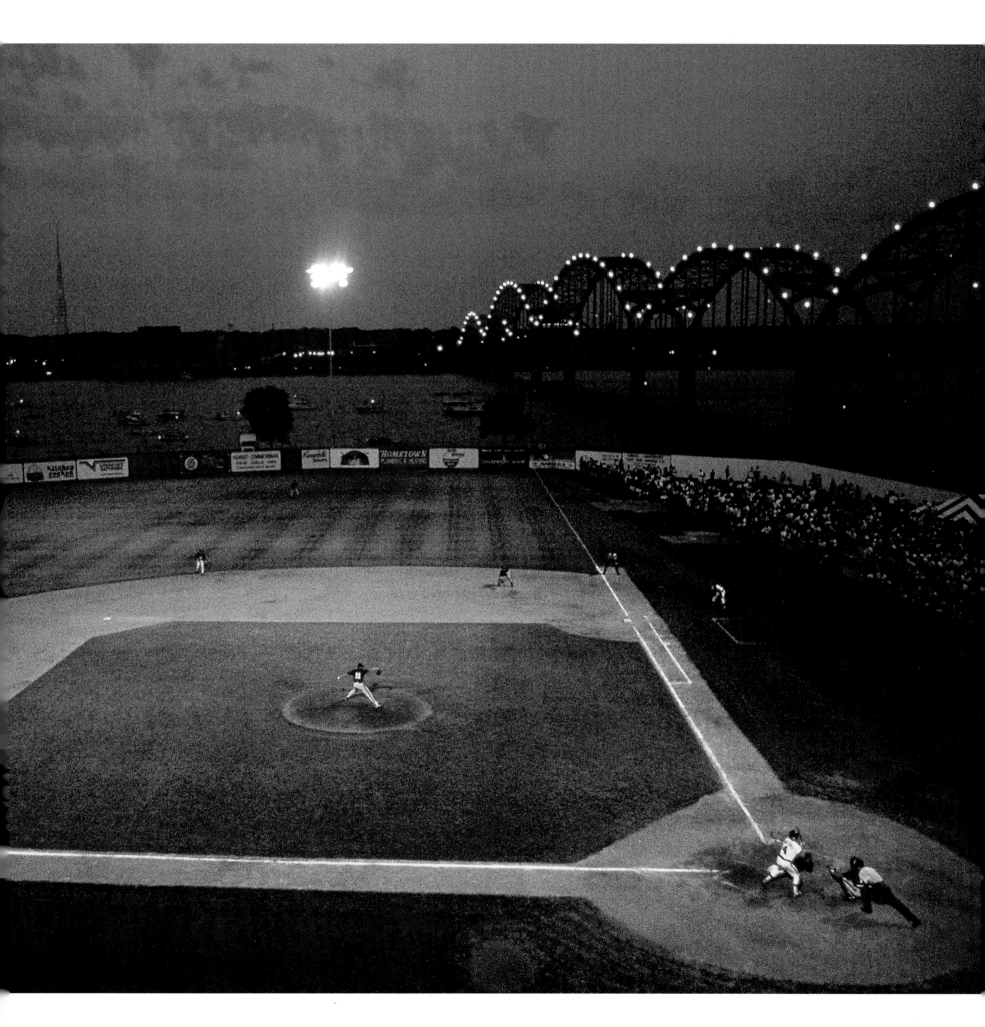

THE QUAD CITY ANGELS and the Waterloo Diamonds square off at John O'Donnell Stadium in Davenport, Iowa, by the Mississippi River.

He wrote:

"I found…a refreshing honesty and innocence. Baseball felt like a game again, a ritual of summer. In the informality of small parks…dwelt the hopes and humor of being good enough to dream."

But Lamb also found the players' world a competitive, tightly focused one. The prospect of being in a magazine story meant little to the young ballplayers. "Probably from the age of six or seven these kids were really good ballplayers, superstars in high school and college. They have done nothing but think about baseball and pursue this dream of making it to the majors. So it was difficult to have a conversation about the world, about anything that strayed far from the self-focused goal that they had.

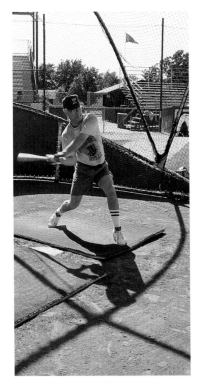

PHOTOGRAPHER WILLIAM ALBERT ALLARD on assignment "A SEASON IN THE MINORS" APRIL 1991

PHOTOGRAPH BY WILLIAM ALBERT ALLARD

"The one exception was a really wonderful kid, Frank Mattox, at El Paso; he went to the University of California at Berkeley and had a degree in resource economics, which made him kind of suspect in the eyes of a lot of the scouts. Frank got injured quite a bit, and some of the Brewers people said, 'Well, if he hadn't gone to Berkeley, if he just played baseball all the time….'"

The assignment was magic to Allard, then 52 years old, who grew up on baseball and simple truths in Minnesota. Thomas R. Kennedy, the GEOGRAPHIC's director of photography, had offered Allard a choice between this assignment and one on the new Russia. Russia didn't have a prayer. Savoring every minute, Allard hit the road and headed for Durham, North Carolina; Beloit, Wisconsin; El Paso, Texas; and Stockton, California.

"I convinced the GEOGRAPHIC to let me rent a convertible," Allard told me, "and I remember driving at dusk by the orange groves in California, smelling the blossoms, thinking, This is right. This is good."

Allard, who seldom plans too much in advance, said he "just hung out with the players, went to the games." He looked for ways to illustrate the dream of getting to "the show," as the players call it—baseball's major leagues.

Allard, too, noted the players' tight focus. "The most important thing for them was to get that swing down. Get that swing." One of Allard's photographs is of a young infielder who got married in uniform on the diamond before a game. "He's walking off after the game with his bride. She's on his arm, but he's got a big Coke in one hand, and he's got his two bats in the other. Those guys don't go anywhere without their bats.

"The vast majority are never going to make it to the show. Only 1 out of 14 does. But still, for them to be able to say to their children and grandchildren: 'I played the game. I was good enough to play the game professionally.' There aren't many American males who can say that."

STORIES ABOUT SPECIAL COMMUNITIES of Americans—be they baseball players, cowboys, harvest workers, Native Americans, or Amish farmers—can be both difficult and immensely satisfying for journalists. Writers and photographers are intrusive by definition, and they must work hard to build trust and gain access into societies that seem closed. But when they succeed, they find the struggle has created a mutual respect that carries beyond magazine assignments and forms the base for lifelong friendships.

Journalists who succeed at these stories create networks of friends as they work around the country. "When you go into the field," photographer Richard Olsenius told me, "you become a temporary; you have a temporary pass into these communities. And if you're a good person and they accept you, you become a part of their lives."

Bill Allard continues to be one of the most successful in working with people. In the 1970s he wrote and photographed what became almost an anthology of western Americans: "The Hutterites, Plain People of the West," July 1970; "Two Wheels Along the Mexican Border," May 1971; "Cowpunching on the Padlock

Ranch," October 1973; and "Chief Joseph," March 1977, a chronicle of the Nez Perce chief who held out against white authority. Allard also photographed *The American Cowboy in Life and Legend,* a Society book, with text by senior staff writer Bart McDowell and has published, *Vanishing Breed: Photographs of the Cowboy and the West,* his own book on the cowboy.

"I had a long, long unabashed love affair with the American West and the American cowboy," Allard said. His West resonates with the simple pleasures of work, the texture of leather, the bond between father and son. He sometimes carried his own saddle, although he was not an experienced horseman. "I guess I played at being a cowboy a little bit, and I might have made better pictures if I had not done that. But that's the way I work; I tend to participate.

"There is no great secret, except time, to developing intimacy with your subject. Honesty is your best opening card. Somehow you have to project—through your words, your mannerisms, something in your voice—that you're trustworthy, because you're asking to be allowed to be a witness, to be present. If the subject shows some kind of resentment or hesitation as you start to take a photograph, you don't need to have a Ph.D. in psychology to see it. I've walked away from pictures that I later thought maybe I should have taken, but I'd rather err on the side of the subject."

At the end of an assignment, any honest journalist wants to be able to come back to the people he or she has depicted. Allard ended his story on the Padlock Ranch, in the rolling grassland of Montana, with a scene including ranch hand Jack Cooper:

"We walked back and the children went inside, carrying the milk pail to their mother. Jack and I stood for a moment in the yard, talking about his life and mine. We both live with our work: his in the meadows and mountains that surround his home, mine with my cameras and wherever they take me. We said good-bye at the white wooden gate that led to his house, its windows flushed with light, warm beneath a darkening sky.

"'If you ever get discouraged in your travels,' he said at the end, 'think of us. We're pretty happy here.'"

SOME AMERICAN COMMUNITIES have been notably difficult for journalists to penetrate, understand, and document. Native Americans do not always allow intimacy.

When NATIONAL GEOGRAPHIC was founded, America's clashes with Indian tribes were drawing to a close. The Apache warrior Geronimo had surrendered about a year and a half earlier, in 1886. The magazine soon began to report on Native American ethnology and territorial issues.

The magazine published, in July 1907, a portfolio by Edward S. Curtis, whose sepia-toned photographs glint with the sad wisdom of a cornered people. Quoted in the article were words by President Theodore Roosevelt, describing Curtis and his forthcoming 20-volume series on Native American ethnography:

"He has lived on intimate terms with many different tribes of the mountains and the plains…He has not only seen their vigorous outward existence, but has caught glimpses, such as few white men ever catch, into that strange spiritual and mental life of theirs, from whose innermost recesses all white men are forever barred."

From 1937 to 1949 the magazine published a landmark series of articles on Native Americans, beginning with "America's First Settlers, the Indians," November 1937, by Matthew W. Stirling, Chief of the Smithsonian Institution's Bureau of American Ethnology. The article included reproductions of 24 oil paintings by Wilfrid Langdon Kihn, who spent most of his days living among, and painting portraits of, Indians in the western United States and Canada. The two men collaborated on six more major articles, each describing tribes within a region of North America.

Stirling was a preeminent figure in Middle American anthropology and archaeology, a man who once crossed South America by foot and canoe and lived with the head-shrinking Jívaro Indians of the Upper Amazon. He was a member of the National Geographic Society's Committee for Research and Exploration, and he gained international fame with his discovery of the Olmec civilization in Mexico. Among the many objects unearthed there were 11 enormous stone heads.

As Native American societies through the years searched for ways to keep spiritual energies intact, they sometimes grew defensive and rejected those who came to study or document them. In 1971 irate Navajos

smashed two of staff photographer Bruce Dale's Nikon cameras in a misunderstanding while he was photographing "The Navajos," December 1972, with text by Ralph Looney.

One of the most recent articles on Native Americans, "Powwow: A Gathering of the Tribes," June 1994, by freelance writer Michael Parfit and photographer David Alan Harvey, focused on events which are open to the public. Powwows are festivals in which Indians of many tribes come to dance, sing, gamble, and socialize. The featured events include dance contests, based on traditional dances that were once part of spiritual ceremonies but today bring out ethnic pride in a heritage that is enjoying a resurgence.

Hundreds of powwows are held each year around the country, and one is the Crow Fair, held on a reservation near Hardin, Montana. Parfit described the scene:

"Crow Fair is a city of a thousand tepees—and hundreds of pickup trucks, campers, and tents. Young Crow boys on horses race bareback through camp…a camp crier comes around every morning at sunrise in a pickup truck, shouting wake-up calls in Crow through speakers mounted on the cab."

Parfit knew that it would be tough to get close to the participants, so he joined the workforce. "I spent the entire powwow at the announcers' table, typing dance-contest scores into my laptop computer," he said. "Harvey kept coming around saying, 'Parfit, what are you *doing?*' But it provided me with a way of participating, looking behind the scenes." Parfit described his work:

"Familiar names rise to the top of the standings. Terry Fiddler is running away with the Men's Traditional, and Jonathan Windy Boy will take home a thousand dollars for the Men's Grass."

The assignment took Parfit back and forth across the continent. After a powwow at the Civic Center in Hartford, Connecticut, he decided to travel to another in Yakima, Washington, with two powwow performers—Jonathan Windy Boy, the grass dancer, and Bernard Bob, a Cree singer from Canada. Parfit wanted to know the men better. "You just don't get to know people in an hour's interview.

"The grass dancer was an athlete, and he drove like an athlete. We seldom saw the slow side of 90. I wondered if I was going to survive. I would drive while he slept, but he was impatient, so if I didn't go at least 80 to 85, he would take over. The Cree had a hand drum, and when I was driving, they would sing. I'm sure I was being tested. We'd be cruising along in the middle of the night, and they would be looking like they were asleep. And all of a sudden, in the back seat, the Cree would strike his drum, making an incredibly loud noise that sounded like the tires had blown out. And then he'd start to sing."

Only by getting into the middle of things, Parfit told me, could he see how important such powwows were to the cultures of Native Americans. "I would have thought that this powwow stuff was designed for tourists," he said. "I wouldn't have realized that these people were doing it for their own sake." Photographer Harvey, too, worked hard to penetrate the culture. When he first went to Rocky Boy Reservation in Montana, the chief took him into a sweat lodge. "And he's talking to me, and it's getting hotter and hotter, and I'm thinking, I cannot breathe; I'm going to have a heart attack.

"And he finally said, 'You know, you're here to make photographs, and I'm here to tell you that photography has no part in our lives. It's not important, and we don't believe in it, and there are certain things you're not going to photograph. Our history is an oral history.'

"Now I'm a driven man, driven to make photographs. But this man was so convincing both by what he said and by the physical pain of being in this sweat lodge, that when I came out of there, I felt no need to make any photographs."

Harvey eventually captured some significant scenes in the powwow celebrations but found that the chief's words rang true: Other moments were just beyond his reach.

"Most of us want to preserve things," Harvey said. "We write things down, we paint, we photograph, we can't stand the thought of losing things. We die, we go to heaven. It's a Judeo-Christian thing, a European thing, and Native Americans don't have any of that. They don't want to preserve. They don't want their artifacts frozen in some museum. They want them to sit out there in the sun and the wind and the rain. They figure the tree sprouts, it grows, it dies, it comes back to earth. It continues to live."

CONCERNS OF THE SPIRIT are paramount when journalists approach a community such as the Old Order Amish. This community considers photography to be a matter of vanity, of idolatry. When Robert W. Madden, then a contract photographer, was assigned to "Maryland on the Half Shell," February 1972, with text by Stuart E. Jones, he approached an Amish bishop in western Maryland. Said Madden, "The bishop looked at me and said, 'If you think I'm going to give you permission to take pictures of us, you're crazy!' And he turned on his heel and slammed the door."

PHOTOGRAPHER ROBERT W. MADDEN with friends made on assignment "MARYLAND ON THE HALF SHELL" FEBRUARY 1972
PHOTOGRAPH BY DEVON JACKLIN

Madden finally gained access in a more relaxed district. "I knew a Mennonite who knew some of the Amish folks," Madden said, "and I finally ended up at the milking barn of an old man named Miller. He thought a moment, then said: 'Well, we don't go for pictures around here, but have you talked to Simon Swartzentruber?'"

Simon Swartzentruber had four offspring—a daughter and three sons. "The older son wouldn't allow me on his property. His second son didn't mind if I photographed from the road, but every once in a while he would run me off. The daughter was different—I was in her house. I photographed her son's important 16th birthday celebration. But when the Amish were in a group, the peer pressure would be too strong. Forget it.

"One time the women held a quilting bee in a non-Amish house, so the Amish could say, 'Oh, I didn't give him permission to take pictures.' I worked with a little Leica camera, and I'd pull it out of my pocket and I'd toy with it, and I'd look, and if I got bad vibes it would go right back in my pocket. If I didn't get bad vibes, I would take only a few photographs, and then back in my pocket it went. It made them so nervous. Unbelievable! I must have missed nine pictures out of ten—pictures I just couldn't take."

Still, Madden made headway. Once, on a day when he had been photographing in the fields and all his shoes except one pair were caked with mud, an Amish friend stopped by and asked if he was going to a funeral that afternoon. "They have these three-and-a-half-hour services," Madden said, "and they sing a cappella in German. It's like stepping back in time. But all I had left clean was this pair of red tennis shoes, so I said, 'Well, gee, I'd love to go, but I've just run out of shoes. Do you think they'd mind if I went to the funeral in red tennis shoes?'

"And the guy looked at me and said, 'Well, Bob, we don't care what *you* wear.' I was so far outside their world, they didn't care.

"One of the nicest things that happened—I was in this kitchen one night and heard a horse and buggy coming up the road and went out on the front porch and waved, and I suddenly realized what I had done. I said to my friend, 'Man, if I saw a horse and buggy when I first came up here, I'd run and get my camera. Now I go out on the porch to see if it's one of my friends going by.'

"'Well, Bob,' he said, 'if you stay up here any length of time, you won't even have to leave the kitchen, because you can tell who it is by the step of their horse.'"

AMISH LIFE REMAINS VITAL, but time seems to be running out for the Shakers, a religious community founded some two centuries ago and noted for its piety and celibacy as well as for the making of fine furniture. Their name derives from how they would tremble from head to foot in religious ecstasy. To record their ways, the GEOGRAPHIC sent senior staff writer Cathy Newman and photographer Sam Abell for "The Shakers' Brief Eternity," September 1989.

"When I proposed the story," Newman told me, "the Editor said, 'Well, we're not sure there's anything there. Why don't we have Cathy write it, and if it works, we'll illustrate it.'"

What Newman found was that the Shakers, who in 1845 numbered nearly 4,000 in 18 communities from Maine to Kentucky, had dwindled in number to fewer than a dozen in two communities. And these two communities had split on policy.

The parent ministry at Canterbury, New Hampshire, consisting of three elderly women, had closed the covenant, in effect ruling that no new Shakers could join. They were resigned to a quiet ending, believing Shaker values would endure in different form. The community at Sabbathday Lake, Maine, with nine members, four of them younger people, demurred. They tended sheep, dried herbs, allowed others to try the life.

"There was also a question about money," said Newman. She felt she had no choice but to report on the dispute. "It was the sort of thing you find in a family after the parents have died, people squabbling over inheritance. Except in this case it was more poignant than usual, because the Shakers were a sect that aspired to perfection. It was sad, and very ironic."

Newman wrote warmly of the Shakers' history, their unstinting craftsmanship, their piety—they accepted Christ's injunction "Be ye therefore perfect" and sought to bring heaven down to earth. She described her trip to New Hampshire and the visit to the three members there, all now gone to their reward:

"In spring's tender green I journeyed to Canterbury, on a ribbon of road that unfurls past New Hampshire's maple groves and apple orchards. Shaker sisters live here, but it is more a museum now, a still life in white and green: meetinghouse encircled by a picket fence, manicured herb garden, trim white shops and dwellings, clean-swept stone walks. 'There is no dirt in heaven,' Mother Ann said."

But the discussion of the disagreement between the two groups rattled some people on the outside who had protectively surrounded the Shakers. "People expected a warm, fuzzy story," Newman told me. "I would not be surprised if there wasn't a feeling of betrayal. In some instances, a writer may seem like a hit-and-run driver. You don't mean to, but you injure people's feelings. You don't go back to the scene of the accident and say, Do you feel betrayed? Are you sorry you met me?

"I got letters from a woman accusing me of yellow journalism and muckraking: 'Why did you have to bring this mess about the Shakers into full view? These marvelous structures, the pretty fences—why introduce emotions like greed and envy?' But if it hadn't been for that tension, it would have been a story about pieces in a museum. I think it was a beautifully human story about how, as much as we all aspire to be perfect and unblemished, at the end we're all human. And thank God for that. Amen."

TO COVER AFRICAN-AMERICAN STORIES, GEOGRAPHIC editors have often called on African-American journalists. Writer Frank Hercules and photographer LeRoy Woodson, Jr., documented "To Live in Harlem…" February 1977; writer Charles L. Blockson told the story of "Escape from Slavery: The Underground Railroad," July 1984, through his own family history.

Poet and author Maya Angelou wrote the foreword for a collection of portraits of black women in "I Dream a World," August 1989. And in "Philadelphia's African Americans: A Celebration of Life," August 1990, photographer Roland L. Freeman documented a rich and vibrant urban culture.

For "Blues Highway," a GEOGRAPHIC article scheduled for 1998, former staff writer Charles E. Cobb, Jr., was invited to write the text. The article focuses on one of history's great treks. Beginning in the second decade of the 1900s and continuing until the 1970s, millions of African Americans, in search of a better life, migrated from the South to cities in the Northeast and the Midwest. They took with them their music, including the blues—soulful songs of lamentation born from slave field hollers and working chants on plantations and farms of the Deep South.

Cobb builds his story around that part of the migration that took place from the Mississippi Delta upriver to cities such as Memphis, Cairo (Illinois), and Chicago. The corridor these migrants and their music followed north, including the legendary U.S. Highway 61 to Memphis and beyond, came to be known as the "Blues Highway."

For Cobb, it was a fitting assignment. "Mississippi and I go back a long way," he told me. "There are family ties and personal political ties from the Civil Rights movement in the early 1960s. I was up and down those roads and small towns, so I have friends there."

In his story Cobb tells of the death of his great-grandfather, Samuel Kendrick, who was born a slave and became a farm owner in Mississippi. Kendrick was beaten with ax handles by a mob of whites, angry that he

had hired a black worker off one of the plantations. When Kendrick died of pneumonia at age 56, his youngest daughter, Hattie, moved to Cairo in 1927 and became a schoolteacher. Hattie's brother, Cobb's grandfather, came to Washington, D.C., where Cobb was born.

"It was a complicated assignment," said Cobb, "because it's really two stories—the migration of the sharecropper families and the discussion of blues. But when you talk about people's culture and what they took with them, you wind up discussing the blues. Blues is not about us being sad; it's about us surviving, a metaphor for movement and freedom.

"It's the musician, after all, who first got the greatest amount of freedom. He could travel. Somebody like David 'Honeyboy' Edwards, now a professional blues musician in Chicago, runs away from home at 16 because he can play the guitar, and he never comes back. All of these songs talk about travel, trains, and movement."

Cobb interviewed older migrants, coaxing out details of their lives. He described how Elnora Jones, now 77, first came to Chicago from Mississippi with her three small children more than 50 years ago. Jones's mother had arrived in Chicago earlier, moving into a neighborhood where other family members had settled. Cobb recorded Jones's memories of arriving at night at the Twelfth Street station:

"We couldn't see Mama, but we could see all those big buildings and bright lights. It was the biggest place I ever saw. Then I saw her and yelled, 'There's Mama!' and we all went running. We came out of the station, everybody holding hands so we wouldn't get lost. And we took the trolley bus.

"Before that bus I'd never been beside white people before. It was crowded and I'm standing there holding the rod when a white man got on and his hand touched mine, both of us holding the rod. I let my hand go; then I put it back. Wow!"

As a black journalist, Cobb carried a few extra bags. "Race operates in a funny way in coverage," he said. "The way the GEOGRAPHIC works, an assignment involves fashioning a kind of personal and social existence in the field. You're someplace for six weeks, during holidays, on weekends, and you begin to develop a kind of social life. People invite you to dinner; you find people to drink with, to go to church with. And race sometimes affects the choices you make about what to do during downtime. My inclination is to find a jazz club, or a blues club. I'm interested in the situation of black people in any place."

Race works against him only occasionally, Cobb said: "On assignments you sometimes drive for long hours, and because you have an interview the following morning in some little town, you try to find a motel, and you pull up to ask directions. And if you're a single black man walking into a convenience store at 1 a.m., they don't know whether you're there to buy cigarettes or to stick 'em up. You just push on through with what you want to do."

MANY MODERN NOMADS TRAVEL the highways of the nation: migrant workers, circus people, rock-and-roll bands, wheat cutters following the harvest. One such community carries bees, to pollinate the nation's crops and to make honey. Staff writer Alan Mairson and Maria Stenzel, then a contract photographer, followed this unique group for the better part of a year for "America's Beekeepers: Hives for Hire," May 1993.

"It was the perfect GEOGRAPHIC story," Mairson said. "It not only told you something about people, their livelihood, and agriculture, but it was also a road story. You were moving, and the notion that you could have a job, and be on the road, and work on the land and produce something that people want, was terrific."

Mairson and Stenzel started by attending the American Beekeeping Federation's annual meeting that year in San Diego. There were some 2,000 commercial beekeepers, about half of whom migrated in their work. "I put out word that we were doing this story," said

WRITER ALAN MAIRSON on assignment
"AMERICA'S BEEKEEPERS: HIVES FOR HIRE" MAY 1993
PHOTOGRAPH BY MARIA STENZEL

Mairson, "and that we wanted to follow one family of beekeepers through the cycles of the season. And then we did more or less a casting call: We made appointments to meet beekeepers, eat lunch, and get profiles—asking, 'What do you guys do? Are there photo possibilities?'"

They found Joe Tweedy and his family, among them wife Florine, daughter Christine, son-in-law Jeff Anderson, grandsons Jeremy and Aaron, and workers—16 in all. The Tweedys were third- and fourth-generation beekeepers and devout Seventh-day Adventists. To avoid the disruption of changing schools during their migrations, Christine and Jeff home schooled their children. Mairson and Stenzel decided to build the story around the Tweedy family.

"Their year begins in early February in California," Mairson said, "and they stay there until mid-May, moving their bees from almond groves to cherry groves, pollinating. Then they pick up all their bees, stick them on flatbed trucks, and on Mother's Day weekend drive to Eagle Bend, in central Minnesota. They spend their summer there, putting the bees on clover and harvesting the honey."

It's a family affair. As Mairson wrote about their leave-taking of California:

"Early the next morning everyone is in motion. Jeff double-checks the straps that hold the hives on the truck and the nets that keep the bees in. His ten-year-old son, Aaron, sprinkles the hives with water to keep the bees cool. Florine packs clothes, a typewriter, treadmill, and VCR into the motor home while Christine and her kids pack their van and trailer.

"At 8 a.m. we gather beside the trucks for a prayer. Moments later our caravan—a motor home, a van, two 18-wheel trucks, and 1,120 of their beehives—hits the road."

Being stung was the price exacted for the story. "The bees are very smart and very vicious," said Stenzel. "They go for the eyes. They'll get you through the mesh. They hurt; you swell up. Half the time I looked like a battered wife."

Mairson had arranged with a beekeeper in San Diego to get a sting on the back of his hand, just to get the first sting out of the way. "It was a stupid thing to do," he admitted. "I had not brought any drugs, in case I had an allergic reaction. But at some crazy level, I *wanted* to be stung. I had to get in there."

He could have waited. In Minnesota one day Stenzel forgot her protective bee suit and asked to borrow his. "Our suits were really good ones," said Stenzel, "made in England, with head nets that were like sweatshirt hoods; when you needed it, you flipped it on, and you were very well sealed. The Tweedys wore these pith helmets, with stiff mesh hanging from them. You couldn't get the camera up to your eye with them. So I talked Alan into lending me *his* English bee suit. 'You can borrow one from Joe,' I told him."

The borrowed suit didn't exactly fit Mairson's six-foot-four-inch frame. "Maria and I were out in the field and the air was lousy with thousands of bees," he remembered. "And she said, 'Would you like me to take a picture of you for the 'On Assignment' page [of the magazine]? Why don't you crouch down....' And as I crouched down, the back of my suit separated from the net around my head and two or three bees got in. I was running around trying to rip off the hood. And at the end of the day my head looked like it had gone through a battle."

But the picture was a success. "He made the 'On Assignment' page and I didn't," Stenzel said. "It still makes me laugh! But I felt so guilty that I gave him back his bee suit and took the pith helmet."

In Minnesota the Tweedys had a small house, with their extended family living in mobile homes around the lot. "Alan, I, and the truck driver slept right outside Joe and Florine Tweedy's bedroom," said Stenzel. "We'd go out to work the bees in the mornings, and the women would make us sandwiches. I was the only female going, and I'd get into the truck with the guys, and they would listen to talk radio. The Tweedys were lovely, lovely people; they thought of me as a daughter."

Mairson shared Stenzel's sentiments toward the Tweedys. He said: "The journalist and critic Janet Malcolm once suggested that journalism is morally reprehensible, that journalists manipulate people. But with a story like this, especially, I didn't feel like I was manipulating anybody. I felt warm about the Tweedys; I admired them and what they did. I didn't think there was anything for them to lose by participating. I thought they had a story to tell."

And when Mairson said good-bye, Joe Tweedy invited him to visit again, using a migrant beekeeper's phrase: "Come back and see us," he said. "...if you can find us." ■

"AMERICA'S BEEKEEPERS: HIVES FOR HIRE"

May 1993

photographs by
MARIA STENZEL

text by
ALAN MAIRSON

IN A FALL RITUAL to avoid winter's chill, Dave Hackenberg trucks his bees from Pennsylvania to Florida's citrus groves.

BEES CLUSTER on pallets of hives, ready for moving,
after pollinating blueberry crops in Deblois, Maine
(above); Vince Vazza uses a smoker to pacify bees
as he works his hives in Hermiston, Oregon.

"THE CHEROKEE: TWO NATIONS, ONE PEOPLE"

May 1995

photographs by
MAGGIE STEBER

text by
GEOFFREY NORMAN

CEREMONIAL DANCER Ron Moses at the
Cherokee National Holiday Powwow, Oklahoma.

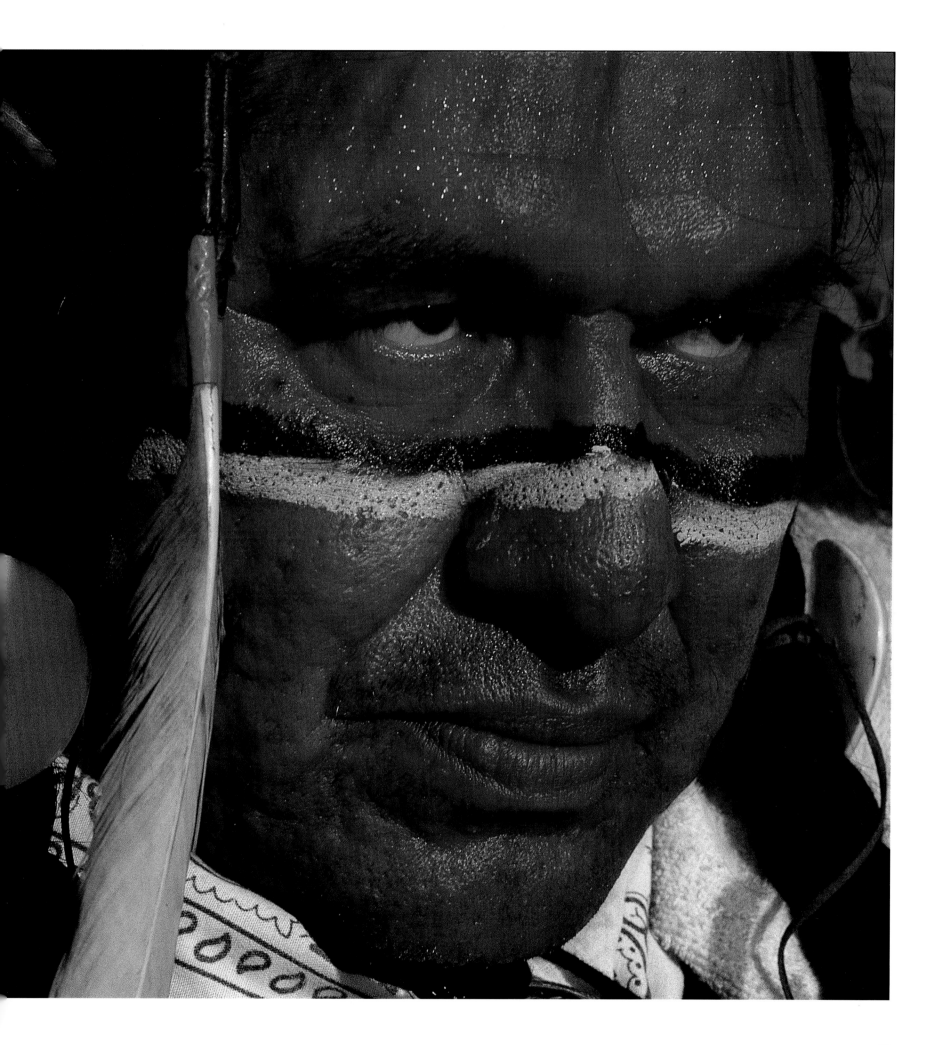

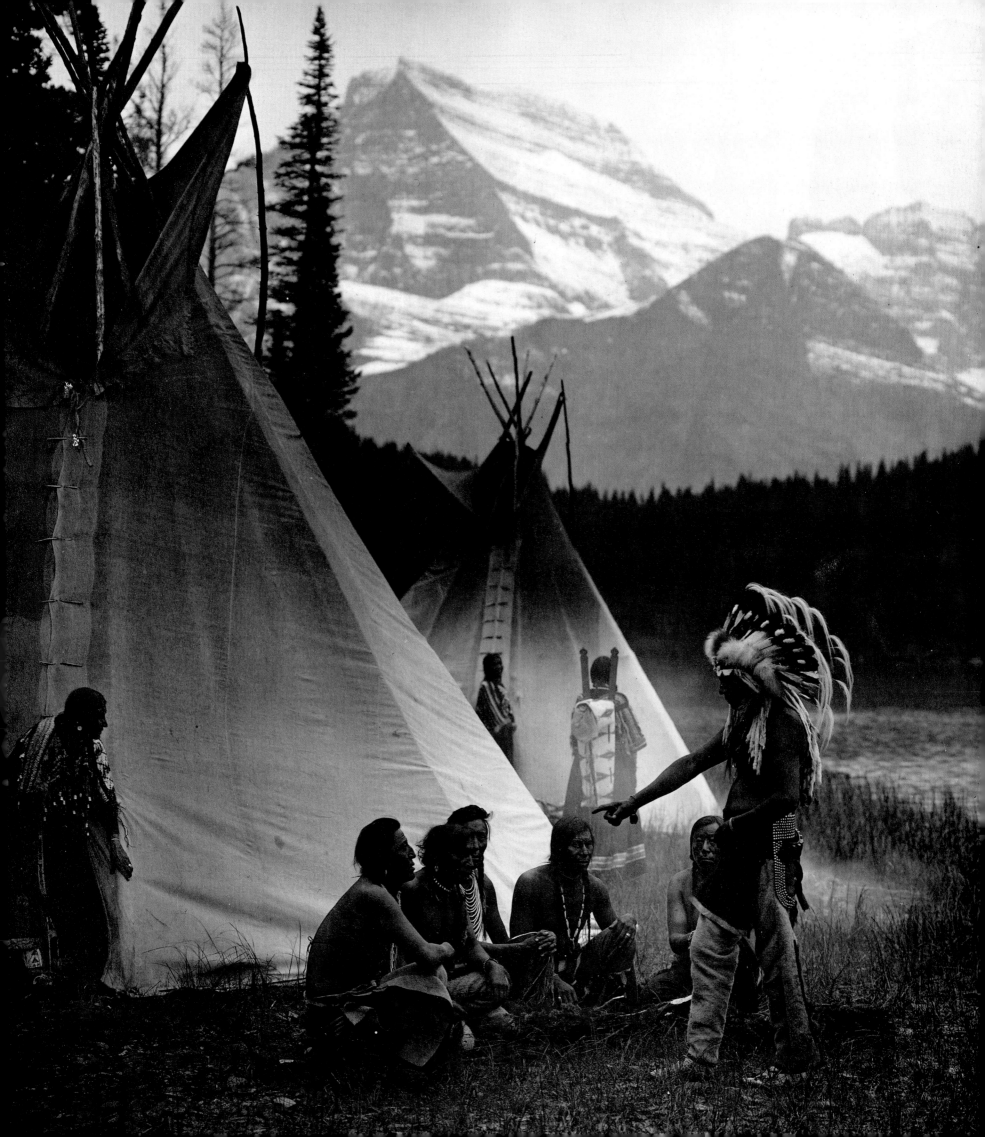

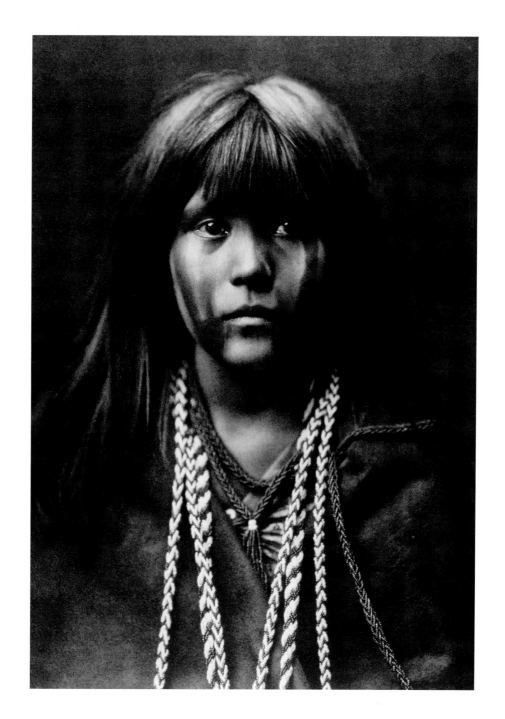

"NORTH AMERICAN INDIANS"

July 1907

photographs by
EDWARD S. CURTIS

PHOTOGRAPHER EDWARD S. CURTIS spent years documenting Native Americans, like Mósa (above), in the hope of preserving their traditions for future generations; a Roland Reed photograph of a council meeting (opposite), circa 1920, is from NATIONAL GEOGRAPHIC Image Collection.

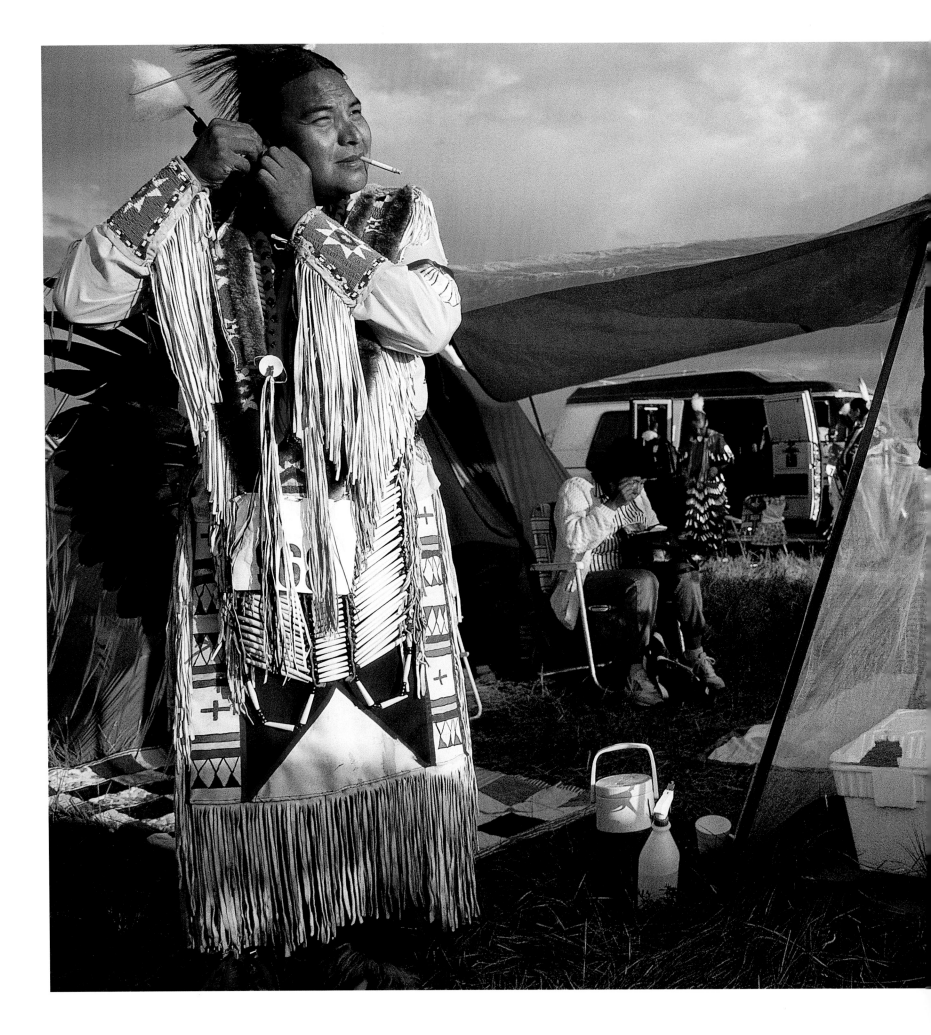

"POWWOW: A GATHERING OF THE TRIBES"

June 1994

photographs by
DAVID ALAN HARVEY

text by
MICHAEL PARFIT

ED BLACKTHUNDER, a Sioux from South Dakota, readies his Traditional Dance costume while his wife, Oriann Baker, far right, attaches a venerated symbol— an eagle plume—in preparation for a powwow at Rocky Boy Reservation in Montana.

"THE HUTTERITES,
PLAIN PEOPLE OF THE WEST"

July 1970

photographs and text by
WILLIAM ALBERT ALLARD

A HUTTERITE BOY surveys the peaceful
domain of his Montana community.

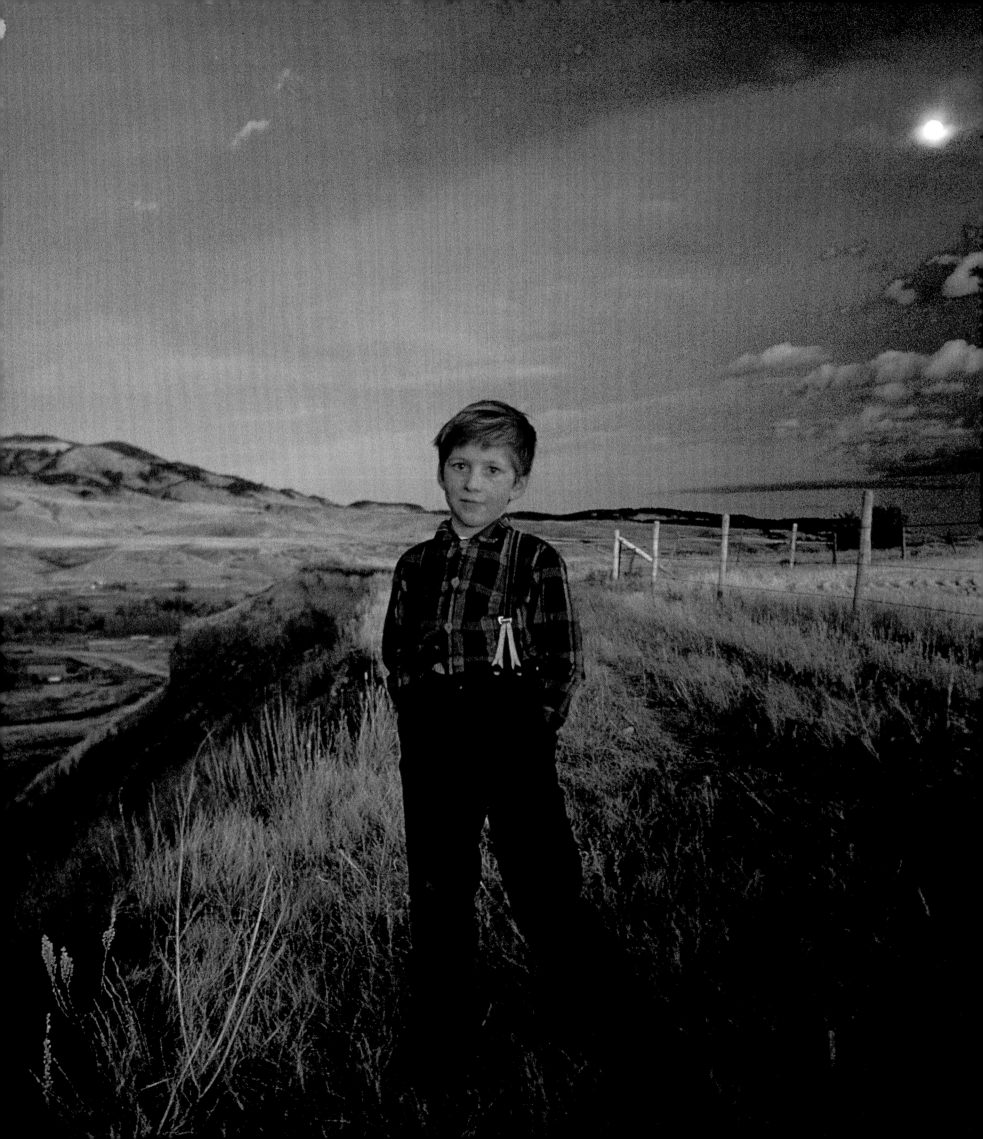

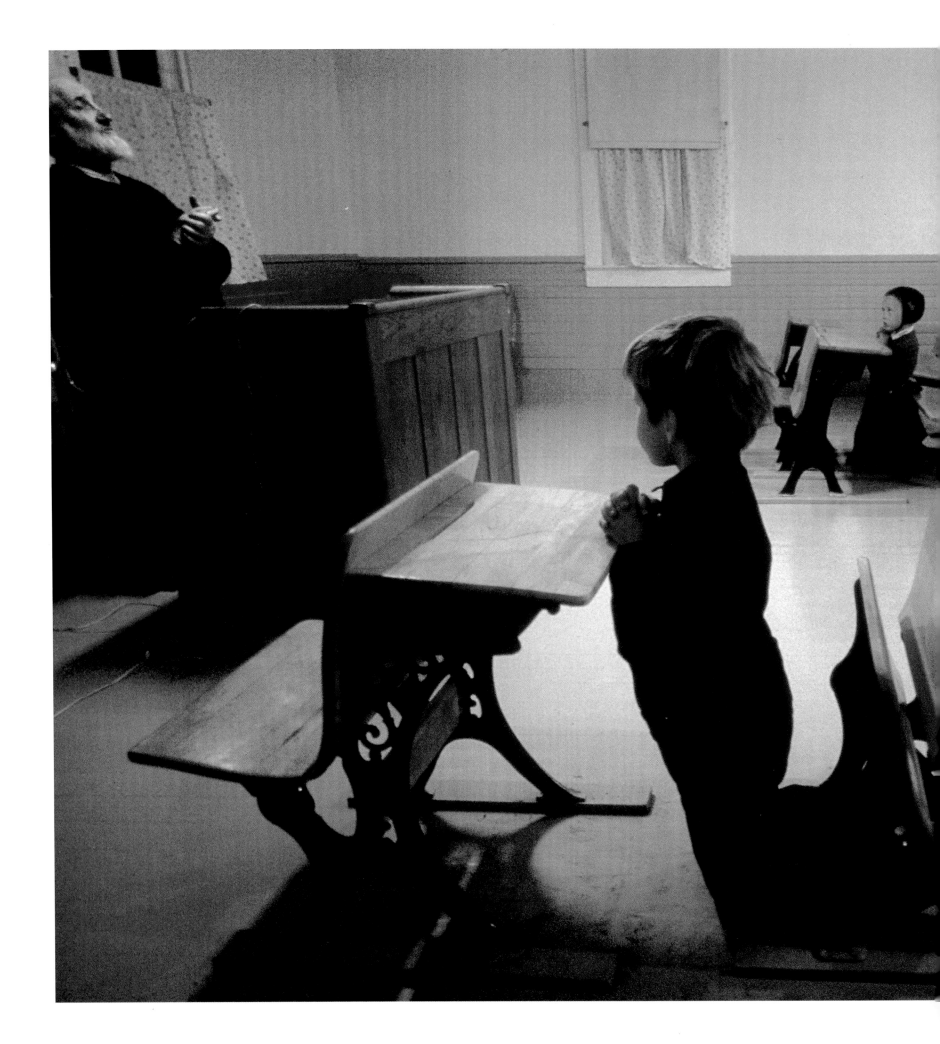

PREACHER PAUL WALTER leads evening prayer
at the colony in Spring Creek, Montana (left);
a young girl braids her hair back and front, a
Hutterite tradition for more than four centuries.

"PHILADELPHIA'S AFRICAN AMERICANS: A CELEBRATION OF LIFE"

August 1990

photographs and text by
ROLAND L. FREEMAN

BRIDESMAIDS AWAIT the hansom cab that will transport the bride and
groom to their nuptials (opposite); spectators wearing American Legion hats
watch the annual parade to Veterans Cemetery.

AMERICAN MOUNTAIN PEOPLE

1973

photographs by
BRUCE DALE

text by
JOHN FETTERMAN

MINER WILLIS CARROLL, with his children Sissy
and Bobby, after a day in Cannelton Coal Company's
Mine No. 115, near Montgomery, West Virginia.

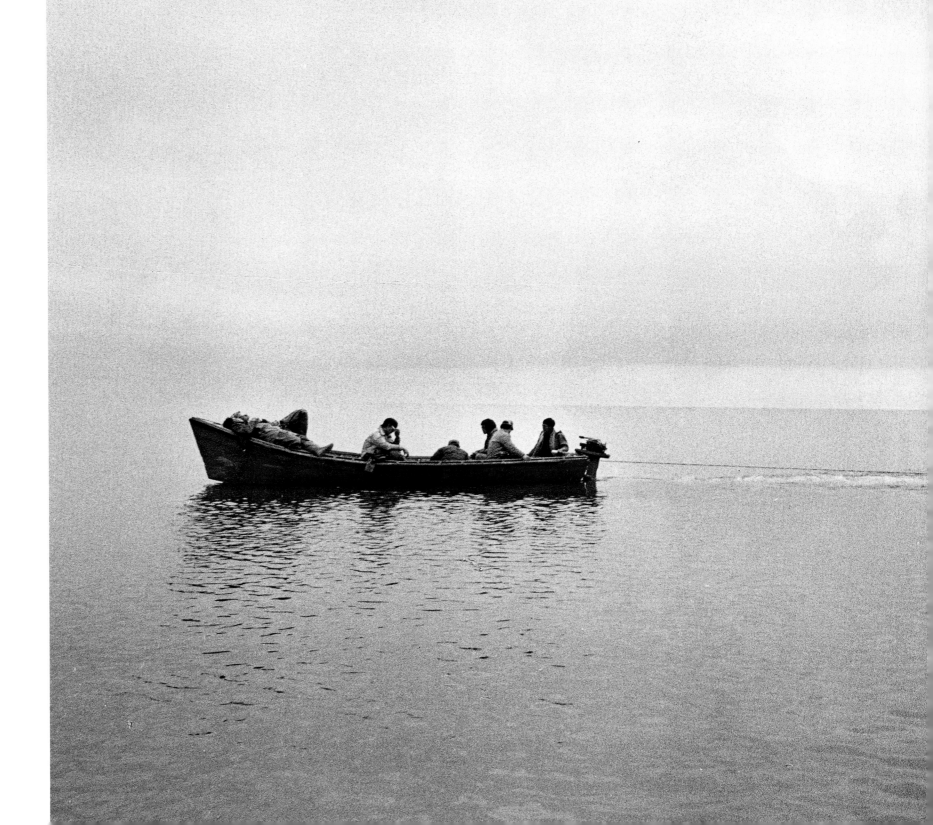

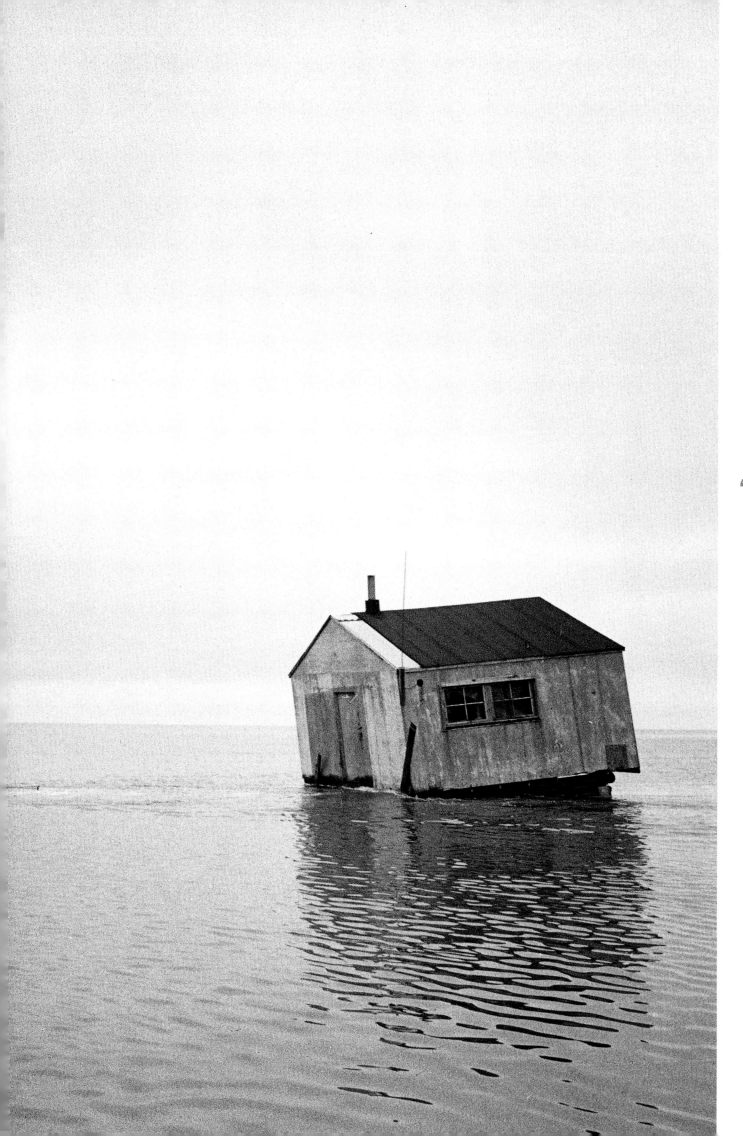

"ESKIMO HUNTERS OF THE BERING SEA"

June 1984

photographs by
DON DOLL

text by
BRAD REYNOLDS

TO SAVE THE EXPENSE of a new house, a recently married Yupik Eskimo couple, with the help of other villagers, loaded this dwelling onto 55-gallon drums and towed it from the old fishing camp at Umkumiut to the new village of Toksook Bay, Alaska.

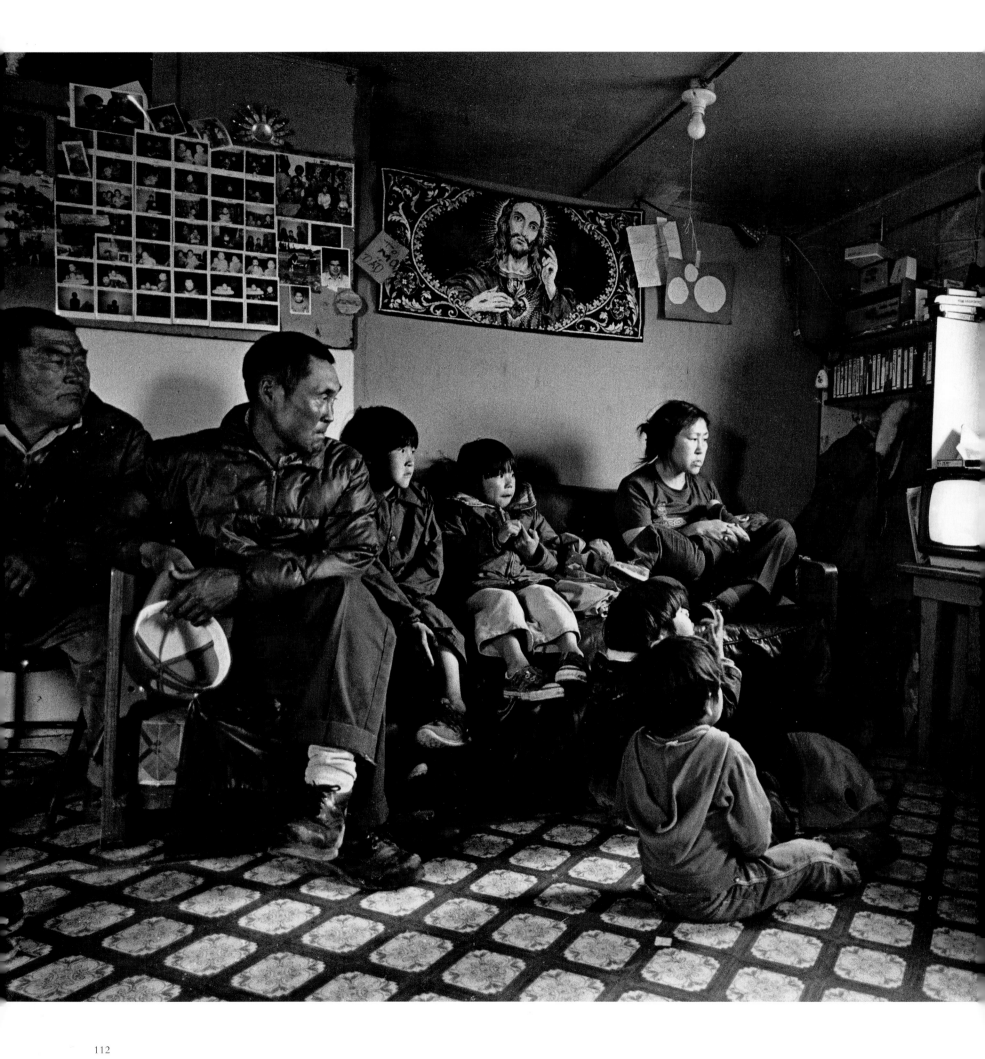

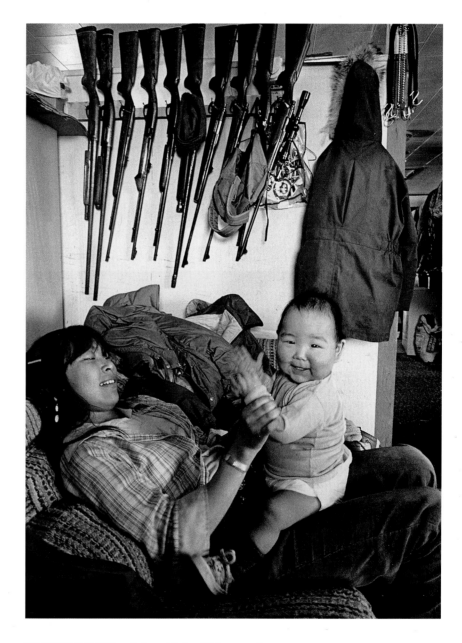

SIMEON JULIUS, at left, and John Alirkar watch
videocassettes of cartoons with neighbor children behind
storekeeper Larry John's shop in Toksook Bay (left);
in former mayor Paul John's living room his daughter
Agatha plays with grandson Vernon.

THE AMERICAN COWBOY IN LIFE AND LEGEND

1972

photographs by
WILLIAM ALBERT ALLARD

text by
BART MCDOWELL

TWO-YEAR-OLD JOHN HAND at the Ake
Ranch near Magdalena, New Mexico.

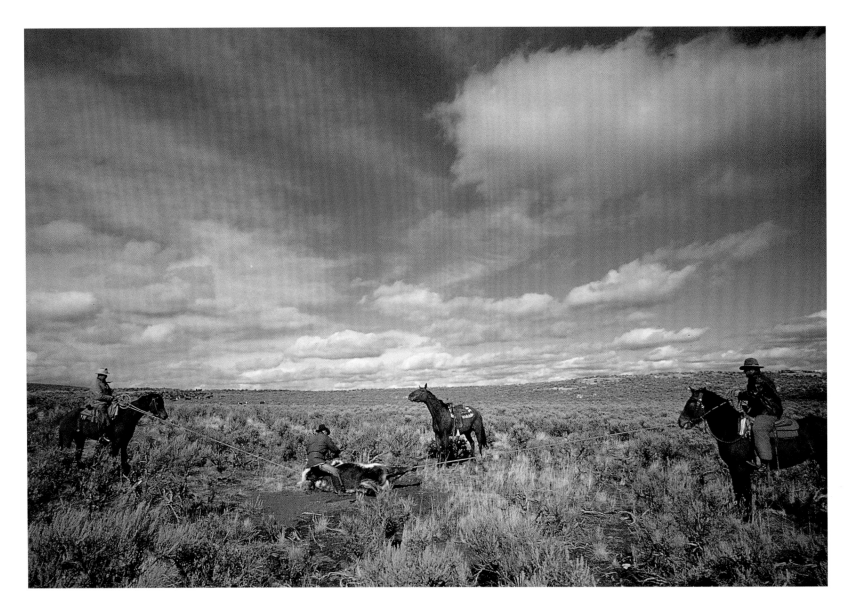

THE AMERICAN COWBOY IN LIFE AND LEGEND
1 9 7 2

WRANGLERS ROPE a calf for branding, Nevada.

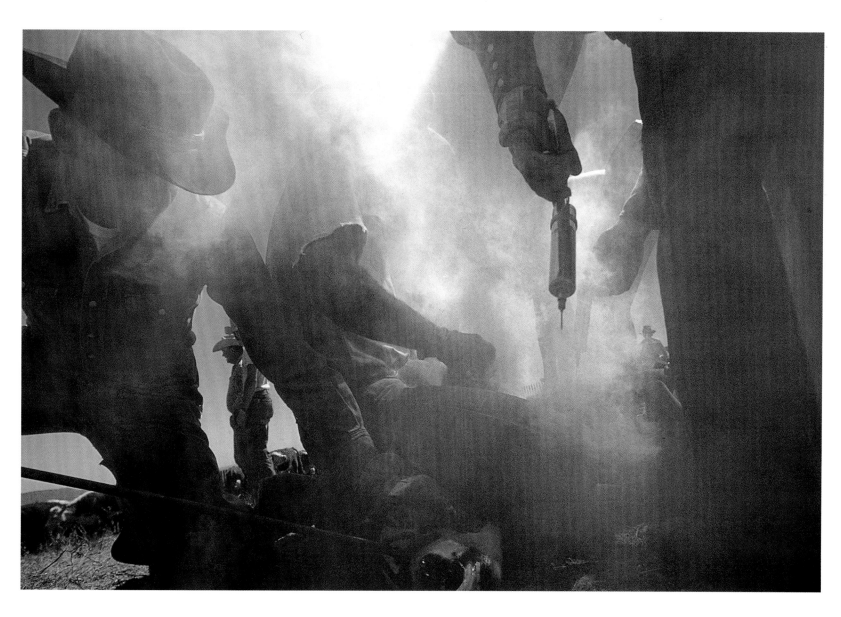

"COWPUNCHING ON THE PADLOCK RANCH"

October 1973

photographs and text by
WILLIAM ALBERT ALLARD

COWBOYS PREPARE to vaccinate a calf, Montana.

THE AMERICAN COWBOY
IN LIFE AND LEGEND
1972

FRED MARTIN, an 87-year-old
rancher, and his daughter-in-law
in a saloon near Magdalena,
New Mexico.

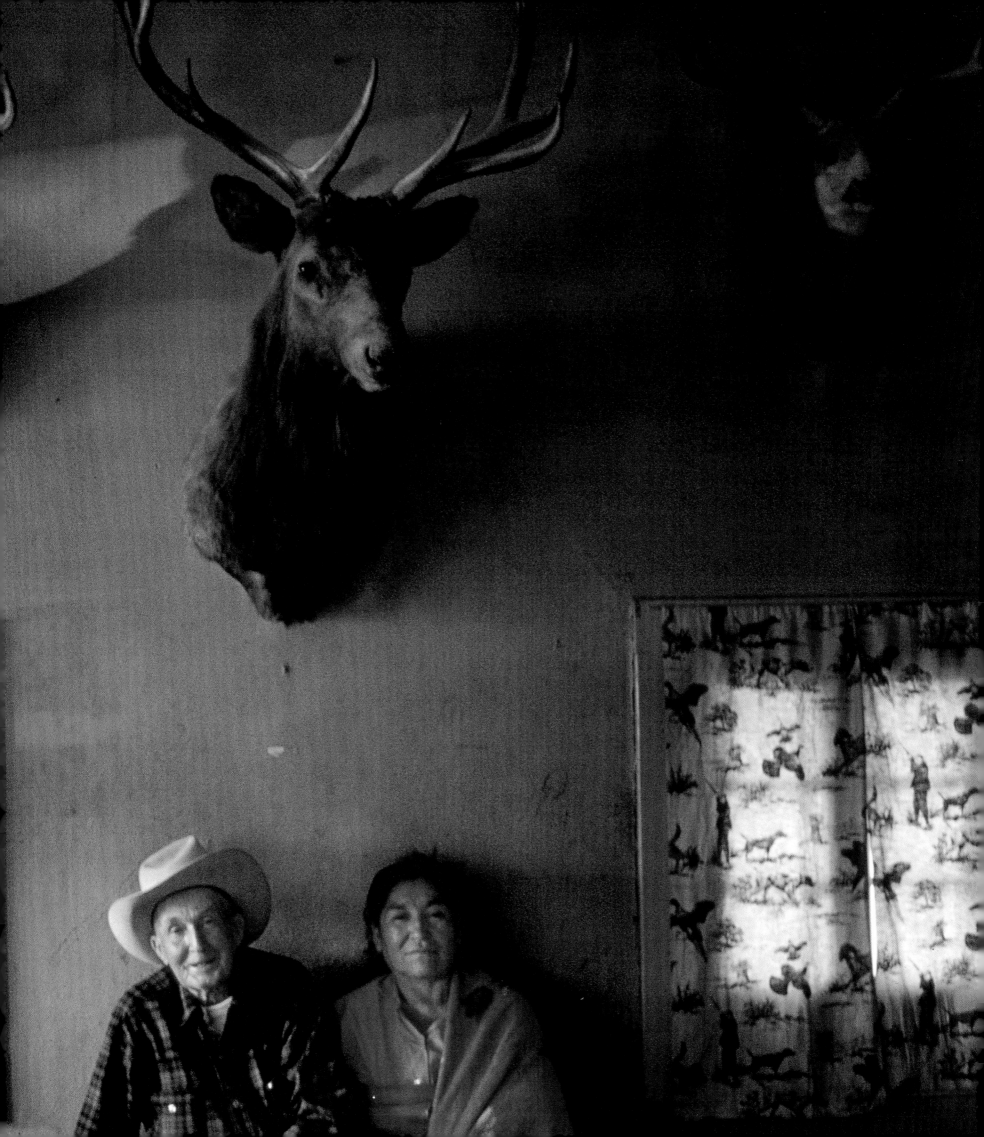

"THE SHAKERS' BRIEF ETERNITY"

September 1989

photographs by
SAM ABELL

text by
CATHY NEWMAN

SHAKER MAN'S HAT hangs on
traditional peg, Pleasant Hill, Kentucky.

CHAPTER THREE JOURNEYS

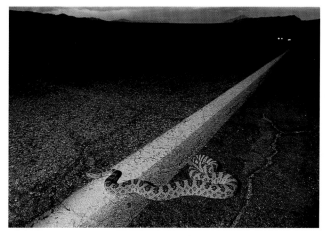

"I always loved that road and its frontier character... People there live close to the bone..."

—MICHAEL PARFIT

"THE HARD RIDE OF ROUTE 93"

December 1992

photographs by
CHRIS JOHNS

text by
MICHAEL PARFIT

" The road draws me
on, away from
beautiful deep
sunlight of afternoon
in the high desert
out into low windy
clouds and nightfall
north of Twin Falls.
I rise and fall as the
road crosses hills of
lava, the lights of
small towns showing…
in the distance. "

—MICHAEL PARFIT

COWBOY CHETH WALLIN puts in
14-hour days in south-central Nevada.

preceding page:
A RATTLER seeks a warm patch of pavement in Nevada.

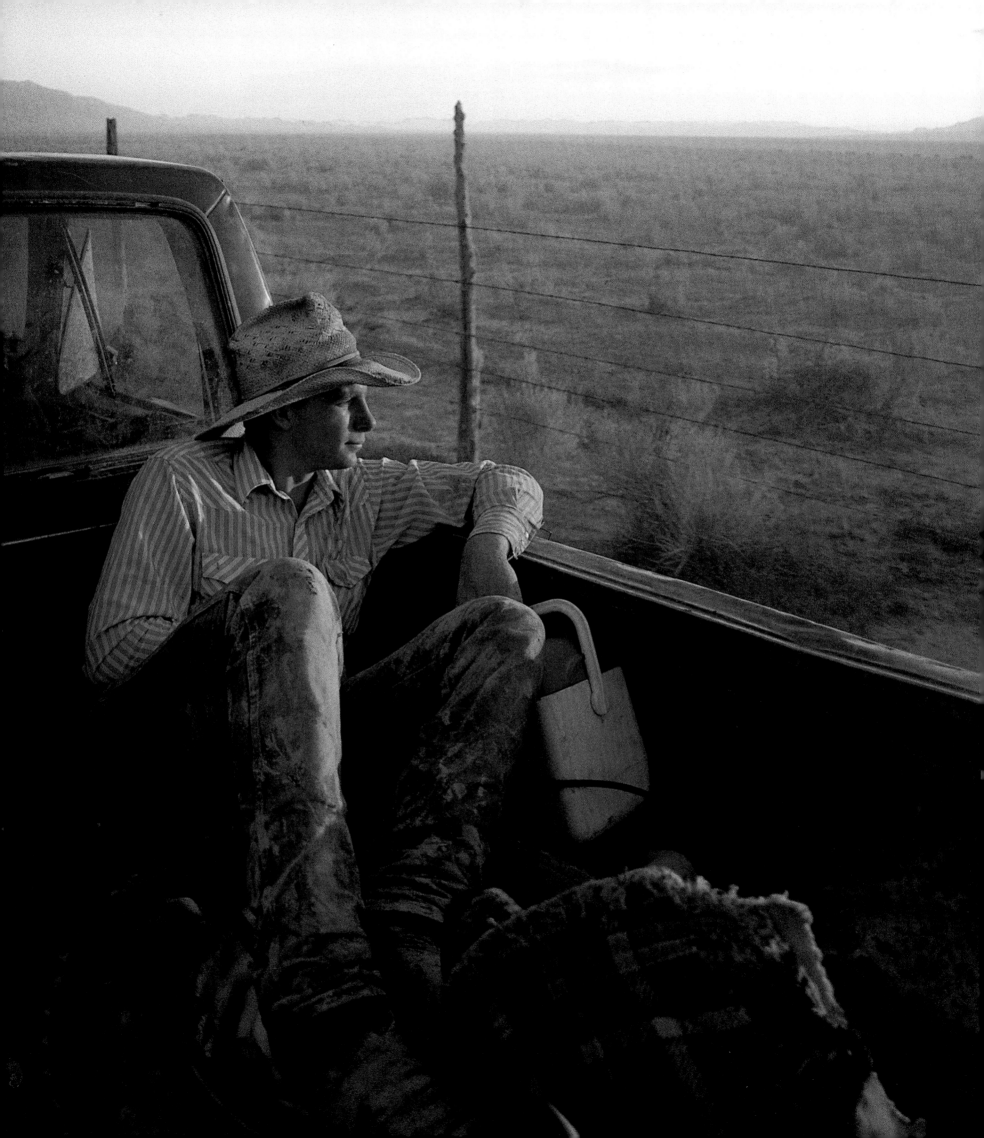

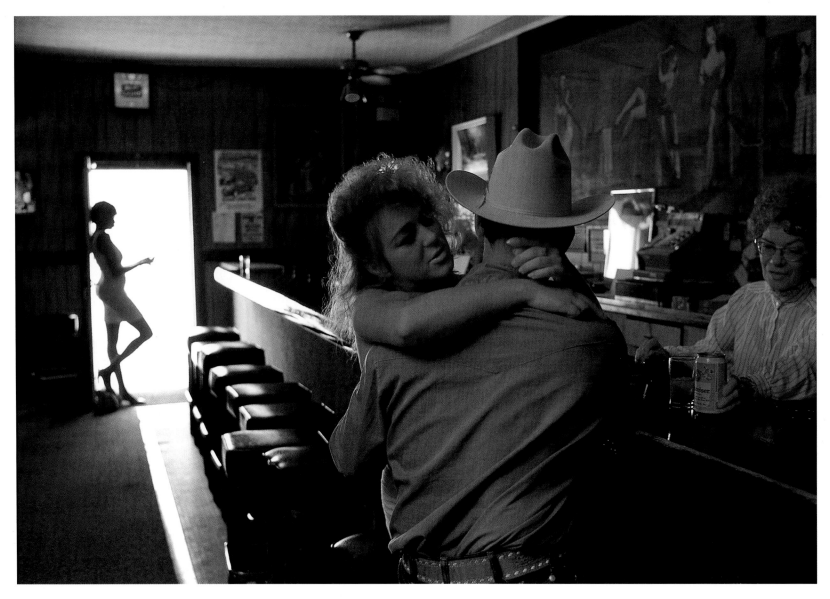

“Another quart of oil, another hundred miles. Ely stands high and windy at a junction of valleys and highways, 93, 6, and Route 50—nicknamed 'the loneliest highway in America.' I drive past the junction thinking: In some places there might not be many cars on 93, but I would never call this highway lonely.”

—MICHAEL PARFIT

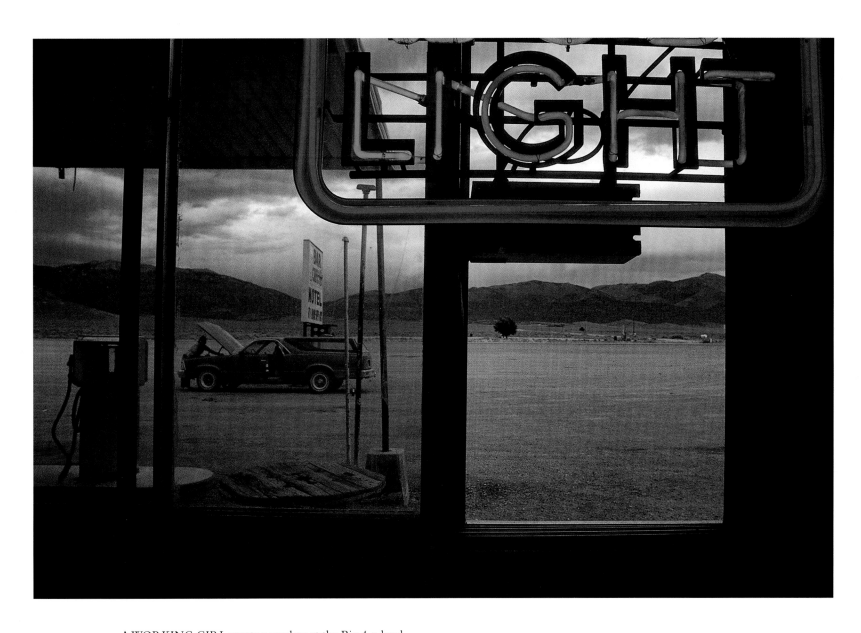

A WORKING GIRL greets a cowboy at the Big 4, a legal
bordello and bar in Ely, Nevada (opposite); selling gas, oil,
and cold beer, Nevada's Schellbourne Station is located 27
miles from the nearest town.

J OURNEYS. YOU START IN one place and go to another. Trails, rivers, roads in their linear simplicity organize travel as a plot organizes a book; they are stems around which people and experiences cluster, rich material for writers and photographers. Journeys are also metaphors for life, beginning to end, birth to death, and so laden with emotion.

For Michael Parfit, a freelance writer, an assignment to cover Route 93 in the West became a journey through pain. His wife, Debbie, died of breast cancer while he was working on the story. They had been separated for a year, and divorce and sudden illness arrived together. Parfit dropped his work to spend time beside Debbie as she weakened and died. When he resumed the assignment, he was torn by grief and learning how to be a single parent to two children. As he traveled, he left pieces of his suffering strewn along the highway, and on the pages of the magazine.

He wrote about how he and Debbie had once lived along the highway in an old homesteader's cabin, a place that Parfit felt compelled to revisit:

"Much of each winter, snowdrifts would block our dirt road, and we would have to walk a mile to the house. It seems now that it was always 40 below and the wind was always blowing. But she hung in with me, cooked our meals, heard out my heartache, and walked with me in the bitter wind."

The visit overwhelmed him:

"The storm of memory roars above me. I cannot touch it. Then I walk away from the house, and out of my mouth come unplanned words: 'Debbie, where did you go?' The storm hits like lightning and I'm on my knees in the sagebrush."

"The Hard Ride of Route 93," December 1992, with Chris Johns, then a contract photographer, was built around the tough, two-lane blacktop that runs 1,860 miles from Phoenix, Arizona, to Jasper, Alberta, and through Parfit's hometown of Saint Ignatius, Montana. The story was a groundbreaker at the GEOGRAPHIC with its strong, intimate material, but Parfit said he didn't plan it that way: "I don't care to intentionally write tearjerkers, but the kids—Erica was 13, and David, 11—were trying to deal with the emotions of divorce. And then came the cancer. How were we to juggle these things?

"People ask me, 'How can you write such personal stuff?' But as a writer, you feel exposed anyway. You put those words down and you're putting yourself on the spot. I know that people who watch television

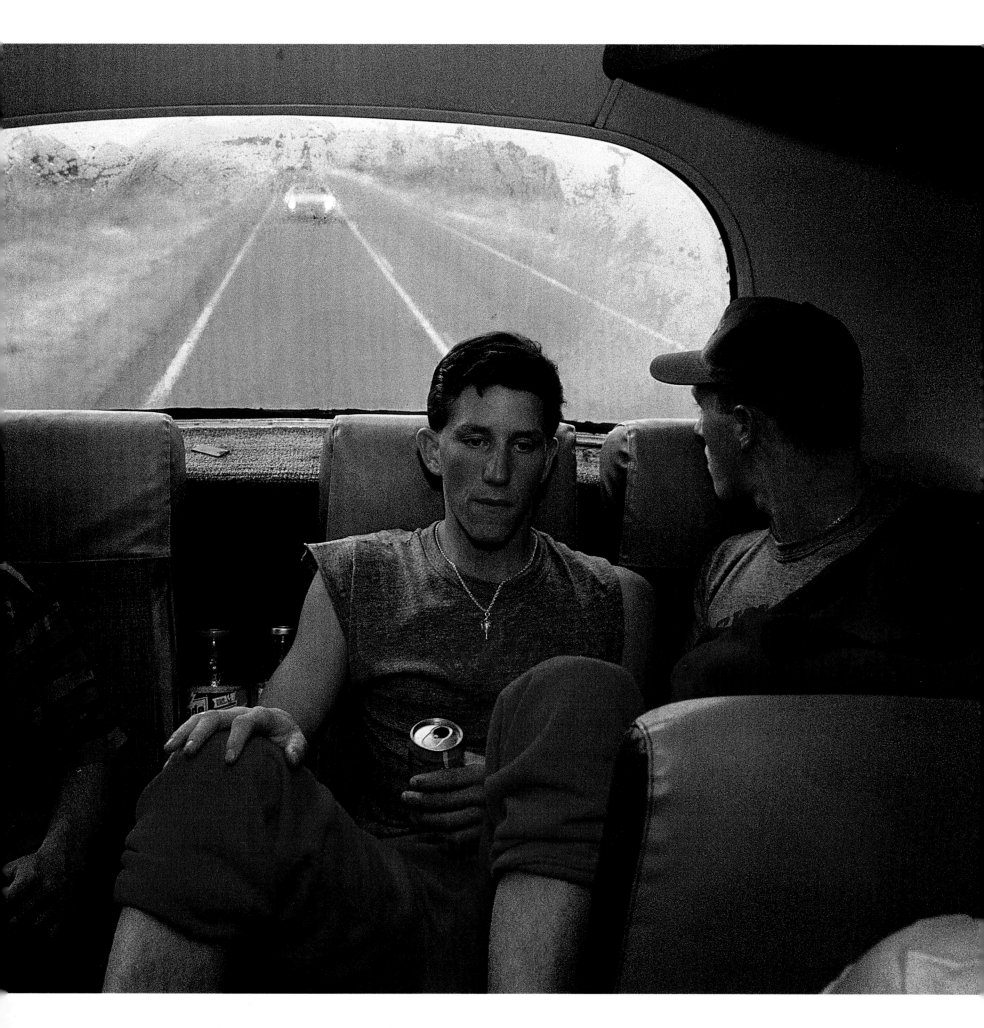

IDAHO'S CHALLIS HIGH SCHOOL Vikings travel to their last football game of the season.

morning shows often feel that the emcees are their friends. Well, I feel the same way about readers, that they're my friends. Maybe that's why some people write, because they feel a part of this mysterious thing out there—and I want to move people."

Parfit had begun the Route 93 assignment by climbing into an old Ford pickup "with a toolbox in the back, a CB up front." He told me: "I always loved that road and its frontier character. People there live close to the bone, and in a sense, when you meet a person there, you already know a lot about him. It's like an accent.

"I'd already been driving that highway for 20 years, and I drove it four more times for the story. There's no way I could have done it with one trip, because you wouldn't be able to walk in and sit down with these guys and be on familiar terms. It's much better to go back to visit for the second time. They relax; you're a friend. They tell you more about themselves."

As in most journey stories, writer and photographer did not journey much together. "I'd come tooling into some gas station with my pickup truck, and there's Chris. I haven't seen him for months. 'Well, hi!' We'd talk for fifteen minutes and be on our way. It was a small-town road, and I always felt that he knew what it was all about."

Said Johns: "Highway 93 took me back to where I grew up, the West, open spaces, people I'm comfortable with. It was a very personal story. I felt Michael's words and my pictures played off each other. We shared a sense of romanticism about the West. But writers and photographers—you have different rhythms out there. I can remember spending a night with Michael in his cabin, talking to him in the small hours, thinking, 'Gee, I like this guy. Wonder if he's going to pull off the story.'"

Parfit did, and set a new standard for what was acceptable. "You never know when you're going to hit that emotional level," he said, "but if you do, and if you connect with some person, all of a sudden the story takes on depth and power. You write intense stuff in your journal, and sometimes it works for the story, and sometimes not. But you gotta keep trying. It's like that country music song: 'You gotta dance like nobody's watching.'"

THE MAGAZINE'S EARLY journey stories danced to a different drumbeat. They were, in keeping with the times, sober narratives of exploration. Among them: "Recent Explorations in Alaska," January 1894; "Two Hundred Miles up the Kuskokwim," March 1898; and "The Mount St. Elias Expedition of Prince Luigi Amadeo of Savoy," also March 1898. In August 1914 appeared a prototype of more recent stories, "Experiences in the Grand Canyon," which covered 86 pages of the magazine, held 70 black-and-white photographs, and began with a rousing account of struggles with burros loaded with cameras and dry photographic plates. The authors were two brothers, Ellsworth and Emery Kolb, who spent 12 years exploring and photographing the Grand Canyon of the Colorado River and its tributaries.

They built a studio 3,200 feet below the canyon rim to process still plates and motion picture film. They also carried a darkroom tent as they descended the river in wooden boats. For processing, they "settled the mud in a bucket of water by placing the bruised leaf of a prickly pear cactus in the vessel. A substance which oozed out settled the mud and made the water sufficiently clear to develop our plates."

For action shots, one brother would barrel through a tough rapid, while the other photographed from shore, ready with a life preserver and line. "Get the picture first," Emery would bark in the fanatic but time-honored credo of the photojournalist, through choking, icy swims and shattered dories.

The West remained a fertile area for GEOGRAPHIC journey stories, with the Grand Canyon among the strongest magnets. This was appropriate: A Society founder, John Wesley Powell, Director of the U.S. Geological Survey, in 1869 led the first river expedition through the vast canyon, which he named. In June 1928 appeared "Photographing the Marvels of the West in Colors," by Fred Payne Clatworthy, a pioneer with Autochrome, the first successful color photography method. "The Grand Canyon's transparent purples and blues defy the artist's brush," Clatworthy wrote. "[I]t has remained for the autochrome plate to reproduce its exact colors."

Latest to take the plunge was Michael E. Long, former staff writer and former Marine Corps jet pilot

and aerobatics instructor, for "The Grand Managed Canyon," July 1997. Long didn't go to explore, of course; that's all over. He went to see how the National Park Service seeks to manage the almost five million visitors each year so that the great canyon, its beauty, its ambience are not destroyed. But as Long started downriver in a dory, he got a dose of old-fashioned adventure. "We flipped in Crystal Rapids," he told me. "The problem is a big hole wave in the center. We start through and our oarsman loses his left oar, and suddenly we were looking at this monster of a wave, and we're going up it. And I remember thinking, The son of a gun is shaking its fist at me. The next thing I know, I'm underwater.

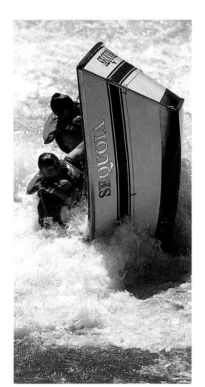

WRITER MICHAEL E. LONG on assignment
"THE GRAND MANAGED CANYON" JULY 1997

PHOTOGRAPH BY PETER ESSICK

"I'm down for what seems a long time, and I come up. Someone's hollering, 'Swim right, swim right!' Ahead there's a debris field of rocks. I'm trying to swim right, but I'm headed for this rooster tail of foam. I go right through that sucker. Next thing I know, a hand is reaching down, and I'm reaching up, and this boatman is grabbing me. He's a muscular guy, and I hang on. And here comes the dory, capsized. They finally right it, drag me and others aboard.

"I spent four minutes in 49-degree water, pretty cold, and I never felt it. Too busy surviving. When we reached the beach, I got my tape recorder out; it wasn't wet. I started interviewing people: 'What did you see? And what did *you* see?' I was banged up, my left leg and hand bleeding like a stuck pig; but, well, I was working, you know."

THE PROMISE OF PERIL ALWAYS makes a journey sing with expectation. In "Along Our Side of the Mexican Border," July 1920, prolific staff writer Frederick Simpich approached the story with his usual barrage of exclamation marks:

"The Mexican border! What a frequent phrase! How it hints at turmoil and intrigue, at wild night rides by cavalry patrols, at gunrunners and smugglers! How suggestive it is, too, of brown-faced, snappy-eyed girls in red skirts and mantillas, *peddling* tamales *and* dulces...."

Photographer Bill Allard, then 33 years old and also mindful of snappy-eyed girls, followed Simpich's meandering path on a motorcycle, both writing and photographing "Two Wheels Along the Mexican Border," May 1971. It was a mellow time; the movie *Easy Rider* had set the standard for hip travel, and Allard found it easy to fit the mold.

"Franc Shor [an associate editor] called me in and said, 'How would you like to do a story on the U.S.-Mexico border?'" Allard told me. "I said, 'As long as you don't want me to make it look like the kind of place you would send your friends to for a summer holiday.' Then I blurted out, 'What I'd really like to do is do it by motorcycle.'" Hot stuff.

And so it was. It caught the imagination of Shor, an adventurous man who, as staff members recall, had worked in U.S. intelligence before coming to the Society in 1953 and had once parachuted into China with nothing but a typewriter. "I picked up a bike in Baltimore," said Allard, "a brand new Triumph 650, for $1,352, and Mike Schaeffer, who headed up our custom equipment shop, designed a rack to hold my two Halliburton cases full of photographic equipment. It was a one-of-a-kind, beautiful, tubular-steel structure that operated with aviation bolts. We crated the bike, sent it to L.A."

Allard crossed the border at Tijuana. Not all went smoothly. At the Gulf of California he was accosted by a Mexican naval officer and a sailor with a submachine gun. They accused him of photographing a guardhouse, an illegal act. "He had that thing pointed right at my middle, and the bolt was being drawn back. What could I do but hand over the roll of film?" Allard got the film back later. He happened to meet an old friend, who knew the officer. That night the three went to a cantina for dancing and drinking; all misunderstandings were cleared up.

As for the bike, it was ecstasy:

"In and out of the mountain curves I leaned one way and then the other. Lazy and easy, a slow dance with the road. I simply followed its lead, and it rewarded me with an exhilaration unknown to most travelers. Everything seemed to open up in a burst of freedom where the vision was clear and the smells were sharp."

He dumped the bike once, a bruising spill on a desert road. And he had a chest-thumping collision with a low-flying nighthawk that left him stunned. Never mind.

Allard has been both writer and photographer for seven of his American assignments and says the dual role can be exhausting. "It can work great," he told me, "because you have a story seen through one set of eyes, one heart and mind. On the minus side, it requires tremendous energy to do both. It's a little bit like tuning in to two radio frequencies at the same time, and your day is never, ever done."

JOURNEYS HOLD LESSONS. I learned one as a young staff writer while doing fieldwork for "The Ohio—River With a Job to Do," February 1977. Freelance photographer Martin Rogers and I made an initial 981-mile trip downriver on a towboat from Pittsburgh to the Mississippi. Then we returned, again and again, to specific places, in different seasons, hoping to understand better the character of the area and its people.

I took various jobs along the river. I felt the approach would give me a sense of the often gritty life. I remember a conversation with towboat captain Louis Carroll Himes, who had taken on a big risk with me on the crew:

"The tow's a dangerous place," he warned, "on-account-a you can't make no mistakes out there. In a factory you lose maybe your hand, but out there on the tow you're liable to get killed. That's why I take special pains with the greenhorn."

Sometimes I did not identify myself as a journalist, playing on anonymity to get closer to the people. Toward the end of my coverage I played that game a step too far. In Cairo, Illinois, a town with a missing-tooth look, I decided to check into a cheap motel, put on ragged jeans, slick back my hair, and go down to the unemployment office. I made up a hard-luck story and took it down the road, wondering how a jobless stranger would be treated in struggling southern Illinois.

My plan came to a crashing halt outside town, at a small hamburger joint, when I asked the owner if he needed kitchen help. They had no work, sorry, but he and his wife offered compassion. A place to sleep, perhaps? A free cup of coffee? It suddenly weakened my knees with shame to realize what a fraud I was. I left quickly, thanking them. I never did that again.

JOURNEY STORIES OFTEN MIRROR the times. In the 1950s, as good highways began to inch across the nation, linking cities, and families became more mobile, the long-distance road trip became an American institution. "One summer morning I left Washington, D.C., to see something of the country by bus," wrote staff writer Howell Walker for his July 1950 opus, "You Can't Miss America by Bus," with photos by the author.

"I rolled home in autumn, 9,000 miles and 38 buses later." His trip made a loop around America and took him through 27 states. Walker, a genial and civilized man, enjoyed the trip but, it is said, seldom rode buses thereafter.

The 1950s were a time of earnest patriotism, and much of the nation felt blessed, prosperous, self-confident. It was also an era of conformity, with a focus on the idealized family, as represented in the TV show *The Adventures of Ozzie and Harriet.* The GEOGRAPHIC, too, had its family adventurers.

Ralph Gray edited the *National Geographic School Bulletin,* a publication for classroom and home study use, predecessor of today's WORLD magazine. Gray had some loose time each year as the *Bulletin* rested for

WRITER PRIIT VESILIND on assignment "THE OHIO" FEBRUARY 1977

PHOTOGRAPH BY MARTIN ROGERS

summer holidays. He approached the editors of NATIONAL GEOGRAPHIC with the idea of taking his wife, Jean, and their three photogenic children on an educational trip for the magazine. He said he would take the pictures himself. Said Gray, who retired in 1985: "Without fully thinking it out, we were a representative American family, trying to understand the past, along with the wonderful feeling of being an American and appreciating our heritage."

The first of the Gray family excursions was "Vacation Tour Through Lincoln Land," February 1952. Next came "Following the Trail of Lewis and Clark," June 1953. Gray tied his red canoe, *Trout*, to the roof-rack of a wood-paneled Chevrolet station wagon. He stocked the inside with a compact library, including the journals of Lewis and Clark, which he would use as guidebooks, as well as camp gear, toys, cameras, and clothes. The children were 12-year-old Judith, sister Mary Ellen, 10, and 6-year-old Will, then a chubby-faced scamp, now a vice president of the Society and director of the book division.

The Gray family logged 10,000 miles in three months following Lewis and Clark through an idyllic, sun-splattered America. It was never winter, never dreary on a Gray family story, and the kids posed for pictures: Judith standing amid fireweed along a trail, Will sipping ice-cold water from a stream that had refreshed Lewis and Clark.

They visited cities, farms, historic sites. "Those trips looked like they were easy," said Gray, "but they took a lot of planning." To evoke Sacagawea, the Shoshone woman who with her child and husband accompanied Lewis and Clark from the Missouri River to the Pacific and back, Gray sought a modern Shoshone princess. He found her, Alberta St. Clair, a University of Wyoming student. She agreed to travel with the Grays for three weeks, share her knowledge of the Native American past, and pose in Native American dress.

When the Grays reached the Pacific, Ralph wrote of the heroes whose trail they had followed:

"Through rain and wind the intrepid men pushed on. One wretched November day the fog cleared. The Columbia straightened and widened into a great bay. William Clark expressed the elation of the entire group:

"'Ocian in view! O! the joy.'

"For us, the skies not only cleared as we came to the Pacific. The sun burst out and bathed the spectacular Oregon coast in golden light."

For the July 1961 article "From Sea to Shining Sea," the family followed U.S. Highway 40 through 14 states, from Atlantic City, New Jersey, to San Francisco, California. They put 17,000 miles on a seven-passenger Chrysler Windsor station wagon that the GEOGRAPHIC purchased for the trip.

"That story almost died in the office," Gray told me. "There was a feeling in the illustrations department at that time that I was an amateur. Some just couldn't see publishing pictures of a guy traveling with his family. So the story hung around and hung around, and finally Melville Bell Grosvenor, then Editor, said, 'I'm going to look at those pictures.' He resurrected the story." Staff photographer Dean Conger was sent to fill out the coverage.

For their final vacation journey "From Sun-clad Sea to Shining Mountains," for April 1964, the Grays followed a route which led from Mexico's Gulf of California up U.S. 89 and into the Canadian Rockies. This time they luxuriated in a 26-foot Dodge motor home they named *Roadrunner*. "I went to Detroit and picked up the third one off the assembly line," said Gray. "The story was the first to introduce the recreational vehicle in a mass-oriented magazine."

Mary Ellen was already a college student on the run up U.S. 89. Will was 16. Donna, 7, was a new addition to the family. Behind the motor home followed staff photographer James Blair and Society cinematographer Gerald L. Wiley in their own car, *Roadrunner-up*. Romance followed along, too; Wiley and Mary Ellen Gray married four months later.

Ralph Gray recalls that both "Following the Trail of Lewis and Clark" and "From Sea to Shining Sea" were rated by readers as the most popular articles in the years they were published. "It proved again that it is the editorial *idea* that counts," said Gray, "as much as the execution. And the fact that these stories were probably more on the level of our readers. I think I understood the readers quite well. I was kind of an ordinary guy, writing for an ordinary reader."

THOSE SEEMINGLY CAREFREE YEARS were followed by a time of troubles: Vietnam, racial strife, assassinations, social turmoil. In this new era, many students, minorities, and others saw the bright America of Ralph Gray and his family as a joke or delusion. Anger and disappointment swept across campuses and down main streets. Then in October 1973 a barrel-chested young man, Peter Gorton Jenkins, walked unannounced into the GEOGRAPHIC with his half-malamute dog, Cooper, and told us he was walking across America. He said he wanted to see if America was as bad as it seemed to him and many of his generation.

Jenkins had earlier written Harvey Arden, a staff writer, to tell him that he was considering such a journey; he had been inspired by an article Arden had written on John Muir, the naturalist, who as a young man had taken a 1,000-mile walk through the Appalachians and the South to the Gulf of Mexico. Arden had not encouraged Jenkins; a walk across America was a tough, perhaps dangerous journey.

But now the young man was sitting in front of him, the walk already begun. He had hiked from Alfred, New York, his college town, to Washington, D.C. "He comes up to my office in a green sweat suit, mangled gym shoes—a red-haired kid, very raw," Arden told me. "He sits down and starts telling me all about how he and Cooper are heading down through the Appalachians and maybe down to Florida and may eventually end up in California. Would we like to do a story on him?

"He was very bright, ebullient, likable. But he was turned off by America."

"I didn't know anything about publishing," Jenkins remembered of that day, "and Harvey takes me upstairs to meet Gil Grosvenor, who was the Editor then. Cooper is with me, and he walks right into Gil's executive rest room and starts drinking water out of the toilet. The thick hair on his neck is all dripping from the water and he jumps up on Gil's sofa, and I'm thinking, We're outta here. But Gil laughs and he says, 'Don't worry about it. I've had chimpanzees, all kinds of animals in here.'

"And he told me something that altered my life. He said: 'You're a young man and your tendency is going to be to hurry. I would recommend that the slower you do it, the better it's going to be. Then you can really experience America.' That has made a lot of difference."

"The editors," Arden said, "were hesitant to give him an official assignment; it seemed such a long shot. But Gil wrote a memo: 'Let's keep an eye on the story; it could be a sleeper.' And Peter went on his way. He'd call back, tell me where he was, how things were going.

"The magazine was advancing him some money for expenses, and supplying him with film and camera equipment. I remember once sending him a new pair of shoes. He wore out 13 pairs. He went into the heart of America, up mountaintops, lived with a black family in North Carolina, saw a hermit, lived on a hippie commune in Tennessee, finally reached New Orleans. Took him three to four years."

Jenkins also credits the illustrations editor, Thomas R. Smith, who mentored many photographers, for keeping him on track during the long years. He would look at the film Jenkins sent in, give him tips. "He was almost a father figure to me," Jenkins said. "Somebody I could bounce ideas off. For example, I called Tom once and said, 'I've been in this rural black church and it was so emotional that some people fell to the floor!'

"And Tom says, 'Peter, are you taking pictures?'

"I said, 'No, I was too overwhelmed to take pictures.'

"He said, 'As a writer you can sit down later and write about these things, but as a photographer you have to become sort of detached from yourself. You have to stay above it. And don't let an experience pass because you think it will happen again. It almost never does.'"

Jenkins turned in a 183-page manuscript, full of humor, with detailed descriptions of what he saw, the people he met, the jobs he held. He told how, as he walked, his bitterness toward America diminished. "A Walk Across America," April 1977, was a huge success.

It began with a reference to the amount of water he drank that day:

"It was another two-gallon day. We had been heading down Alabama country road 117 at our customary speed: three miles an hour. We means my dog, Cooper Half Malamute, and myself. Some eight hours back a farm lady had said we'd come on a country store in ten miles or so. But we'd gone twenty...."

In New Orleans Jenkins fell in love with and married a seminary student named Barbara, and when he set out to do the second half of his walk, to the Pacific, there were two of them. And when they reached the Pacific they were almost three; Barbara was pregnant. "I went out to Oregon and was there when they walked into the ocean to end it," Arden said. "There were 200 people on the beach, including my children, and, of course, Gil Grosvenor. It was inspiring." "A Walk Across America: Part II," August 1979, by Peter and Barbara Jenkins, was the sequel.

The book that Peter Jenkins wrote as an extension of the first article has gone through 75 printings and sold more than three million copies. It is still published in hardback, said Jenkins, used in some 3,000 schools as required reading, and is still a best-seller in Germany. "I've written a lot of other things since then," he told me, "but I'll always be identified as the guy who walked across America."

DIFFERING PERCEPTIONS OF AMERICA: The question of how others viewed our nation intrigued Editor Wilbur E. Garrett, a Midwesterner with a restless mind. In 1987, as the National Geographic Society and the magazine approached their centennial, he assigned Polish photographer Tomasz Tomaszewski, his wife, journalist Małgorzata Niezabitowska, and their daughter, Maryna, age eight, to go out and discover America through Polish eyes. The story would be titled "Discovering America" (January 1988).

The husband-and-wife team had already published one story in the GEOGRAPHIC, "Remnants: The Last Jews of Poland," September 1986. They were spending a year in the United States, Niezabitowska as a Nieman Fellow at Harvard University. Of the three, only young Maryna spoke English.

"We decided simply to rent a car and drive west," Tomaszewski told me, "Go west, boys! This is what I remember from American movies, which I always admired and loved when I was growing up in Poland. There was only one condition, written in our contract in bold type: We had to have our seat belts on when we were driving."

They crisscrossed the country for three months, recording their impressions:

PHOTOGRAPHER TOMASZ TOMASZEWSKI on assignment "DISCOVERING AMERICA" JANUARY 1988

PHOTOGRAPH BY MAŁGORZATA NIEZABITOWSKA

"You have to drive through America to understand how enormous it is...Americans love money. Not with greater fervor than other peoples, but certainly with more brashness...Wealth and waste: This was one of our most vivid impressions of America."

But his photographs raised hackles at the office. Where Tomaszewski had seen a junkyard with an abandoned automobile as an arresting symbol of a throwaway culture, some at the GEOGRAPHIC saw the resulting photograph as America bashing. Poland was still part of the Soviet bloc, these critics said.

Additional photographs brought further complaints: "All they saw was junkyards," one Society officer complained. Bill Garrett replied: "The reason they saw junkyards was because in Poland there *are* no junkyards. They have to reuse everything again and again. We are the most wasteful society on earth. Junkyards! A valid observation."

Tomaszewski was upset by the misunderstanding. "I had no idea to make this country look bad," he said, "but I felt more comfortable with ordinary people. I was attracted by somebody who ran a little garage sale, or by a homeless person, maybe because I did not expect to see those things."

They continued to report what they saw—the pleasant, the unpleasant.

When it was all over, Tomaszewski told me, his greatest impression of Americans was that they are "a very different, friendly, and positive people." He still marvels that desk clerks at the hotel where he stays when visiting GEOGRAPHIC headquarters in Washington, D.C., remember his name, even after five or six months. "'Hey, Tomasz, welcome back!' they'll say. That doesn't happen anywhere else in the world. America. Here I feel comfortable; here I feel at home."

SOJOURNERS FOR THE GEOGRAPHIC have utilized so many kinds of conveyances—mules, horses, airships, airplanes, canoes, sailing yachts, cars, trucks, motorcycles, their own legs and feet—that editors sometimes begin to think there are no more new ideas for journeys. Then in comes a fellow like Roman Dial. He and his friend Carl Tobin do "hell biking." That's just what Tobin named their freewheeling way of traveling the Alaskan wilderness on mountain bicycles. Hell biking.

Dial, a writer and professor of ecology and conservation biology at Alaska Pacific University in Anchorage, pitched this proposal to GEOGRAPHIC adventure editor Peter Miller in 1995: Three fit and borderline-fanatic wilderness-loving dudes would take their bikes and all their gear and cover 775 miles along one of North America's great cordilleras—the Alaska Range, which stretches from the Canadian border and arcs around southern Alaska. The feat had never been done, and the story would appeal to the young and the strong, a demographic group the magazine was eager to attract. Miller took Dial upstairs to see the other editors.

Bicycling stories had fallen from favor at the GEOGRAPHIC, perhaps because biking did not seem dignified or exciting. Dial argued that mountain biking gives a better feel for the land than hiking. "When you hike," he said, "you just put one foot in front of the other. With wilderness mountain biking, there are no marked trails, no routes on maps, and you can't bike everywhere you can walk. So you have to tune into the landscape and feel it. It's like watching for moguls when you ski.

"And biking is a joyous experience. It's so improbable that this thing on two wheels is able to stand up to begin with, and when people see you on a bike, they connect to their youth and their memories."

Putting it that way, Dial got his story, "Biking Across the Alaska Range: A Wild Ride," May 1997, written by Dial and photographed by Dial and freelance photographer Bill Hatcher, who biked along with the group in key stretches. The others were Tobin, also an environmental science professor in Alaska, and Paul Adkins, a professional mountain-bike guide from West Virginia. The journey took seven weeks, along glaciers and creek beds of a country so hostile that it was barely passable on foot. It became an endurance test against woolly weather that kicked up snowstorms in midsummer and miles of scrub brush that forced the men to pick up bikes and haul them on their backs.

The concern that bikers would scare away game proved unfounded. "I see more game on the bike than when I'm walking," said Dial. "We've had a female bear come after us, bearing down and trying to scatter us. They can sprint 30 miles an hour, and there's no way you can get away on the bike if they really want you—the terrain is too rough. But the bears' behavior strikes me as something between curious and fearful. We've had caribou run at us, as close as ten yards, then bolt away. Once in the Brooks Range a pack of wolves followed us."

Of the journey, Dial wrote:

"When luck rides with us, our path rolls across a silky smooth valley bottom, following a caribou trail incised into the tundra by cloven hoofs, then merges with bear trails as we muscle up a ridge of polished granite slabs. When our luck runs out, we stumble through alder brush as thick as an arm that snags our handlebars, seats, pedals, and, if we're not careful, an eye or two."

And at the end it was journey as an art form. "They say the left side of the brain handles intellectual and logical aspects of thinking," Dial told me, "and the right side the emotional and creative. When I do my adventures, I use the right side. I feel my adventures are creative. Alaska is this big landscape, and I paint bold strokes across it. It's like an artist's canvas for me, since there are no trails and no roads, and the creative challenge is to find an aesthetic way across." ■

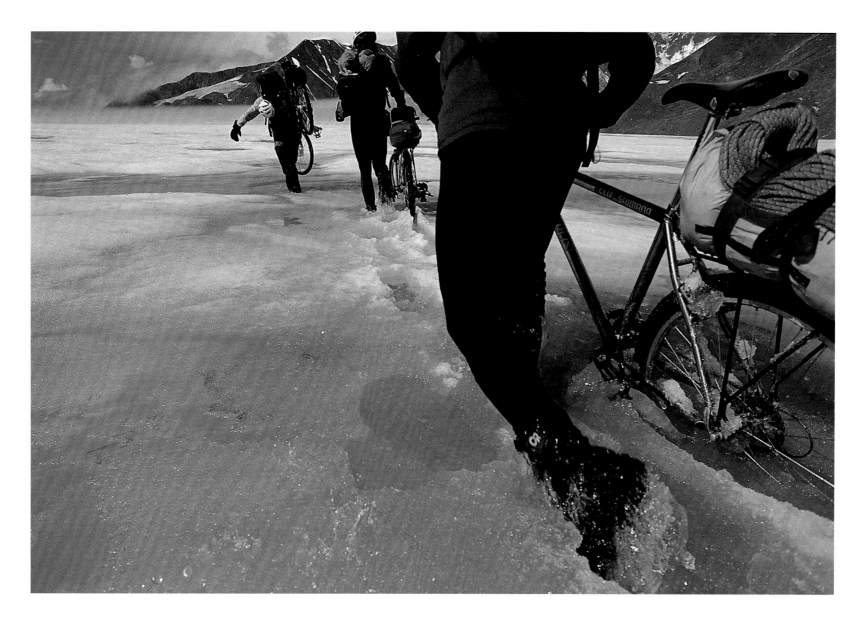

"BIKING ACROSS THE ALASKA RANGE: A WILD RIDE"

May 1997

photographs by
BILL HATCHER

text by
ROMAN DIAL

SLUSHING THROUGH soft ice, three adventurers cross the 6,000-foot-high Black Rapids-Susitna Pass during their 775-mile expedition across the Alaska Range by mountain bike.

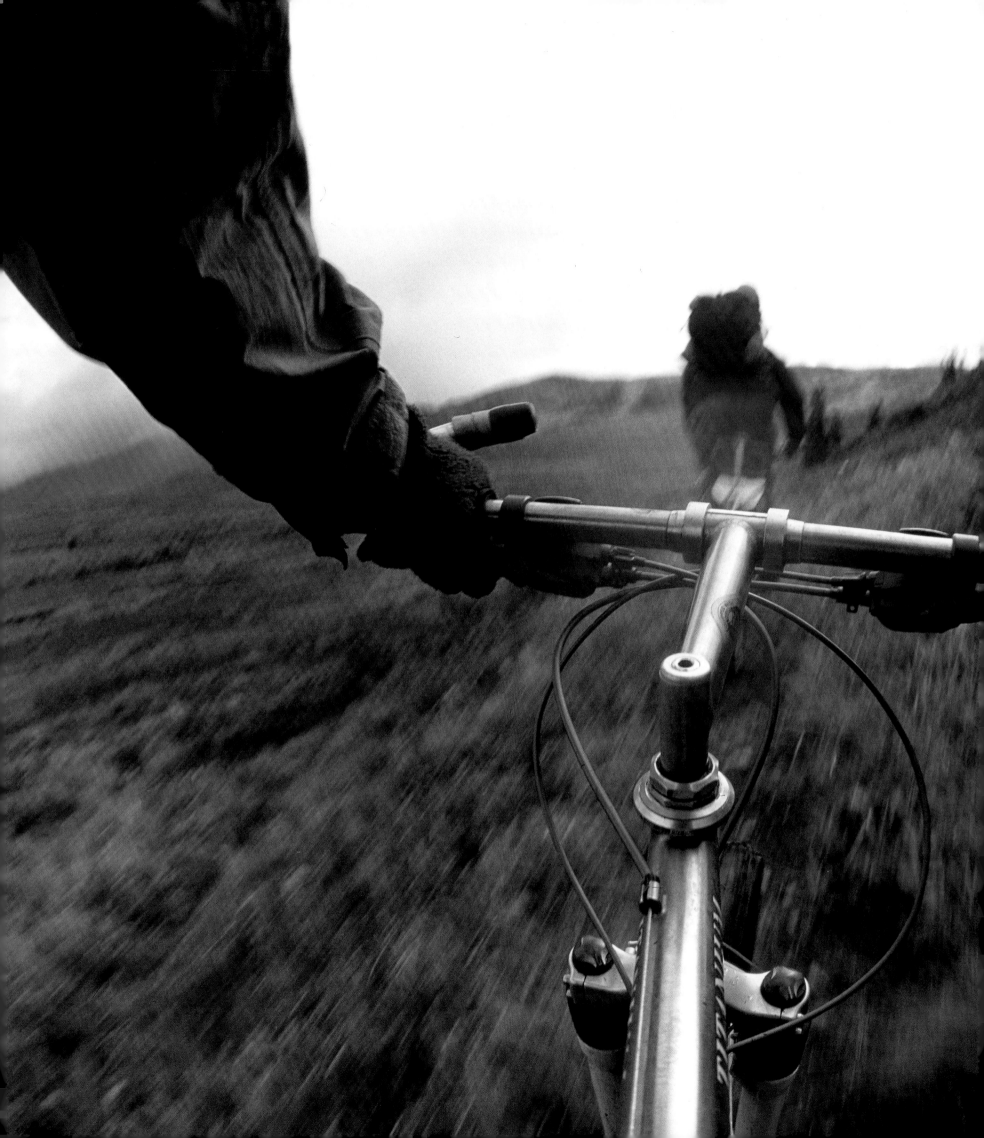

A MOUNTED remote-control camera captures a biker's-eye view of the terrain sweeping past Lake Clark National Park, Alaska.

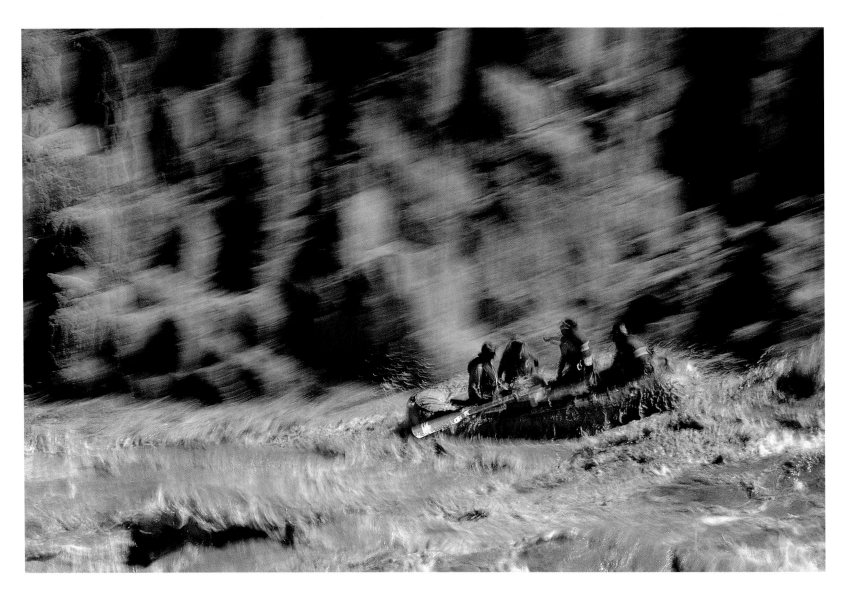

"GRAND CANYON"

July 1978

photographs and text by
WILBUR E. GARRETT

MULE PARTY ASCENDS the North
Kaibab Trail (opposite); on the waters of
the Colorado River, swollen and red with
silt from floods, rafters churn through
Granite Rapids.

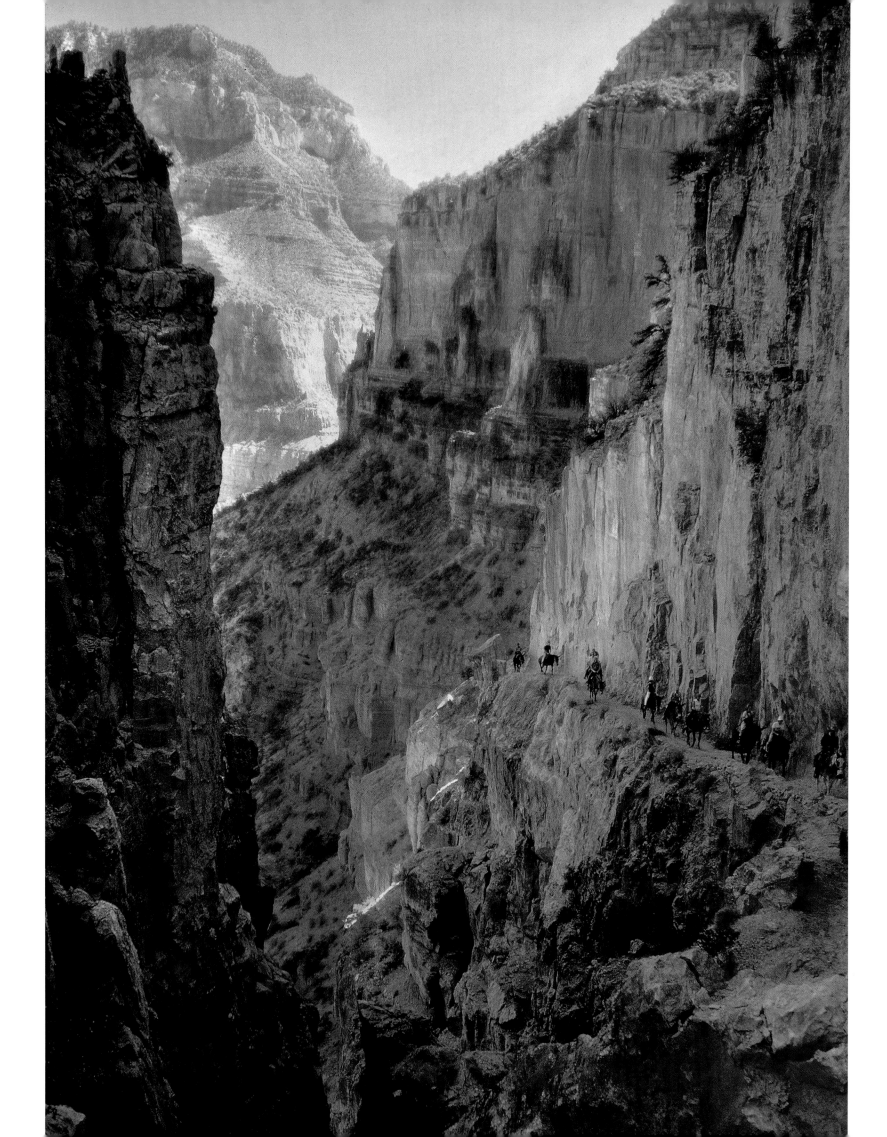

"ALASKA HIGHWAY: WILDERNESS ESCAPE ROUTE"

November 1991

photographs and text by
RICHARD OLSENIUS

THE MAGNETIC NORTH draws dreamers and
settlers on a pilgrimage along the Alaska Highway,
which stretches 1,500 miles from Dawson Creek
in British Columbia through Yukon Territory to
Fairbanks, Alaska.

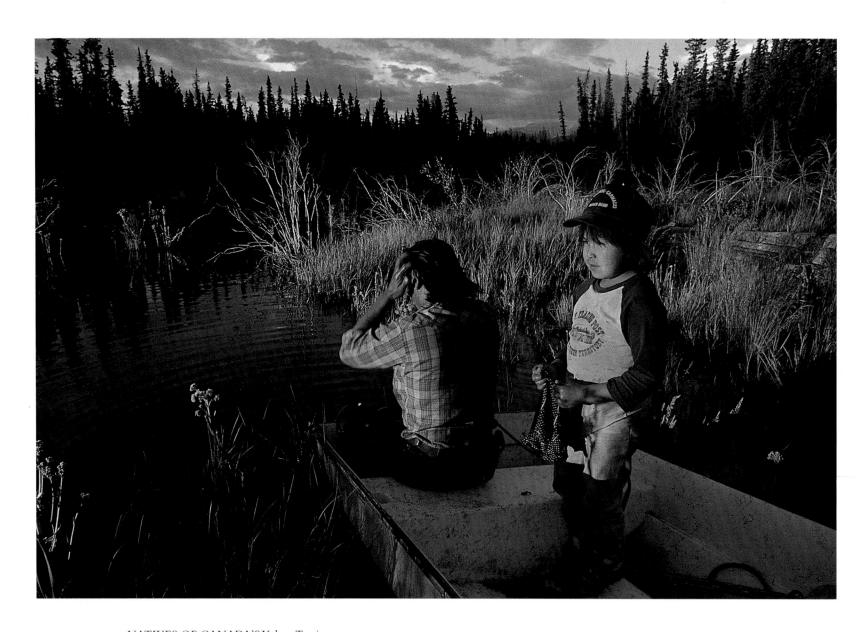

NATIVES OF CANADA'S Yukon Territory,
Benson Billy and his son, Dion, relax after a
trip by horseback up the Dalton Trail.

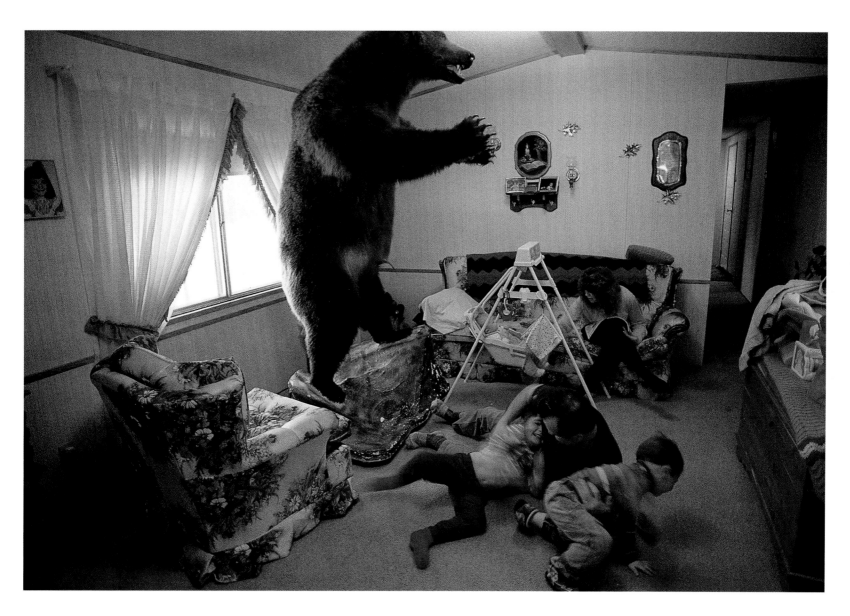

TEN-FOOT GRIZZLY, shot for killing
dogs near Haines Junction in Canada's
Yukon Territory, stands stuffed in the living
room of Leonard Beecher.

"ERIE CANAL: LIVING LINK TO OUR PAST"

November 1990

photographs by
BOB SACHA

text by
JOEL L. SWERDLOW

DRIVER LEADS MULE off canal towpath
in Medina, New York. Mule-drawn barges
transport tourists, recalling an earlier time on
the 363-mile Albany-to-Buffalo waterway.

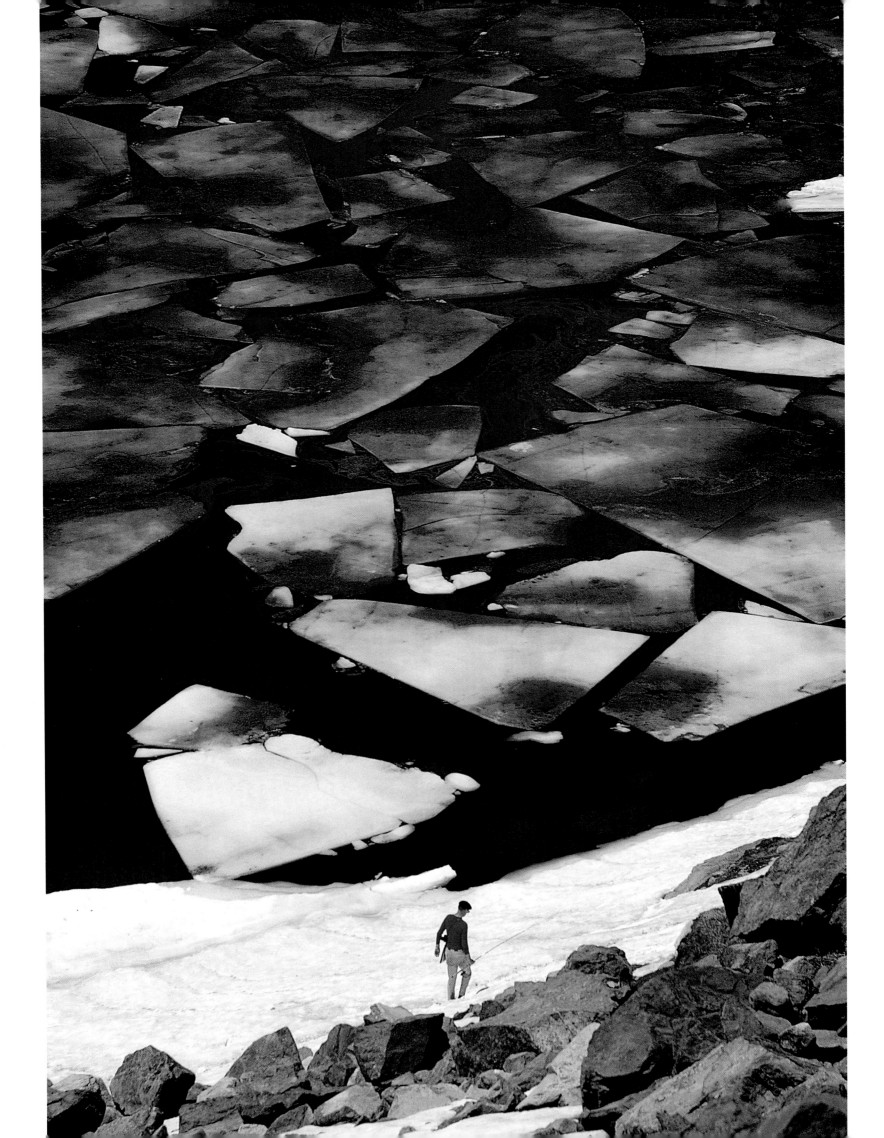

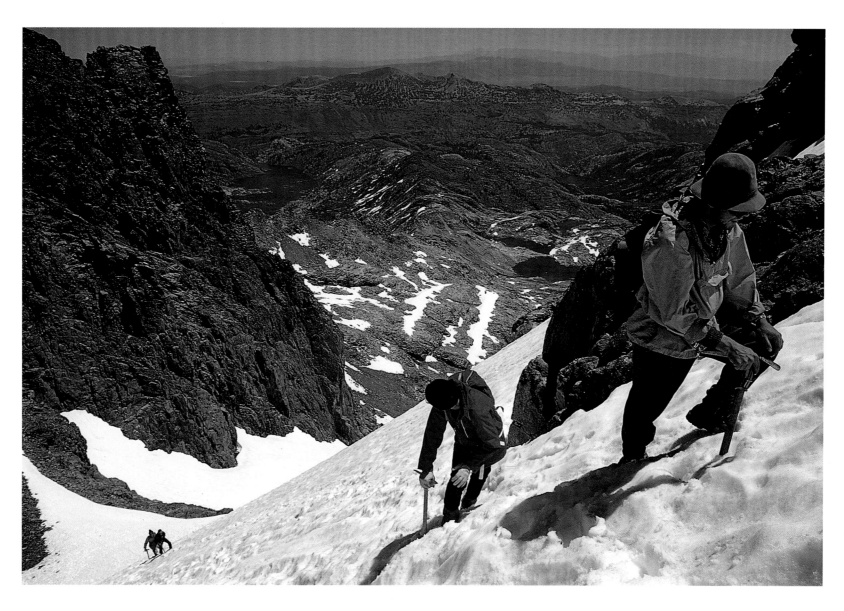

"MEXICO TO CANADA ON THE PACIFIC CREST TRAIL"

June 1971

photographs by
DAVID HISER

text by
MIKE W. EDWARDS

IN INYO NATIONAL FOREST in California's High Sierra, midsummer floes clutter Iceberg Lake (opposite), near the base of Mount Ritter. Hikers (above) climb toward the mount's 13,157-foot summit.

"ALONG THE SANTA FE TRAIL"

March 1991

photographs by
BRUCE DALE

text by
ROWE FINDLEY

IMAGE FROM THE PAST, a gunfighter's
shadow recalls the Wild West along the
900-mile Santa Fe Trail, which was used
by settlers moving west.

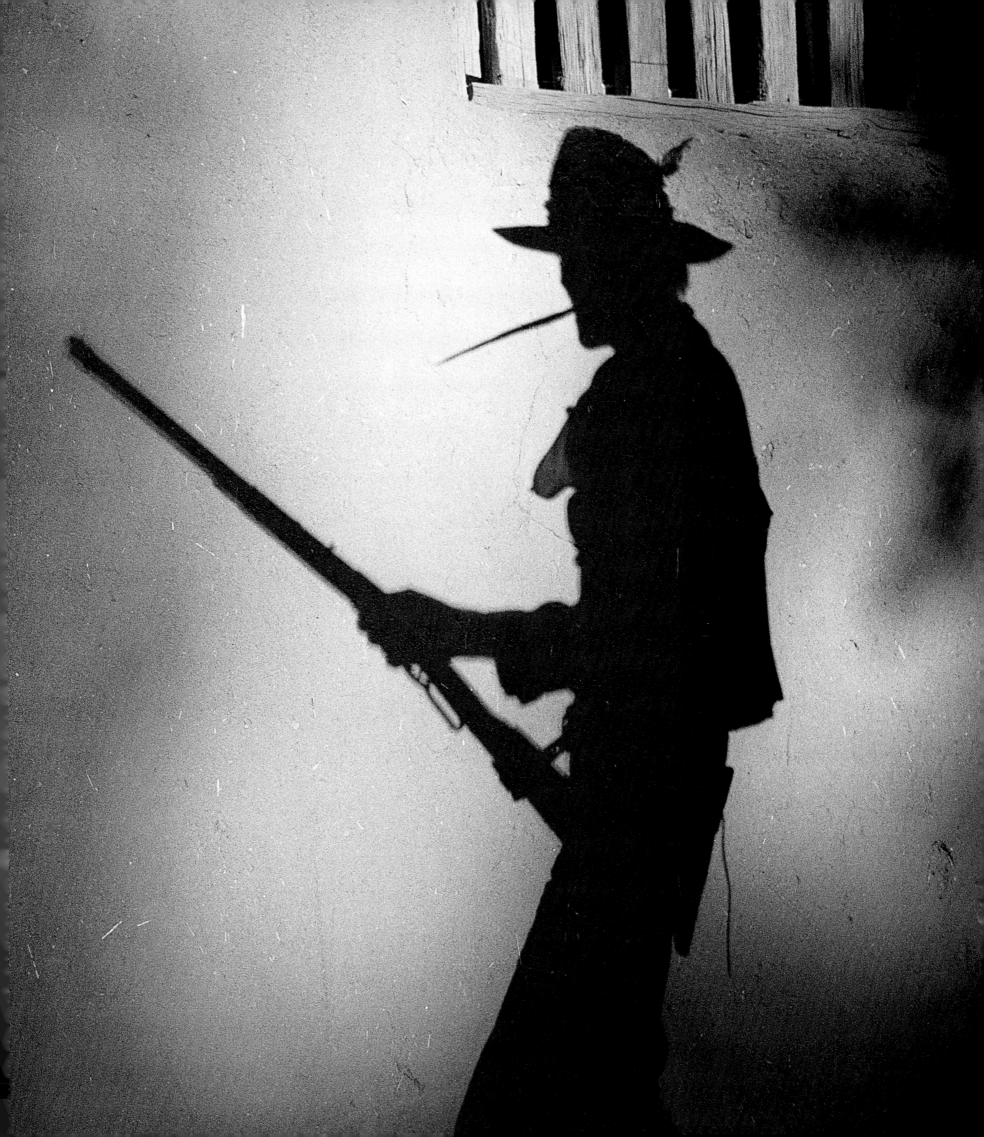

POTOMAC RIVER
"THE NATION'S RIVER"

October 1976

photographs by
JAMES L. STANFIELD

text by
ALLAN C. FISHER, JR.

CAROLINAS PEYTON, an 86-year-old
blacksmith, makes horseshoes in Owens, Virginia.

ROY BUTTS, foreground, sits with friends
on a porch in Gormania, West Virginia.
Butts was a miner for 64 years.

"A WALK ACROSS AMERICA: PART II"

August 1979

photographs and text by
PETER AND BARBARA JENKINS

TEXAS STORM near Gilliland
threatened hikers Peter and Barbara Jenkins
on their American journey.

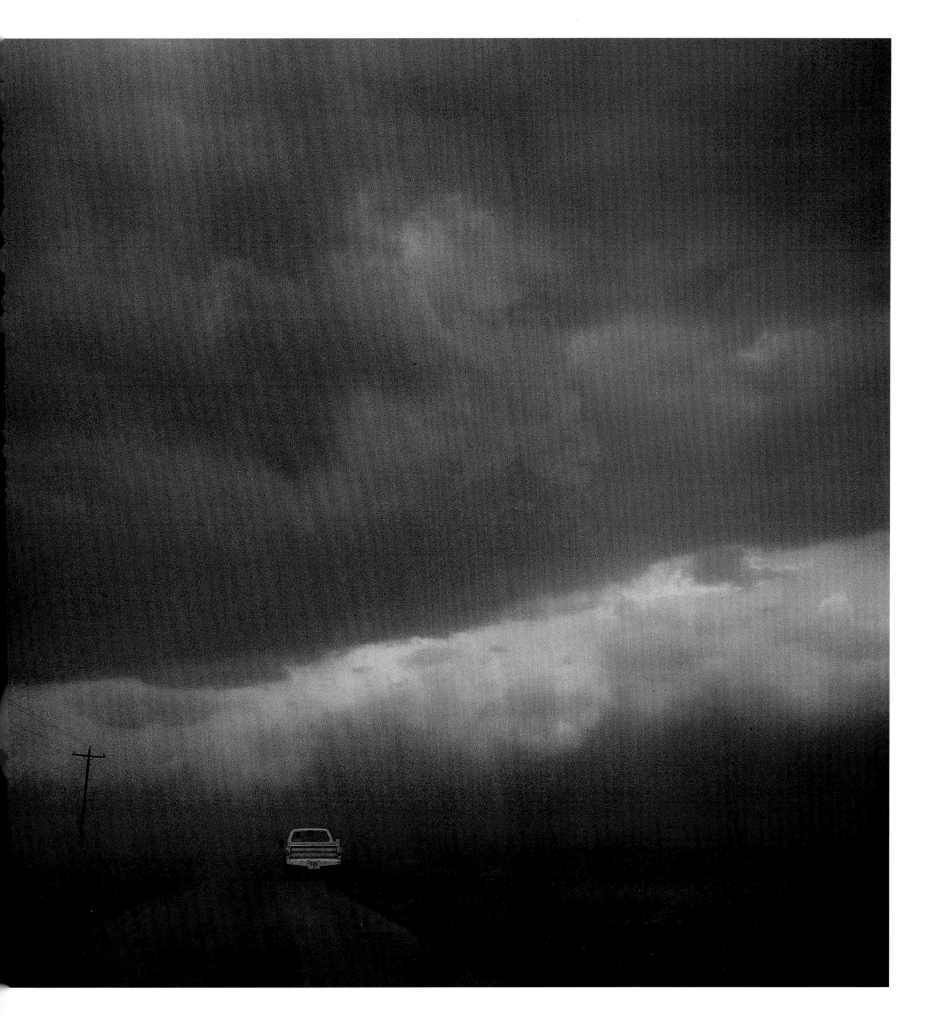

CHAPTER FOUR DISASTERS

"Hurricanes, floods, earthquakes…can be seen as disasters only when viewed through the prism of man's hopes and ambitions…"

—PRIIT VESILIND

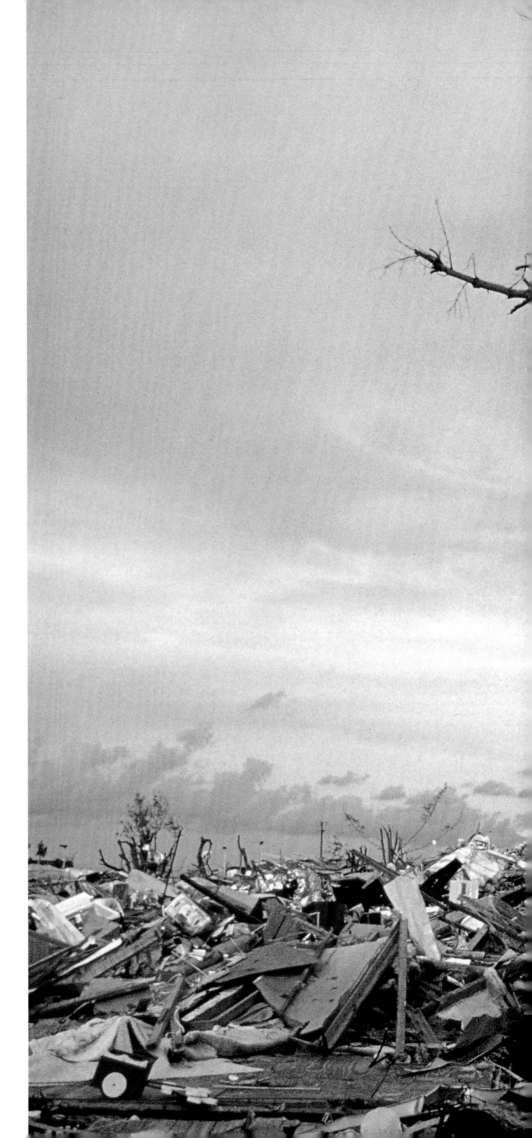

HURRICANE ANDREW
"ANDREW AFTERMATH"
April 1993

photographs by
JOEL SARTORE

text by
RICK GORE

"After the storm, the people of south Dade County found themselves broiling under a withering sun without power, water, food... Thousands of cars lay demolished... Almost every tree had been blown down or stripped of its leaves."

—RICK GORE

FLORIDA CITY, FLORIDA, shows the devastating effects of Hurricane Andrew.

preceding page:
A DOLL LIES amid hurricane's debris in New Iberia, Louisiana.

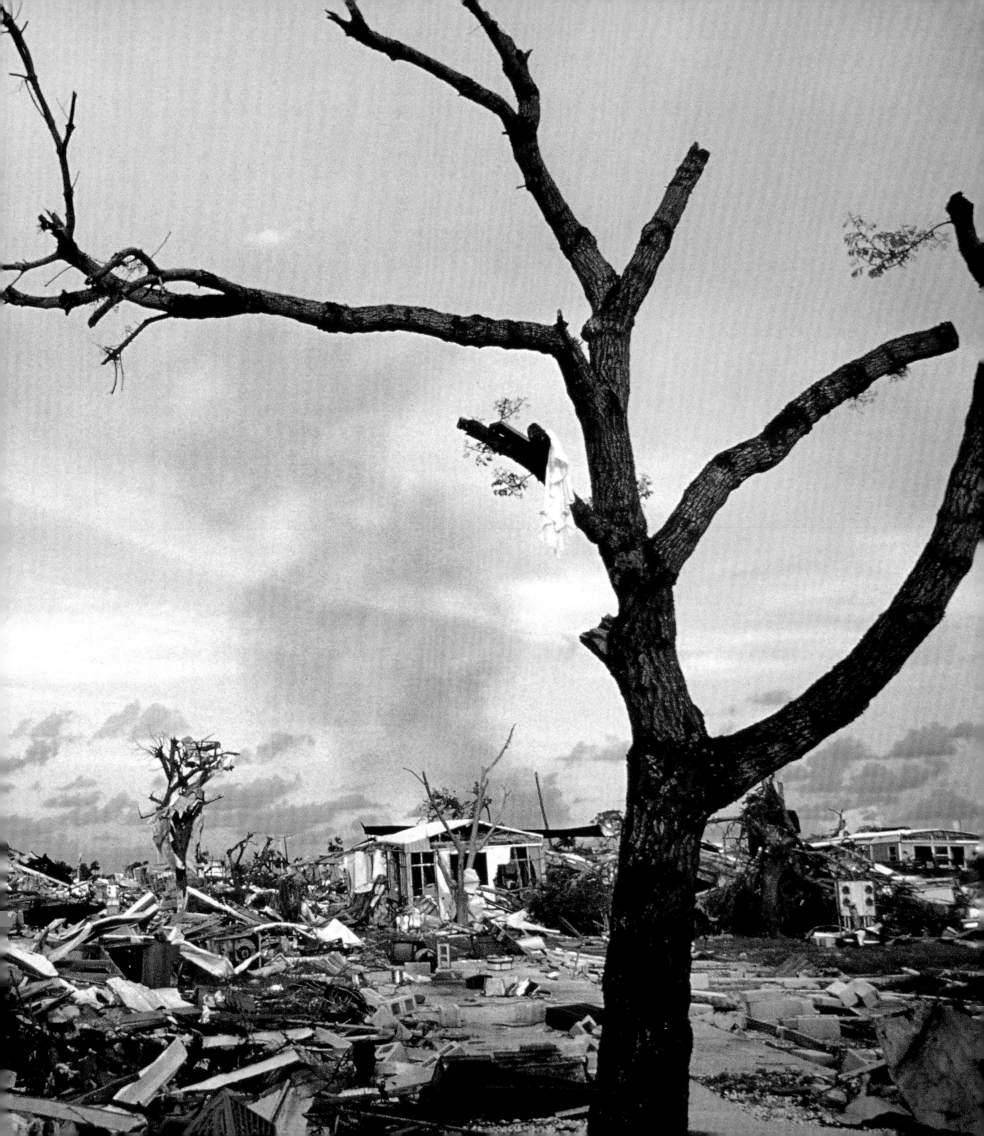

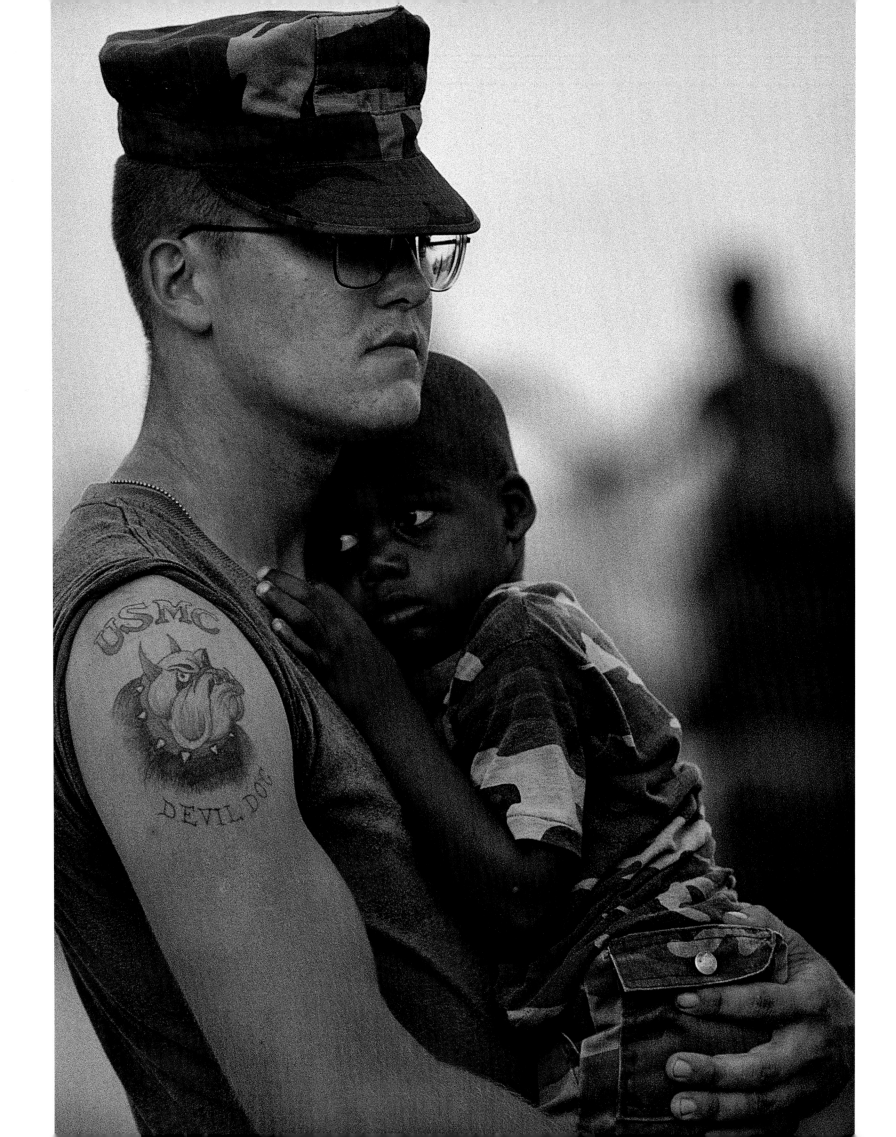

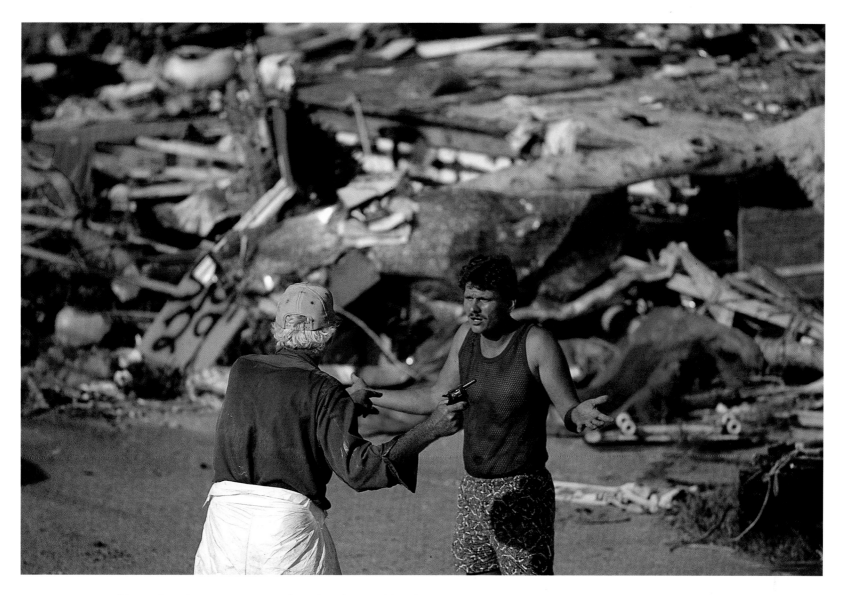

MARINE DAVID KETCHAM, member of a military aid detachment, comforts three-year-old Jarvis Williams, who lost his home (opposite); an armed Homestead resident confronts a looter.

66 'Oh hon, on the day after, people were crazy,' she says. 'They were breaking into stores, stealing and grabbing. And it was so hot! Lord, on the day after, if I could have had anything in the world, it would have been an ice cube in my mouth.' 99

—RICK GORE

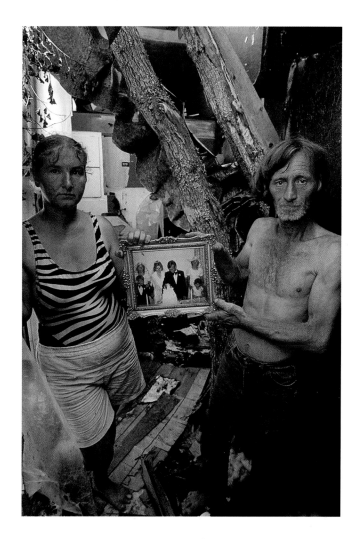

CAGED INDOORS as the hurricane raged, all but two
of Lex Beatrou's Red-lored Amazon parrots survived (left);
Linda and Larry Higgins of Franklin, Louisiana, hold their
wedding portrait, plucked from the wreckage left by Andrew.

HURRICANES, FLOODS, EARTHQUAKES are merely physical events—nature shifting around a bit. They can be seen as disasters only when viewed through the prism of man's hopes and ambitions. And they are deadly, so they both lure and repel us; when they strike, GEOGRAPHIC journalists are off like beat reporters.

Disaster happens. There is no convenient time.

Freelance photographer Joel Sartore had made big plans in March 1992. He and Alan Bone, a buddy from his hometown in Nebraska, share a passion for comedian Jerry Lewis and Lewis-related stories—a fun hobby that's partly tongue in cheek, partly admiration. They were going to a Jerry Lewis telethon in Las Vegas, held to raise money to aid children with muscular dystrophy.

Bone, a friend since the third grade, serves as a sort of touchstone for Sartore. After every GEOGRAPHIC assignment, Sartore writes him a long letter, a way of keeping a record. "I tell him about whatever odd things have happened to me," Sartore explained. "It's cathartic for me. We do so much in our jobs, there's no way, when I'm old and gray, that I'm going to remember a tiny fraction of those things."

But the Lewis plans fell through in late August. Remembered Sartore: "Kent Kobersteen [associate director of photography] calls just before we were to leave and says, 'We need to send you to Hurricane Andrew.' And he noticed a hesitation, and he says, 'Well, what?' And I told him.

"And he banged his phone on the desk and says, 'Excuse me, that wasn't *you* who turned down maybe the biggest natural disaster in the history of the U.S. for a Jerry Lewis telethon, was it? I think we must have a bad connection.'

"I said, 'No, no, I'll go.'"

Rick Gore, the magazine's senior assistant editor for science, was equally unready. He was tired of traveling and anxious to stay home and work on his new house when Editor William Graves called: "Florida— Hurricane Andrew!" No arguments necessary.

Gore had grown up in Fort Lauderdale, just north of Miami; his earliest memories included scenes of hurricanes. Yet, as he wrote in "Andrew Aftermath," April 1993:

"…I feel stunned as my plane approaches Miami International Airport at night. All that land to the south, usually a sea of light, is now a black hole. Waterlogged from post-Andrew rains, the void glistens as lightning flashes. It is indistinguishable from the dark Atlantic."

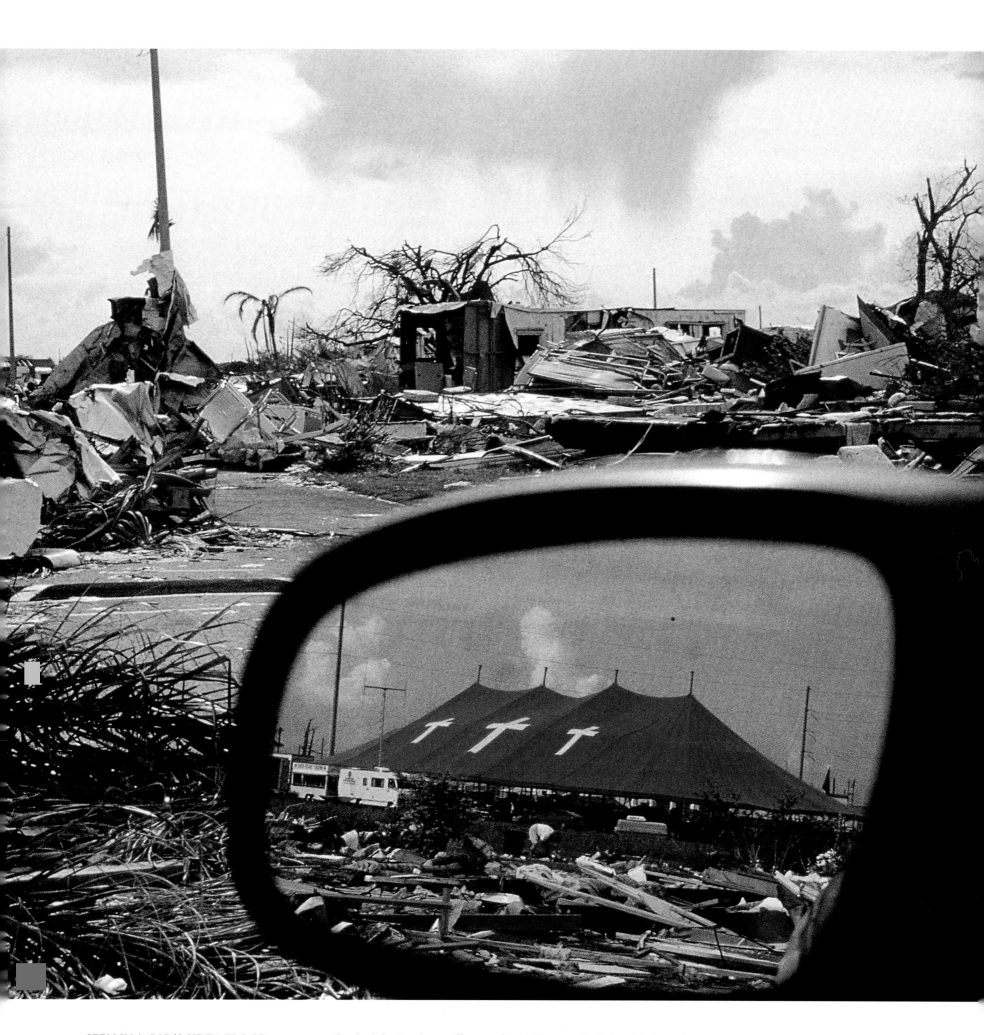

SEEN IN A CAR'S SIDE MIRROR, a tent set up by the Salvation Army offers comfort in Homestead's DeSoto Trailer Park.

Andrew began about August 13 as a patch of thunderstorms over western Africa; it moved out over the Atlantic, became a hurricane, nipped the Bahamas at night on August 23. On the morning of the 24th, a Monday, it struck south Dade county with winds of 145 miles an hour. Andrew would claim some 65 lives, demolish or render uninhabitable 80,000 dwellings, and destroy perhaps $30 billion worth of property. In its toll of destruction and economic loss, it would be the most devastating natural disaster ever to strike the United States. Recognizing the scope, the GEOGRAPHIC sent a team of photographers.

Gore and Sartore hit the ground running. Driving south from Miami, Sartore said, "It looked like a nuclear bomb had gone off. Everything was rubble, not a tree standing, nowhere to get out of the sun, and solid heat. Everyone was nervous and the traffic lights were all out, and people were driving crazy, blazing through intersections. They would just run into each other.

"You got a glimpse of what the world would be like after nuclear war. Pets get loose and then hungry, and you'd see a pack of dogs—a collie, a St. Bernard, a poodle—and they're killing cats and eating them. You'd see monkeys, escaped from zoos and homes, going around and raiding people's refrigerators."

He photographed the owner of a wrecked mobile home pulling a gun on a looter. "I saw a lot of ugliness. You had people guarding their caves with the biggest sticks they could find. Overnight their biggest worry had changed from going to the mall and saying, 'I'm tired of Chinese, let's eat Italian,' to wondering if they are going to get clean drinking water or if they're going to get anything that night to eat."

But the most moving thing, he told me, was going into the tent cities raised by the thousands of U.S. troops sent to help. "The soldiers who had been assigned there had become surrogate fathers for poor, inner-city kids who didn't really have fathers. The kids would hold on to their legs, and there was no such thing as race or bigotry."

That was the scene Sartore captured for the magazine's cover—a marine with a tattoo of a ferocious bulldog, and a frightened, three-year-old boy cradled in his arms.

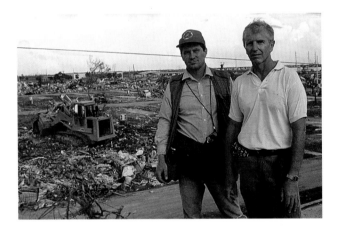

PHOTOGRAPHER JOEL SARTORE AND WRITER RICK GORE on assignment in Homestead, Florida "ANDREW AFTERMATH" APRIL 1993

PHOTOGRAPH BY JOEL SARTORE

FOR GORE THE TASK was "talking to people, getting their stories." Anxiety as well as tragedy lay all about. "Often they came to us because they needed to talk, needed to vent their feelings. Rather than being intruders, we were helping people deal with their losses." In the low-income neighborhoods of Homestead, Gore found children who called Andrew "the monster" and believed it would return:

"'I think it's coming back,' says a seven-year-old Haitian girl, Ernesta Jacques. 'I'm gonna cry, cry, cry…And the windows are gonna pop, pop, pop….'"

At Red Cross headquarters, officials told him volunteers had been cautioned that they would, without realizing it, absorb feelings of anxiety and depression from all the people they were trying to help and that it would become very stressful for them. "And then I began to wonder if I was in denial also: Was this the reason I was feeling so depressed?

"So I decided to take the day off and go visit my family in Fort Lauderdale, and it was almost like magic. As I left the ruined area and got up into Broward county, all the trees were green, and nothing was destroyed. I had to stop the car and pull over, and I just started to weep. Sometimes you just don't know where the tears are coming from, but I was just so grateful that my childhood home had survived."

As for Sartore, "I felt guilty getting on the plane to go home. I had been out there for two weeks. And now the plane is air-conditioned, and the flight attendant asks, do I want a Coke on ice? And I say, 'Wow! Ice?' There was so much left to do, so many tree limbs to cut. The people there were not able to leave. They had to stay, rebuild their lives."

Jerry Lewis, for the moment, had been forgotten.

HUMAN FEELINGS PLAYED a less central role in early stories. The GEOGRAPHIC's first disaster story appeared in its very first issue: "The Great Storm Off the Atlantic Coast of the United States, March 11th-14th, 1888," by Everett Hayden, in charge of the Division of Marine Meteorology, Hydrographic Office, Navy Department. The article was a meteorological study; it laid out information about various pressure patterns and barometer readings and analyzed in detail the violent weather patterns that wracked the Northeast. The blizzard claimed many lives, but it was only toward the end of the article that Hayden moved, briefly, to the human dimension.

The *Charles H. Marshall,* a pilot boat, was floundering off New Jersey:

"By 8 A.M. the wind had increased to a hurricane, the little vessel pitching and tossing in a terrific cross-sea…She had been driven 100 miles before the storm, fighting every inch of the way, her crew without a chance to sleep, frostbitten, clothes drenched and no dry ones to put on, food and fuel giving out, but they brought her into port without the loss of a spare or a sail…."

In the October 1900 issue, W J McGee, an associate editor of the magazine and a former official with the U.S. Geological Survey, recounted "The Lessons of Galveston," in which he offered an apocalyptic summary of the human toll (thousands dead) as well as stark warnings against building on sandbanks. Galveston sat on an island, its highest point about eight feet above sea level. Hurricane winds struck the city on September 8, 1900; the tide came in rapidly. Sea and bay converged, covering the city with 6 to 15 feet of water.

"The darkest horror of American history has fallen on our southern coast; a city comparable in population and wealth with Ephesus and Sodom of old…is blotted out in a night…overwhelmed and doubly decimated by wind and wave in the darkness; literal thousands are crushed in their own falling houses or drowned in the raging waters…."

TERRIBLE DISASTERS SEEMED to cluster around the turn of the century. On April 18, 1906, came another—the San Francisco earthquake. It was followed by days of fires; several hundred people died. News of the tragedy flashed across the continent to the click of telegraphers' keys; less than one month later the GEOGRAPHIC published "The Probable Cause of the San Francisco Earthquake," by Frederick Leslie Ransome, a geologist with the U.S. Geological Survey. Ransome wrote with candor:

"As these words are written, three days only have passed since San Francisco was shaken by the most destructive earthquake in her history, and the subsequent unparalleled ruin wrought by fire is not yet ended. In such a stunning disaster, when communication with the outside world is interrupted, when to the heart-shaking terrors of heaving ground and toppling buildings is added a form of devastation even more appalling, and when the human aspect of the tragedy so overwhelms all other considerations, it is impossible to obtain at once and at a distance from the scene the data necessary for a satisfactory explanation of the initial catastrophe."

No photographs of the disaster were available for the article; photographs had to come overland by train. But the article held illustrations showing the quake's vibrations as recorded by seismograph and magnetograph at government offices in Washington, D.C., and Maryland. The following month's GEOGRAPHIC contained 27 photographs of the stricken city, along with captions.

Ironically, though communication was slow in those days, the magazine was fast in getting stories into print. The GEOGRAPHIC could publish its San Francisco stories relatively quickly because, with a membership and pressrun of some 15,000 and with only black-and-white photographs to engrave, printing was a much simpler matter. Today with a pressrun of more than nine million; complex color reproduction of photographs, maps, and art; and thorough research and checking procedures for all material, publishing takes longer. "Andrew Aftermath," for example, was published seven months after the event.

When disaster hits today, Kent Kobersteen said, "We can't compete in speed of publishing with the weekly news magazines; what we try to bring is thoroughness, depth. We report on the damage and the human drama, but we also explain the scientific reasons for the event and the long-term effects."

Associate Editor Bob Poole added: "We come along weeks after the news magazines and say, 'Now

we're going to tell you what really happened.' And there will be that involvement, the human connections. You're going to walk away from a GEOGRAPHIC article knowing what you need to know. People look to us for authority, reliability."

EARTHQUAKES MAY SHAKE you, but great floods come on cats' feet. "Since time began," staff writer Frederick Simpich wrote in "The Great Mississippi Flood of 1927," September 1927, "the fact that water runs downhill has warped the fate of men and nations." The fight against the waters, particularly those of the Mississippi, Simpich wrote, is a stupendous struggle:

"Its battle front is flung from the Ohio to the Gulf. In heat, mud, and miasma, slaving men and sweating animals, toiling through the years, have thrown up 2,500 miles of huge, fortlike levees. Higher and higher they build them, hoping always that some day, somehow, they may achieve perfect flood control."

But the Big Muddy and its tributaries remain untamed. In 1993 they surged again; their waters would inundate 8 million acres of farmland, render 12 million acres unfit to cultivate; they would also leave an estimated 50 people dead and some 70,000 homes affected. Alan Mairson, a young staff writer who enjoys analyzing everything with a Talmudic perspective, was assigned; he would find himself troubled by the contradictions inherent in covering such a story ("The Great Flood of '93," January 1994).

"The Editor gives you two days to get your bags together and get out there," he told me. "You go first to the Army Corps of Engineers' Emergency Operations Center in St. Louis. You look at the big map there, talk to men who have been following the flood and know the trouble spots. You look for a town that is apt to be flooded, a town that will give a particularity, a face, a voice, to something that is affecting much of the nation's heartland.

"You pick East Hardin, Illinois, near the confluence of the Illinois and Mississippi Rivers, and you find out that in one week's time the water is going to crest there and might flood the town.

"You drive an hour and a half north of St. Louis to the town. You see people filling sandbags and piling them on top of the levee. You go to the high school gym, see supplies being brought in by the Red Cross, see people getting tetanus shots in the cafeteria, and you meet a family. The father is running out to the lowland to empty his house of cherished possessions because in a few days it might be underwater."

Mairson added his back to the fight against the flood:

"…I joined 20 people sandbagging at the corner of Park and Franklin Streets. Porch lights from houses glittered on the water and broke the darkness. We worked in pairs—one person held an empty bag, the other shoveled in sand…Midnight came and went. Thunder and lightning rolled in from the west. Then more rain. The river crept up the street. It didn't look particularly powerful or menacing, more like the edge of a big puddle—shallow, calm, seemingly harmless."

For five days, Mairson met people, made connections, shared the growing sense of anticipation, fear, excitement. The river was due to crest around 10 o'clock Sunday morning, July 18.

The night before, Mairson said, "Everyone was praying that the levee would hold. And I'm sitting in my hotel room. What am I hoping for? I'm hoping for the flood. It's not that I'm hoping for disaster, but if the flood doesn't happen here, I'm in trouble. Because you can't call back to the office and say, 'Sorry, it did not come.' I've put all my eggs in one basket, because I have to tell the story through this town. That's a very odd situation to be in.

"So your feelings are mixed. You've been living with these people; they've fed you breakfast; you've been shopping with them. Do they know why I am here, what I am hoping? Sure. And there's part of me that has problems with that. It's not a story to them; it's life.

"But my job is to tell stories. I am here to report. I have a friend who, when people ask what she does, answers, 'I do my best.' And that's what I try to do."

Early Sunday afternoon the river had spilled over the levee, covering fields of corn and soybeans. In East Hardin the river's dark fingers gripped houses and barns, eventually covering them. The flood had come. Mairson had his story.

DISASTER REPORTERS OFTEN become comforters to the people who are suffering. This happened to Thomas Y. Canby, now retired as the magazine's science editor, when he traveled to upstate New York to document one of a number of disastrous storms for "The Year the Weather Went Wild," December 1977. "The snow was piled so high people walked into power lines and electrocuted themselves," he said. "The National Guard was mobilized, and Army and Marine Corps teams were helicoptering food to people in the northern part of the state.

"So I went on those helicopter runs onto a high plateau called Tug Hill. There were a lot of elderly people up there, and they were grateful for the food and fuel. I will never forget one lady whose house we visited with supplies. She immediately took my arm, started talking to me, and wouldn't let me go. Literally wouldn't let me go. And all the time she was talking, her hand sort of kneaded my arm, working up and down; she just wanted to be with somebody, to touch somebody.

"She told me she was worried about starving, not only because she was isolated, but because she was poor. And she was afraid her social security check wouldn't get to her, things like that; she just poured out all her worries in the few moments we had. She had had no visitors for a time, and here this helicopter comes down right beside her little house on Tug Hill.

"And then the helicopter had to go, and I had to leave with it. I had to tear myself away. It was a little tough, but I was glad to have been her friend, if only for a few moments...."

SOMETIMES AN APPARENT DISASTER may pose an interesting question: Is it really a disaster? When fires spread across a tinder-dry American West in the summer of 1988, portions of Yellowstone National Park were set ablaze. This put to the test a Park Service policy that allowed park officials to let fires of natural origin burn themselves out if they posed little threat to life or property.

The theory held that such fires were nature's way of renewing a forest. The Park Service's earlier policy, dating back to the 1880s, had been to extinguish *all* fires as soon as possible; the result was the incredible buildup of kindling which fueled the 1988 fires.

The fires that year reached a magnitude never seen before; on July 21 park managers ordered all fires to be suppressed. By September 6 more than 9,000 firefighters were battling the wind-driven blazes, and flames bore down on the Old Faithful geyser and its adjacent hotel. Critics attacked the Park Service for not fighting the fires when they started; this was our oldest national park, they said, perhaps our most beloved, and it was burning.

It was then that the Editor dispatched senior staff writer David Jeffery to Yellowstone to tell the story of the fire and to sort out the arguments over fire policy ("Yellowstone: The Great Fires of 1988," February 1989, with photographs by freelancer Jay Dickman and others).

"It had been a horrendous fire season in the West," Jeffery told me. "Coming in to Billings, Montana, by plane, I could see the immense size of the fire in and around the park; the wall of smoke we flew through seemed a physical thing. Helicopters were dropping water from what the firefighters called 'Bambi buckets,' 200 gallons each. But on that scale, you might as well just spit at it."

Jeffery spent almost two weeks at Yellowstone. "You need to find the people who really know about the fire," he said, "not the bureaucrats or spokespeople." Jeffery attended pressroom briefings but often put on a fire-protection suit and went with the Forest Service to the front.

"I spent one day on the fire line working with a crew," he told me. "Crew bosses, I learned, really have to know what they're doing. Because you're nowhere near a vehicle for escape, and the only thing you have to fight the fire with is a Pulaski—a cross between an ax and a hoe. You're cutting fire lines and starting small fires in hopes of creating a backfire that stops the fire from coming toward you."

Jeffery and photographer Jay Dickman were just in front of the Old Faithful Inn when a wall of fire crested the opposite hill. "We were saved by the parking lot," Jeffery said. "I never appreciated a big asphalt parking lot so much. The fire was lobbing stuff like mortar shells, firebrands, that landed on the other slopes around us and set them burning." But the fire missed the Inn. "It would have gone up fast," Jeffery said. "It was built like a big wooden chimney."

Then nature turned benevolent: Rain and snow began to fall. Although pockets of fire would continue

burning for weeks, the worst was past. Almost one and a half million acres in and around the park had burned, and only one firefighter had died. Nature could begin to heal. By the time NATIONAL GEOGRAPHIC published the story, several months later, one photograph showed lush green grass growing amid the ash. Jeffery wrote:

"The earth soon started to renew itself. John Varley, the park's chief of research, looked forward to a 'great increase in plant species, as much as tenfold in 20 years. There will be a rise in fauna too, from insects upward through the food chain...

"'But to an ecologist what happened is neither good nor bad. It's just the natural progression of things...like spring, summer, fall, and winter....'"

Yet, Jeffery said, "Yellowstone's burning was for many people a very emotional thing, whatever the ecological consequences. It was like painting the Statue of Liberty's nose red—an affront to a very much loved symbol."

FIRES AND FLOODS tend to be seasonal—fires in high and late summer when the earth is dry, floods in spring with the snowmelt. Volcanoes blow in all seasons and are treacherous, deceptive. They may hint at an eruption, puff and swell, then subside, seemingly demure. Then they unleash their hellish power. For one of the century's most dramatic natural disasters, the eruption of Mount St. Helens in southwestern Washington State in May 1980, the GEOGRAPHIC offered the benediction with two exhaustively complete articles.

WRITER ROWE FINDLEY at friend Harry Truman's grave marker on assignment "MOUNT ST. HELENS AFTERMATH" DECEMBER 1981

PHOTOGRAPH BY STEVE RAYMER

Assistant editor Rowe Findley, a mild-mannered Missourian with a perpetual pun on his lips, took on the assignment; it would change his life. Twenty-two photographers contributed to "Mount St. Helens," January 1981, and "Mount St. Helens Aftermath: The Mountain That Was and Will Be," December 1981. The two stories remain the most popular articles published in NATIONAL GEOGRAPHIC in recent years, surveys show. In the first, Findley wrote:

"I refer to no notes in setting down these events, because they have cut a deep track in my mind. In fact, my memory unbidden replays sequences unendingly, perhaps because of their awesome magnitude and perhaps because they involve a deep sense of personal loss. I have only to close my eyes and ears to the present, and I see the faces and hear familiar names...."

Findley was at headquarters working on a prospective article on U.S. national forests when, on March 21, a Forest Service friend called from Portland, Oregon. The friend told him that earthquakes were shaking Mount St. Helens in the Gifford Pinchot National Forest. Findley began to read about Mount St. Helens; he discovered it last came to life in 1831 and sputtered intermittently for 25 years thereafter. An eruption before the end of the 20th century was predicted.

As the quakes grew in number and force, Findley booked a flight west. On March 28, when he arrived at the mountain, plumes of steam and ash rose two miles above it and tinged its northeast slopes sooty gray. Still, as Findley would write, "The very beauty of the mountain helped deceive us." Scientists arrived to study the mountain, setting up stations on it; photographers and sightseers, hikers and others came to look. It was during this period that Findley, traveling by helicopter to and from the mountain, came to know some of the men who were working or living there.

Among these men were Reid Blackburn, a young newspaper photographer on loan to the U.S. Geological Survey and to the GEOGRAPHIC to document the mountain's activities; David Johnston, a young geologist with the USGS; and Harry Truman, a colorful codger who swore to stay in his mountain lodge despite the danger. As the weeks passed, anxieties eased.

Then, on May 18, a beautiful Sunday, came these words: "Vancouver! Vancouver! This is it...." David Johnston was reporting by radio from his station six miles from the mountaintop. The words were his last. Blackburn, Truman, and some 57 others would also die in the eruption.

The energy released was that of 500 Hiroshima bombs; an entire mountainside fell, triggered by an earthquake; gases exploded with a roar heard 200 miles away; 230 square miles of forest were leveled; pillars of fiery hot, sulfurous ash rose to 60,000 feet. The bright Sunday turned black as night. Findley wrote:

"As soon as I can, I get airborne for a better look, and recoil from accepting what I see.

"The whole top of the mountain is gone.

"Lofty, near-symmetrical Mount St. Helens is no more. Where it had towered, there now squats an ugly, flat-topped, truncated abomination...."

Photographer Bob Madden was with a GEOGRAPHIC team—researchers, artists, editors—at their base at the Thunderbird Motel in Vancouver, Washington, 40 miles away. "We had chartered a helicopter for several weeks," Madden said, "and as soon as the mountain blew, the pilot took off and flew there to try and get Blackburn and Johnston. He couldn't get in; he circled the ash cloud and came back to Vancouver airport. Rowe went to meet him. Rowe said there were tears in the guy's eyes, and he kept saying, 'I couldn't get in! I couldn't get in!'

"Soon Army National Guard helicopters came in, and they gave rides to the media. We got the first one out and went up on the mountain looking for survivors. The air was so full of ash and heat, it was hard to breathe. Spirit Lake, where Harry Truman lived, was gone. The ash was very deep, very powdery. I had scratches on my film for six months from the ashes getting into my cameras. The hardest part was to show the immensity of the destruction. It would take you 20 minutes to fly over it. How do you show that in a photograph?"

FOR MONTHS, EVEN YEARS, afterward, Rowe Findley was not the same. "You can't go through something like that and not be affected," he told me. "Seeing how an event could move people's lives around, put some on an upward course, or invite tragedy.

"The 200 or so Weyerhaeuser workers who would have been in the woods on a weekday were not there, and so lived; by the same token, since it was a beautiful Sunday, sightseers were drawn to the mountain to get pictures, and they were among those who died. And if the eruption had occurred on Friday morning, I'd probably be dead, because I was on the mountain then."

Findley visibly suffered in the retelling of the story he had lived 18 years before. He later wrote me a letter describing his feelings more fully:

"I began to be weighed down on the 19th of May by the realization that the residual heat in the ashfall was hot enough to slow-cook the bodies of the victims...On overflights of the devastated area, I was almost always the lone writer among photographers who wished to go repeatedly where bodies lay, and I saw those same gray forms so often that I still see them lying there...I want you to know how I dreaded the service for my friend Reid Blackburn, where I would have to fight against my feelings in the presence of Reid's young wife, his siblings, and parents. That was when I was really down, and I came out feeling like I'd gone through a wringer."

The day of the service was Findley's 55th birthday; that evening friends took him to dinner. "But sad images kept claiming my mind," he wrote.

"It gives you something to think about—the fate of chance and timing. In a way, that's very unsettling, but in another way, the fact is that in all the universe, as far as we know, only this little sandwich of earth and atmosphere, with terrible pressures and heat below, and inviolable cold and void above, has existed for this long and nurtured life as we know it. Now isn't that remarkable? It's reaffirming for people who believe in a loving and caring Creator." ■

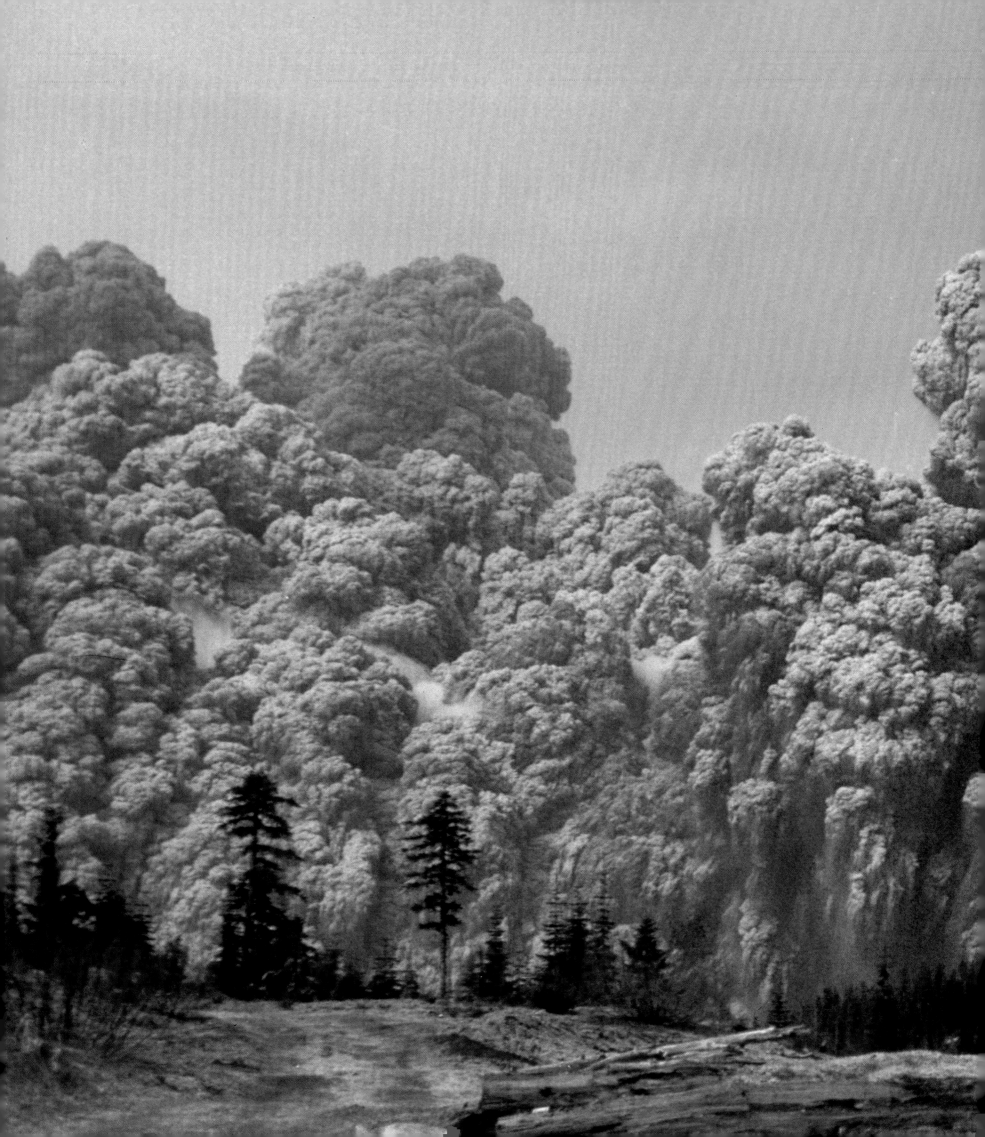

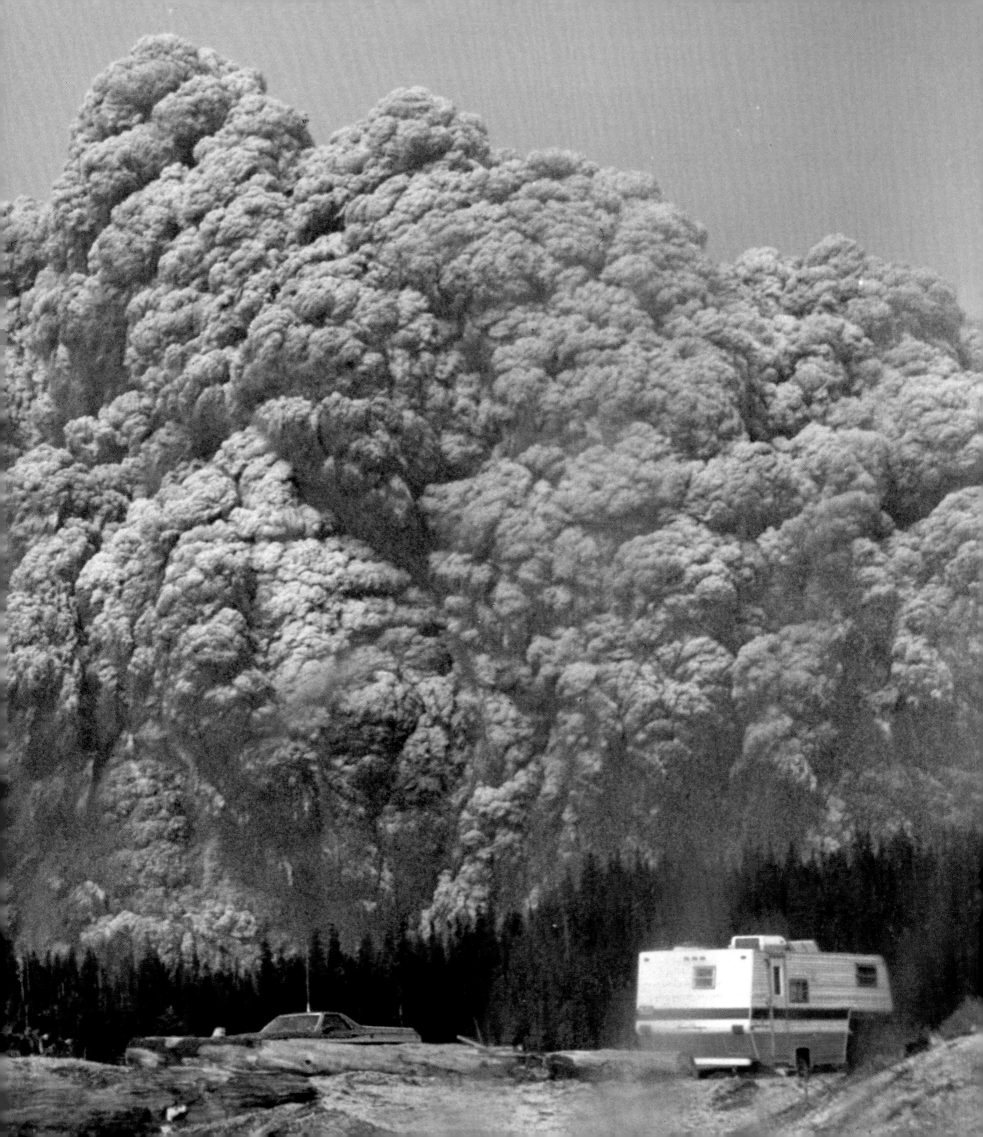

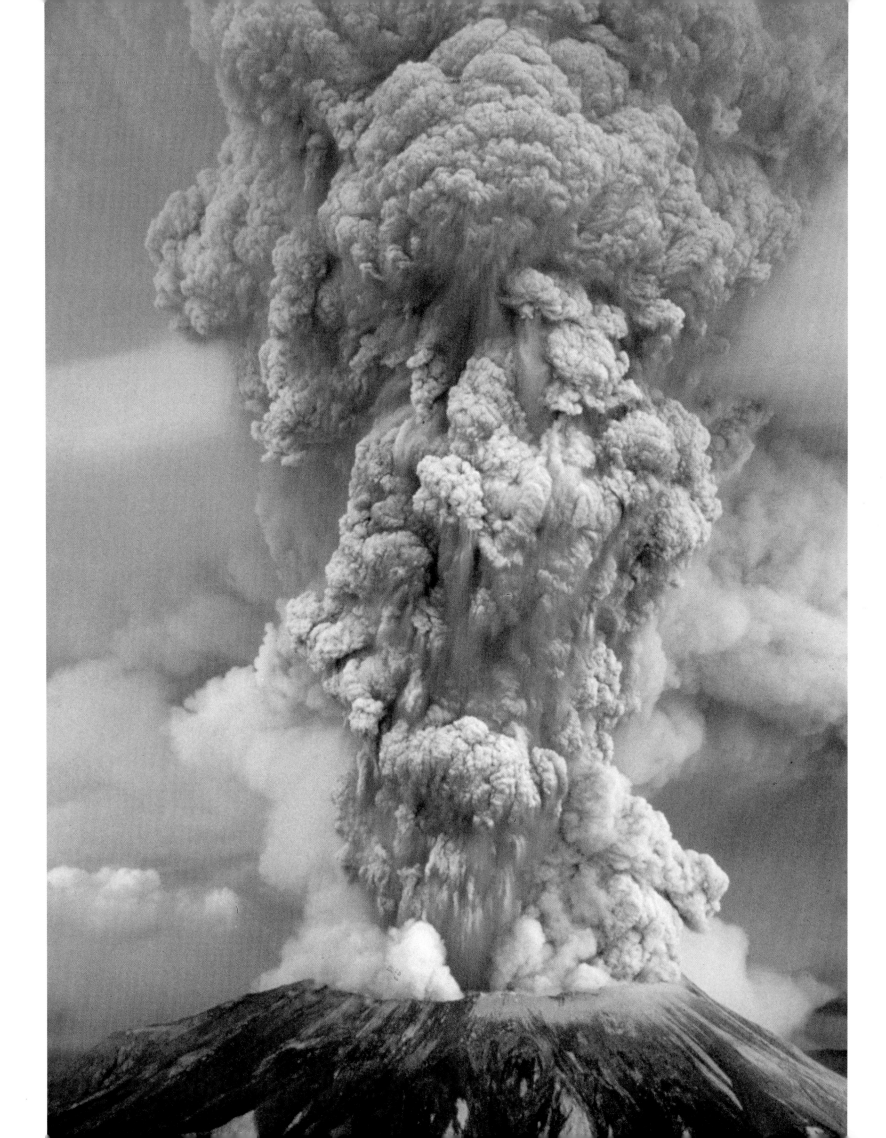

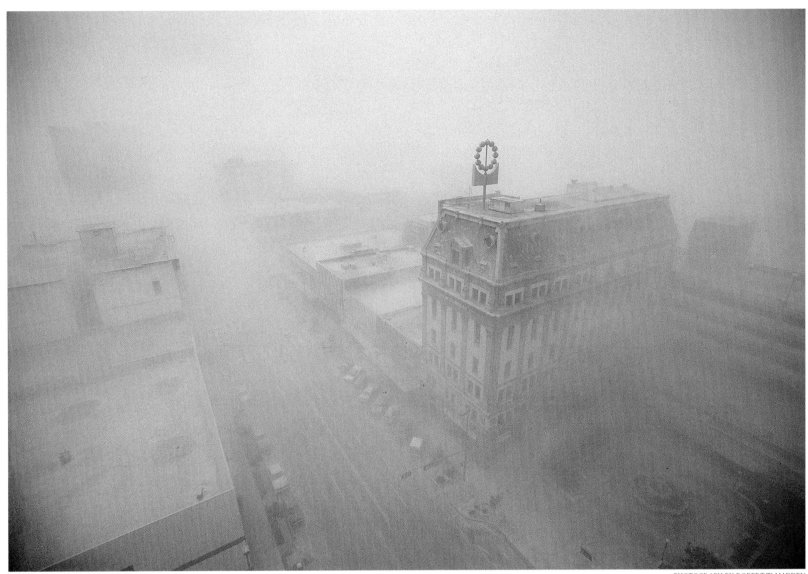

"MOUNT ST. HELENS"

January 1981

text by
ROWE FINDLEY

WITH THE FURY of a ten-megaton bomb, forces in Mount St. Helens blow away the top 1,300 feet of its crest (opposite); stiff breeze stirs up ash—600,000 tons in all—that fell on Yakima.

preceding pages:
WALL OF SEARING GAS, ash, and rock is propelled at 200 miles an hour as Mount St. Helens erupts in Washington State. View is from Bear Meadow, about 11 miles northeast of the crater.

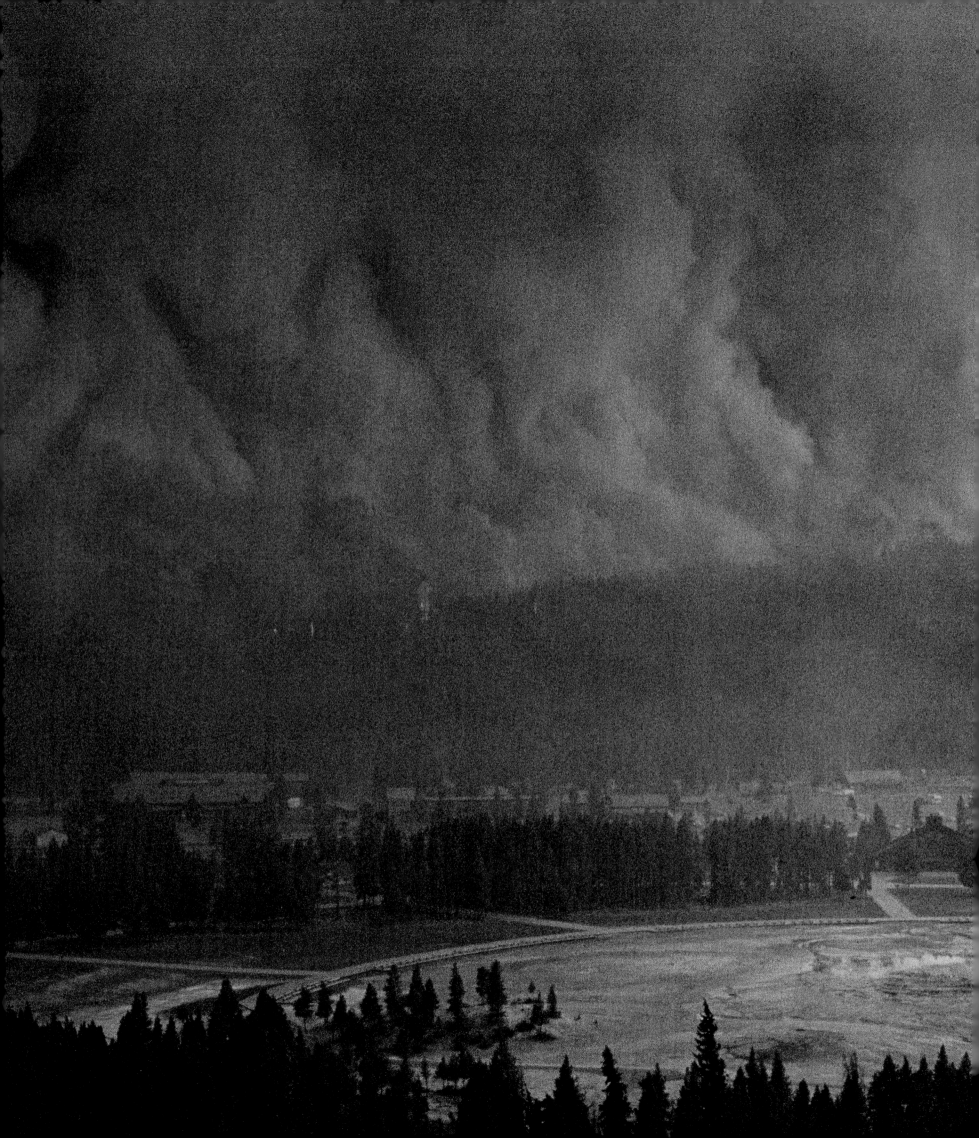

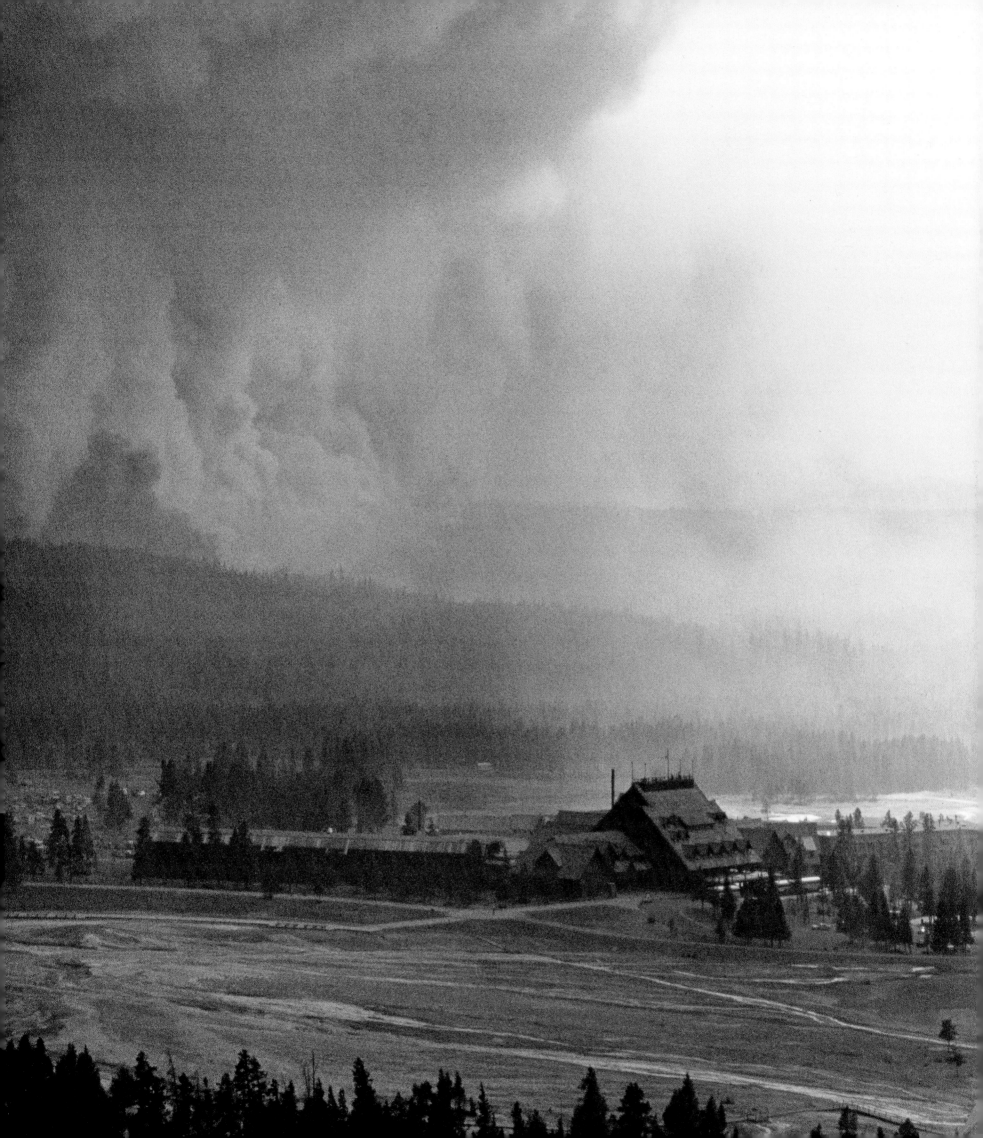

"YELLOWSTONE: THE GREAT FIRES OF 1988"

February 1989

text by
DAVID JEFFERY

BULL ELK SEEKS a mate in the blackened forest along Obsidian Creek.

preceding pages:
DRIVEN BY 50-MILE-AN-HOUR GUSTS, flames advance on Old Faithful geyser. Old Faithful Inn, at far right, escaped; 24 smaller buildings did not.

PHOTOGRAPH BY ALAN AND SANDY CAREY/SYGMA PHOTO AGENCY

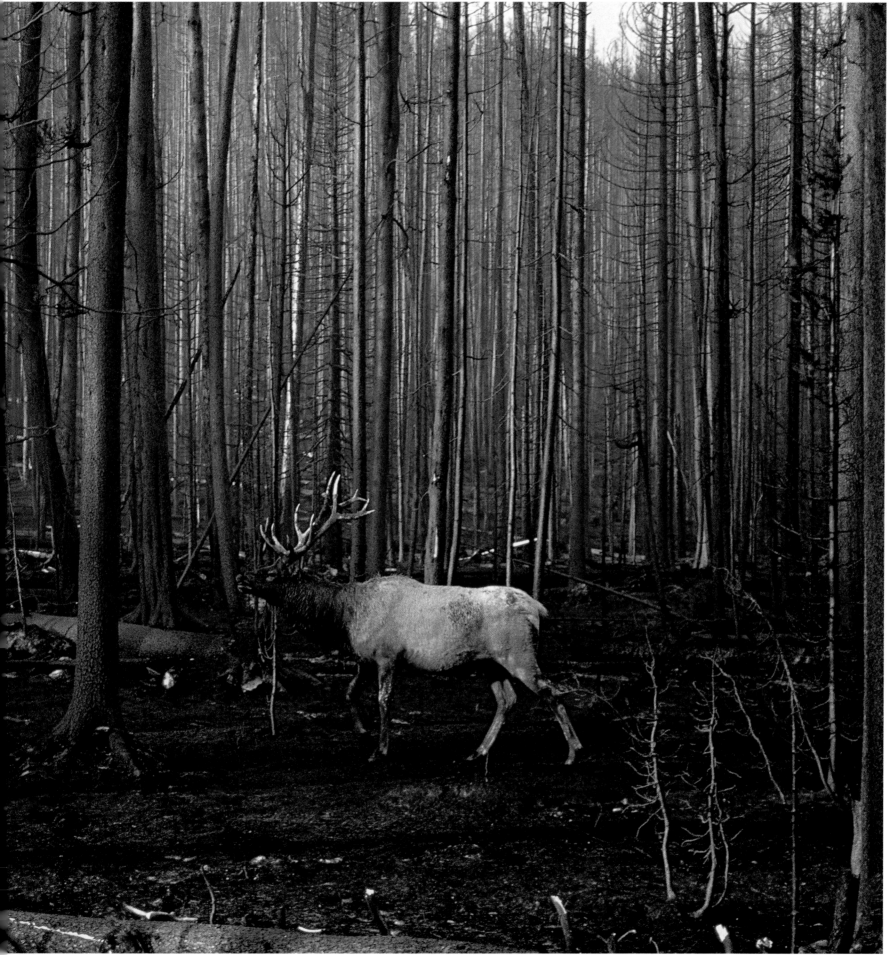

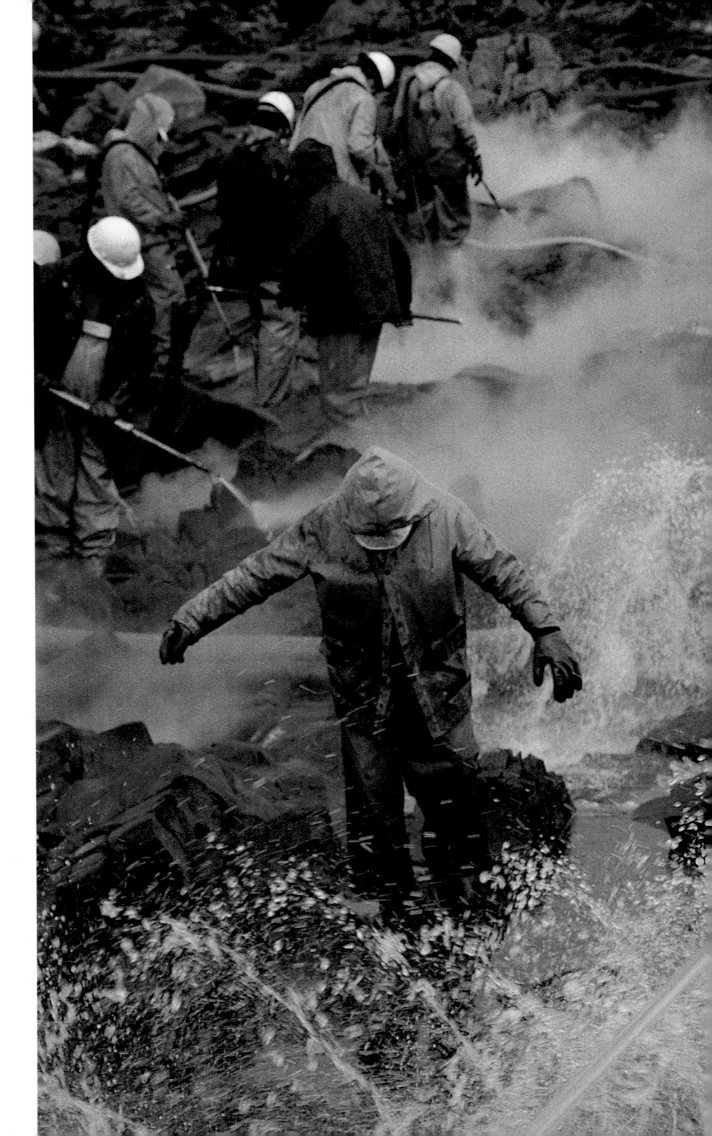

"ALASKA'S BIG SPILL—CAN THE WILDERNESS HEAL?"

January 1990

photographs by
NATALIE FOBES

text by
BRYAN HODGSON

WORKERS use high-pressure
hoses to break up tarry residue
along the shores of Green Island,
Alaska, after oil spill from
tanker *Exxon Valdez*.

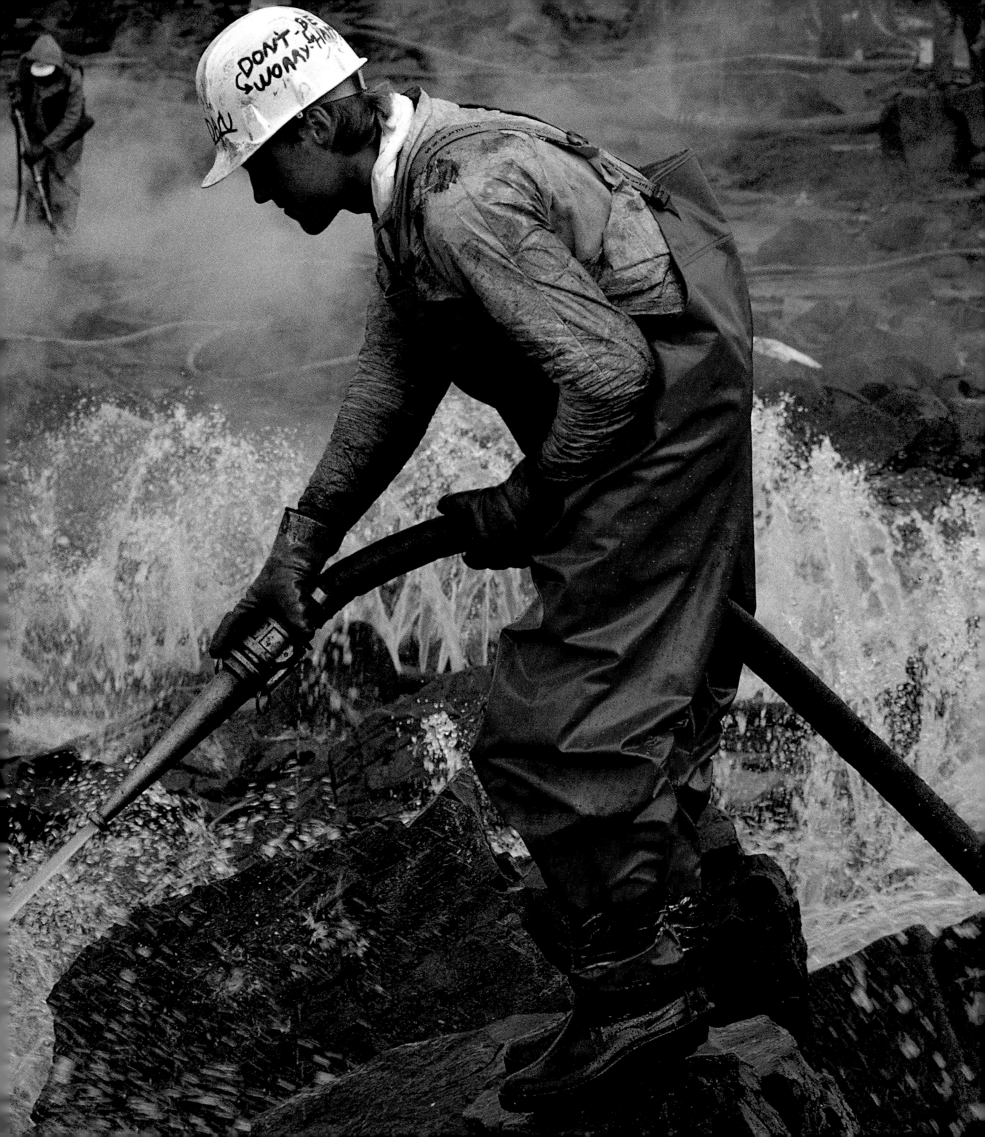

OIL-COVERED GREBE, one of 36,000 dead
seabirds discovered after the *Exxon Valdez* oil spill.

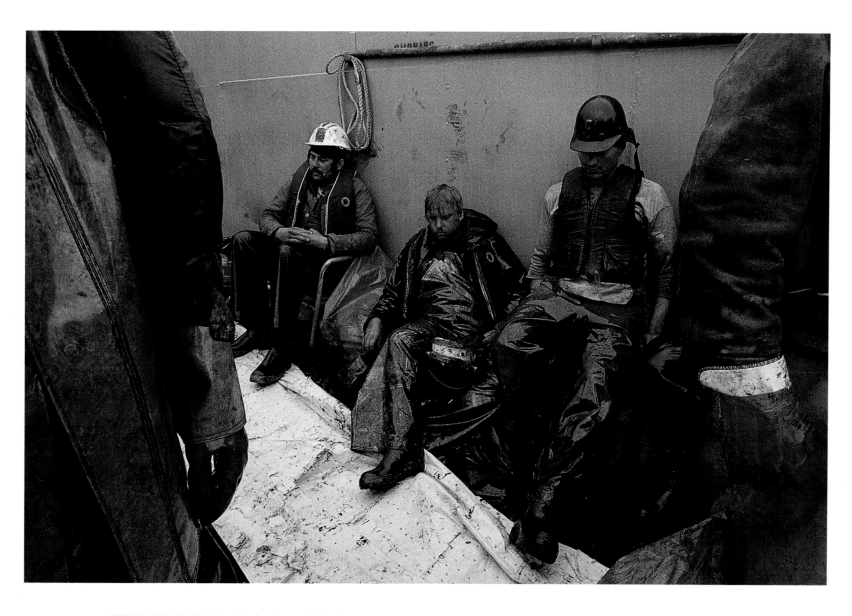

EXHAUSTED CREW rides landing craft back to
dormitory ship after a day of cleanup duty on Eleanor Island.

"LIGHTNING, NATURE'S HIGH-VOLTAGE SPECTACLE"

July 1993

text by
WILLIAM R. NEWCOTT

DOUBLE TROUBLE—lightning
and waterspout—is spawned
by storm over Florida's Lake
Okeechobee.

PHOTOGRAPH BY FRED K. SMITH

PHOTOGRAPH BY DAVID PETERSON
DES MOINES REGISTER

"DES MOINES, IOWA: RIDING OUT THE WORST OF TIMES"

January 1994

text by

BILL BRYSON

AFTER RACCOON RIVER flooded,
Patty Savage recovered prized pictures of
her mother and of Christ from the ruin
of her mother's home in Des Moines, Iowa.

CHAPTER FIVE **PLACES**

"I love it on the prairie, on the ocean, on the desert – where the light lingers, and it's yours..."

—ANNIE GRIFFITHS BELT

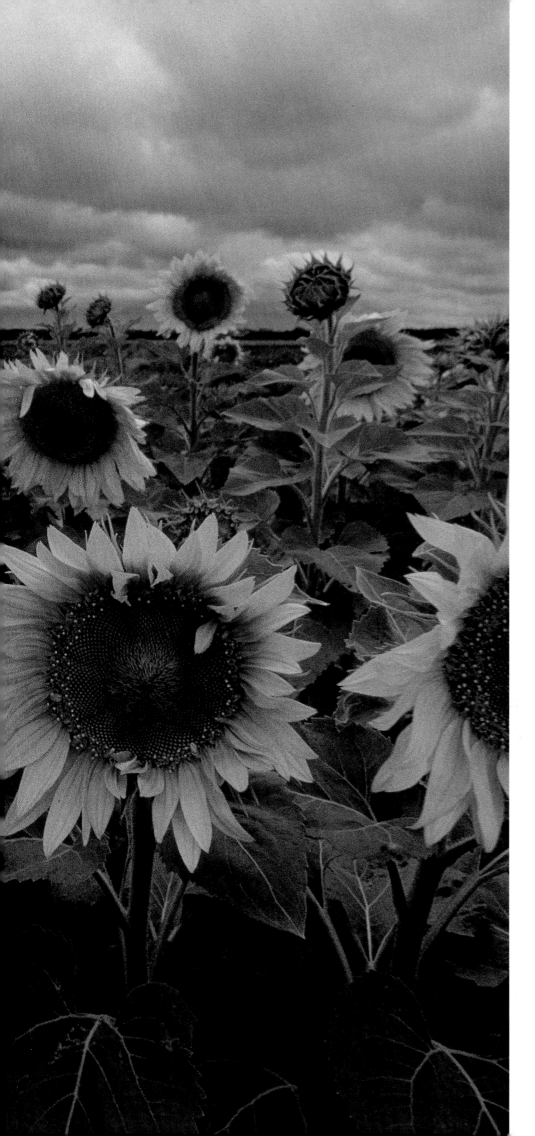

"NORTH DAKOTA—
TOUGH TIMES ON THE PRAIRIE"

March 1987

photographs by
ANNIE GRIFFITHS BELT

text by
BRYAN HODGSON

" Vast wheat fields
are stitched into
the prairie like
machine-made
carpet. Regiments
of sunflowers
gaze so uniformly
east that I've felt
compelled to glance
that way too. "

—BRYAN HODGSON

SIX-FOOT-TALL sunflowers ripen
in the Red River Valley.

preceding page:
GARRISON DIVERSION CANAL, built
to carry Missouri River water for irrigation.

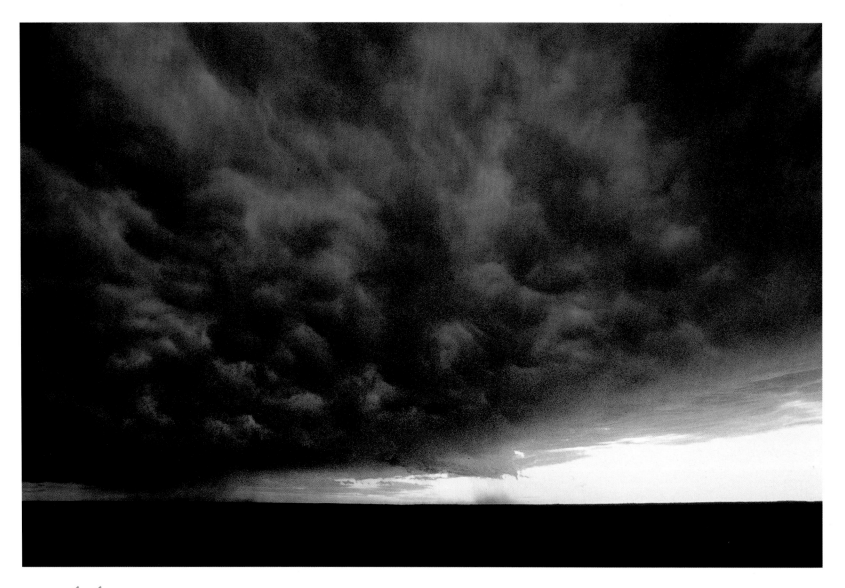

66 Whatever that future brings, North Dakota will never let itself be taken for granted. It is still a part-time wilderness where tornadoes and hailstorms and drought can tip the most carefully computed balance sheet. 99

—BRYAN HODGSON

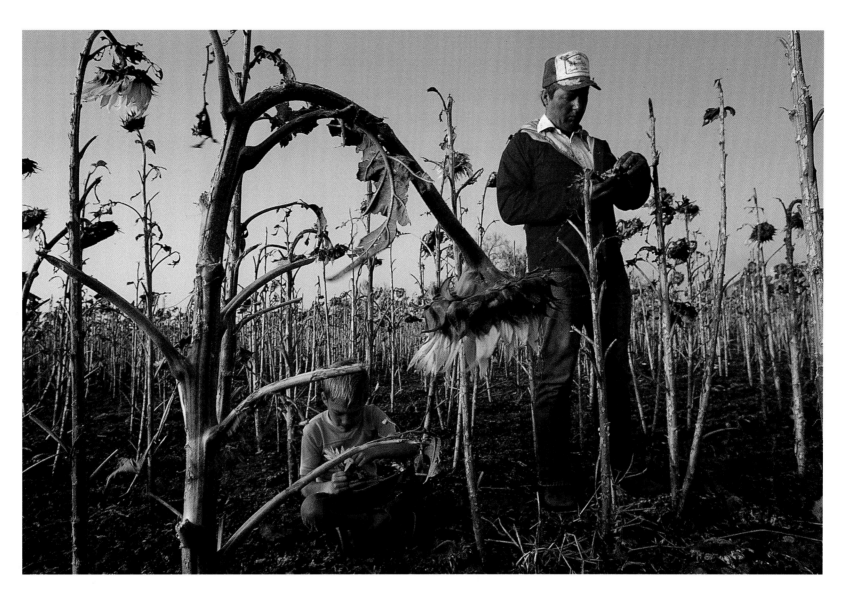

WHEAT FIELDS READY FOR HARVEST endure a
storm in the Red River Valley (opposite); farmer Ken
Lang surveys the damage from a hailstorm that leveled
half the sunflowers on his farm west of Fargo.

NORTH DAKOTA WAS A STORY nobody cared about," said photographer Annie Griffiths Belt. "And in the end it was a very beautiful, interesting story that a *lot* of people cared about. I met people who were so wonderful to me, and at a time when they were under great stress."

Belt covered "North Dakota—Tough Times on the Prairie," March 1987, with senior staff writer Bryan Hodgson. The assignment was not widely coveted. It was a state story, a type known for difficulties and frustrations. And this state was remote, had severe winters, and held only 685,000 people—not a lively prospect. But there was an angle: Its 33,000 farmers were in bad trouble.

Hodgson explained in his text:

"Across this prairie panorama marched gleaming machines at work on one of the mightiest harvests in North Dakota's history…400 million bushels of wheat… 250 million bushels of barley, oats, and corn…800,000 tons of sunflower seeds.

"But this enormous productivity lay like an invisible blight upon the land."

The world food market was glutted; U.S. farm exports had dropped 40 percent in five years. North Dakota's farmers were some $5.7 billion in debt. Thousands were delinquent in mortgage payments and threatened with foreclosure on their farms.

Belt found nearly the entire population affected by the economic crisis. "There was so much shame and fear attached to admitting that they were going under," she said, "that people would say nothing, and put a gun to their heads. Those people who were so stoic and had such a work ethic, who didn't have another lifestyle—their shame knew no bounds. They felt they'd let down their kids, their parents, the neighbors. They were good, hardworking people, many of Scandinavian descent, who didn't show a lot of emotion."

Belt also sensed a sort of inferiority complex. "They don't think that they're interesting. They're so touched that anyone's paying attention to them, and they're astonished that the magazine is featuring them— their faces, their place, their concerns. The first day of my assignment I arrived at the Holiday Inn in Fargo, and this guy at the front desk noticed me sign in, and he said, 'What's NATIONAL GEOGRAPHIC doing in North Dakota?' And I said, 'Well, I'm about to do a story on your whole state.' And he said, 'Well, you won't need more than five rolls of film.'"

To capture the character of the place and its people, Belt knew she would have to dig deep.

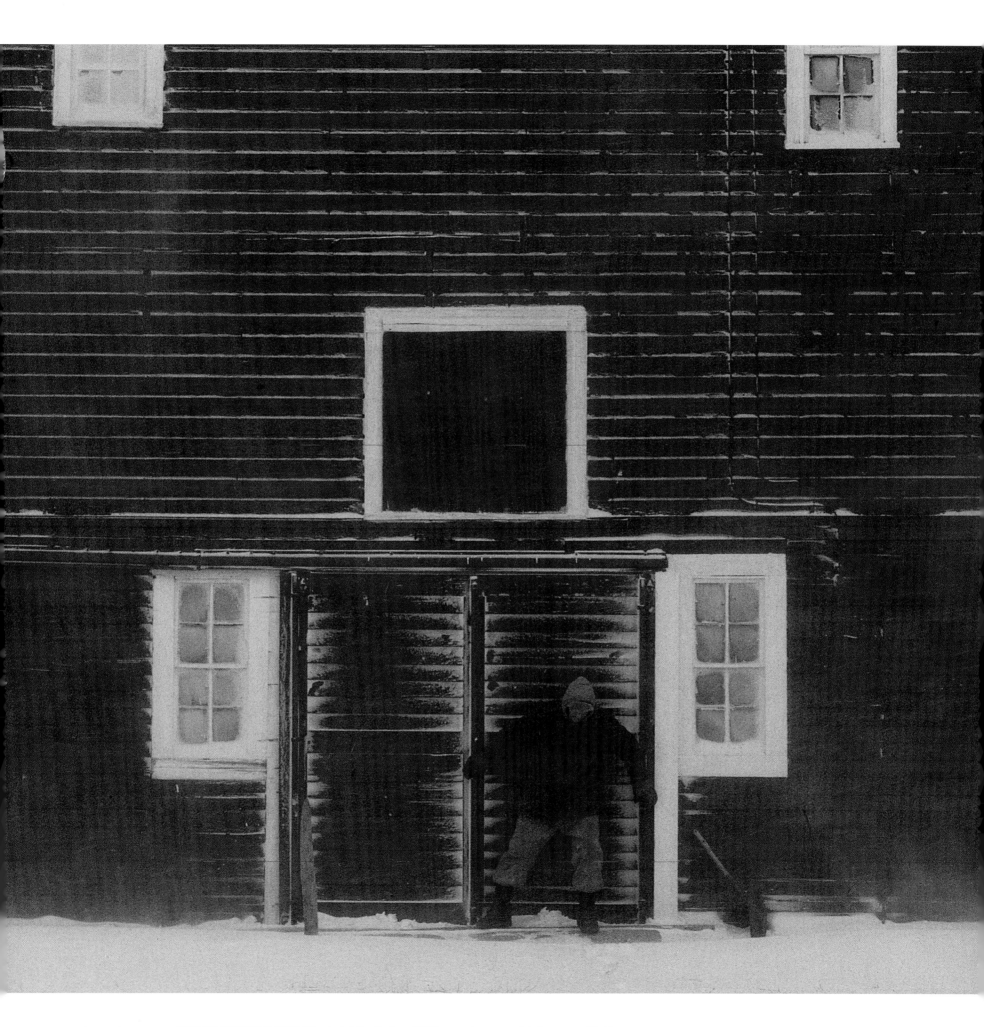

HELGE HOLTE BATTLES windchill of minus 80°F to tend cows on his farm near McGregor.

"The way I shot that story," she told me, "was very much seasonally because North Dakota has some of the greatest extremes in climate anywhere in North America. It is an extraordinary place in terms of weather. And when you are dealing with an agricultural subject, seasons become very important. So I went up and spent two weeks in winter, then two weeks in spring, then two weeks in summer, and then two weeks in the fall to give that sense of change."

The seasonal approach gave depth to her coverage. She photographed an elderly farmer, Helge Holte, of Norwegian ancestry, outside his barn in a blizzard. "The windchill was 80 below, and he was going out just to check on the cows in the barn," said Belt. "I got about ten frames off, and that was it for the camera—it froze up. But to me this shot and this person epitomize what I saw in North Dakota—the strength of the land and the strength of the people."

When the legends writer assigned to the North Dakota story researched this picture, he could talk only to Holte's wife and a neighbor, for Holte had died. The neighbor remembered with great respect what good care the old farmer had taken of his livestock. "Even in the dead of winter he loved to work," the neighbor said. "In my next life I want to come back as one of Helge's cows."

PHOTOGRAPHER ANNIE GRIFFITHS BELT on assignment
"NORTH DAKOTA—TOUGH TIMES ON THE PRAIRIE" MARCH 1987

PHOTOGRAPH BY PHIL SCHERMEISTER

Another time Belt found depth was while photographing a teacher, Janice Herbranson, in a one-room schoolhouse in a cattle town of 40 people southwest of Fargo. It was the last day of the school's existence. Three students were graduating, one was moving away, and only one would remain—not enough to keep the school going.

"She was a trooper throughout the whole day," Belt said, "and she made it a fun day for the kids and packed them all off with hugs and kisses, and then she walked back into the classroom, and she burst into a sob. Just sobbed. I had become friends with her and yet I had to take a couple of pictures of her weeping at the window before I could go and hug her."

Annie Belt was raised in Edina, Minnesota, near Minneapolis. "Most people have some love for their home—the landscape they were born from. I love the light in flat places. The light lasts for a long, long time in a flat place. I get so frustrated and claustrophobic in the mountains—where the light's suddenly gone. It's robbery! Wait just a darn minute! It's 3 o'clock and I'm out of light? That's a huge loss. Light is everything. I love it on the prairie, on the ocean, on the desert—where the light lingers, and it's yours.

"My daughter Lily [seven years old] is also into light. She'll be brushing her teeth, and she'll come running: 'Mommy, Mommy, come see the light! Come and get a picture!' It's very touching to me that she understands that already."

THE GEOGRAPHIC EARLY saw itself as a magazine of record, committed to documenting the political units of the nation as well as its natural geographic regions. All 50 states were featured at least once between 1915 and 1960, as well as dozens of regions such as Florida's Everglades and the Black Hills of South Dakota.

Early articles, chockablock with cheerful optimism, had a role in imprinting the character of American regions on the national consciousness before the age of television. Millions of readers learned that lobsters go with Maine, mountains with Colorado, hot sauce with Louisiana, and saguaro cactuses with Arizona. For them, as well as readers today, the GEOGRAPHIC became a kind of reference library. And the postcard-size photographs by stalwarts Charles Martin, Edwin L. Wisherd, Clifton Adams, and others, printed two to a page in color in the 1930s and '40s, became the national photo album.

Among the magazine's earliest full-blown state stories was "The Wonderland of California," by writer Herman Whitaker, July 1915. Most of the article's 45 photographs were scenes of nature such as redwood

forests and Yosemite Valley. Of cities, only San Francisco, rebuilt from the earthquake nine years earlier, rated a picture. Whitaker did not pretend to define the huge state but perceived in San Francisco the California spirit:

"[T]o be a staunch friend, a good neighbor; to live well and broadly; to love beauty in all its forms. Nothing ascetic about it; nothing highfaluting, but broad and kindly, thoroughly Californian."

William Joseph Showalter wrote one of the first stories on a northeastern state, "Massachusetts—Beehive of Business," March 1920. The tone was different from Whitaker's California ode; it was industrial. Photographs showed factories making medicine, toothpaste, watches, shoes, cloth. One set of pictures illustrated how GEOGRAPHIC paper was made—from lumber to pulp to coating. Showalter also observed human change:

"Where Paul Revere lived in Revolutionary times is now Little Italy…With only a third of the State's population born of parents who first saw the light in America, how small must be the percentage born of full colonial lineage!"

When the GEOGRAPHIC covered its first Deep South state, Georgia, that state had not yet recovered from the Civil War. In "Marching Through Georgia Sixty Years After," September 1926, assistant editor Ralph A. Graves cited some of Georgia's problems—the dissolution of rich tobacco lands, the ravages of the boll weevil, the cutting down of the pine forests. Graves, whose son William would become Editor of the GEOGRAPHIC 64 years later, wrote a somber lead unusual for the magazine:

"In common with many other Georgians living outside the State, the writer's pride had been seared by these facts; so that, after an absence of more than twenty years, he undertook, with much misgiving, a tour of the Commonwealth to see what of good and encouragement could be found within her borders."

As the nation grew and changed, nostalgia crept into some articles. Frederick Simpich, who authored a remarkable 89 articles over 37 years, allowed himself a personal reminiscence when he revisited a familiar place in "Out in San Francisco: Fed on Gold Dust and Fattened by Sea Trade, a Pioneer Village Becomes a Busy World Port," April 1932:

"An Army transport from Manila had just docked when, as a youth, I first saw this panoramic water front…soldiers in khaki, campaign hats, and the laced leggings of Spanish-American War days crowded down the narrow gangplank, singing, to the tune of the Battle Hymn of the Republic, that Philippine war song which began:
 'Underneath the nipa shack,
 Where the mangy monkeys scratch….'
"Huge Clydesdales, with big feet, hairy ankles, and brass-studded harness, pulled low, rumbling, iron-tired drays, piled high with freight, over the splintered plank roads along the wooden pier sheds. To-day you see palacelike piers of steel and concrete and impudent, snorting tractors speeding along with whole trains of loaded trucks….But you miss the horses."

"CONNECTICUT, PRODIGY OF INGENUITY" was the GEOGRAPHIC's paean to that state in 1938, written by Leo A. Borah. The subhead told all: "Factories Play a Symphony of Industry Amid Colonial Scenes in the State of Steady Habits." Photographs in the wondrously soft colors of Finlay and Dufaycolor film flattered the state.

Almost 60 years later photographers Joel Sartore and Rick Rickman and writer Thomas B. Allen were assigned to produce "Connecticut," February 1994. The character of the state had changed; many of its industries were suffering. Allen talked to Brian Stanley, an engineer in his early 40s who had been laid off at Electric Boat in Groton, which builds submarines and was one of the nation's largest defense contractors before the end of the Cold War forced downsizing. Allen wrote:

"Brian's job is one of more than 190,000 jobs that the state has lost since 1989, not only in manufacturing but also in such stable old industries as insurance and banking. Connecticut was one of the few states in the nation to lose population in 1992, as unemployed men and women left in search of jobs."

But bedroom communities in the southwest of the state remained affluent. Many there commute to well-paying jobs in New York City. Sartore, an unapologetically genuine man, found them a tough crowd.

"I remember going to a commuter train station in Darien," he told me, "and photographing people at 5:30 in the morning, early, early, early. I would walk around them with a camera, shooting pictures, and they would pretend I wasn't there. People were completely being themselves, rich people in fedoras and long expensive dress coats, reading the newspaper, looking at their watches, nobody talking to each other, waiting. Nobody said a single word to me; nobody looked at me. I still don't know why. It was a unique and wonderful experience because I never thought I could be so invisible."

Sartore could have used a bit of invisibility the night he ventured onto a bridge over the Thames River to photograph a submarine returning to its base at Groton. "The people at the base had told me roughly when it was coming into the harbor," he said. "This bridge was huge and I wanted to look off the inward side, so I was standing out there in the darkness, in the middle of winter, in biting winds, waiting for the sub to come up underneath me.

"And suddenly I'm in a glare of spotlights, surrounded by what seemed like every rescue vehicle in Connecticut—the state police, fire trucks, the sheriff, and the local police. I guess I looked like a jumper, and somebody had called in. And it was right when the sub was coming, too. They wanted to detain me, and I said, 'Look, if you gotta arrest me, do it, but this picture's coming up right now. Two of you can stand on either side of me and wait. I want this picture. And I promise I won't jump!'"

WRITER THOMAS J. ABERCROMBIE on assignment
"WIDE OPEN WYOMING" JANUARY 1993

PHOTOGRAPH BY RICHARD OLSENIUS

RICHARD OLSENIUS, freelance photographer and now an illustrations editor, said that one of his toughest assignments was "Wide Open Wyoming," January 1993, with text by senior staff writer Thomas J. Abercrombie. But he added that the hardship was a kind of catalyst and brought a level of emotion to the story.

"We did it in the fall and winter," said Olsenius, "and there were a lot of miles between pictures, and between people. Most of the time people were inside, and they could see you coming from 20 miles away. It's hard to surprise someone there. They have a lot of horizon line, and people's barriers are extended a lot further out, too.

"To me there is nothing more powerful than crossing the Missouri River about the 100th meridian and seeing the prairie begin to rise up. Because there's nothing to hang on to out there, your soul taps into the ground a little stronger. You become more self-reliant. And you identify so strongly with your landscape that you have a sense that you are only a guest on the land.

"I've learned one thing. If you drive by some guy walking along a road in Wyoming, by gosh, you get out and talk to him. Everyone has a story, if you take the time to listen to him. I can't count the number of times I've had people say, 'I've never been able to sit down and talk to someone about this.' In Wyoming or on the Alaska Highway or in the Arctic, there are many people who lead lonely lives. When they have someone sitting at their kitchen table that they're comfortable with, that they'll never see again, it just pours out of them.

"It's scary what you tap into sometimes. And that's the joy and the problem with a story—you start tapping too deep, and suddenly it's not just a story for NATIONAL GEOGRAPHIC. You find yourself into something that is so complex and really full, and frightening. This job really goes beyond gathering a story, beyond putting on your hardware for the day and getting a snap. It really is getting out and embracing life as it happens. If you're not really interested in the guy who's sitting at a table with a coffee cup who's going to go out and do some branding, I think you're going to be weeded out of this business pretty fast."

Tom Abercrombie, who at the magazine had specialized in foreign assignments, especially in the Middle East, gladly donned blue jeans and headed west to the Cowboy State. He headquartered on a ranch, rode horses, mended fences, rounded up cattle in the snow; he went out with trappers and visited a small gun factory, testing the product by firing into a woodpile. And he, too, noticed the distances:

"Driving is what you do a lot of in Wyoming. Here, where the sky is half a man's world, you can take true measure of yourself and have the time to do so. As I wheeled past grazing cattle and sheep—even the occasional herd of domesticated buffalo—country and western music helped pass the long miles: 'Hands that worked so hard all day need someone soft to hold….'"

MOST WRITERS AND PHOTOGRAPHERS agree that state stories can be devilishly difficult. An Editor's note addressed the problem with a disclaimer at the end of Frederick Simpich's "So Big Texas," June 1928: "It is impossible to present between the covers of a magazine the entire story of a great State. A complete description of the multifold industries, interests, and beauty spots of Texas and of each of her hundreds of progressive cities and towns would require volumes."

When staffer Boyd Gibbons received his first assignment, it was a state story. The instructions were simple: "Do Arkansas." Gibbons would pen a convincing portrait of "Easygoing, Hardworking Arkansas," March 1978, with photographs by Matt Bradley, but it would take some work.

"I just drove to Arkansas, in the early spring. It was cold and blustery, and I'd read some things about Arkansas, but I don't recall any great preparation. I was just a traveler, a lonesome traveler."

Gibbons had some thoughts on how to approach a state story. "You can just go and vacuum that state up and redeliver it in those boxcars of facts—these snippets of information that you are trying to stuff in like mortar between bricks. Or you can go down there and nose around and find out things that say 'Arkansas' to you. You don't want an encyclopedia. You don't want to bury the reader in statistics. You want to sense what the place smells like, tastes like, feels like."

Nosing around, Gibbons met an auctioneer of used farm equipment, Tom Blackmon, and followed him around. "These auctions are held in the winter," he said. "The farmers are finished with their crops, and the well-to-do farmers are down at Hot Springs, vacationing and attending the horse races, and this is the time to move used farm equipment. And this theme of making do, of resourcefulness, was a legitimate theme about the state."

Gibbons also met a man who had fighting dogs—Staffordshire terriers. "This guy was a sweetheart, but he was raising dogs to fight—to me a repulsive activity. He had this dog chained, with a logging chain, to a large tire filled with concrete. The dog lunged at me, and the tire bounced around like a poker chip. It was one of those odd situations you find yourself in, where the person may be fascinating, but the kind of work that he's doing repels you. But you are there to observe."

Gibbons remembered Arkansas as "a state that's very self-conscious about the Al Capp image of Dogpatch, but the people you meet are delightful and genuine, and the food's fantastic." He wrote:

"In Dumas, in Little Rock, in roadhouses all over the state—as well as in the Schroeders' kitchen—I became pleasantly addicted to crisp green onions, hush puppies, and fried fresh catfish, rolled in cornmeal and dropped in cast-iron pots of peanut oil hot enough to light a kitchen match."

He also received his first lesson on being a GEOGRAPHIC writer. It was at a public library in Little Rock. "I wanted to go into their section on state history and spend the day there. The librarian came up to me, stood very close, and said, 'I've never met a GEOGRAPHIC writer. May I touch you?' And she pressed her finger against my chest. I was speechless."

WHEN SENIOR STAFF WRITER CATHY NEWMAN, a Miami Beach native, was assigned to "North Carolina's Piedmont: On a Fast Break," March 1995, with photographs by Pete Souza, she approached the subject as she would an overseas assignment. "Dealing with the United States regionally is really not much different from dealing with a foreign culture," she told me. "Every place has its own anthropology and folk heroes." When Newman began gathering material on the Piedmont, she discovered that one of the region's biggest heroes was Richard Petty, the retired stock-car racer.

Newman decided to enroll for a day in Petty's stock-car driving school. "It's always been a GEOGRAPHIC dictum: '*Show* the reader, don't tell them,'" she said, "but I'm terrified of cars because I was in this bad wreck in 1974; I fractured my back in two places."

Swallowing fear, Newman took the wheel for a one-day course, but photographer Souza, she told me, quickly declined when the instructor offered to let him ride with her. It seemed like a good choice in hindsight. "I nearly drifted into the path of oncoming cars going more than 100 miles an hour," said Newman. But the experience put her in the Piedmont spirit.

She found the region to be a mixture of traditional rural values and new sophisticated-intellectual pursuits. "Charlotte is, next to New York, the high-finance capital of the country, and you have these wonderful universities like Duke, North Carolina, and Wake Forest."

Regional differences blur in the cities, Newman emphasized, "but once you get off Interstate 85, like 10 to 15 miles off, you're in the rural Piedmont, the small-town Piedmont." As she wrote:

"Here is the bedrock Piedmont—land of fish camps, flattop haircuts, and kids cruising on Saturday nights with the bass cranked so loud it rattles the plate-glass windows on Main Street. Where the soft drink of choice is Sundrop or fizzy-sweet Cheerwine, and the worst thing a man can do is 'get above his raisin'.'"

"And basketball!" she said. "The 'Dean Dome' is like Mecca for that part of the country. [The athletic facility, named for head coach Dean E. Smith, is home of the University of North Carolina at Chapel Hill men's basketball team.] The first basketball game I ever went to was in the Dean Dome. And I'm sitting up in the top, where everybody has season tickets, and they all wanted to know how I had gotten this coveted ticket. I was sitting next to a professor of foreign languages, and she tried to explain this basketball phenomenon to me: 'Just think of it as Piedmont ballet.'"

When Newman went down to the Piedmont for Easter, she attended a service in a small fundamentalist church. "And in the sermon the preacher drew this very intricate analogy between finding Jesus and slam-dunking a basketball," she said. "I thought, This is real. This is what's important to these folks—Jesus and basketball."

ONE STATE STORY THAT DELIGHTED the photographer assigned to it was "Nebraska," scheduled for publication in 1998. Nebraskan Joel Sartore had his positive feelings for his home state reinforced. "What I found is that the very rich in Nebraska are just as nice as the very poor. And that Nebraska is full of nice people, and one of the best places I've ever had the privilege of working.

"The people at the Aksarben Coronation Ball [Omaha's society ball] have a big gala every year, and they're just as down-to-earth as any people I've ever met. They weren't snooty at all. They were honored that NATIONAL GEOGRAPHIC was there, and I was honored that they were including me in their evening."

Despite the fact that both live in Nebraska, Sartore still plans to write to Alan Bone, the boyhood friend he sends long letters to after each assignment, describing his adventures.

"I'll tell him about the Wayne Chicken Show, where the whole town takes on chicken-related events. They have the 'national cluck-off,' where the person who does the best chicken cluck wins. They have the egg drop, where you try to catch an egg dropped from a utility truck's crane bucket. They have the 'best beak' contest [noses] and the 'best chicken legs on a human' contest. The whole thing was funny. The 'Chickendale dancers'—guys in the same black spandex shorts with cuffs as the Chippendales [a male stripper group], but they're all real fat and have big guts.

"I judge a place usually by the amount of time it takes to get invited to dinner and by how often I'm invited. In Nebraska it's been five out of seven nights." Recalling my own experience, I asked Sartore why photographers seem to get invited to dinner more often than writers. His answer: "The writer is saying to a person, 'Justify your existence,' and the photographer is asking, 'Be yourself.'"

NO GEOGRAPHIC PHOTOGRAPHER has had a better feel for "the mountains" than Bruce Dale. He explored the Ozarks and Appalachians in "Through Ozark Hills and Hollows," November 1970, with text by staff writer Mike W. Edwards, and "The People of Cumberland Gap," November 1971, with text by John Fetterman. These stories led to the Geographic book *American Mountain People* in 1973. Then in July 1975 came his picture essay, "An Ozark Family Carves a Living and a Way of Life."

"My guideline," Dale told me, "whether conscious or unconscious, was to show this region and its people through their own eyes, not through the eyes of an anthropologist or a journalist. And one of the greatest compliments they gave me is that they were always *proud* of these pictures."

At Pine Mountain Church of God, outside Harlan, Kentucky, Dale gained rare access to worshipers who follow literally the words in Mark 16:18: "They shall take up serpents; and if they drink any deadly thing, it shall not hurt them."

When he rose from the pew to photograph the service, said Dale, "the people acted like I wasn't there. They were dancing around with these snakes, really worked up. One man had rattlesnakes wrapped around him, and I was shooting pictures with a wide-angle lens, which distorts distance. And there was a woman behind me who was chanting and yelling and pushing me forward, and I didn't realize how close I was because of the lens. When I lowered the camera, there was a rattlesnake about ten inches in front of me wiggling its tongue. But the people were completely oblivious to me. They were in a trance."

The bonds he built were strong, and Dale has been back many times to the mountains, if only to pay respects. "I photographed an old man named John Caldwell," he told me. "They called me a couple of years ago and told me John had died, and would I come down for his funeral. So I drove down to Harlan.

"The preacher had written this little thing, and he said it was going to mention the GEOGRAPHIC; 'I hope you don't mind.' Then during the service he said to the assembled relatives, 'You should be proud of your Uncle John: He was always the workingest man in Greasy Creek, and one of the highlights of his life was when he was photographed for NATIONAL GEOGRAPHIC magazine.'

"And after the funeral we left in the rain in this little procession, and as we drove through town, all of the traffic coming in the opposite direction stopped and waited for the funeral procession to go by. Construction workers along the highway put their hard hats over their hearts and stood at attention. We'd be going up this mountain pass and see an oncoming coal truck, and it would stop. It wasn't for John; it was just out of respect for their neighbor—and that's what I liked about the region."

ALASKA IS A PLACE journalists seldom forget: The working conditions and the isolation are tough. In 1967, while researching *Alaska,* a Geographic book, staff photographer George Mobley and freelance writer Bern Keating got stranded for ten days in a small Eskimo village on Little Diomede Island, a lonely outpost in the middle of the Bering Strait, only a few miles from the Siberian island of Big Diomede. There was little to do, and the biggest problem was how to keep occupied.

"I photographed everything in the village, over and over, mostly the blowing snow," said Mobley. "The diet there consisted mostly of seal, which had been stored underground for a long time, and it was in the condition of an aged cheese. That's all there was. That and seaweed. Well, after several days a couple of walruses came swimming by, and it sounded like World War II had broken out in the village. They hooked one with a grappling hook thrown from

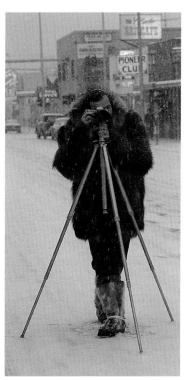

PHOTOGRAPHER GEORGE F. MOBLEY
on assignment *ALASKA* 1969

PHOTOGRAPH BY WINFIELD I. PARKS, JR.

shore, and we had fresh walrus, which really tasted great after the seal. Normally you wouldn't rate walrus quite so highly."

Fourteen years later, when I flew into Little Diomede to write part of "Hunters of the Lost Spirit," February 1983, I battled through those frigid winds into the shelter of a community center. An old Eskimo man sat there, wrinkled in the window light, carving a miniature kayak from walrus ivory. I introduced myself, told him I was from the GEOGRAPHIC, and he looked up at me with serious eyes. "Tell George Mobley," he said, "that he's a lousy Scrabble player."

Mobley, a warm and reflective man, built much of his GEOGRAPHIC career around assignments in the far north. "There's something primeval about the Arctic that attracts me," he said. "When the Alaska sun is really low, it skims in over the land with an incredible beauty, a magic light off the snow and the tundra. I love the vast, vast, vast areas that are empty, where there is nobody, areas where the low sun outlines every bit of geography, every texture, where the days linger throughout the night. Sometimes the light is so beautiful that I become nocturnal—stay up all night and sleep during the day. The people are up, too, in those little Arctic communities. Kids go out and play, and the sun is shining in the middle of the night."

BUT THERE IS ANOTHER kind of place, a place we carry with us always, locked in memory—the place of our childhood. Photographer Bill Allard got the chance to revisit his childhood place for "Minnesota Memoir: A Lifetime of Lakes," September 1992. It was to be such a personal work that Allard knew he had to write it himself. "I couldn't expect another writer to have the same feelings," he told me. "It was my youth." And he wrote with a sense of affection and loss:

"When I was a boy, the lake was my own special world for one week each year. Not nearly as far away from my home in Minneapolis as I envisioned, it was far enough away from the confines of the city to make me crave to be there, where the pines were tall and the forest deep. I wanted to run to the dock in early morning, when sunlight glistened off the dew-covered boards as if they were inlaid with diamonds. I wanted to see what creatures had passed along the water's edge while I had slept, leaving their footprints as calling cards for my imagination."

The emotional attachment to this place had been a constant in Allard's life. Ten years earlier, he had returned to Gladstone Lake, and with his mother, sister, and younger brother had gone out in a boat to scatter the ashes of his older brother "in that calm cove where he used to catch sunnies in five feet of water." Allard's father, who had immigrated to Minnesota from Sweden at the age of six, stayed on shore, his days on the lake over.

"Minnesota Memoir" hit a chord with readers. "I got a tremendous response," said Allard. "The story turned out to be a lot more personal than I had thought it was going to be."

TALKING WITH MY COLLEAGUES about their fieldwork, I was struck by how often they spoke of their childhood places and how these had shaped their lives and careers.

Writer Noel Grove, an Iowan, told me: "I grew up in the country and just liked it. Even as a kid, there would be work to do, but I'd be down by the creek. I was a trapper then. I'd look forward to trapping season like other kids looked forward to Christmas. I was reading signs every summer, thinking, Where are the muskrats? The mink?" In time Grove gave up trapping but not his love of the land and its animals. He became the first environmental editor for the magazine.

Photographer Jim Brandenburg remembered: "Growing up in southern Minnesota, in the farm country, where it's all cornfields, virtually no trees, almost no native prairie grasses left—I think was an advantage rather than a disadvantage. There was no great, grand landscape to poke a lens at, and we always felt that if we could make a picture in that part of the world, we could make a picture anywhere."

And photographer Jim Richardson put it this way: "Perhaps it is true we can never go home again, but we can never entirely leave it behind either. Everybody comes from someplace, and Kansas is my place—neither sophisticated nor spectacular—not even a land of beauty, really, unless you were born to it. But it often strikes me what a wonderful privilege it is to be a photographer, to stand midstream in life and feel it swirl around you, as real as the prairie wind." ■

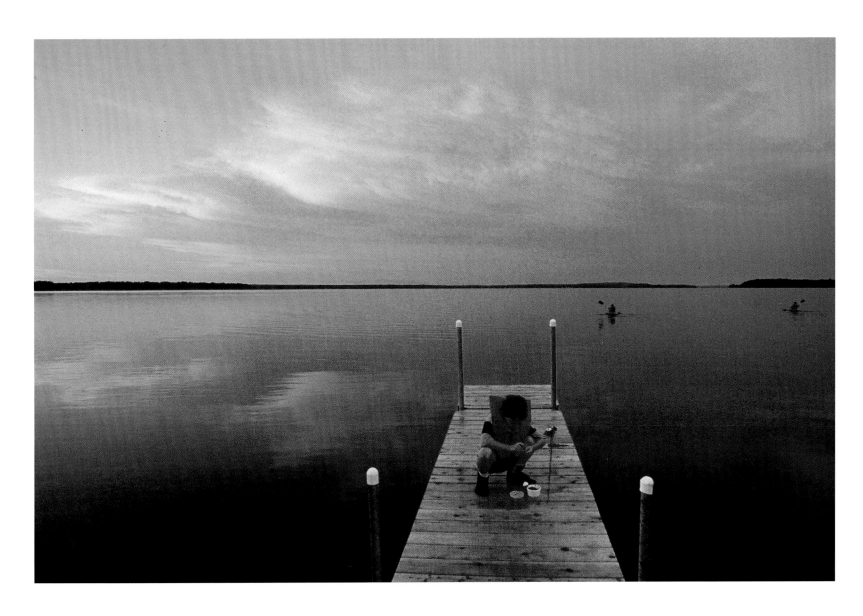

"MINNESOTA MEMOIR: A LIFETIME OF LAKES"

September 1992

photographs and text by
WILLIAM ALBERT ALLARD

DAY LINGERS over Upper Whitefish Lake, where generations
of Minnesotans have gathered for summer vacations.

NORTHERN CALIFORNIA
"CALIFORNIA'S NORTH FACE"

July 1993

photographs by
JOEL SARTORE

text by
DAVID YEADON

RANCH HANDS David Flournoy and
Rick Littler pack hay in Modoc County.

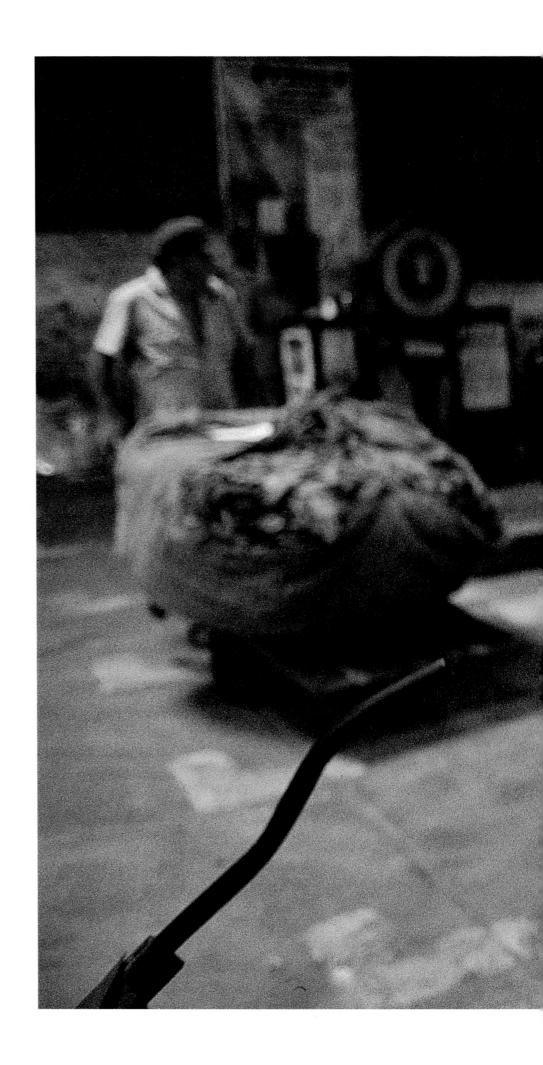

"NORTH CAROLINA'S PIEDMONT: ON A FAST BREAK"

March 1995

photographs by
PETE SOUZA

text by
CATHY NEWMAN

JAMES "GRANDDAD" DEARMIN
lights up a cigarette during a break from
unloading farm trucks at Pepper's Tobacco
Warehouse in Winston-Salem.

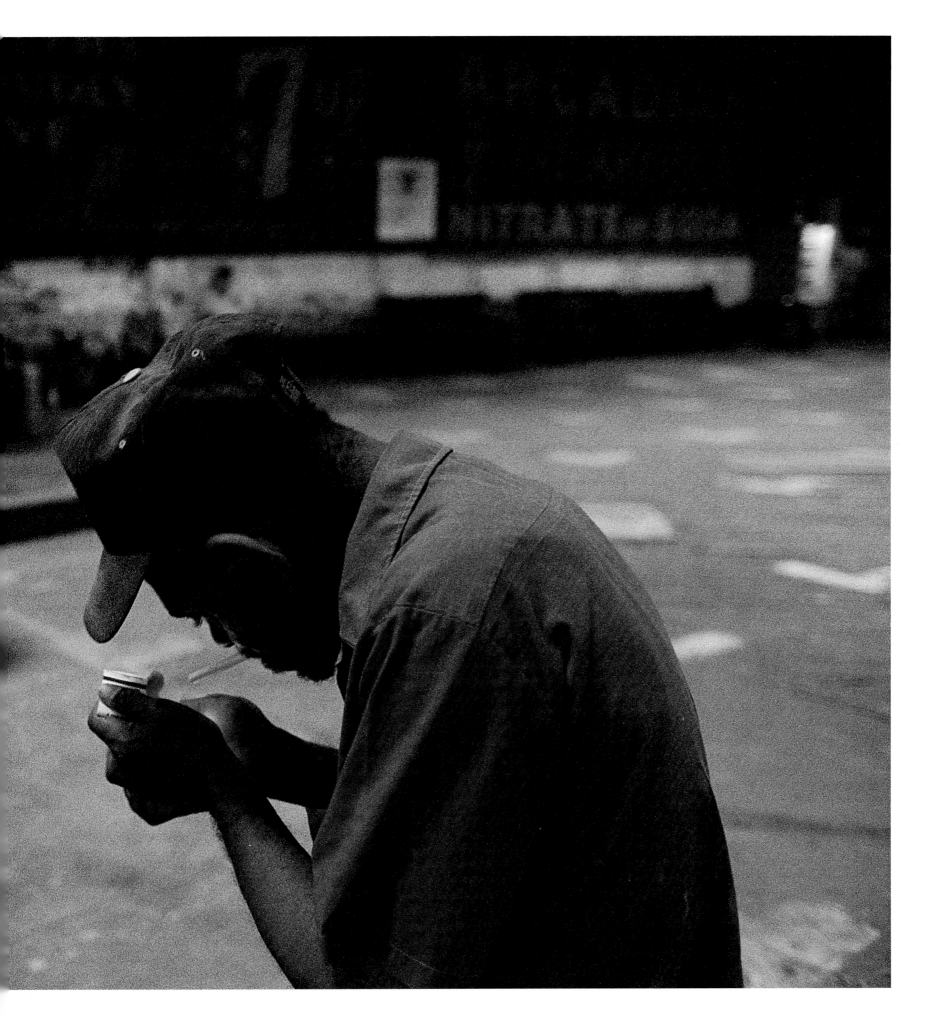

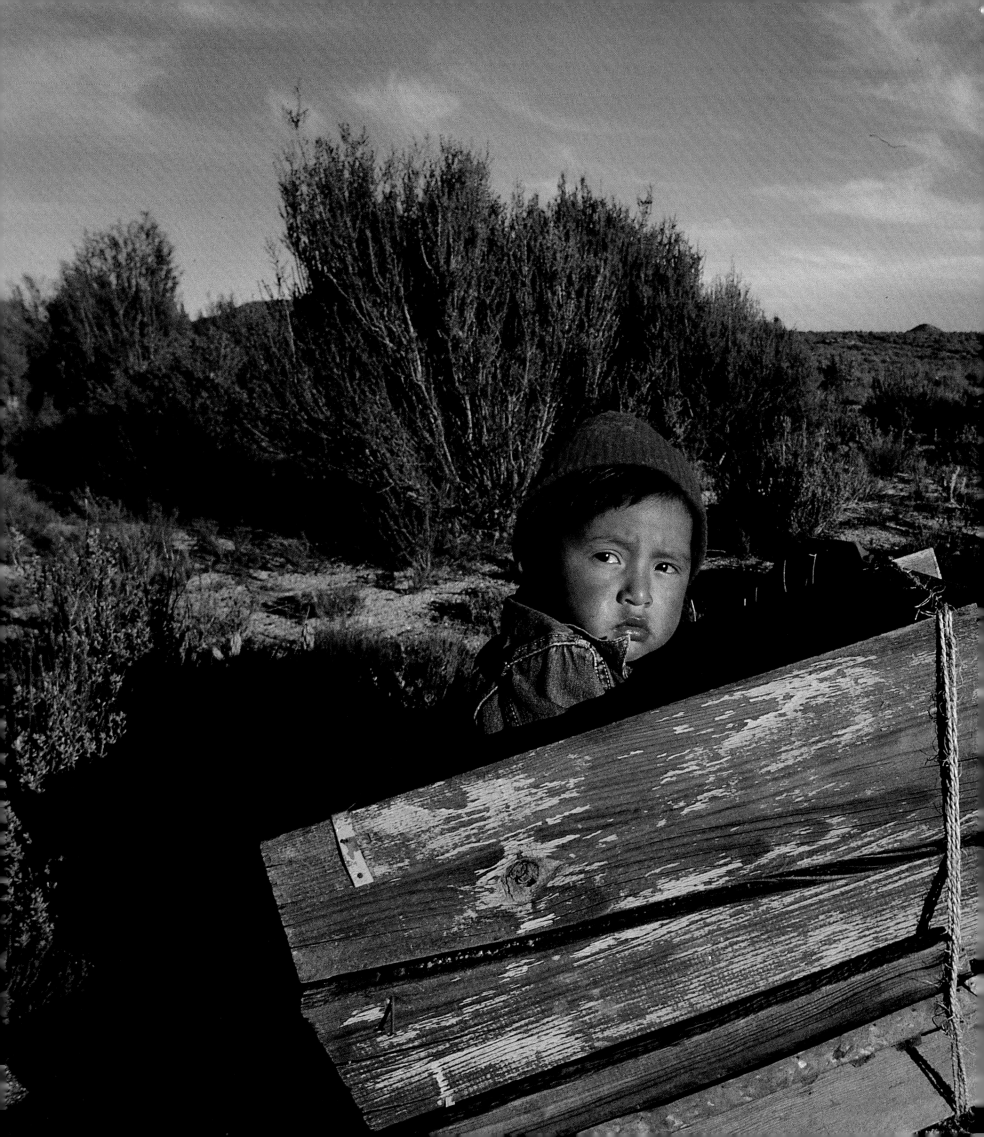

"BAJA CALIFORNIA: MEXICO'S LAND APART"

December 1989

photographs by
ANNIE GRIFFITHS BELT

text by
DON BELT

PAIPAI INDIAN Teresa Castro and her grandson, Miguel, scour the desert for firewood near Santa Catarina.

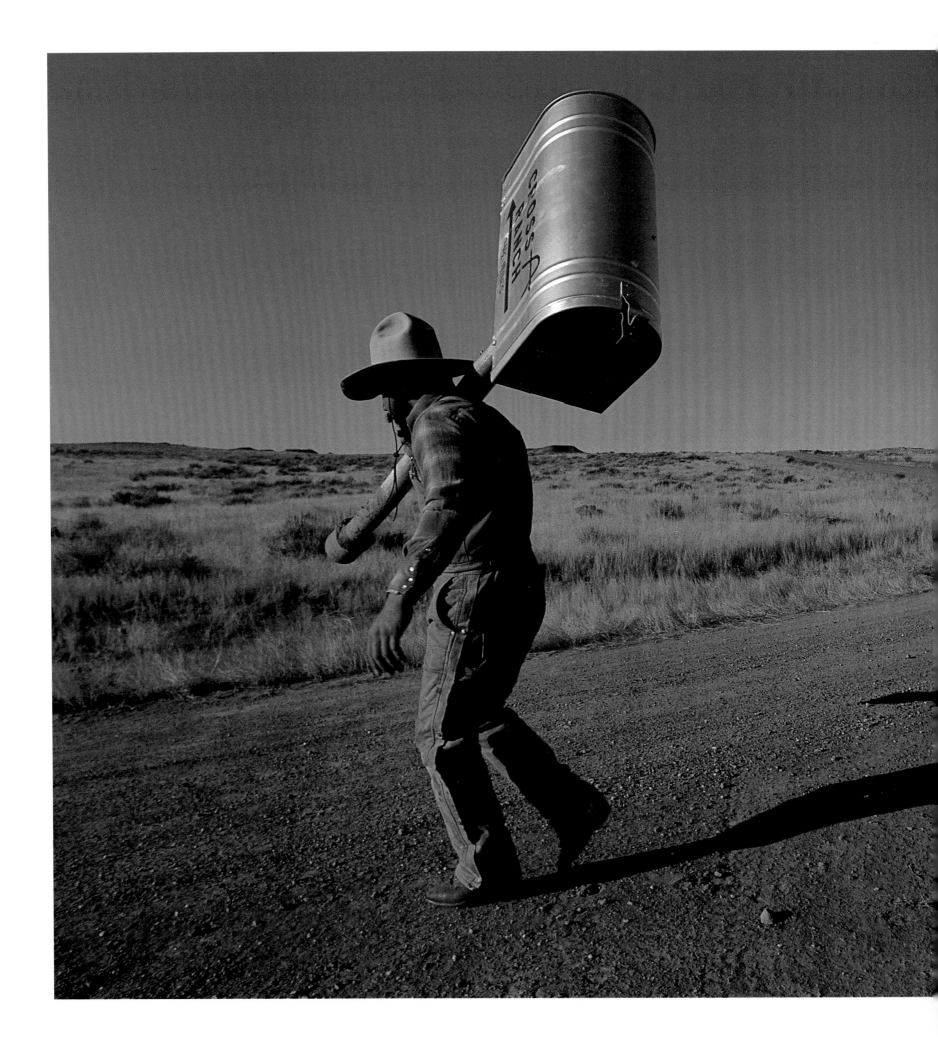

"WIDE OPEN WYOMING"

January 1993

photographs by
RICHARD OLSENIUS

text by
THOMAS J. ABERCROMBIE

AT THE RON BROWN ranch in Lusk, a cowboy moves a mailbox across the road in order to comply with a new postal regulation, a rare intrusion in the spirit of freedom that ranges across the nation's least populated state.

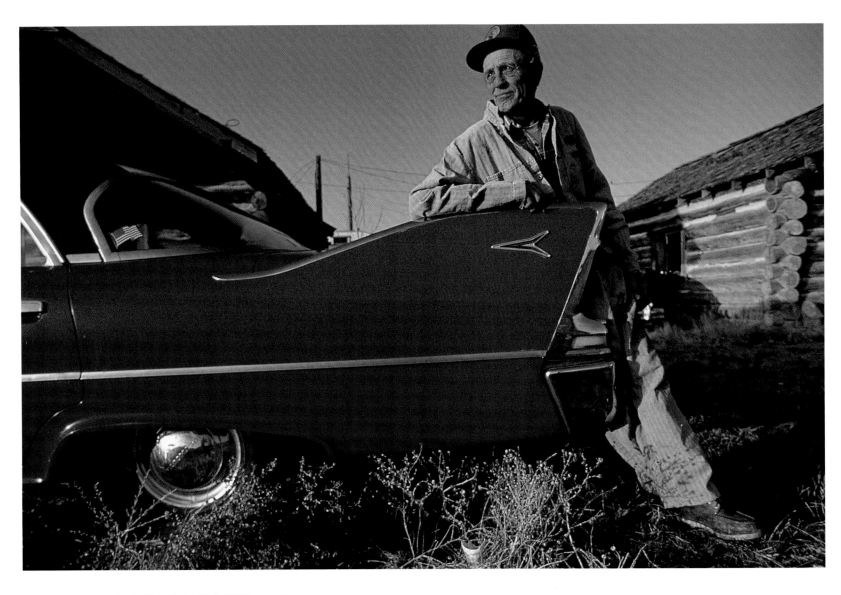

FLOYD WIDMER RESTS on a vintage
car, one of many he keeps parked behind the
restaurant he runs with wife Shirley
in Waltman, Wyoming.

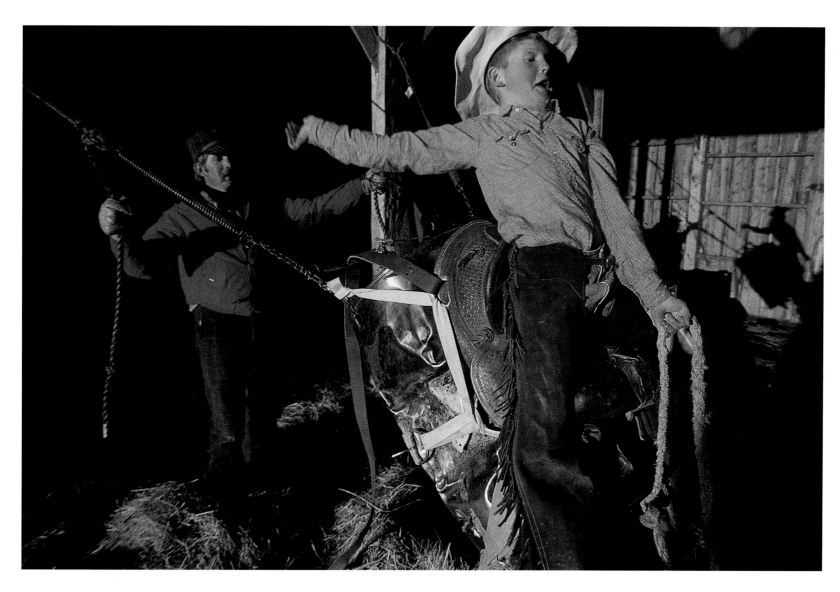

HOPING FOR A CAREER as a bull rider,
11-year-old Wes Miller practices riding
a barrel, jerked by his dad, on the family
ranch in Big Piney.

"AMERICA'S THIRD COAST"

July 1992

photographs by
JOEL SARTORE

text by
DOUGLAS BENNETT LEE

THEATRICAL MERMAIDS entertain
visitors at Weeki Wachee Spring, north of
Tampa, on Florida's Gulf Coast.

LIVING ON THE EARTH

1 9 8 8

PHOTOGRAPH BY CHRIS JOHNS

AFTER RUGGED DAYS of fishing, crewmen from the *Angelia*
belly up to the bar in Pelican, Alaska, a town of 200 residents and a
frequent stopping point for fishermen (opposite). Later, bold talk
turns to horseplay.

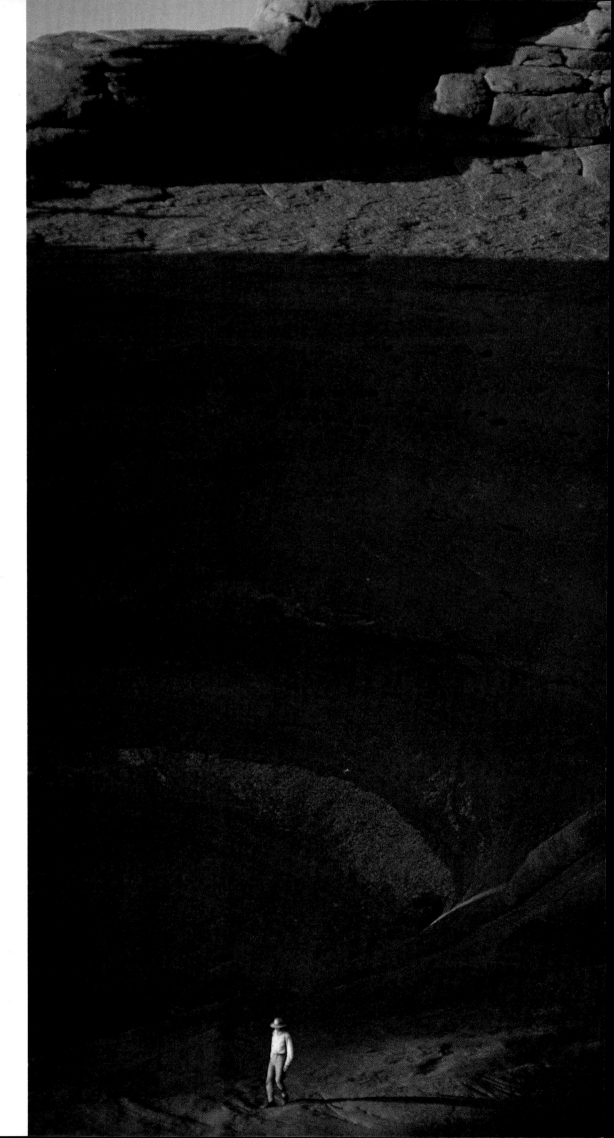

"UTAH: LAND OF PROMISE, KINGDOM OF STONE"

January 1996

photographs by
JOEL SARTORE

text by
DONOVAN WEBSTER

DELICATE ARCH, one of 2,000
found in Arches National Park,
forms a natural sculpture.

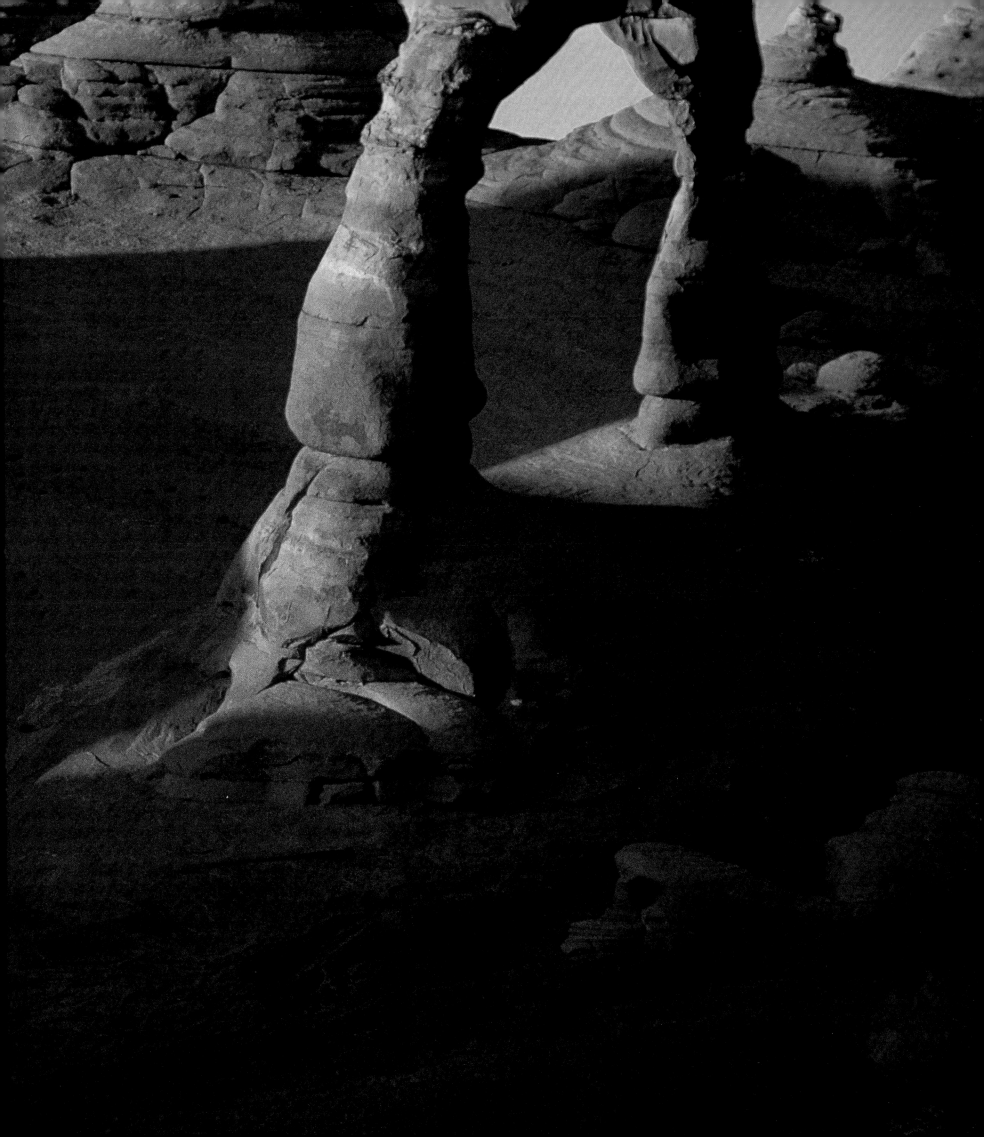

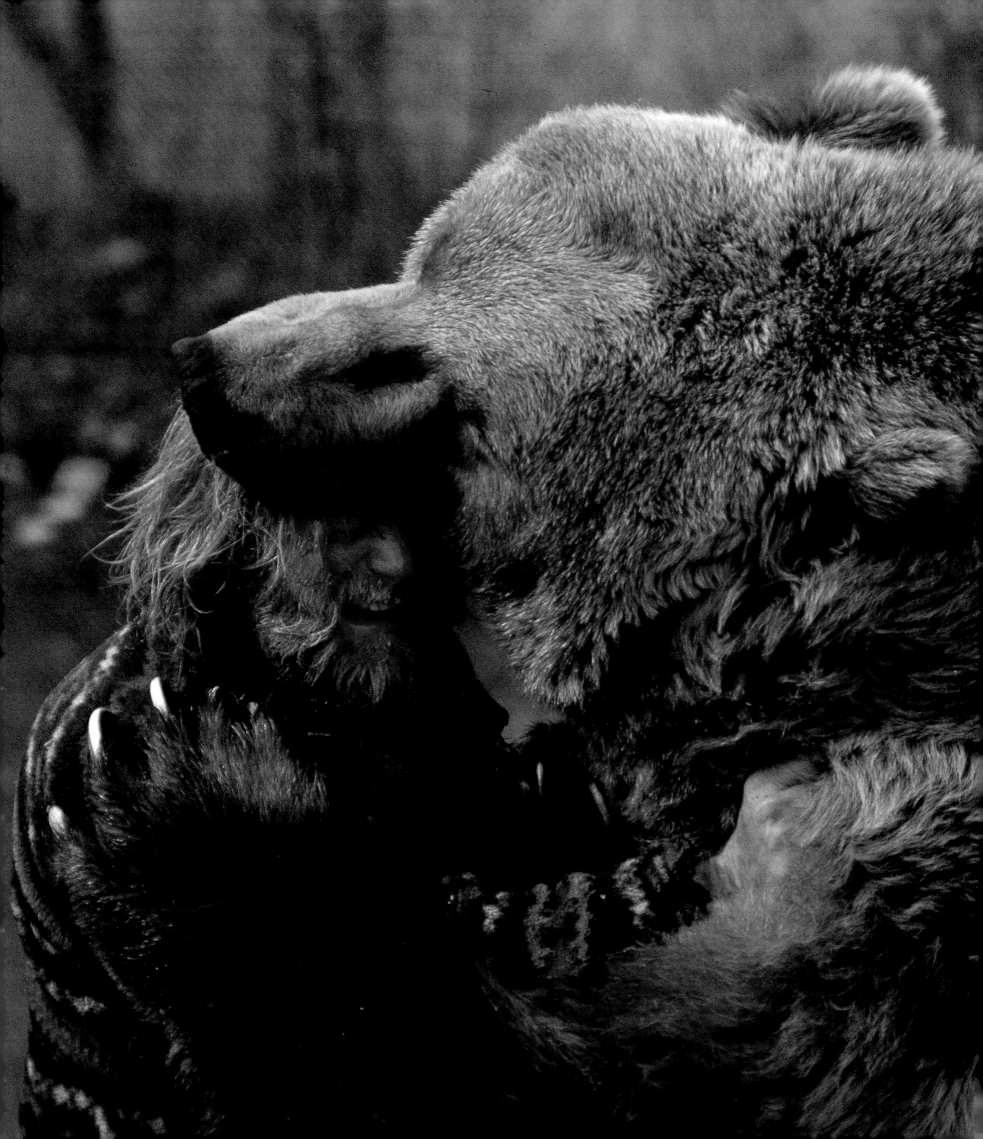

IN HEBER CITY, Utah, animal trainer
Doug Seus is bathed in affection by Bart, a
1,500-pound Kodiak brown bear—and star
of several films.

CHAPTER SIX PROGRESS

"...the membership of our Society... desire to promote ...and to diffuse the knowledge so gained, among men..."

—GARDINER GREENE HUBBARD, 1888

"THE SENSE OF SIGHT"

November 1992

photographs by
JOSEPH MCNALLY

text by
MICHAEL E. LONG

" Sight enlivens our language. We celebrate poets for their 'insight.' The politician we acclaim today for 'foresight' may tomorrow, in 'hindsight,' be abhorred...And blind people, who have lost this precious gift, become the most poignant reminders of our fear. "

—MICHAEL E. LONG

A SPECTACLE-MOUNTED
microscope helps to magnify a document
for a visually impaired reader.

preceding page:
SURGICAL LASERS CUT through
eye tissue to restore sight.

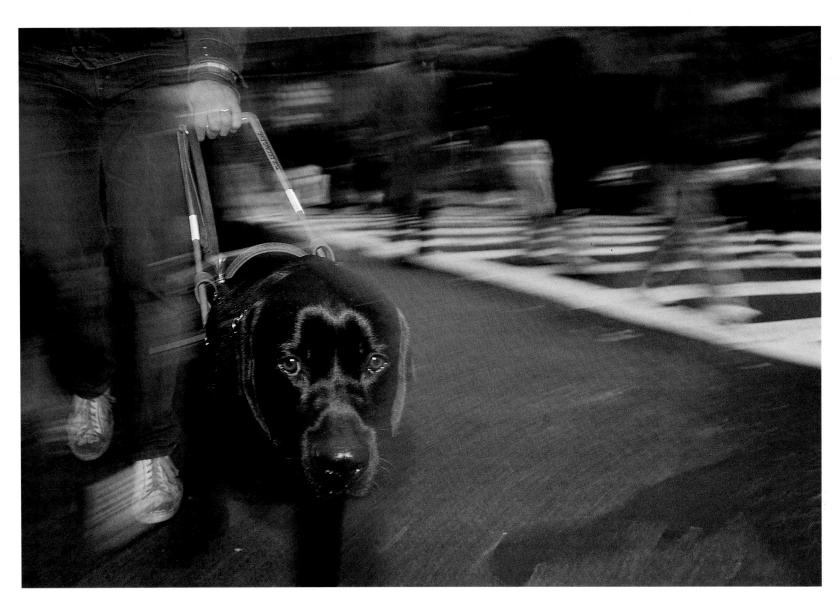

SHERMAN, a Seeing Eye dog, guides his
partner, Jeff Wiegers, through the streets
of Manhattan.

DOCTORS AT JOHNS HOPKINS
Hospital in Baltimore perform microsurgery
inside the eye, where a millimeter can mean
the difference between sight and blindness.

THREE-YEAR-OLD Courtney Glonka, blind since birth, runs as part of her mobility training in her school's low-vision program.

THE IDEA OF BLINDNESS both horrified and fascinated Michael E. Long. As a former Marine Corps jet pilot and aerobatics instructor, and as a onetime illustrations editor as well as staff writer for the GEOGRAPHIC, both his life and his job had at times depended on his eyesight. So it was with a special interest that Long tackled an assignment about "The Sense of Sight," November 1992, with photographs by freelancer Joe McNally.

As always, Long plunged fully into the story. For part of his research, he walked for half an hour in Manhattan blindfolded, accompanied by a Seeing Eye dog. "I wanted to experience blindness," he said, "but I was a little concerned, even scared. There we were, starting out from Madison Square Garden and going up Broadway. This dog, Jade, was newly trained, but boy! That dog knew exactly what to do. I remember once she jerked me to a halt, and I heard this car moving in front of me. The trainer never intervened.

"Very shortly I became very sensitive to traffic and conversations. And smells—a bakery, a restaurant. Things you might notice normally, but only on the periphery of your consciousness, became very central. I still remember the smells, and I still remember a couple shouting at each other in Spanish. When your brain is deprived of vision, other things pop right in. And when we finally got to the end of the trip, I just let Jade give me a good face lick."

A deliberate craftsman, Long has written many technical articles for the magazine, among the subjects: high technology, flight safety, animal navigation, sleep. I have seen him buried in medical journals, reading glasses perched on his nose. His skill is to turn the arcane into the comprehensible, the requisite skill for GEOGRAPHIC science writers.

"What it amounts to is learning how to speak the scientific language," Long told me, "and being able to talk with the scientists without interrupting every other minute by saying, 'What do you mean by that?' I got pretty good at understanding what they were talking about. Then the problem was to translate it."

Long's story chronicled the remarkable progress scientists and surgeons are making in understanding our sense of sight and in correcting eye problems, but he was also reminded—very personally—of the distance still to be traveled.

Beginning his fieldwork, Long made a spot decision at the Wilmer Eye Institute in Baltimore. "I had spent the morning with glaucoma specialist Dr. Harry Quigley," he told me. "His patients had serious troubles.

And I said to myself, You know, I haven't had an eye exam for a time, and I asked him to do it. And he looked at my eyes and said, 'I'm sending you upstairs to see Susan Bressler.' She was a retina specialist, and she examined my eyes and immediately said, 'You have a disease called age-related macular degeneration.'"

Age-related macular degeneration is the leading cause of blindness in people older than 50 in the Western world, a disease that in its "dry" form causes the gradual loss of central vision and for which there is no cure.

"I was ready to fall through the floor," said Long. "What she saw were these drusen, spots beneath the retina; when they get into the central part of the retina, that's where they do their dirty work."

Long is now involved in an experimental high-vitamin study designed to retard the growth of drusen, but some degeneration has occurred: "Right now they're making straight lines a little crooked for me. When I look at a brick wall, it looks perfectly straight, but with these drusen, things start to get wavy. It's spooky…But this is a very slow, progressive thing."

JOE MCNALLY'S TASK was to photograph a complex and abstract subject. "I spent about a year on the story," McNally told me, "and what fascinated me was that I thought there was going to be a fine line, working with people not sighted, that I wouldn't want to cross. A sighted person instantly recognizes what I'm doing, and I was determined not to take advantage of people who were not sighted. But these people were acutely aware of the click of the camera, of motion and smell. I was prepared to be able to float around without being noticed, but in fact I was working with people who were more aware of me than sighted people.

"The bent of the GEOGRAPHIC is to humanize things and to make things real for the average person. This person is not going to care about the precise scientific cause so much as he will care about the effect of the subject on 'me.' How might this affect *me?*

"I don't have a scientific background, and I've always felt that when I approach a story like this, my lack of knowledge is a strength that identifies me with 90 percent of the readers. For a professional ophthalmological photographer, for example, a picture like the incredibly detailed close-up of an eye is ordinary, a simple diagnostic tool. He may see no poetry in it at all. But when I looked at that picture, I said, 'Wow!' I had never seen anything like that before."

IN THE EARLY YEARS of the magazine, "progress" was a powerful, popular idea: It meant the inexorable advance of science, industry, and commerce, with gains in the standard of living. There was reason for optimism. George Eastman was perfecting his box camera and black-and-white roll film. Thomas Edison was working on some of the more than 1,000 inventions or improved devices he would patent in the U.S., including the phonograph, the incandescent lamp, the alkaline storage battery, and the kinetoscope.

Manned flight, then in its infancy, caught the imagination of Alexander Graham Bell, second president of the National Geographic Society and inventor of the telephone. In 1907, the year after the Wright brothers patented the control system of their flying machine, Bell was experimenting with huge tetrahedral (four-faced) kites at his summer home in Nova Scotia. The January 1908 article, "Dr. Bell's Man-Lifting Kite," written by Gilbert H. Grosvenor, his son-in-law and the magazine's Editor, included photographs showing the kite dragged by a steamboat until it lifted high in the air above the bay, with Army Lt. Thomas Selfridge tucked into its "manhole" compartment.

Bell's fascination with flight laid the foundation for NATIONAL GEOGRAPHIC's nearly one hundred years of documentation of aviation and space, including ballooning, stratospheric research, jet aircraft, rockets, the breaking of the sound barrier, and penetrations into space by the various devices of the National Aeronautics and Space Administration (NASA).

The greatest of these adventures in progress, for both the nation and NATIONAL GEOGRAPHIC, was the epic American quest to put men on the moon. The magazine tracked this story as closely as NASA's radar tracks a just launched rocket.

In "Reaching for the Moon," February 1959, assistant editor Allan C. Fisher, Jr., having witnessed the launching of three Pioneer rockets, speculated on the grand enterprise of leaving the bounds of earth. In

October 1959 he tackled "Cape Canaveral's 6,000-mile Shooting Gallery," with photographs by Luis Marden and Thomas Nebbia, both staff.

Fisher, who served as the magazine's first aviation editor, described how the three men toured the down-range island empire "from its beginning to end, the only outsiders who have been privileged to do so…We spent three months at the task and logged a combined total of more than 40,000 wearying miles."

One of Marden's many photographs showed the Army's Jupiter rocket, Pioneer IV, as it powered off on a voyage past the moon and into permanent orbit around the sun. Wrote Fisher:

"…during star-filled nights in the islands, Luis would shake his fist at those distant beacons, Mars and Venus, and exclaim jubilantly, 'We'll get you both, you rascals!'"

TO ASSIST NASA and to position NATIONAL GEOGRAPHIC for the best coverage of the space effort, Editor Melville Bell Grosvenor in 1960 loaned photographer Dean Conger to the agency for three years. Conger, a tall, easy-going man with a Wyoming lilt to his voice, arrived at the peak of Project Mercury, the nation's first manned flights.

Conger remembered the crush of media at NASA, handled then by Lt. Col. John A. "Shorty" Powers, USAF. "Shorty had a tough job," Conger said, "because he had the world's press beating on him—everybody wanting exclusive access to this or that—and some of them thought that NATIONAL GEOGRAPHIC had this inside track, which we didn't. The magazine usually did come out well because they could take a longer, slower look at the photos—often finding shots that others overlooked in their haste to meet a deadline."

Conger, a former *Denver Post* photographer, knew how to operate in a crowd. "Part of it is getting so everybody knows you, so that when the day of the launch comes, they don't push you aside," he said. "By the time of the Gordon Cooper flight [1963], NASA had grown so much—personal contact was lost.

"We'd do pictures in the suit-up room, and it was tough for the motion picture guy because there wasn't enough light in there. I could use a flash if I had to, although the astronauts didn't like the flashes. They were getting pretty anti-picture because at every turn, someone was going, 'click, click, click, click.'

"Well, we got some lights installed up along the edges of the room, and the astronauts didn't like that either. One day they came in with sunglasses on. Another day we flicked on the light switch, and nothing happened. No lights. Somebody had taken electrical tape and covered over the end of every bulb. We figured Shepard [Astronaut Alan B. Shepard, Jr.] did it because he was the backup for Cooper, and he liked to do those kind of jokes. So we put one of those whistling, firecracker-like devices that goes 'Whooom!' and blows up when you start the car, on Shepard's Corvette."

Conger's photographs of Shepard's preparation and takeoff, America's first manned venture into space, appeared in September 1961, "The Flight of *Freedom 7*," with vivid and intimate text by Carmault B. Jackson, Jr., M.D., physician for the astronauts. Conger's photos of the recovery illustrated the accompanying article, "The Pilot's Story: Astronaut Shepard's Firsthand Account of His Flight."

The countdown had begun. In March 1964 Hugh L. Dryden, Ph.D., Deputy Administrator of NASA and one of the Society's trustees, wrote in "Footprints on the Moon":

"Before the end of this decade man will launch his greatest voyage of discovery, a journey whose magnitude and implications for the human race dwarf any high adventure of the past. For the first time he will leave his home planet and set foot upon another world, the luminous satellite of earth we call the moon."

The quest culminated in the magazine in December 1969, slightly more than four months after *Apollo 11* touched

PHOTOGRAPHER DEAN CONGER with Astronaut Alan B. Shepard, Jr., for "THE FLIGHT OF *FREEDOM 7*" SEPTEMBER 1961

PHOTOGRAPH BY WILLIAM TAUB, NASA

down on the moon. The GEOGRAPHIC's five-part package, "First Explorers on the Moon," included historic words and photographs by Neil A. Armstrong, Edwin E. Aldrin, Jr., and Michael Collins; a small phonograph record, *Sounds of the Space Age;* additional material by assistant editor Kenneth F. Weaver; and a look into the future by Dr. Thomas O. Paine, Administrator, NASA. As Weaver wrote:

"No one who sat that July night welded to his TV screen will ever forget the sight of that ghostly foot groping slowly past the ladder to Eagle's *footpad, and then stepping tentatively onto the virgin soil. Man had made his first footprint on the moon.*

"Neil Armstrong spoke into his microphone. And in less than two seconds the message that will live in the annals of exploration flew with the wings of radio to the huge telescope dish at Honeysuckle Creek, near Canberra, Australia, thence to the Comsat satellite over the Pacific, then to the switching center at the Goddard Space Flight Center outside Washington, D.C., and finally to Houston and the rest of the world:

"'That's one small step for a man, one giant leap for mankind.'"

THE MAGAZINE HAS CONTINUED to keep readers abreast of the latest from space: shuttle flights, a proposal for a giant colony, extraordinary photographs of the planets and the stars. But other subjects now crowd the stage of progress. More recently the magazine has followed scientists on another startling voyage into space—not outer space but inner space, into the body, deeper and deeper, into the cell, the gene, the essence of life. Science editor Rick Gore told me that it was while working on a groundbreaking three-part series for September 1976, "The New Biology," that he first glimpsed "the complexity about to leap on humanity as we began to tinker with the secrets within the cells."

After a marathon of interviews with scientists, from New York City to California and Hawaii, and peering into their electron microscopes, Gore, in Part I, "The Awesome Worlds Within a Cell," put the new knowledge into words that captured both its complexity and its romance:

"The cell has turned out to be a micro-universe, science now tells us, abounding with discrete pieces of life, each performing with exquisite precision, and often in thousandths of a second, a biochemical dance its ancestors began to perfect countless generations ago in the primordial ocean."

With this kind of material, said Gore, it is not enough only to explain the scientific processes. "We have to make our readers feel the pulse of science and technology, to give them a hands-on experience."

THAT WOULD DESCRIBE the work of Karen Kasmauski, a freelance photographer and young mother of two, who recently tackled two stories that left her acutely aware of her own vulnerability.

"Living With Radiation," April 1989, with text by Charles E. Cobb, Jr., then a staff writer, presented hazards for both journalists. The coverage reached from Hiroshima, Japan, to radioactive sand dunes in New Mexico, to sites of accidents at nuclear power plants at Three Mile Island, Pennsylvania, and Chernobyl, Ukraine.

Kasmauski faced a potential crisis in Goiânia, Brazil. There, about three months earlier, she told me, "a junk dealer had broken open an old medical machine that had been used for treating cancer patients with radiation. He had taken out a nickel-size piece of cesium, and his wife had taken the cesium in a jar to a health clinic. She exposed all the workers and patients there, including pregnant women, to radiation. The government came in and tore down five square blocks to remove contaminated material. But there was still a lot of dust flying. I had mud flowing on top of me, and this was all radioactive material."

The illustrations editor working with Kasmauski on the radiation story was her husband, William T. Douthitt, now a senior assistant editor. "On her last day there," said Douthitt, "Karen was given faulty information by one of the cleanup crew, and she went into an area where some of the more contaminated material was stored. She spent about an hour photographing there. She was putting her camera bag down, picking it up, then carrying it next to her. The bag may have been contaminated. I was petrified. What have I sent my wife into?"

Douthitt hastily called the National Institutes of Health in Bethesda, Maryland, and arranged for his wife to be given a whole body radiation count when she arrived back in Washington, D.C. "I met Karen at the airport," he remembered, "and drove her directly to NIH. They placed her in a chamber behind thick steel walls,

and she was examined. It was determined that neither she nor her equipment had been contaminated.

"For the rest of the assignment," Douthitt said, "Karen carried a radiation meter with her. She was contaminated three times doing the story—twice in nuclear waste facilities that had radiation leaks. None of the incidents was serious."

Writer Charles Cobb also visited NIH for testing after visits to some questionable sites. "But nothing turned up," he told me. "I walked into the closet, and I didn't glow."

Cobb was impressed by the strong reaction to the subject. "When I asked people about radiation, I was immediately confronted by notions of right and wrong," he said. "These broke down to: Radiation is awful, or, it's the greatest thing since electricity. And they expected you to take sides, to advocate. If you were in a place like southern Utah, where scores of people suffer from leukemia or other cancers, and they all say it has to do with the atomic bombs that were being tested just down the road in Nevada in the 1950s and later, they wanted you to take a stand on their behalf.

"On the other side were scientists in the field who are under assault from antinuclear activists. These scientists wanted to tell you how unfair and unscientific these assaults were and how it was your responsibility to make *their* case—to make people see how unfair they've been. You were constantly buffeted in that way.

"The energy released by the atom is so awesome that the emotion created is deeper than any fear I have encountered. You can sense it in old movies about monsters being created from nuclear blasts or in the thoughts of the physicist Robert Oppenheimer after the first atomic bomb was exploded: 'I am become Death, the shatterer of worlds.' It's a deeper kind of fear, an irrational fear, a fear that with nuclear power we are now acting on the level of God and the gods."

ONE OF KAREN KASMAUSKI'S most recent human health assignments was "Viruses: On the Edge of Life, On the Edge of Death," July 1994, with text by freelance writer Peter Jaret. Among the viruses covered: AIDS. Jaret had dealt with that subject in an earlier story, "Our Immune System: The Wars Within," June 1986, with illustrations by microphotographer Lennart Nilsson.

PHOTOGRAPHER KAREN KASMAUSKI on assignment
"LIVING WITH RADIATION" APRIL 1989
PHOTOGRAPH BY KAREN KASMAUSKI

The virus story unsettled Kasmauski from the beginning, but compassion for the victims of viral diseases shines through her work.

"When I was handed the assignment, I was six months pregnant with my daughter," she told me. "My obstetrician was concerned. She questioned assigning a story on viruses to a pregnant woman." Kasmauski wasn't worried about AIDS, because that virus could not be contracted through normal contact with patients. "But I could get CMV [cytomegalovirus], a virus common in AIDS patients, which would give me mild flu-like symptoms, if even that, but could be potentially fatal to my unborn child."

At the U.S. Centers for Disease Control and Prevention in Atlanta, one scientist implored Kasmauski to scrub down strenuously before returning home from trips for the virus assignment. She followed the advice. "I was traveling with needle-exchange workers in New Haven, Connecticut," she told me, "and there was barely room in the van for the drug addicts to squeeze past my pregnant belly to collect their needles. I climbed on the back of trucks to photograph rabid raccoons. But I never took a risk that I felt would endanger the child. I refused, for example, to photograph patients with tuberculosis.

"One subject with AIDS that I was photographing told me, with amusement, 'You're not the first pregnant woman to interview us.' And then she added, 'Maybe you and other pregnant women are a life force.'"

There was something to that idea, Kasmauski conceded. Often when she visited families with seriously ill people, "the patient got so excited that he would be up from his bed. We'd find a vital person. The visit

energized him for a day. I think we sometimes don't realize the impact we have in the field. You may be the only person who comes in from the outside and takes an interest in that person's life. Sometimes it becomes the one event where he says, 'My life was worth looking at; my life was worth recording.'"

THE JUNE 1995 COVER STORY, "Quiet Miracles of the Brain," by Joel L. Swerdlow, with photographs by Joe McNally, examined something infinitely more complex than any machine ever invented—the brain, that which makes us human. Part of Swerdlow's research was to find people whose brains had suffered traumas. In that search he made friends with some special individuals, and he learned not only about the power of science but also the power of love. One new friend was Matthew Simpson, who began to have seizures just before his fourth birthday. He was later diagnosed with Rasmussen's encephalitis. When he was six, doctors, in an effort to control the life-threatening seizures, performed a hemispherectomy—removing nearly half of his brain.

"I looked at a CT scan," Swerdlow told me, "and I saw that half of Matt's brain area was filled with cerebrospinal fluid only. But when I met him, in Albuquerque, he was shooting basketball with the girl who lived next door. He walked with a slight limp, and when he smiled, you could see his smile wasn't quite straight. But otherwise he was normal. I couldn't really understand why." As Swerdlow wrote:

"The left side of the brain of a right-handed person—precisely what was cut out of Matt—specializes in handling music, poetry, and mathematics. Yet Matt enjoys piano lessons, and math is his strongest subject in school. Somehow, knowledge and capability traveled from one side of his brain to the other."

Swerdlow puzzled over the question. "When you're out there in the field," he said, "often things don't fall into place until you stop looking for them. Sometimes you're just there, just living. One morning I was driving with Matt and his mother on some errands; I had long since finished my research; I had no agenda. And his mother looked up to the sky and said, 'What do you see, Matt?' And they had this wonderful, wonderful conversation about the shapes that they saw in the clouds. They made up stories.

"Afterward she explained to me that this was more than being a good mother. She made a conscious effort to do things that stimulated his brain, and it was then that I really understood that his progress was not only from the love that they were giving him, but that they were combining that love with the best understanding of the biology that was going on in his brain.

"You see, when learning occurs, the brain sends out threadlike extensions called dendrites, from the billions of neurons, the specialized cells of the nervous system. This develops the brain.

"So this conversation was really therapy—it was making Matt grow dendrites on his neurons. I hadn't known that his mother was consciously doing that, and then I realized that the amazing person that Matt was…didn't just happen."

Another friend Swerdlow made through the assignment was Patsy Cannon, a woman who had injured her head in a car accident and suffered severe amnesia. "She had no known physical damage to her body," said Swerdlow, "but her memory was gone—everything. What planet are we on? What is this thing with five little things sticking in front of me? A hand? What's language? She had no language. And she had no memory of her daughter, Leah.

"We have become very good friends, and I know that Patsy reinvented herself as a person who is an advocate for people with brain injuries. She's brilliant—doing writing and public speaking, and working with nonprofit organizations and insurance companies on behalf of people with brain injuries.

"But when I first met her, when she came to Washington, I didn't know what to expect. And she seemed—again—normal. And articulate. I asked her, 'Will you remember this conversation?' She said, 'Sure, that's no problem. I've mastered that.' She told me she just had to triage, figure out what was important for her to remember and what was not important.

"But the question I always have for Patsy is, 'Is the old Patsy still inside?' She says she doesn't know and doesn't care, because she's who she is. I have asked her, 'Does the old Patsy come out in your dreams?' And she said, 'No.'

"It brings up the question, what makes us *us?* No one knows. I'm not really a very good technical science writer, but I think I show the people who are doing the science as real human beings. And I show the

people who are affected by injury or disease and how their lives are changed. To have your memory destroyed like Patsy's memory was is very unusual. And when I spend time with Patsy and her daughter, Leah, and talk to them about love, I think of how Leah remembered her mother before the accident and had to adjust to the new Patsy, who didn't recognize her own daughter. And I think, What does this mean for me and my children? What binds you to your family if not memories?

"I came back from my time with Patsy with an increased sense of how vulnerable we all are. And when I went in my children's rooms and I looked at them sleeping, I realized how specially hard it must have been for Patsy to answer my questions. I haven't suffered a memory loss, but if someone asked me to express how and why I love my children, it would be beyond language."

BILL DOUTHITT has specialized in scoping out complex scientific subjects for the magazine. "Science subjects are increasingly subtle," he told me. "We're looking at finer and finer resolution—in the world of the atom, inside the human body, in new technologies. The challenge is how to make increasingly difficult concepts palatable to a mass audience.

"In some cases, perhaps, it's not possible. When 'chaos theory' became popular in the late '80s, we discussed how it could be addressed in the magazine, and we decided it was too abstract. We never did that story."

Although their work is seldom credited in an article, illustrations editors are critical in planning photographs to illustrate technical subjects. Douthitt, one of the staff's multimedia pioneers, outlined the painstaking efforts he and photographer Louie Psihoyos took to cover "Information Revolution," October 1995, with text by Joel Swerdlow.

"This story was about the convergence of a number of technologies, all becoming digital," Douthitt told me. "We wanted to address the

PHOTOGRAPHER LOUIE PSIHOYOS, seated, with assistant John Knoebber, standing, and digitized colleagues (clockwise, from left): David Griffin, Allen Carroll, Bill Douthitt, and Joel Swerdlow "INFORMATION REVOLUTION" OCTOBER 1995
PHOTOGRAPH BY LOUIE PSIHOYOS

question: What is the impact on society when previously separate technologies—consumer electronics, television, personal computers, movies, audio—all become linked through the digital coding of information?

"The story got started when I went to a digital media conference in early 1993, and I really felt like I'd been transformed. I wanted to get on top of this subject very badly. It took a few months, but I got the story approved by the Editor. I arranged for Louie and me to spend a couple of weeks in Silicon Valley, in California, visiting the Apples and the Intels and the various software firms that were making the information revolution come about."

Psihoyos is an inventive photographer who never met a concept he couldn't shoot. "There is an image of the NATIONAL GEOGRAPHIC photographer toting a little camera bag and with a Leica around his neck," he said, "always with an eye out for what photographer Cartier-Bresson calls 'the decisive moment.' My decisive moment happens the instant the idea occurs to me for a photograph. It's really more like 'the decisive idea.'"

"We were running around Silicon Valley talking to four or five companies a day looking for ideas," said Douthitt. "Louie would drive, and I'd set up appointments with a cellular phone in the car.

"We were trying to find symbolic photographs for each area we were interested in—entertainment, commerce, education, and the military. And we wanted to avoid photographing people in front of a computer

screen; that is a boring situation. We were looking for something that abstracted each concept down to a simple, single statement."

For the lead photograph of the article, a person sits in an armchair in front of 500 television screens, each with a different image. This photograph represents the immense new capabilities of digital cable technology. To arrive at the concept, Douthitt and Psihoyos sifted through several options—such as shooting the scene in the desert in the middle of sand dunes or a "reverse" situation in an auditorium, with TVs in the rows of seats and the viewer sitting in an armchair on stage. But these didn't work. Eventually Psihoyos persuaded Mitsubishi Electric America to loan him the equipment and a place to stage the picture.

"Louie and his assistants spent a week in Los Angeles putting the set together," said Douthitt. "They made 500 videotapes to play on closed loops. Each tape was of a still picture, so the image on the screen would stay the same. We wanted to control the content, not have something weird unexpectedly appear on a screen.

"After we published, there was a huge frenzy from other media wanting to know where this room was, but the fact was that the room didn't exist anymore; the whole set was taken down after the picture."

MICROSOFT CHAIRMAN BILL GATES
"INFORMATION REVOLUTION"
OCTOBER 1995

PHOTOGRAPH BY LOUIE PSIHOYOS

In one startling photograph Microsoft Chairman and CEO Bill Gates, one of the nation's richest men, is dangling atop two 55-foot-high stacks of paper in the woods near Seattle, holding a CD-ROM disc in one hand. That was Douthitt and Psihoyos's way of pointing out that one CD-ROM can hold more information than the two stacks of paper in the picture—330,000 sheets of single-spaced text.

"A lot of our best thinking came in hotel-room brainstorming sessions," said Douthitt. "At first we wanted to get an airplane hangar, paint the floor black, and lay down the paper, but after a few calls to Boeing and McDonnell Douglas, we heard mostly, 'Thank you, our hangars are quite busy.' And then we thought we'd stack up the paper into a big tower.

"Gates answered us very quickly through e-mail with just three words: 'I am willing.' I think he was intrigued, and bemused, at how much trouble we were willing to take to get this picture."

Psihoyos hired a crane to hold two strands of heavy cable that ran through the centers of the papers in the stacks and held the stacks erect. He hired a professional mountain climber to rig a safety harness for Gates, then hired a crane from a power company to deposit the computer mogul atop the stacks. Psihoyos also used the cherry picker as his photographic platform. It took about one month to assemble all the elements, a week to set up the photograph, and ten minutes to snap it.

DOUTHITT ALSO WANTED to explore the digital manipulation of still photographs, a capability the advertising industry uses every day but one that raises questions in journalism about the integrity of the image.

"To demonstrate the technology, and with the Editor's permission," said Douthitt, "we decided to create one preposterous picture. I wanted it to be a surprise—and to have humor. We found a very elegant library room in Boston, that of the Boston Athenaeum, and Louie photographed that. Then he spent one day photographing a chimpanzee as it moved about in front of a blue screen. And then we hired a digital artist to combine these elements in a computer, seamlessly blending them."

The result was a hilarious composite of a hundred chimpanzees in the library, swinging from the stacks and sitting behind laptop computers typing out bogus Shakespeare works with titles like *MacBeast*. The possibilities for digital manipulation of photos were clearly demonstrated.

"One of the things I've learned over time," said Douthitt, "is that whatever idea you start out with will almost invariably turn out to be wrong—as you learn more and more about the subject. So what is finally built for a story is never what you had in mind in the first place—it's something much better." ■

"INFORMATION REVOLUTION"

October 1995

photographs by
LOUIE PSIHOYOS

text by
JOEL L. SWERDLOW

CROWD OF CHIMPS writing Shakespeare was inserted into photograph of reading room in the Boston Athenaeum with digital imaging.

FIVE HUNDRED SCREENS, representing the many channels digital technology is able to put on cable television, fire away in a photograph specially set up for "Information Revolution," October 1995.

"LIVING WITH RADIATION"

April 1989

photographs by
KAREN KASMAUSKI

text by
CHARLES E. COBB, JR.

MASK AND BRACE keep Bonnie Frost's head perfectly still as she undergoes radiation treatment for a tumor on her spinal cord at Lawrence Berkeley Laboratory in California.

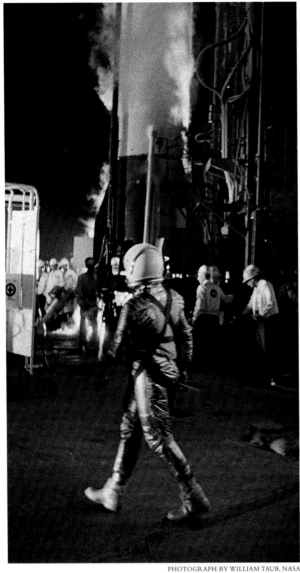

"THE FLIGHT OF *FREEDOM 7* "

September 1961

text by
CARMAULT B. JACKSON, JR., M.D.

WEARING AN ALUMINIZED pressure suit,
Alan B. Shepard, Jr., marches toward the launchpad
at Cape Canaveral on May 5, 1961, in his bid to be
the first American in space (above); Shepard is pulled
from the sea after his successful mission.

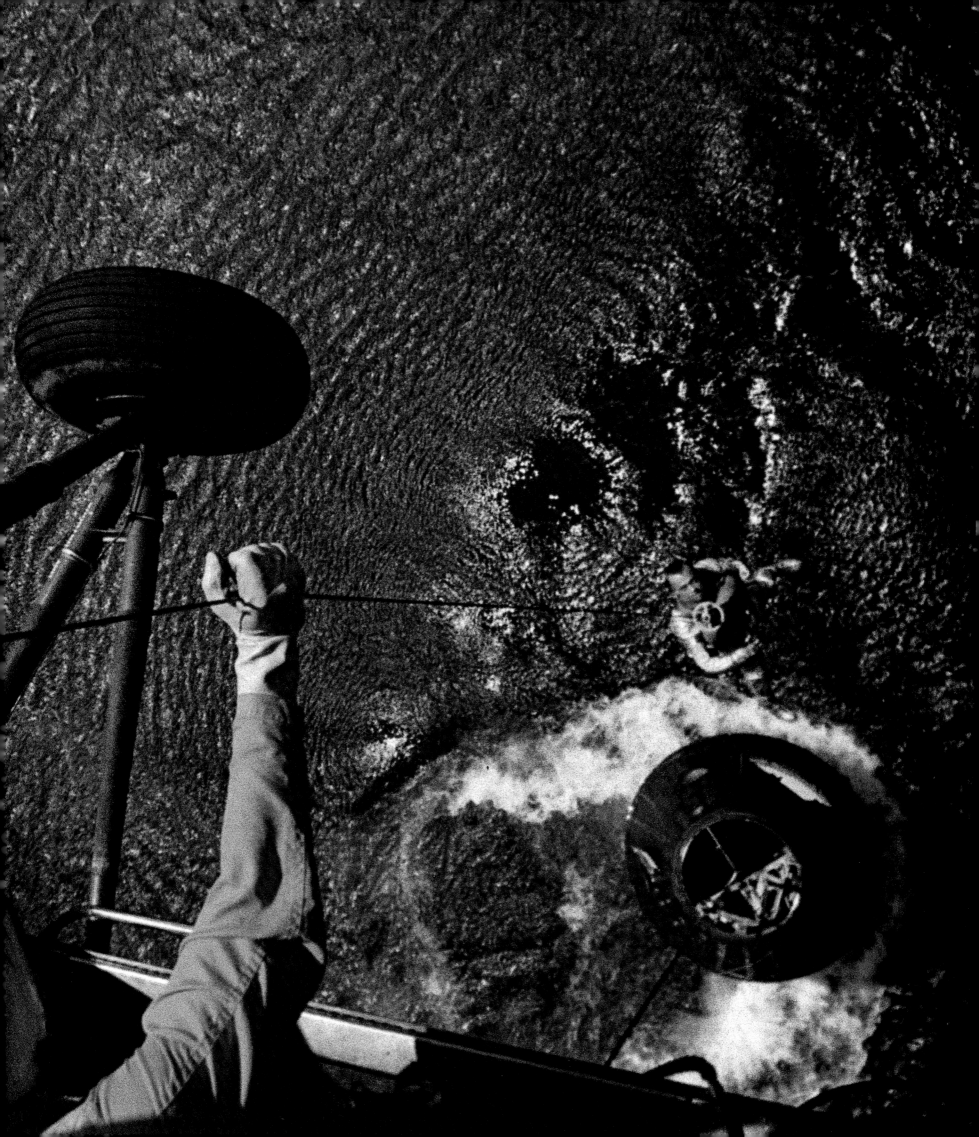

"DINOSAURS"

January 1993

photographs by
LOUIE PSIHOYOS

text by
RICK GORE

BY MEASURING THE WATER a model
Chinese *Mamenchisaurus* displaces, Indiana
paleontologist James Farlow estimates the
weight of such animals at about 23 tons. The
information is used to estimate growth and
reproduction rates.

"THE INTIMATE SENSE OF SMELL"

September 1986

photographs by
LOUIE PSIHOYOS

text by
BOYD GIBBONS

CHIEF PERFUMER for International Flavors
& Fragrances, Inc., of New York, Bernard Chant
whiffs a cologne he created (left); odor judges at
Hill Tip Research, Inc., test the efficiency of an
underarm deodorant on paid volunteers in
Cincinnati, Ohio.

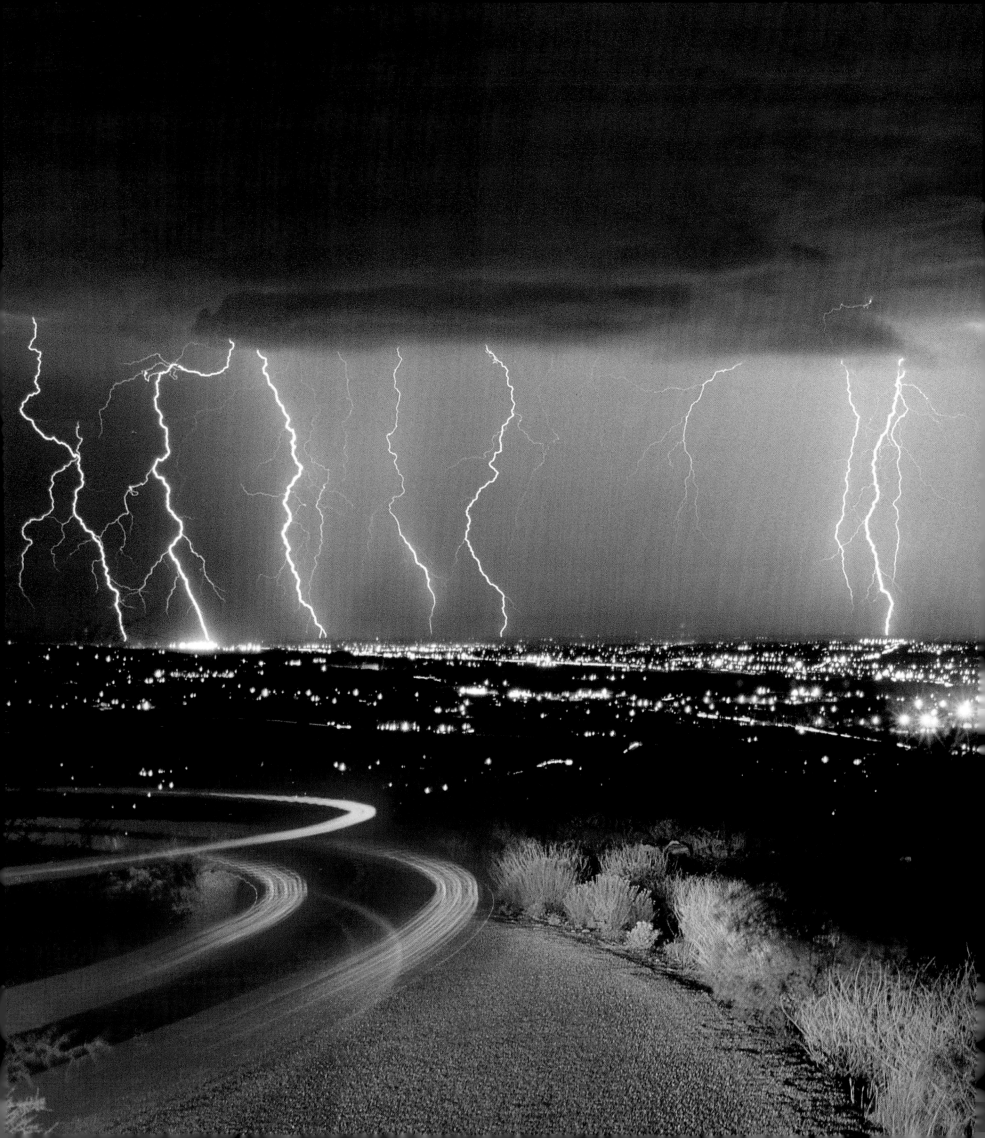

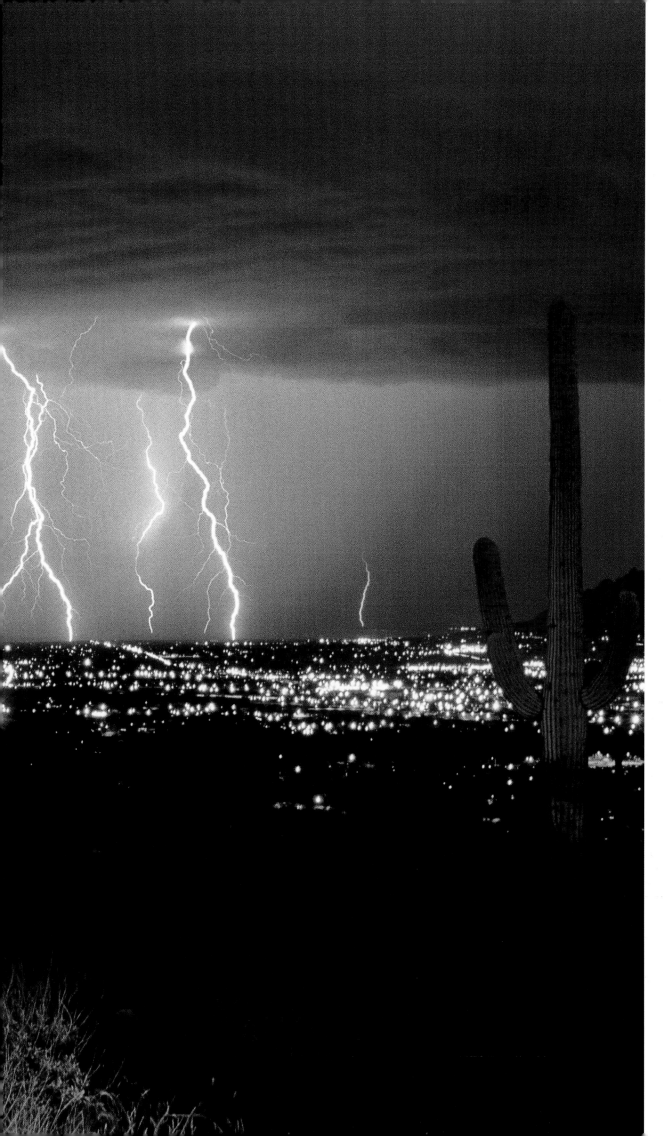

"LIGHTNING, NATURE'S HIGH-VOLTAGE SPECTACLE"

July 1993

photographs by
PETER MENZEL

text by
WILLIAM R. NEWCOTT

LIGHTNING ERUPTS in the stormy
skies over Tucson, Arizona, caught in a
five-minute time exposure from
Tumamoc Hill.

"THE ENIGMA OF TIME"

March 1990

photographs by
BRUCE DALE

text by
JOHN BOSLOUGH

HIGH-SPEED PHOTOGRAPH freezes
time, capturing the instant a bullet shatters
a wristwatch. Bullet was traveling at
3,200 feet per second.

CHAPTER SEVEN CITIES

"Cities are where people go to express themselves ...A city story is really a people story..."

—JODI COBB

"BROADWAY, STREET OF DREAMS"

September 1990

photographs by
JODI COBB

text by
RICK GORE

66 Now it all comes back. Life in New York. Waking up each morning to horns blaring and garbage trucks groaning down below. Waking up and worrying: Can the show—can *I*—make it in this toughest town in the world? 99

—RICK GORE

STEAMY DIVERSIONS abound
along Broadway's Times Square area.

preceding page:
FLOAT IN MACY'S Thanksgiving Day Parade.

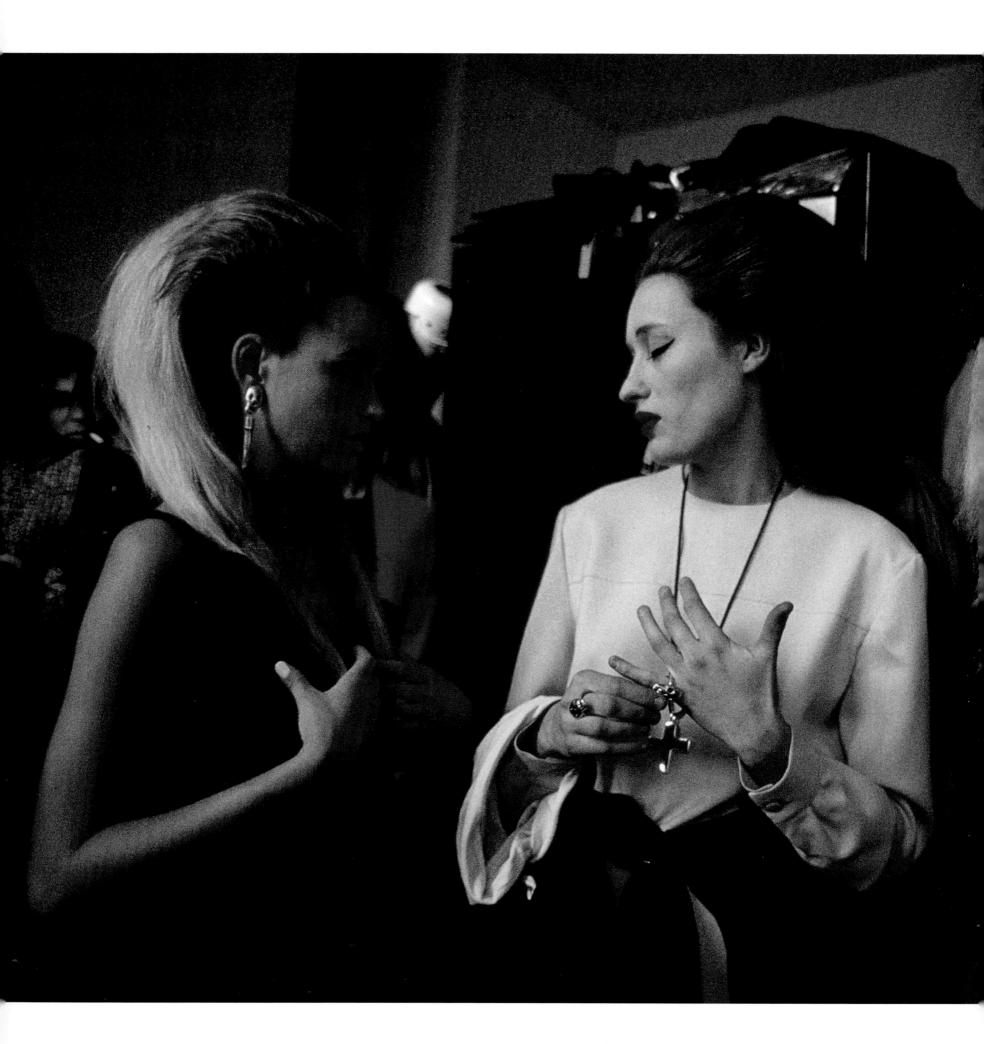

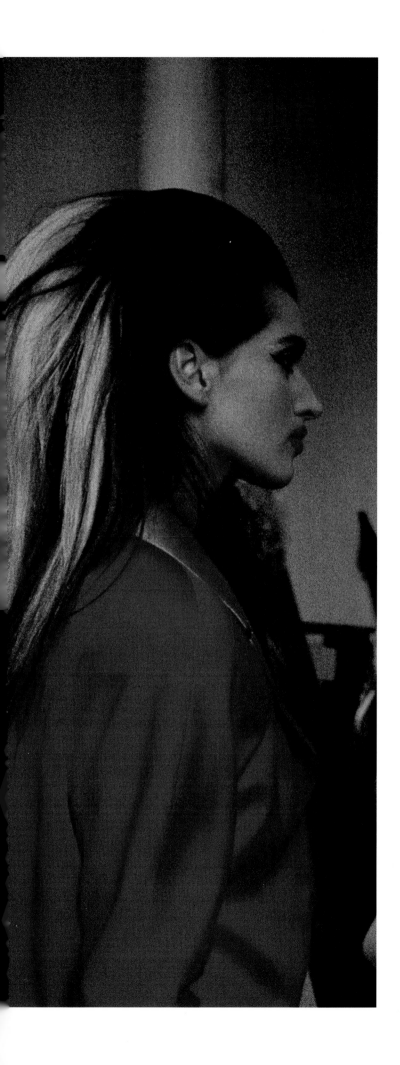

ONE OF BROADWAY'S mid-price fashion houses flaunts its wares (above) during spring fashion week; models for designer Stephen Sprouse await their cue to go onstage.

LANDMARK TRINITY CHURCH
and the distant towers of the World
Trade Center reflect off the hood of
a Wall Street limousine.

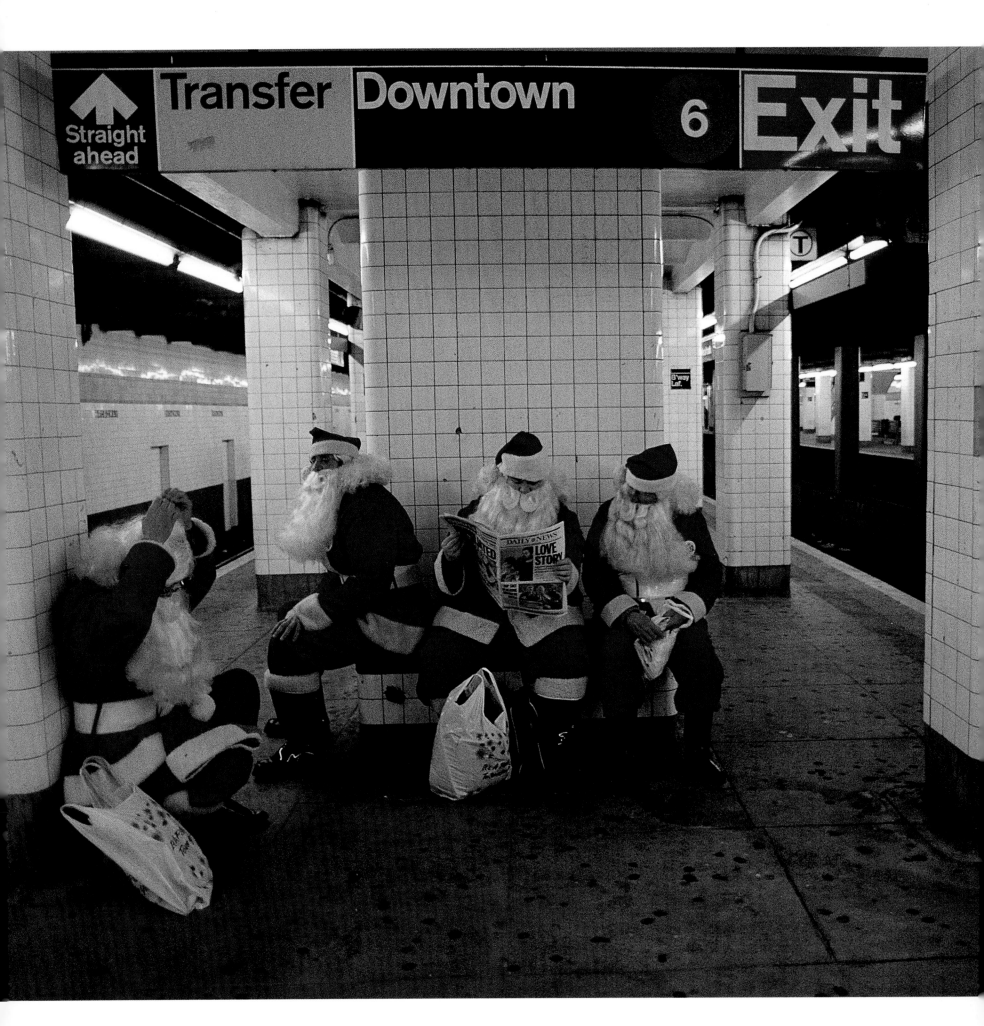

MANHATTAN SANTAS await subway ride to their jobs.

CITIES ARE MAGNETS for those who dream of better things, of starting anew. For Rick Gore, then an assistant editor, the assignment to write about New York City's boulevard of bright lights, "Broadway, Street of Dreams," September 1990, with photographs by staff photographer Jodi Cobb, was a chance to chase a dream, too.

The romance of Broadway had simmered in Gore's imagination since adolescence. "One of the most exciting moments in my life was my first trip to New York with my older brother Christopher, when I was 13," Gore told me. "We saw Ethel Merman in *Gypsy*, and I remember this incredible voice belting out, 'I had a dream!' That made a riveting impression on us."

The memory took on new meaning when Christopher, a playwright and lyricist who went on to write the motion picture *Fame*, died of AIDS. Christopher had made money and become trapped in the glitter of Hollywood. Before his death he had written a musical, which would be called *Children of the Sun*, about the Egyptian pharaoh Akhenaten and his queen, Nefertiti. He saw the show produced in Chicago but died before he could get it to Broadway.

"I made my brother a promise that I would do what I could to get his work to Broadway," Gore told me. He took the show to New York for a staged reading, the first level of production. At the same time, he began work on the "Broadway, Street of Dreams" article.

Rick Gore knew New York. "I lived there six years," he said. "I had the usual love-hate relationship with the city, and I'd always been frightened of urban reporting. It intimidated me." But Gore sublet an apartment near Lincoln Center, right on Broadway and its subway line.

The subway became the lifeline of the story, said Gore. "You could take it everywhere, so the story in many ways organized itself, like a river." Broadway begins near Wall Street on the south tip of Manhattan, runs through SoHo with its artists and art galleries, the garment district, the theater district, past Lincoln Center for the Performing Arts, on through the Upper West Side, Harlem, the Bronx, and on to suburban Yonkers and Tarrytown.

Along the line Gore talked to young people reaching for their dreams, such as music students at the famous Juilliard School; to those who had achieved a dream, such as fashion doyenne Liz Claiborne; and to those who had long since lost a grip on any dream. He ventured into the old Fort Washington Armory on 168th Street, then serving as a homeless center:

"Some 700 cots fill the vast drill floor below. Men, many desperate, some crazed, all homeless, mingle beneath the harsh lights. A foul, institutional odor wafts up…

"We go down on the floor. Our badges identify us as people who might help, and we are besieged. 'You ever eat green liver?' asks one man. 'That's what they're serving downstairs. But if you can fight, you might get yourself some chicken.'"

In his story, Gore captured the sweep of humanity on the great boulevard and told of his hopes for his brother's musical. But he and collaborators would fail to raise enough money, and the effort would prove unsuccessful. He keeps the dream, however.

JODI COBB ALIGHTED in New York after nearly eight straight years of photographing foreign assignments. She was glad to be coming back to her own culture with fresh eyes.

"I like cities because I like photographing people more than landscapes," she told me. "Cities are where people go to express themselves. They're the home of the arts, the preservers of culture. And cities have definite personalities—usually an exaggeration of the personalities of the people who inhabit them. A city story is really a people story."

Cobb spent months on Broadway. Going up in December, she said, "The first thing that jumped out at me were the Santa Clauses on the streets; they were everywhere. I was overcome with the emotion: *Here* was an icon of my own culture. On my recent assignments I had been looking for Middle Eastern icons. And here was Santa Claus, our icon."

When she approached one Santa who was ringing his bell in front of Macy's department store on Herald Square, she learned that he and many of his colleagues were recovering alcoholics who lived in a group residence in the Bowery district and took this job as seasonal work. She got his permission to visit their residence the next day.

Arriving early, she was able to photograph the Santas waking up, eating breakfast, and putting on their costumes and beards. Then she followed some of them to work. "There were masses of Santas walking down the street together," Cobb said with delight. "And in the subway here was this wonderful scene: Some of them were going uptown, and if you looked across the tracks, you could see another group of them going downtown. The subway was full of Santa Clauses."

Jodi Cobb is an unthreatening figure—cheerful, slim, polite—but when they reached the next station and started up the exit stairs, Cobb following the Santas, she was attacked. "Some guy started grabbing my camera because he thought he had been in the pictures. He was shouting at me, and I was shouting at him, and he was physically assaulting me, and other New Yorkers were just walking by, ignoring us.

"And then two Santas heard my shouts, came back, and started screaming at this guy. And that brought the other New Yorkers to a halt, hearing obscenities coming out of Santa Claus's mouth. The guy backed off. Confronted with Santa Claus, he beat a hasty retreat."

Over her career Cobb has established a reputation for photographing the offbeat and the infamous as well as the famous. An illustrations editor once complained to Cobb that she was photographing only "kooks and oddballs."

"Well, humanity is a sliding scale," Cobb told me. "It's not like there are normal people on one hand, and kooks and oddballs on the other. It's a continuum of lifestyles with every component that God has given us; we are all mad in our own way. I love people who create things, who make music, who leave something behind." In New York, she photographed Calvin Klein backstage at a fashion show, Neil Simon at the opening night of one of his Broadway plays, and Mikhail Baryshnikov training dancers at his studio.

Cobb had problems, too. "I was dealing with my father's death, which hit me very hard. And there was a switch in writers. All of that made my emotions raw as I walked the street—which maybe brought more of an edge to my photography. The pictures I made are still some of my favorites."

THE EMOTIONS AND FOCUS on people that mark the Broadway story are a far cry from early GEOGRAPHIC city stories. One of the earliest, "The Nation's Capital," June 1913, was an adaptation by the

Woodson unblinkingly offered up some of the grimmest scenes of urban decay published by the magazine, as well as portraits of Harlem's dreamers and survivors. "Despite the formidable difficulties Harlem faces," Hercules wrote, "it is a triumphant, not a defeated community."

JOURNALISTS ASSIGNED to city stories must determine a focus. Space is limited: Which themes will they concentrate on? When Peter Miller, now senior assistant editor for expeditions, and photographer Nathan Benn were assigned to "Pittsburgh—Stronger Than Steel," December 1991, they adopted these criteria: What is most important to know about Pittsburgh? What is most unique to it?

"It seemed to me a Pittsburgh story should not be about problems that it shared with other cities, such as substandard housing and race relations," Miller said. "It should be about how it reinvented itself. So I told that story." He explained how the city, its economic base of steelmaking destroyed by foreign competition and a shrinking market, bounced back:

"Shaken by the collapse of the steel industry, which had provided them with an unshakable sense of identity for more than a century, Pittsburghers hunkered down and built a new economy based on services, medicine, education, and technology."

He described how businesses, government, and academia—especially Carnegie Mellon University and the University of Pittsburgh—collaborated to shape an environment and a workforce attractive to high-tech companies.

And the shrinking of the city's population by 45 percent since 1950 had at least one positive consequence: helping to improve the quality of life. "There are enough schools, parks, and roads to go around," Miller wrote.

For photographer Benn post-industrial Pittsburgh presented a challenge. "The traditional icons for Pittsburgh have long been the steel plant and the smoky steelworker. You can still find these things there; I spent one week in the mills photographing exactly that. But that's not what Pittsburgh is today. There are more lawyers working in Pittsburgh today than steelworkers. Pittsburgh is a business services center, a health care center."

PHOTOGRAPHER NATHAN BENN
on assignment "PITTSBURGH" DECEMBER 1991
PHOTOGRAPH BY ROBERT LUSCOMBE

Benn decided not to plan his coverage so much as to react to what he saw. The results were mixed, he said, but he thought one shot "one of the ten best pictures I have taken in my career." It shows an old fin-tailed car, a modest house with an American flag hung on the porch, and the shirtless homeowner, Robert Kenney. "I've been in this house 39 years," Kenney said. "A lot of my neighbors have been here even longer. They're people you can count on...."

"A sound image," Benn said. "It was taken on the first day of shooting on the Pittsburgh assignment. There is no way to recapture that experience of seeing a place for the first time, with the adrenaline flowing and the sense of discovery."

Benn had an assistant, Rebecca Abrams, to help photograph Fourth of July celebrations. Abrams was a graduate student in photography at Yale University and an intern at the GEOGRAPHIC. "The Fourth of July shots didn't work out," Benn said. "We both spent quite a bit of time finding positions to photograph the fireworks. We found ideal balconies, but both of us took really bad pictures." But something did work out. They were married in May 1996.

IN FEBRUARY 1989 the GEOGRAPHIC focused for the first time on that proud and exhilarating monument of the city, "Skyscrapers." Bill Ellis, then an assistant editor, and photographer Nathan Benn dissected these near-fictional giants like some insect or plant species. Ellis sang their praises in his text:

"In its making, the skyscraper draws on colossal egos, on financing almost inventive enough to warrant a patent, and on the talents of the world's leading architects and engineers. All else in matters of design and construction pales in comparison to this—to erecting a frame a thousand feet high and then draping it with a curtain of stone or glass, all the while compensating for the winds that play on the upper floors like a pick on the strings of a banjo...."

"There's so much drama to towers," Ellis told me. "There's a romance about the whole business of architects and great new developments, and so I guess I really got into it. I carried a great advantage, an entree to people, because of the GEOGRAPHIC name. All the great architects in the world readily agreed to the interviews I requested."

Looking for a way to dramatize the excitement of skyscrapers, Ellis's imagination soared to the 1933 film *King Kong,* in which a giant ape scaled the Empire State Building with the ravishing and blond Fay Wray in its hand. "And I said, 'Dammit, I need to get Fay Wray in this story!'"

Nothing seemed impossible in the lofty atmosphere of skyscrapers, so Ellis arranged to meet the actress, an enchanting, gracious woman of 81, in the Trump Tower, where she had an apartment. "And as I interviewed her there, I turned to her, and I said, 'Miss Wray, have you been to the top of the Empire State Building since *King Kong?*'

"'No, I haven't.'

"'Would you go with me now to the top?'

"'I'd be happy to.'

"So we got into a cab, and we went to the top of the Empire State Building, Fay Wray and I."

Ellis described the moment:

"When we got there, to the top, she looked out over the city and then turned back to face the crown of the tower. 'This building,' she said, 'belongs to me.'"

NATHAN BENN, A THOUGHTFUL and meticulous photographer, considers his work on skyscrapers the highlight of his 20 years with the magazine. The centerpiece of his coverage was a series of portraits of architects and their buildings. "It was a very studio-oriented approach, untypical of my career at the GEOGRAPHIC. It was a very elegant presentation, very satisfying.

"There's a sympathy between a building and its designer. My trick in doing the portraits was to extend my personal interests in the decorative arts, especially in furniture, to the task. I invited each of the architects to be photographed in his favorite chair.

"We would pick up the chairs from the office, home, or vacation house of the architect. We had someone drive three and a half hours to the Adirondacks to get the favorite chair of David Childs [of Skidmore, Owings & Merrill]."

Benn nearly added himself to the sidewalk debris while in Chicago. "I was standing on top of a tall building," he told me, "and I got caught by a breeze at my back and swept forward. There was no guardrail, and my one foot caught the edge of the roof, while the front half of my other foot was already over the edge of the building. And I will never forget that. That was as close as I ever came to 'buying the farm.' And I'm afraid, profoundly afraid, of heights."

"Afraid of heights?"

"Yes, but I asked for the skyscraper story. The point of a career is not to run away from your fears but to face them."

WHEN I WAS ASSIGNED to write the text for "Upbeat, Downbeat, Offbeat New Orleans," January 1995, with photographs by freelancer Bob Sacha, I discovered that Harnett T. Kane had gotten the place right in his 1953 article. New Orleans is one of the few American cities that can absolutely seduce you. And it might as well not be in the United States at all. Many of its citizens think the city was meant to be the capital of some amorphous, loose-living empire of the Caribbean.

But a GEOGRAPHIC article is not just a travel story, and Sacha and I would have to look not only into

Mardi Gras, jazz and zydeco, Creole and Cajun cooking, voodoo, and all-night party-ing, but also into the economic hard times and crime that were plaguing the city.

When the oil and gas industry collapsed in the mid-1980s, New Orleans plunged into a depression. Gambling, or "gaming" as its proponents called it, was offered as a way to compensate for lost jobs and revenues—to become the industry of the future. Many New Orleanians opposed the idea. They said gambling casinos would cheapen the city, harm its unique cultural and historic character.

I moved into an apartment in the elegant Garden District for three weeks, then for three more weeks in old slave quarters in the French Quarter, a place that could be reached only through a patio filled with lush banana trees. Every day I poked into corners of the city, getting people to tell how life in New Orleans looked to them.

A friend told me: "It is a city still full of a free-floating kindness, where people are not educated enough to be angry." But parts were dangerous. The violence was fueled by poverty, alcohol, cocaine. When I told the director of a private security ser-vice that I wanted to walk through the city's low-income housing projects, he blanched. "Never make it out alive," he said. "Somebody might kill you before even thinking you were a journalist."

Sacha's photograph of a man sitting on a bench, hands covered with blood, sur-rounded by emergency medical personnel and a policeman, condensed the city's spi-raling crime rate into a single, arresting image.

PHOTOGRAPHER BOB SACHA
on assignment "NEW ORLEANS" JANUARY 1995
PHOTOGRAPH BY BOB SACHA

TO SEE WHAT MOTIVATED the hundreds of people applying for jobs in the gambling industry, I spent an afternoon as an interviewer for the *Queen of New Orleans,* the city's first floating casino on the Mississippi. At a job fair held in the gymnasium of a public school, a man named Johnson told me he had moved to Chicago when oil and gas failed, "but things didn't work out." A woman named McCaskill said she was applying because the fried-chicken restaurant where she worked was getting robbed too often. A nursing student came in for part-time work as a cocktail waitress. She needed money, and gam-bling was "gonna bring jobs, gonna boost the economy. We have a lot of people out of work in New Orleans."

I discovered that the one thing in which everyone in New Orleans joined was Mardi Gras. Every group had a stake in it, and every group had its own way of celebrating it. Aristocrats held masked balls; suburbanites packed fried-chicken picnics for afternoon parades; African-American neighborhoods sent "Indian gangs"—their chiefs dressed in elaborate costumes of rhinestones and feathers—into the streets to hold mock confrontations against groups from other parts of the city.

So Sacha and I joined a krewe—Orpheus—a new group, multiracial, started by the singer Harry Con-nick, Jr., a New Orleans native. On the evening of "Fat Tuesday" we join our krewe on one of its floats, armed with thousands of beads to toss. The experience was magical but enervating. I wrote:

"We are safety-belted to the side like galley slaves. My post is in front of a four-foot-tall speaker blaring rock-and-roll oldies. We inch toward Napoleon Avenue, where the parade begins, and where unreality hits: a sea of outstretched arms and shouting faces, begging for our beads. The float lights flash green and yellow; the loudspeaker blasts out 'Louie, Louie.' Young women sitting on their boyfriends' shoulders bare their breasts, as custom dictates, bargaining for better, longer, beads...."

Later that night, sick with a cold and exhausted from efforts to keep up with my hosts, I collapsed into a corner. Harry Connick would soon be singing in the ballroom, and my Orpheus brothers and sisters would be drinking champagne and dancing on the tables. Too much for me. My next assignment, I determined, would be into some lonely wilderness.

LOS ANGELES IS ANOTHER magnet town; it attracts the hip, the talented, the provocative. GEOGRAPHIC journalists assigned to cover it have had differing reactions. Jodi Cobb, after photographing "Los Angeles: City

in Search of Itself," January 1979, with text by Bill Ellis, compared it to other great cities of the world she knew. "If people go to Jerusalem out of religious passion, they go to Los Angeles from personal ambition. 'In Paris you fall in love,' wrote the author Benjamin Stein. 'In Boston you go to school. In L.A. you hustle. And you try to become beautiful.'

"A story on L.A. was formidable. The third largest city in the U.S., it was more an idea than a place, a haven for people who pour in to fulfill their dreams, to reinvent themselves, or to live a fantasy."

The magazine's most recent story on Los Angeles was "Sunset Boulevard: Street to the Stars," June 1992, with photographs by Steve McCurry and text by senior assistant editor Rick Gore. McCurry, a savvy and pugnacious freelance photographer from New York, has specialized in exotic places such as India and Afghanistan. He confessed he had a tough time getting started on Sunset Boulevard. The problem was he couldn't find anybody outside.

"I must have driven up and down the boulevard maybe five hundred times," he told me. "In New York people walk; even if you're a zillionaire, you still walk on the street, you still go out and get into a cab. In Los Angeles you have someone in a dark limo, with air-conditioning on, the windows up, dark. You don't see anybody; everybody's in a cocoon."

It was not a welcoming town, McCurry said. "I found the most access, the most warmth in the Hispanic barrios and in the gay community. As soon as you crossed from West Hollywood into Beverly Hills, a big shutter came down. Suddenly there was no access, no people. The only people you saw on the streets were the maids walking the dogs. You didn't see joggers; they must all work out on machines at home."

WHEN GORE ARRIVED to begin his coverage, he still felt the weight of the loss of his brother. "In some way, I was making peace with Christopher's life and death," Gore explained. "He had lived right in the area, and it was very difficult for me to return there, to be on that street where we'd spent time together, and I didn't know if I could do it. In some ways I could understand the appeal of that kind of life that has brought tragedy to so many bright people—the great longing that's out there, and the excess, the wretched excess, and almost a sense that nothing can harm you."

Gore covered thoroughly the roughly 24 miles of Sunset Boulevard, from Hispanic barrios in the city center, through Hollywood and Beverly Hills, to upper-middle-class Pacific Palisades by the sea. His strongest writing seemed to come when he met people who had taken a turn that led to troubles. Visiting a foster home for adolescents, he wrote about a teenage girl named Jennifer, who had AIDS:

"Jennifer is not gay, but many of the hundreds of runaway kids in Hollywood are…Her housemates include Brett, whose parents had him jailed after he stole their credit card and ran up a $5,000 bill. After jail he ran away and became a prostitute. And Daniel, a Navajo boy, a recovering alcoholic who runs marathons and sometimes dresses as a girl. Then there's 17-year-old Deborah, who wears only boys' gang-style clothes. Her brain, says program director Sharon Kidd, has been fried by drugs."

Gore knows that not every city story will have the intensity and passion that Sunset Boulevard and Broadway had for him. "But every story can be written as a journey," he said, "and if you don't know what your journey is, then the story has to be the discovery of the journey. Otherwise, there's no adventure, no beginning, no end, no surprises. You have to find the journey, or nobody's going to want to read your story.

"The first time I drove the length of Sunset Boulevard, I drove around a corner, and I saw a place called the Self-Realization Fellowship Lake Shrine. And I just stopped the car. I smiled, and I said to myself, I know where the end of this story is going to be. You go from turmoil to finding peace, and realizing who you are." ■

"SUNSET BOULEVARD: STREET TO THE STARS"

June 1992

photographs by
STEVE MCCURRY MAGNUM

text by
RICK GORE

BIKERS CRUISE the clubs
and crowds of Sunset Strip.

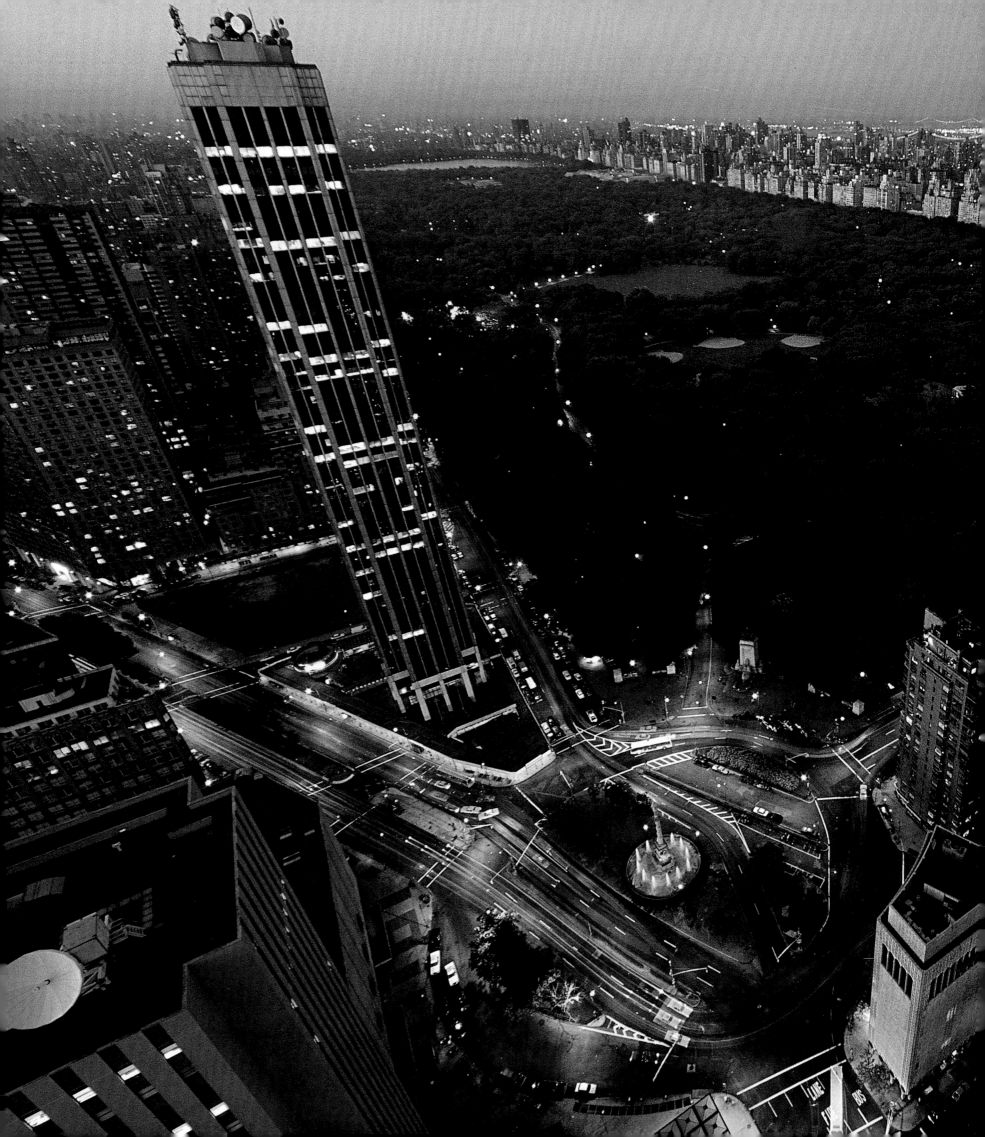

"CENTRAL PARK: OASIS IN THE CITY"

May 1993

photographs by
JOSÉ AZEL

text by
JOEL L. SWERDLOW

CENTRAL PARK appears
as an oasis of green amid
concrete ramparts from high
above Columbus Circle.

271

"UPBEAT, DOWNBEAT, OFFBEAT NEW ORLEANS"

January 1995

photographs by
BOB SACHA

text by
PRIIT J. VESILIND

MARDI GRAS REVELERS in full
regalia prepare to depart for a ball.

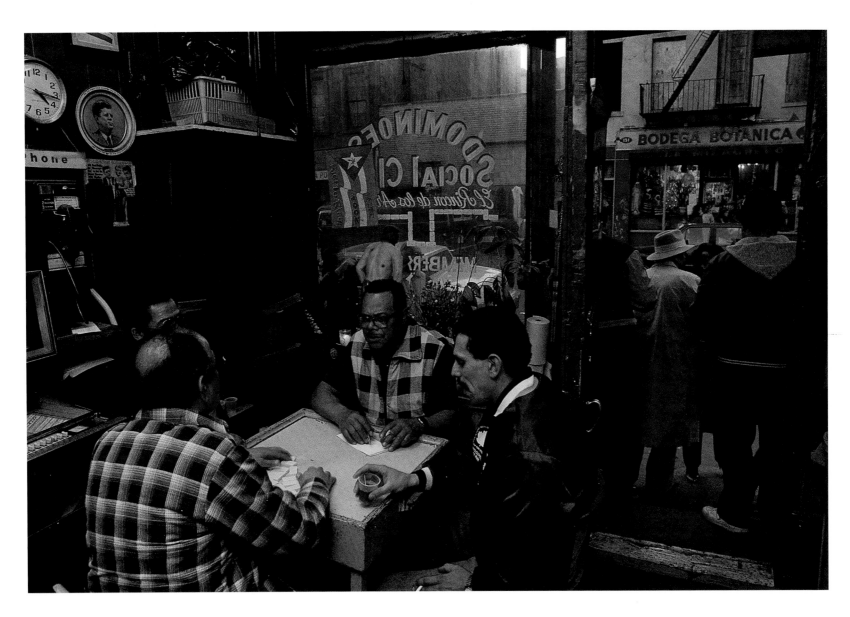

"GROWING UP IN EAST HARLEM"

May 1990

photographs by

JOSEPH RODRIGUEZ BLACK STAR

text by

JERE VAN DYK

AT A 110TH STREET OLD-TIMERS CLUB, men play dominoes after work (opposite); Orlando Oquendo warms up before marching in winter parade celebrating Three Kings Day, the Feast of the Epiphany.

"MIAMI"

January 1992

photographs by
MAGGIE STEBER

text by
CHARLES E. COBB, JR.

BROTHERS MANUEL AND RUBEN
Rodriguez grow up amid the lively street
theater of Biscayne Boulevard.

"BELIEVING LAS VEGAS"

December 1996

photographs by
MARIA STENZEL

text by
WILLIAM R. NEWCOTT

IN A NIGHTLY SHOW a powerful light
is projected from the top of the pyramid-
shaped Luxor Hotel.

279

TOURISTS PLAY the one-armed bandits of a Las Vegas casino (above); in the ring at Caesars Palace, Oliver McCall, left, awaits the starting bell in his bout against former champion Larry Holmes.

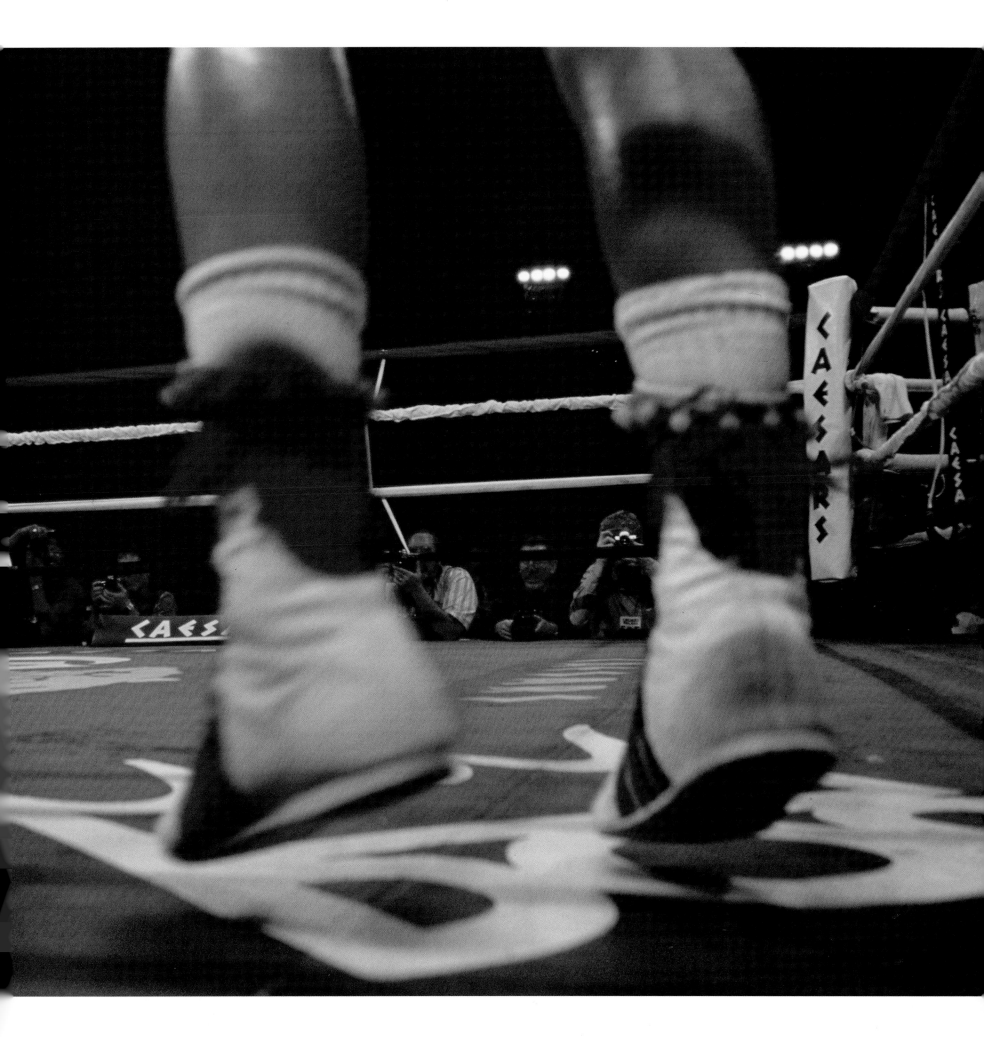

"THERE'S MORE TO NASHVILLE THAN MUSIC"

May 1978

photographs by
JODI COBB

text by
MICHAEL KERNAN

SINGER HANK SNOW awaits his cue backstage at the Grand Ole Opry,
Nashville's famous institution (opposite); performer David Allan Coe
and his mirror image relax behind the scenes at Fan Fair, an annual event
of concerts and autograph signings for country music followers.

283

"PITTSBURGH—
STRONGER THAN STEEL"

December 1991

photographs by
NATHAN BENN

text by
PETER MILLER

RUSTED GIRDERS at the
defunct 100-year-old Duquesne
Works steelmaking plant meet the
demolition man's acetylene torch.

"BOSTON: BREAKING NEW GROUND"

July 1994

photographs by
JOEL SARTORE

text by
WILLIAM S. ELLIS

MEMBERS of the L Street
Brownies, named for their deep
summer tans, rinse off. They are
famous for taking a dip every day
in Dorchester Bay no matter how
inclement the weather.

CHAPTER EIGHT HEROES

"To see a place through the eyes of an American hero has been a rewarding challenge..."

—PRIIT J. VESILIND

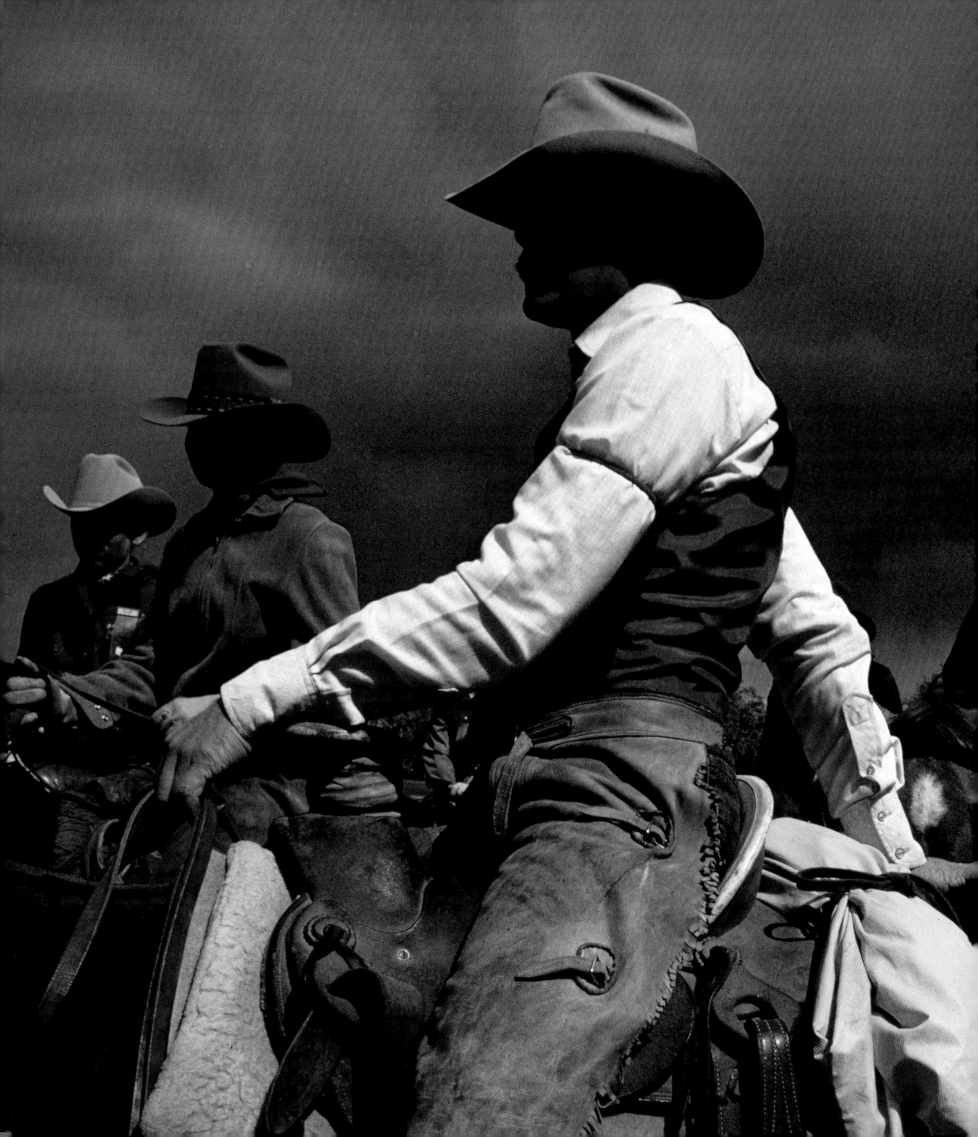

"C. M. RUSSELL, COWBOY ARTIST"

January 1986

photographs by
SAM ABELL

text by
BART MCDOWELL

66 Cowboying began for Charley in the raw spring of 1882, when he started as night wrangler for about 400 horses. Soon he was night-herding cattle. It was the loneliest work a cowboy could do: He was a human substitute for a fence. 99

—BART MCDOWELL

RIDERS FROM Cornwell Ranch watch the Ranch Roundup competition in Miles City, Montana.

preceding page:
RANCHER'S DOG, Square Butte, Montana.

66 Lonesome. It was a word Charley Russell spelled variously but used a lot. It caught the spirit of night-wrangling horses in the rain and hot days trailing cattle alone under the Big Sky. It explained the sadness of cowboy songs, the homelessness, the rip and roar on rare trips to town. 99

—BART MCDOWELL

OFTEN A BACKDROP for Russell's paintings, Square Butte sits 20 miles west of Great Falls, Montana.

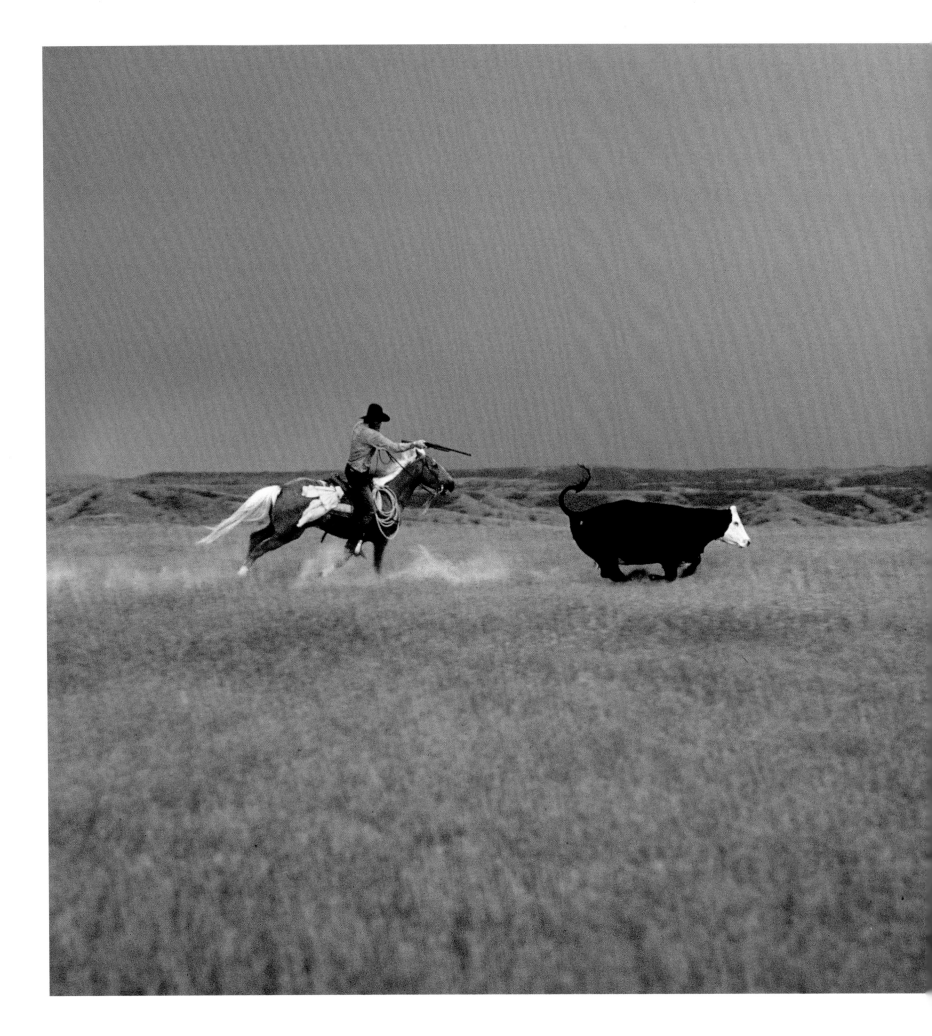

FOR A RODEO BARBECUE
cowboy Lyle Chamberlain shoots
an unproductive cow on ranch near
Mussellshell River, Montana.

THE AMERICAN SYSTEM suffers no aristocracy, recognizes no divine rights. It rewards competence, honesty, and courage. And the heroes that arise among the people are those who best express that exhilarating promise that men can achieve according to their capabilities. Political leaders rule by will of their constituents; artists celebrate the common man.

Some American heroes have personified regions, eras, and cultures: Mark Twain and the Mississippi River; Daniel Boone and the broad-leaved forests of Kentucky; Charles Russell and the American West. To see a place through the eyes of an American hero has been a rewarding challenge for GEOGRAPHIC writers and photographers, blending geography with history and art.

When Sam Abell was assigned to photograph "C. M. Russell, Cowboy Artist," January 1986, with text by assistant editor Bart McDowell, he had just returned from a long and brutal assignment in the Soviet Union. "I asked the director of photography to give me the most American story available," said Abell. "My wife and I got into a van in Virginia and drove country roads all the way to Montana and spent, off and on, a year on this story."

But for Abell, illustrating the work of an artist meant subordinating his own craft. Only a few of his photographs appeared in the finished magazine story.

While Abell was in the field, David L. Arnold, the illustrations editor for the story, spent an equivalent amount of time and energy collating all of Russell's paintings, sketches, and letters, as well as vintage photographs. "Arnold put together Russell's work with my work," said Abell, "to create the visual story that the reader would see. And Arnold emphasized, correctly, the work of Russell.

"Now you ask, how could the photographer be happy? But I was. The story was Charles Russell's American West, not Sam Abell's. My seven pictures—chosen from thousands—were used as punctuation marks in the long and beautiful narrative of his life.

"There's a sense of detective work in this kind of biography, and a sense of poetry. I had wondered if I'd be able to find anything left of Charley Russell in Montana, but I did. Some of the backgrounds of his paintings are still right there. It's one of the richest visual landscapes in North America."

McDowell, now retired, is a tall Texan who remembered as a boy seeing Russell pictures in his grandfather's den, along with deer antlers:

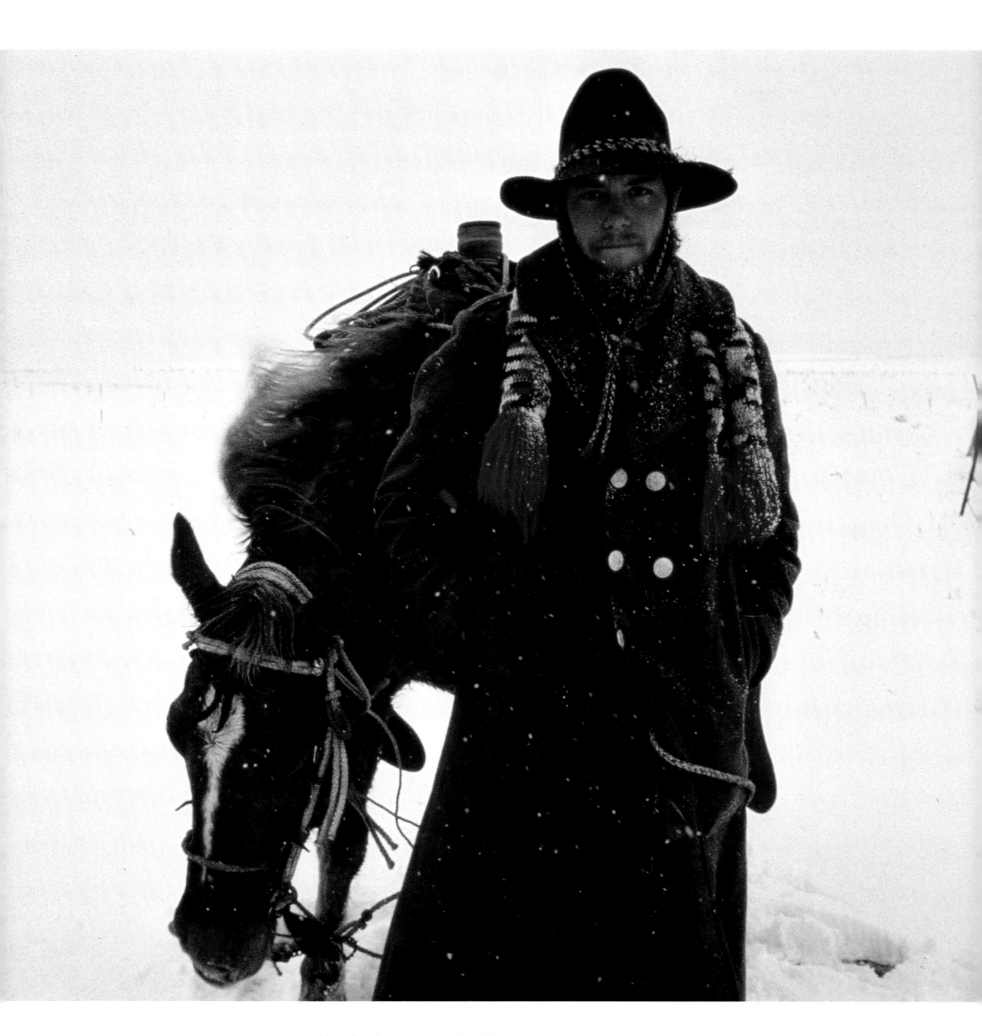

HORSE WRANGLER Gerald Mack endures in Montana's Judith Basin.

"Since my grandfather had once been a wrangler himself and scorned all drugstore cowboys, I knew from the first that Russell pictured life as it was, rough and real, 'with the bark on,' as Texans say."

Russell's 4,500 pieces of art—paintings, sketches, and sculptures—document the workaday life of the West more accurately, perhaps, than the work of any other artist. He had been sent West from St. Louis as a boy of 15 by his parents, to work on a sheep ranch, after a stint at a military academy failed to improve his studies. He would draw everything, McDowell wrote, "and *on* everything: tobacco kegs, shoe boxes, cracker boxes, mirrors, the lining of a Stetson hat, birchbark and buckskin, a bank vault door, even a green silk petticoat."

He was a gregarious young man. "I have always been what is called a good mixer," the artist remarked. "I had friends when I had nothing else."

McDowell went in search of his hero. "Montana has a folksy way about it," he said. "Networking is easy because everybody knows everybody else, or knows somebody's cousin, or somebody in the next town, who knows everybody else. Sooner or later, you're going to find the connection."

He met people who had known Charley Russell, talked with Russell scholars and history buffs, visited the Blood Indians of Canada whose ancestors had allowed Russell to stay with them for weeks. He shared memories with the artist's adopted son, Jack. And years earlier, working on the Society's book, *The American Cowboy in Life and Legend,* McDowell had met people who remembered the brutal winter of 1886-87. Young Russell made a famous watercolor on a scrap of cardboard during that blizzard, showing a gaunt, starving cow. "You could step from one carcass to the next one all along the Judith," one old-timer had told McDowell.

"I had always been interested in Russell as a person," McDowell said, "because he was a great storyteller—not just in paint, but verbally. The people I met who had known him said that when he and Will Rogers would be at a party together, even Rogers would shut up and listen."

McDowell wrote of the artist-storyteller:

"It's his canny dishonesty that I especially like: the touch of caricature, the pin he jabs at pompous balloons, the droll hyperbole of his stories, the schoolboy snicker of his deliberately misspelled letters. His humor reminds me of my own Uncle Bert—and perhaps that's the secret of the Russell mystique…he's a friend of the family. He turns the pages of our own family album."

BIOGRAPHIES WERE NOT common in the magazine in the early days. Great explorers such as Robert E. Peary and Richard E. Byrd and adventurers such as aviatrix Amelia Earhart wrote accounts of their adventures, but their lives were not portrayed.

Earhart, America's sweetheart of the late '20s and early '30s, wrote an article about her solo flight 2,400 miles across the Pacific Ocean to California, "My Flight from Hawaii," May 1935. In the piece, she recalled soaring high and lonesome:

"The night I found over the Pacific was a night of stars. They seemed to rise from the sea and hang outside my cockpit window, near enough to touch, until hours later they slipped away into the dawn.

"But shortly before midnight I spied a star that differed from the others. It was too pink and it flashed as no star could. I realized I was seeing a ship, with its searchlights turned into the heavens as a lamppost to guide me on my way. I snapped on my landing lights, which are on the leading edge of the wings midway to their tips, and had them bravely blink a greeting to whoever might be watching."

Presidents also wrote their way into the magazine. Theodore Roosevelt penned "Wild Man and Wild Beast in Africa," January 1911, and "How Old Is Man?" February 1916. William Howard Taft did Roosevelt several better: He wrote 13 articles for the magazine. These latter were often politically oriented pieces, such as "Some Recent Instances of National Altruism: The Efforts of the United States to Aid the Peoples of Cuba, Porto Rico and the Philippines," July 1907.

For years the magazine spent little time on the lives of modern presidents, although inspirational photographs of Franklin Delano Roosevelt and Harry S. Truman appeared in wartime articles. But in the late

1950s and early 1960s, the magazine began to develop a closer relationship with the White House, which stands only a few blocks away from Society's headquarters.

In 1960 the magazine commemorated the 150th anniversary of Abraham Lincoln's birth, publishing "Our Land Through Lincoln's Eyes," by editorial staffer Carolyn Bennett Patterson, photographed by staffer W. D. "Bill" Vaughn. The words of poet Carl Sandburg, Lincoln's biographer, from a speech made before a Joint Session of Congress on February 12, 1959, served as an introduction ("Lincoln, Man of Steel and Velvet," February 1960). Spoke Sandburg:

"Not often in the story of mankind does a man arrive on earth who is both steel and velvet, who is as hard as rock and soft as drifting fog, who holds in his heart and mind the paradox of terrible storm and peace unspeakable and perfect."

That same year appeared "When the President Goes Abroad," a report by Gilbert M. Grosvenor, then a young assistant illustrations editor, who traveled with Dwight D. Eisenhower to Europe, Africa, and Asia. The next year came "Inside the White House," January 1961, by staffer Lonnelle Aikman and staff photographers B. Anthony Stewart, Thomas Nebbia, and others.

In March 1964 came another elegiac note. Just over three months after John F. Kennedy was assassinated, the GEOGRAPHIC presented "The Last Full Measure: The World Pays Tribute to President Kennedy," by Melville Bell Grosvenor:

"Only the future can assign to John Fitzgerald Kennedy his true place in history. But this I know: When men now boys are old, in distant time beyond the year 2000, they will say, 'I remember. I remember when they brought him home, the murdered President, from Dallas....'"

In November of that year the magazine began a "Profiles of the Presidents" series with text by Frank Freidel, professor of history at Harvard University. It was illustrated with full-page paintings of 35 Presidents, portraits of First Ladies, photographs of presidential homes and memorabilia, and illustrations of historic moments. The series ended in January 1966 with a profile of Lyndon Johnson.

Biographies appeared with increasing frequency during the 1970s and '80s, not only of Presidents, but also of scientists, naturalists, artists, writers, and military leaders. In March 1992, the magazine analyzed the life of "Douglas MacArthur: An American Soldier," with text by historian Geoffrey C. Ward and photographs by Cary Wolinsky. Ward wrote with candor:

PRESIDENT KENNEDY lies in state in Capitol Rotunda "THE LAST FULL MEASURE"
MARCH 1964

PHOTOGRAPH BY GEORGE F. MOBLEY

"No soldier in our history has been more extravagantly admired—or more savagely reviled—than Gen. Douglas MacArthur. And no man embodied more genuine contradictions. He was at once magnanimous and petty, devoted to his men and unwilling to share glory with them, fearless in battle but so fearful of his own mother that he was forced for a time to lead two lives, and unable ever to think himself fully worthy of the soldier father whose deeds his own had long since dwarfed. He achieved some of his greatest triumphs—as well as his worst defeat—by ignoring or defying the civilian superiors whose orders he had sworn to carry out."

A maverick, in other words—the type Americans love.

THE GEOGRAPHIC MADE HEROES of the bad guys in November 1976 with "Riding the Outlaw Trail," written by film star Robert Redford, with photographs by Jonathan Blair. Redford, through family connections, approached associate illustrations editor Tom Smith with the idea. Redford had steeped himself in the history of the West's rogues and scoundrels—Jesse and Frank James, the McCarty brothers, Big Nose George Parrott, Tom Horn—during research for the award-winning film in which he starred, *Butch Cassidy and the Sundance Kid.*

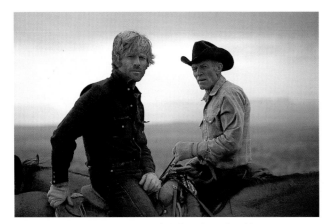

The Outlaw Trail, a string of hideouts and strongholds, wound from northern Montana to the Mexican border at El Paso, Texas, through some of the roughest country in the West. Redford saw the contradiction in making heroes of criminals and wrote.

"As technology thrusts us relentlessly into the future, I find myself, perversely, more interested in the past. We seem to have lost something—something vital, something of individuality and passion. That may be why we tend to view the western outlaw, rightly or not, as a romantic figure. I know I'm guilty of it, and for years I have been fascinated by that part of the West that offered sanctuary and escape routes to hundreds of colorful, lawless men."

Redford and his team rode horses for much of the coverage. Blair made excellent portraits of the effortlessly handsome Redford, but editors resisted the temptation to put Redford on the cover of the magazine. Had NATIONAL GEOGRAPHIC been sold at newsstands, they reasoned, that reluctance might have been business folly, but the membership did not care a whit about celebrity. The membership might even think the magazine was pandering.

I served as copy editor for the Outlaw Trail project and met with Redford one weekend to clean up research queries. For weeks afterward, as the research process continued, Redford would call at night (to the delight of the females in my house) with some minor tweak or nuance in his text, almost always concerning quotes.

The conversations Redford quoted in the story invariably rang authentic. He had a good ear. Searching for the spirit of Butch Cassidy in the old gold-mining town of Atlantic City, Wyoming, Redford wandered into the Mercantile, a combination bar and general store. At the bar, wearing suspenders and a straw hat, sat an old-timer named Larry Roupe. Redford asked if he could buy him a beer. Roupe eyed him, said: "Who the hell are you?"

Perfect. And Redford recorded the rest of the conversation like this:

"'I came from Oregon in 1922 on the Emigrant Trail,' Larry said. 'My dad was a cattle buyer—he'd go down to Texas, buy steers for two dollars a head, then bring them up to Wyoming and sell them.

"'I was just a kid then, but I loved this country. I ran cattle for a while, then took to rodeoin'.'

"'Were you ever an outlaw?'

"'No, I never went that way. I could have—could've been a good outlaw. But I jes' never went that way.'"

Not bad for a celebrity actor who wasn't supposed to be a writer. It dawned on me only later that quotes are essentially dialogue—like movie dialogue—at which he was a master. That Redford went on to direct films came as no surprise.

DAVID ALAN HARVEY THOUGHT he had been handed a dream assignment—to photograph one of America's greatest living artists, Andrew Wyeth, and the extended Wyeth family, one of the most remarkable in America. Three generations, living mainly in the small Pennsylvania community of Chadds Ford, had shaped a dynasty of applied fantasy.

The shoot was to be in black and white, rare for a modern assignment, but calculated to contrast with the color of the art to be reproduced in the article.

Harvey, then a contract photographer, had majored in art history in college and had studied the Wyeths. He knew that the late N. C. Wyeth, the family patriarch, had produced some 3,000 works, including illustrations for 112 books, among them *Treasure Island* and *Kidnapped*. Wyeth had also, in the 1920s, painted five great panels on the theme of "The Romance of Discovery" in the first National Geographic Society building.

So Harvey approached the assignment, "The Wyeth Family: American Visions," July 1991, with text by Wyeth biographer Richard Meryman, with a mixture of awe and anticipation.

Meryman sketched the founding father's character in the story:

"N. C.'s romantic idealism was boundless. He considered the 'spirit of family reverence' a lost art, and when his own family came, he set out to be the ultimate father. Until his death in 1945, he managed a hothouse of creativity to develop each child's talents to the utmost.

"He succeeded to an extraordinary degree."

Two of Andrew's four siblings became painters, one a composer, and one a noted engineer with many patents to his credit. Of 13 surviving grandchildren, 12 were working in the arts.

For Harvey, who is extremely skilled with people, the assignment seemed a long test. "They made me jump through a lot of hoops," he said. "I didn't realize that the family was as—as complex—as they are. You see this straightforward painting style, but this family is complex. N. C. Wyeth, I think, took an almost militarist approach with his kids: 'You will be an artist.' So all of them tried.

"Dick Meryman briefed me about how difficult it would be. He said, 'You're going to have to go slow, and you'll only spend an hour with Andy.' And I said, 'Hey, I've got to spend *days* with the subject.' He said, 'Well, that's not going to happen. I've known him for 25 years.'"

In his text, Meryman sought to explain Andrew's reclusiveness:

"Andrew, while adoring his father, was afraid of him....He...disappeared into the countryside, playing his make-believe games or soaking up alone the look and feel of the woods and cornfields. He developed the obsessively secret world that later would be the center of his creative process."

"Meryman was right, but also wrong," Harvey said. "I didn't live with Andrew, I didn't hang out with him, but I got probably about as close to him as an outsider can get."

When Harvey first arrived at the Wyeth home at Chadds Ford, Andrew told him, "Come round back to the barn; I'll be painting, and you can take your pictures."

"I said, 'OK, I'll take a few, but I'd really like to come back,' and he said, 'Well, this is it.'"

But Harvey managed to show Andrew Wyeth some of his photography, which interested the artist. And Harvey kept at him, spending an hour here and an hour there, waiting for opportunities and feeling, he said, "like a paparazzo."

When he made arrangements to photograph Henriette, Andrew's 83-year-old sister, also a painter, Harvey walked into her room and was surprised to find a virtual photograph waiting. "She was sitting in the light," remembered Harvey, "and I looked at it and thought, This is too good to be true. Who set this picture up? Did she do this? These are visual people. They would want to make it so that I couldn't miss—in case I was a really bad photographer."

One day Harvey went to the studio and Helga Testorf, the enigmatic German woman with thin blonde braids, a model with whom Wyeth had collaborated for 15 years in secret, answered the door. Harvey was shocked: "Nobody sees Helga, and nobody photographs her, and there she is, standing in the doorway. And she says, 'Come on in.' Andy is standing in the middle of the studio, smiling, and Helga immediately goes into the study and closes the door. Andy's saying, 'Well, I'm right in the middle of painting. I can't do anything with you. Wait here, and I'll come back out.'

"So I'm standing in this empty room. Time goes by. More time. An hour. Now it's starting to get dark. I was wearing cowboy boots, and I start pacing with these boots, wanting him to hear me in here. And he finally comes out and says, 'OK, what do you want to do?' He's standing in the middle of the room, and Helga is standing by the doorway. I can almost get a picture of the two of them. But if I make a move, something is going to happen.

"He goes over and starts looking at some tin soldiers on the windowsill, and I see that Helga is coming over to watch him get his picture taken—closer, closer—and I realize that with a 28-mm lens I can get her in the frame. But I'm maintaining eye contact with him. So I take two pictures with her in the right-hand side of

ARTIST ANDREW WYETH with Helga
"THE WYETH FAMILY" JULY 1991

PHOTOGRAPH BY DAVID ALAN HARVEY

the frame, and I realize I have photographs that nobody has taken before—a photographic coup.

"Andy played all these games. I never knew whether *I* was being crafty or *he* was being crafty, but by the end of it I realized that he had completely manipulated me—for fun, probably to see how I would react, just to test me. I think I passed his test. Meryman had written about the Wyeth family for 25 years and had never met Helga."

HUMORIST MARK TWAIN might have had a field day with Harvey's struggles to photograph the Wyeths; the tale is rich with the complexities of life. Twain, whose real name was Samuel Langhorne Clemens, loved such twists and turns. His world of riverboats and small boys was captured in "Mark Twain: Mirror of America," September 1975, by Noel Grove, with photographs by James L. Stanfield, both staff.

Grove, once an Iowa farmboy, decided that he could do no less than test the Mississippi himself. No one at headquarters said no, so he and a Maryland neighbor, Bill Patterson, went off to play Huck Finn. Grove chuckled in hindsight. "It seems absolutely amazing now that a company would pay you to go to St. Louis, rent a chain saw, walk along the river until you found enough driftwood and old lumber, build a raft, then spend three days going down the Mississippi. But you're doing Mark Twain, and his book, possibly the most famous book in our history, is *Adventures of Huckleberry Finn*. So why not build a raft and go down the Mississippi?

"In those days you called your own shots, and my feeling was that if I ever started calling them wrong and started coming up with bad stories, they wouldn't let me call them anymore."

Wrote Grove of their raft:

"It was not an easy voyage. Unseen currents tried to push us aground, or hold us away from the shore. A harmless-looking snag ripped up our deck boards as though they were cardboard. A front oar broke, and with crippled steering we drifted into the upswept prow of an anchored barge and were nearly sucked under."

"It was scary," he told me later. "That river is so powerful. On the last day, a young photographer from the *Des Moines Register and Tribune* jumped on the raft to take pictures. We tried to get back to shore, and we could not. The current would not let us. When I saw his photographs later, the fear was in my face. It was sort of twisted—not a pretty sight. Was I going to drown three people here because of my own foolishness?"

Grove traveled the country in Twain's footsteps, from his boyhood home in Hannibal, Missouri, to his much loved mansion in Hartford, Connecticut, with stops in New Orleans, Virginia City (Nevada), San Francisco, and other places where Twain worked at various jobs such as riverboat pilot, prospector, and newspaperman. Grove noted:

"[H]e ranged across the nation for more than a third of his life, digesting the new American experience before sharing it with the world as writer and lecturer. He adopted his pen name from the cry heard in his steamboat days, signaling two fathoms (12 feet) of water—a navigable depth."

To round out his research, Grove contacted actor Hal Holbrook, famous for his one-man Mark Twain impersonations, perhaps the most complete immersion into one man's psyche by another in history. "Holbrook lectured more as Mark Twain than Mark Twain did," said Grove.

Because most GEOGRAPHIC stories are written in the first-person style, a biography, especially a story about another writer, forces a writer to balance his subject with his own presence. When Grove turned in the Twain manuscript, Joseph Judge, then an assistant editor, told him he had too much Grove, not enough Twain. "*You're* not the funny man," Grove remembered Judge telling him. "Mark *Twain* is." Judge had a point, Grove conceded. He began revisions.

With broad humor, Twain both skewered and illumined the character of his countrymen. Grove quoted his characters with delight, in this case Huck Finn:

"'All I say is, kings is kings, and you got to make allowances. Take them all around, they're a mighty ornery lot. It's the way they're raised.'"

Grove seemed to pick up this spirit. He ended his story with this scene from his raft trip, as he passed Herculaneum, Missouri:

"As we came directly opposite the town, youngsters began detaching themselves from the houses and lawns high above until they stood, tiny dots against the high bluffs, to watch our passage. A shout drifted down:

"'WHERE DID YOU STA-A-R-R-RT?'

"'ST. LO-O-O-U-IS!'

"Silence drifted with us for several seconds, and then…

"'HOW FAR ARE YOU GO-O-I-I-NG?'

"We were moving farther apart with each shout. Long explanations about jobs, of deadlines, domestic duties, and the hundreds of responsibilities that nag at modern man would soon be impossible. I simplified my answer:

"'UNTIL WE GET TIRED OF I-I-I-IT!'

"No response floated back and I wondered if they had understood. I cupped my hands once again, when suddenly a strange sound, so unexpected it startled us, came rattling down the bluff and across the water. It was the sound of small hands clapping."

PHOTOGRAPHER BILL ALLARD wrestled mightily with another great writer in his coverage of "Faulkner's Mississippi," March 1989, with text by Willie Morris, a novelist and editor who then lived and taught in William Faulkner's hometown of Oxford, Mississippi. Said Allard, "I went down with more than a bit of fear because here I am in the shadow of an absolute American genius, in a part of the country that I hadn't touched on. And I decided, hey, I am not going to go down there and try to illustrate Mr. Faulkner's works. It's going to be Bill Allard's Mississippi, such as it is. I'm simply going to reflect what I see in a place that I go to.…"

But it wouldn't turn out exactly that way; Allard is too conscientious, too skilled.

Writer Morris had the advantage of knowing the land, the people. He wrote of Faulkner and Oxford:

"His spirit is still here, of course: in the woodsmoke of November from the forlorn country shacks, in the fireflies in driftless random in the town in June, in the summer wisteria on the greenswards and the odor of verbena, in the ruined old mansions in the Yocona bottoms, in the echoes of an ax on wood and of dogs barking far away…His niece, Dean Faulkner Wells, says that late one night in the house on South Lamar she awakened suddenly to the smell of his pipe. She knew his ghost was there."

Morris wrote that Faulkner's fictional world of "Sartorises and Snopeses, Compsons and Varners, Beauchamps and Gibsons, dogs and mules and woodlands and swamp bottoms was my world too."

"I had read, as a student, one of his books, *As I Lay Dying,*" said Allard. "It was a difficult read then. I didn't know if I was up to it, but I read the others, and I went down there thinking, I'm going to do what I do best, react to what I'm empowered to, and if I can find connections, fine."

Guided by his reading, he found connections. He photographed a horse and tack auction, a dove hunt, a prison cotton farm, small stores, mules, and, among other scenes, a beautiful University of Mississippi student holding a rose. This last photograph became the magazine cover. "I photographed her in a period cotton shift," he said, "in one of two houses in Oxford known as being the locations for Faulkner's 'A Rose for Emily.' I made that connection. The picture was highly successful. I felt good about it; I felt it was honest and that it evokes the Faulknerian world.

"Another thing I did was go to deer hunting camps in hopes of finding something that related to Faulkner's attraction to the woods. Faulkner was not especially a good hunter, but he'd go to the camps and

WALT WHITMAN letter and Lincoln memento
"AMERICA'S POET: WALT WHITMAN" DECEMBER 1994
PHOTOGRAPH BY MARIA STENZEL

tell wonderful stories about the bear and the dogs and the big woods. They used to ride out with the field hands, on mule-drawn wagons; today they go out on all-terrain vehicles.

"I went there looking for a strong image, and the picture we used was of a buck hanging on the porch of a cabin. Someone had left his hunting knife there, and a round plastic ashtray and a cigarette butt. This was shot after dark, and I went by this porch several times. When I have that kind of time, with an inanimate object, I try to take that piece of space and look at it in different ways. Even if it's done in a fraction of a second, you're still putting together a puzzle: How does that space fit together? Where's your sense of grace? There are infinite ways of putting it together, and the difference can be as much as six inches, bending your knees. That picture was successful because of the darkness, and where the light fell.

"But the knife is everything in that photo. It brings up violence. There's violence here—it is the underlying element."

In Faulkner's *Go Down, Moses,* young Ike McCaslin undergoes a rite of passage in the "big woods" of northern Mississippi when Sam Fathers marks his face with the hot blood of the deer the boy has just killed. Allard's Mississippi, Faulkner's spirit.

"STRANGER, IF YOU PASSING meet me and desire to speak to me, why should you not speak to me? / And why should I not speak to you?" Walt Whitman wrote in *Leaves of Grass* with gusto, his exuberant "yawp" transcending regional geography and going to the crux of an earthy American experience. For photographer Maria Stenzel, it was a challenge to create two-dimensional reality of the poet's abstractions for "America's Poet: Walt Whitman," December 1994, written by senior writer Joel Swerdlow.

Stenzel liked Walt Whitman. "I liked his values, his politics," she told me. "Apparently he could be a pain in the neck, self-centered, and maybe I wouldn't have liked him as a person. But Whitman is accessible, because everything is so personal—his poems, his journals. Yeah, I fell for the guy.

"One day I was in my hotel room in Manhattan," said Stenzel, "a crummy room that looked out on a vertical shaft between buildings, where you see other windows and air-conditioning units—a view of nothing. But I happened to look out, and I saw these guys pulling on a rope and hauling some tar paper up, and I thought, Oh, my God, workers! That quick I ran down to the lobby: 'Can I get on the roof of your building?'

"It's a very weird thing to introduce yourself to strangers and tell them, 'I'm doing a story on a poet—can I take your picture?' These were working guys from Brooklyn, and they were incredulous, but they humored me, and we got a good picture. Whitman thought that all manual labor was honorable."

The poet wrote: *"I hear America singing, the varied carols I hear, / Those of mechanics, each one singing his as it should be blithe and strong, / The carpenter singing his as he measures his plank or beam, / The mason singing...."*

"That's part of the pleasure I take in these stories—the intellectual exercise," Stenzel said. "My major in college was American studies, and I felt that I was continuing in my major. I spent four months on Whitman. I started in the spring in Gettysburg; I rushed out to get lilacs [*When Lilacs Last in the Dooryard Bloom'd—* Whitman's tribute to the death of Lincoln]. I never got a great lilac picture, but I was still shooting that following winter. I was shooting in Washington, D.C., where Whitman tended Civil War wounded. I shot at night in the snow, because the snow took away modern stuff."

But when Stenzel poked her lens through the White House fence to illustrate *"...the White House of future poems, and of dreams and dramas,"* a guard intervened. "'Get that away,' he said. 'You can take a picture, but you can't use a tripod.' And I went across the street into Lafayette Park, and I was kicked out of the park, too. To shoot at these places around the White House with a tripod, you need a special permit. Who knew?"

Stenzel's photographs were already finished when writer Swerdlow began. "I loved the idea of being paid

to read *Leaves of Grass* and figure it out," he said. "I had gotten a C in freshman English at Syracuse University, and I was so disappointed that I never took another English course. I loved books but never could connect to poetry. I had a copy of *Leaves of Grass* at home that I had marked up at some point but had no memory of reading it. I was going to use the story as an opportunity to get a relationship with Whitman.

"I was looking for something within myself that could get me to appreciate what I was missing. I went up to Long Island to Whitman's birthplace, which is diagonally across the street from the Walt Whitman Mall. And I was sitting in my motel feeling, What a stupid way to spend my life! Here I am, far from my family. I'm not with my wife, not helping the kids with homework. I'm getting paid to sit here and read Walt Whitman's poetry.

"So I sat back to read his poems, and in a few minutes I'm looking at television. Then I realized that's how most people react to poetry. Given a choice, they're going to watch television. Then I realized that if I didn't get enough understanding of the poetry to genuinely want to read it, the story would be a flop.

"Walt Whitman says in *Leaves of Grass* that what you have to do is read the poetry out loud. And I finally realized that poetry is not something you read silently; poetry is oral, and it's performance."

It was a personal revelation for Swerdlow. He wrote:

"Whether reading silently or aloud, you must participate. You cannot enter this territory as a tourist. Reading Whitman is not like reading a novel or seeing a movie. You cannot sit passively as a story sweeps you away. Rhythm and feeling must come from both you and the poet. Bring your hopes, frustrations, and fears. You are part of the art.

"In many ways my search has ended. I have found Leaves, *which is so personal, so intense, I have also found Whitman. No one can tell where the man ends and the creation begins. He talks to me. Other times he is me, talking to other people.*

"Some evenings I read Whitman for only five minutes. Even then, he leaves me simmering."

OF WHITMAN, SWERDLOW SAYS: "He is a hero of the common people, and I say people, because it was men and women, slaves and nonslaves. In terms of egalitarianism, he was ahead of his time. In his formative years, in the 1840s, he saw that the emotions and the experiences of common people are uncommon, that beautiful art can describe a man fixing a roof, or a mother feeding her children—that art was for the people, and not for the elite."

Whitman's free-spirited sensuality has been a distraction for some who might otherwise admire his poetry more. "There's evidence that he had emotional attractions toward younger men," said Swerdlow, "and it's clear that he wrote powerful, erotic poems, but I can't find in his letters that he had sexual relations with either men or women."

Whitman's embrace of life was all-consuming, and bias toward sexuality, race, religion, national origin, or other factors that might separate Americans is profoundly antithetical to his spirit. Moreover, said Swerdlow, "Prejudice is often based on the values of different times.

"My father was born in a sod hut in North Dakota, and he remembered men from the town who were bored, saying, jokingly, 'Let's go to the reservation and shoot some Indians.' A crude joke, but it is part of the American past and of the human condition. I think there must be biases and notions that we live by now that will shock the next generation. And we don't know what these notions are. We're children of our time.

"One of the powers of Whitman's poetry is that it has a universality and sense of decency and fairness that transcends periods. The next generation, when they look back on us and find our faults, will still find that Whitman inspires them. This ordinary man, suddenly, in his 30s, presented the world with *Leaves of Grass,* which, in its meter and lack of rhythm, revolutionized poetry. He just decided to reinvent poetry.

"America is the country where you can be what you want to be, he said: Come to America and invent yourself if you have the courage and ability. Invent yourself." ■

"AMERICA'S POET: WALT WHITMAN"
DECEMBER 1994

UNIVERSITY OF VIRGINIA LIBRARY, CHARLOTTESVILLE

"AMERICA'S POET: WALT WHITMAN"

December 1994

photographs by
MARIA STENZEL

text by
JOEL L. SWERDLOW

PASTORAL VISION from the window
of a train traveling between Baltimore,
Maryland, and Harrisburg, Pennsylvania,
illustrates Whitman's famous poem,
When Lilacs Last in the Dooryard Bloom'd.

306

"FAULKNER'S MISSISSIPPI"

March 1989

photographs by
WILLIAM ALBERT ALLARD

text by
WILLIE MORRIS

FAULKNER DREAMED of raising
mules, like these for sale in New Albany.

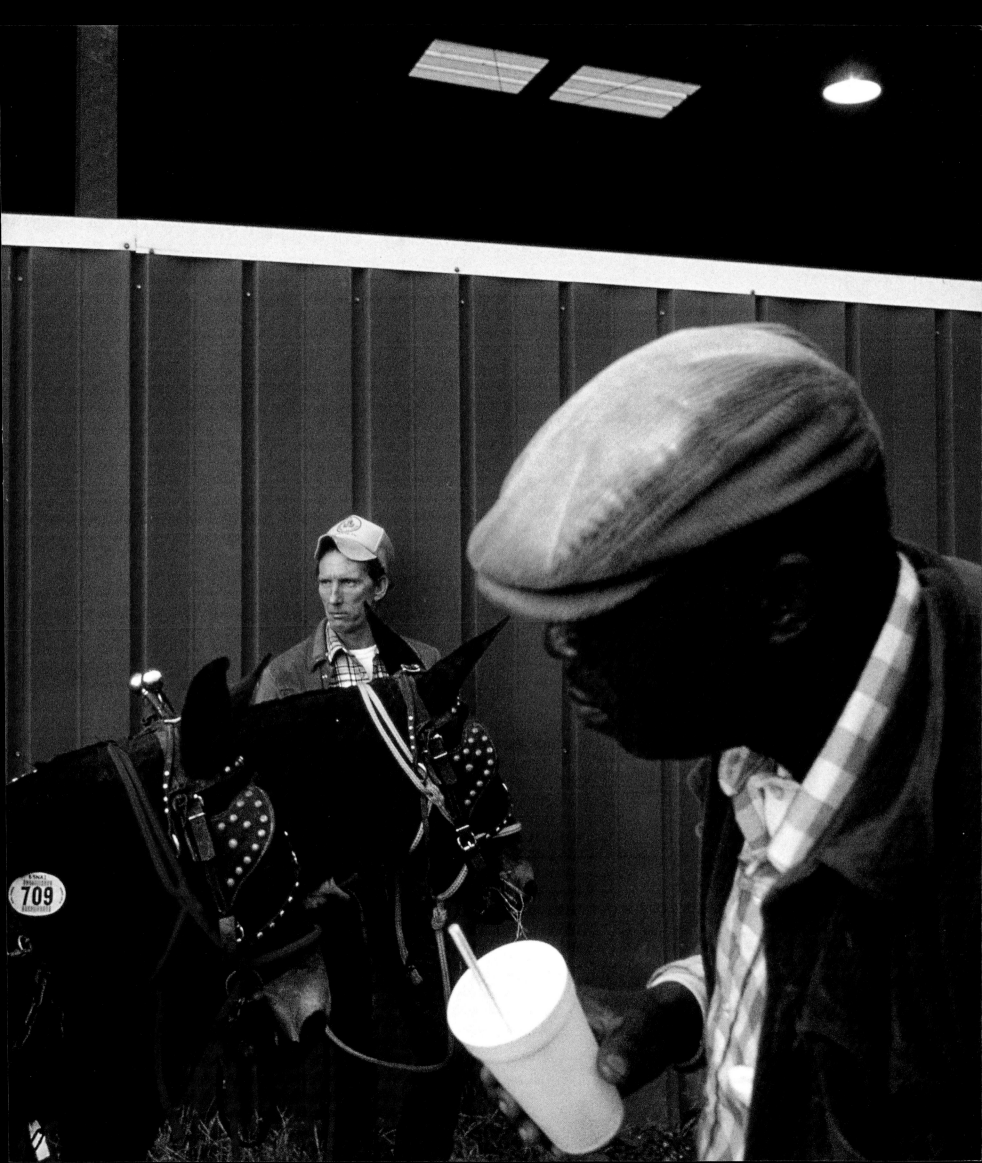

ON A SUNDAY AFTERNOON
friends and relatives of blues musician
Junior Kimbrough relax at his home
near Holly Springs, Mississippi.

NICKY HEWLETT waits for friends
on a porch in rural Taylor.

FRESHLY KILLED BUCK hangs inside the screened porch of a hunting club near Clarksdale. Faulkner savored the drama of the hunt, "the ancient and unremitting contest...which voided all regrets and brooked no quarter...."

"MARK TWAIN: MIRROR OF AMERICA"

September 1975

photographs by
JAMES L. STANFIELD

text by
NOEL GROVE

FARM IN VALMEYER, Illinois, along Twain's
Mississippi. Many of his characters were rooted
in the river's valley.

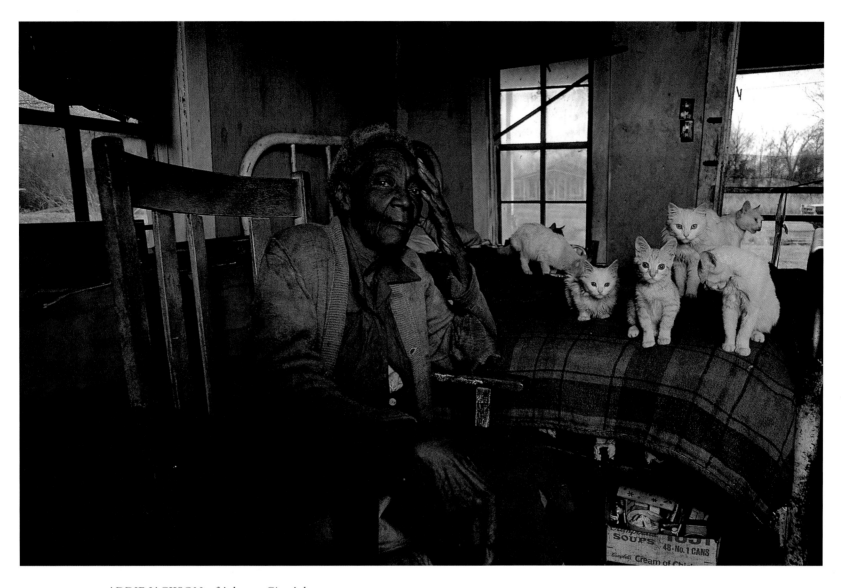

ADDIE JACKSON, of Arkansas City, Arkansas,
survived the record Mississippi River flood of 1927. Twain,
who piloted steamboats on the river, questioned attempts
to control the river's flooding.

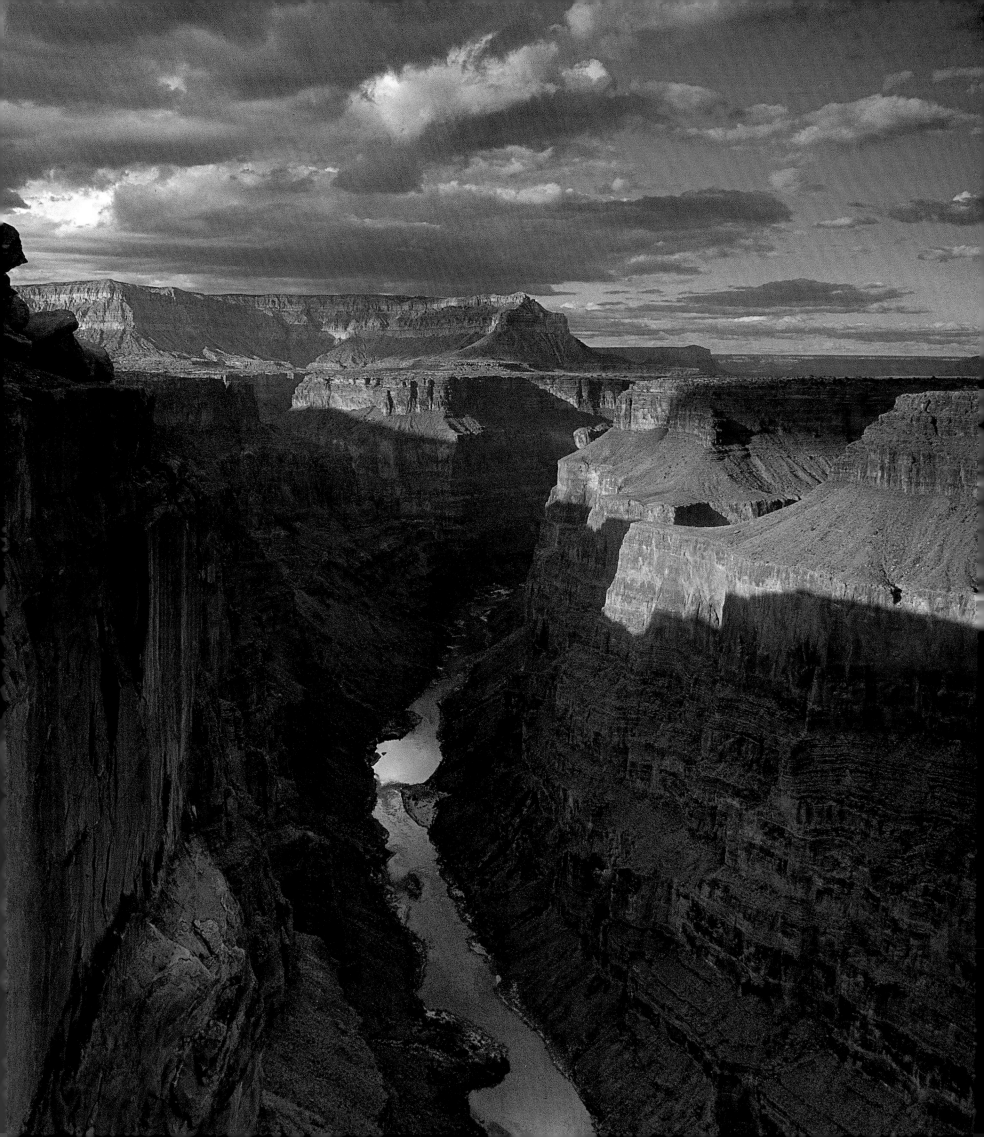

"JOHN WESLEY POWELL: VISION FOR THE WEST"

April 1994

photographs by
BRUCE DALE

text by
PETER MILLER

SUNRISE ILLUMINATES the sandstone face of Toroweap Overlook, 3,000 feet above the Colorado River in Arizona's Grand Canyon (opposite); cannon at Bloody Pond, Shiloh National Military Park, Tennessee, stands yards from where Captain Powell was injured in battle.

"SAM HOUSTON:
A MAN TOO BIG FOR TEXAS"

March 1986

photographs by
CHARLES O'REAR

text by
BART MCDOWELL

SHADOWY SILHOUETTE stands
guard at fortress at Goliad, Texas,
where a detachment of Santa Anna's
forces massacred 352 Texas
defenders just days after Mexico's
victory at the Alamo.

318

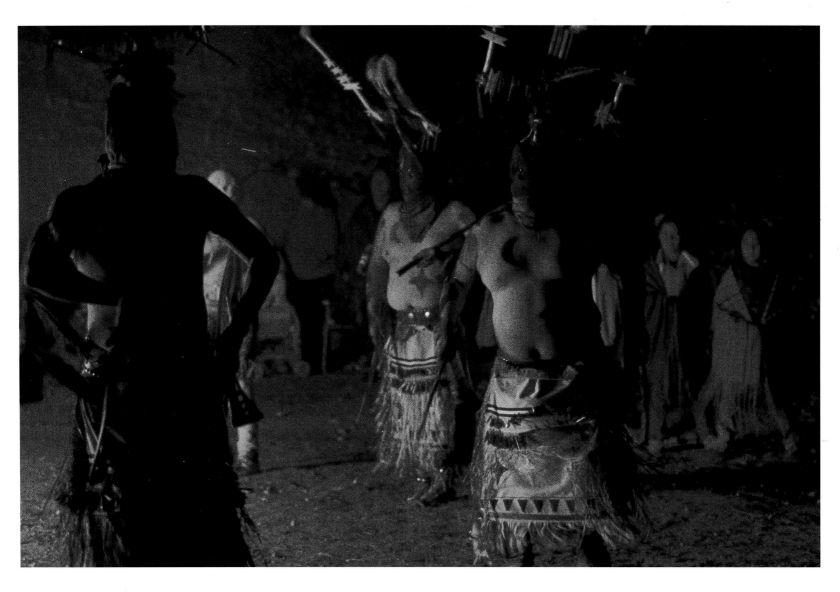

"GERONIMO"

October 1992

photographs by
BRUCE DALE

text by
DAVID ROBERTS

CONNIE RAE RICE, age 14, waits to begin the traditional Apache puberty ceremony, a 12-day rite of passage (opposite); Chiricahua Apache dancers enact the Dance of the Mountain Spirits in Mescalero, New Mexico.

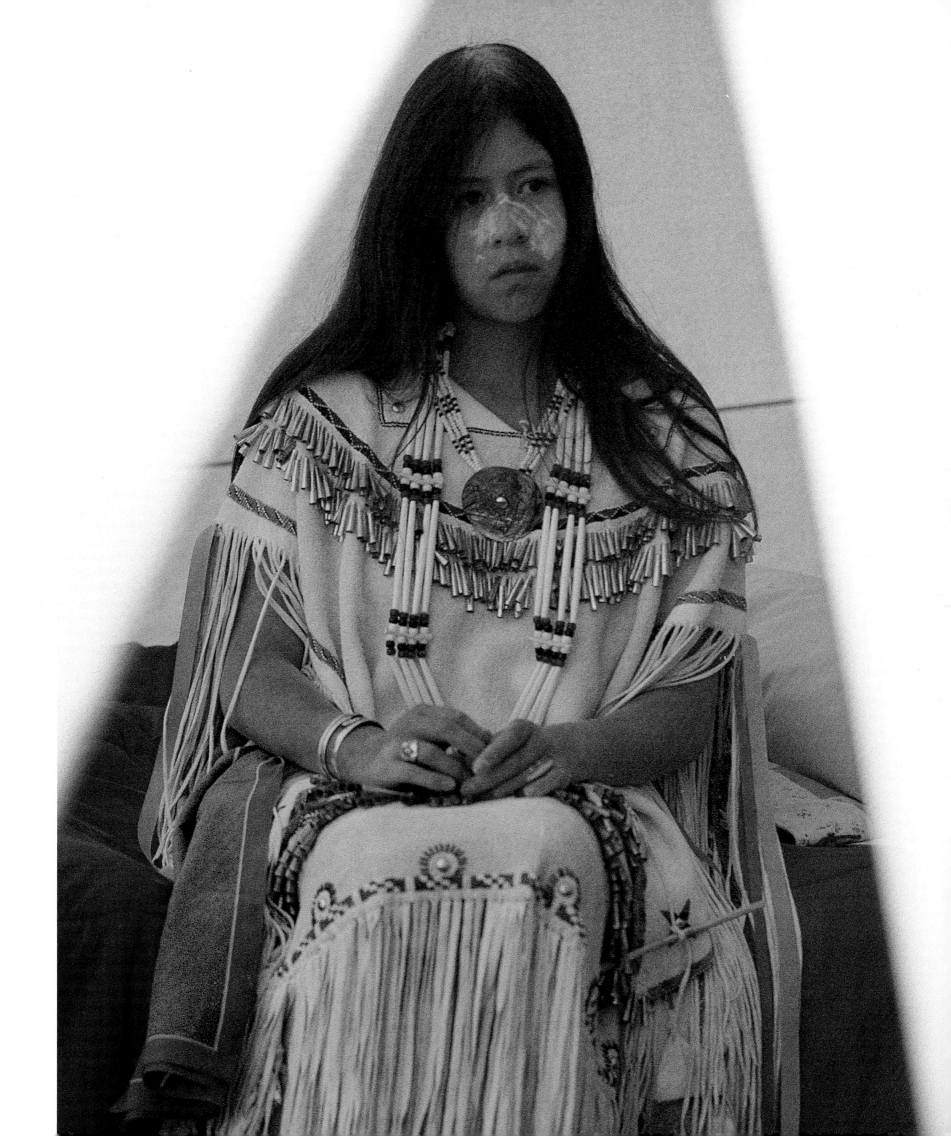

"ALDO LEOPOLD:
'A DURABLE SCALE OF VALUES'"

November 1981

photographs by
JIM BRANDENBURG

text by
BOYD GIBBONS

BARN LIGHTS SIGNAL dusk on a
Minnesota farm. Leopold, a naturalist,
sought to preserve such rural landscapes.

"AUDUBON 'ON THE WING'"

February 1977

photographs by
BATES LITTLEHALES

text by
DAVID JEFFERY

ANHINGA LOOKS for prey in Everglades
National Park, Florida.

"DANIEL BOONE, FIRST HERO OF THE FRONTIER"

December 1985

photographs by
WILLIAM STRODE

text by
ELIZABETH A. MOIZE

MIST SETTLES in the Cumberland Gap
near border between Kentucky and Tennessee.

"THE WYETH FAMILY: AMERICAN VISIONS"

July 1991

photographs by
DAVID ALAN HARVEY

text by
RICHARD MERYMAN

HENRIETTE WYETH, who passed
away in 1997, continued to paint well
into her 80s.

PAINTER JAMIE WYETH, Andrew's son, in portable plywood studio used to shield him from the gaze of tourists on Maine's Monhegan Island.

FROM A BARN WINDOW
painter Andrew Wyeth
surveys his home in Chadds
Ford, Pennsylvania.

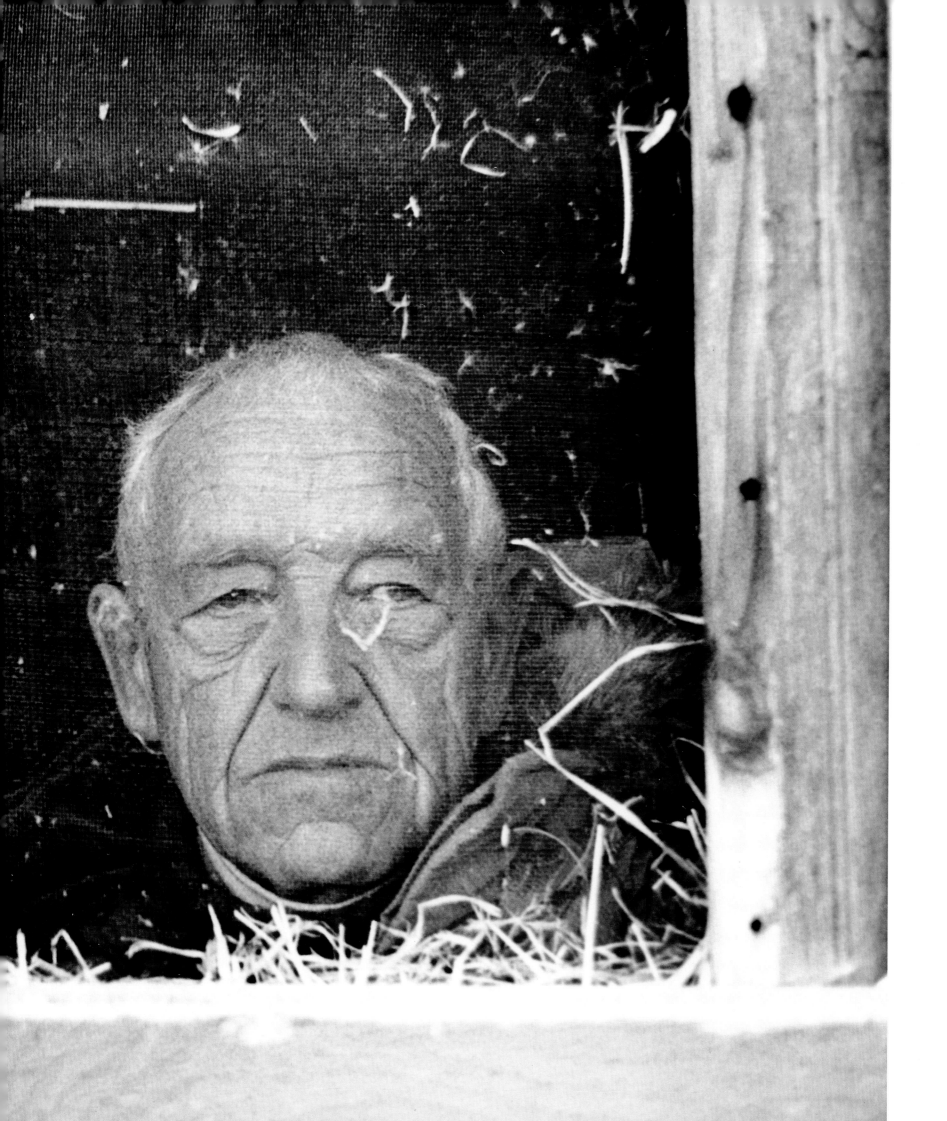

INDEX

Boldface indicates illustrations.

Abell, Sam **24**, 29, 32, 89, 120, 296; photos by **5**, **24**, **121**, **289–297**, **336**

Abercrombie, Thomas J. **198**, 199, 211

Abrams, Rebecca 265

Adams, Clifton 196

African Americans 90–91; Atlanta, Ga. 264; Harlem, N.Y.C. 264–265; Philadelphia, Pa. **106–107**

Aikman, Lonelle 299

Alaska: early NGM stories 130; Eskimos **110–113**, 201–202; *Exxon Valdez* oil spill **180–183**; Highway **142–143**; Mount Hayes expedition (1941) **26–27**; mountain biking 136, **137–139**; pipeline 46–47

Alaska (Keating) 202

Aldrin, Edwin E., Jr. 231

Allard, William Albert **19**, 32, 79, 84, **86**, 87, 131–132, 202, 303–304; photos by **6–7**, **79–86**, **102–105**, **114–119**, **203**, **308–313**

Allen, Thomas B. 197

Allen, William L. 47

The American Cowboy in Life and Legend 86–87, **114–116**, **118–119**, 298

American Mountain People **108–109**, 201

Amish 88–89

Amos, James L. 264

Anders, William A. 46

Angelou, Maya 90

Appalachia, U.S. 201

Arches N.P., Utah **218–219**

Arden, Harvey 134, 135

Arkansas: 1978 NGM article 199–200

Armstrong, Neil A. 231, 232

Arnold, David L. 296

Atlanta, Ga. 264

Autochrome 130

Azel, José: photo by **270–271**

Baja California, Mexico **208–209**

Bears 136; grizzly 4, **70–71**, **145**; Kodiak brown **220–221**

Beekeepers: 1993 NGM article 91–92, **93–95**

Bell, Alexander Graham 230

Belt, Annie Griffiths **19**, 28, 29, 189, 194–195, **196**; photos by **189–195**, **196**, 199, 201, **208–209**

Belt, Don **18**, 29, 209

Benn, Nathan **265**, 266; photos by **1**, **12–13**, **284–285**

Berry, Wendell 50

Bison **42–43**, 72

Blackburn, Reid 171

Blair, James P. 45, 133; photos by **60–61**

Blair, Jonathan 230, 299; photos by **300**

Blockson, Charles L. 90

Blue Cloud, Peter 36

Borah, Leo A. 197–198

Boraiko, Allen A. 47

Borman, Frank 46

Boslough, John 251

Boston, Mass.: swim club **286–287**

Bradley, LaVerne 264

Brain: 1995 NGM article 234–235

Brandenburg, Jim 35, 36, 42, 44, 202; photos by **16–17**, **35–43**, **322–323**

The Bridges of Madison County (Waller) 32

Brower, David 46

Bruchac, Joseph 50

Bryce, James 262–263

Byrd, Richard E. 298

Cache River State Natural Area, Ill.: cypresses **67**

Cahill, Tim 49, 69

California: 1915 NGM article 196–197

Canaveral, Cape, Fla. 230–231

Canby, Thomas Y. 169

Carey, Alan: photo by **176–177**

Carey, Sandy: photo by **176–177**

Caribou **31**

Carrier, Jim 59

Carroll, Allen 235

Carson, Rachel 45

Chadwick, Douglas H. **18**, 48, **49**, 62, 71

Chapman, Wendell 22, **23**; photo by **23**

Childs, David 266

Chimpanzees: digital imagery **237**

Circus acrobat: Port Townsend, Wash. **336**

Clatworthy, Fred Payne 130

Clemens, Samuel Langhorne 302

Cleveland, Ohio 46, **60–61**

Coal miners: W. Va. **108–109**, 153

Cobb, Charles E., Jr. 33, 90–91, 233, 240, 277

Cobb, Jodi **18**, 28, 253, 262, 268; photos by **253–261**, **282–283**

Collins, Michael 232

Colorado River, U.S.-Mexico 130–131, **140–141**, **316**

Conger, Dean 133, **231**; photo by **242-243**

Connecticut: 1938 NGM article 197–198

Cooper, Gordon 231

Cowboys 86–87, **114–119**, **125**, **126**, **150–151**, **210–211**, **213**, **290–291**, **294–297**, 298

Craighead, Frank, Jr. 45

Craighead, John 45

Cumberland Gap and region, Ky.-Tenn.-Va. 201–202, **325**

Curtis, Edward S. 87; photo by **99**

Cuyahoga River, Ohio: pollution 46, **60–61**

Dale, Bruce 88, 200–201; photos by **10–11**, **108–109**, **150–151**, **250–251**, **316–317**, **320–321**

Davidson, Bruce: photos by **21**

Des Moines, Iowa: flood victim **186–187**

Dial, Roman 136–137

Dickman, Jay **19**, 169–170

Dinosaur model **245**

Diomede Islands, Bering Strait 202

Doll, Don: photos by **110–113**

Douthitt, Bill 232–233, **235**, 236; photos by **32**

Dryden, Hugh L. 231

Dufay process 198

Earhart, Amelia 298

East Hardin, Ill. 168–169

Eastman, George 230

Edison, Thomas 230

Edwards, Mike W. 149, 201

Ellis, William S. 264, 265, 268, 286

Endangered species: El Segundo blue butterfly **64–65**; 'i'iwi 48; nēnē **75**; whooping crane carcass **62–63**

Erie Canal, N.Y. **146–147**

Essick, Peter **18**, 47; photos by **47**, **131**

Everglades N.P., Fla.: anhinga **324**; rattlesnake **74**

Farlow, Melissa 54; photo by **57**

Faulkner, William 303–304

Fetterman, John 109, 201

Findley, Rowe 42, 150, **170–171**, 175

Finlay process 198

Fisher, Allan C., Jr. 152, 230, 231

Fobes, Natalie: photos by **180–183**

Football team in bus: Idaho **128–129**

Franklin, Stuart 47

Freeman, Roland L. 90, 106–107; photos by **106–107**

Freidel, Frank B. 299

Fuertes, Louis Agassiz 45

Galveston, Tex.: hurricane (1900) 167

Garrett, Wilbur E. 135; photos by **140–141**

Gas stations: Nevada **127**; Nothing, Ariz. **14–15**

Gates, Bill **236**

Gehman, Raymond 50; photo by **66**

Georgia: 1926 NGM article 197

Georgia, Lowell 48

Gibbons, Boyd 29, 199, 247, 322

Goliad, Tex.: fortress **318–319**

Gore, Christopher 261, 268

Gore, Rick 158, 161, 164, **166**, 232, 237, 244, 254, 261–262, 268, 269

Grand Canyon, Ariz. 26, **54–55**, 130–131, **140–141**, **316**

Graves, Ralph A. 197

Graves, William 47, 164, 197

Gray, Mary Ellen 133

Gray, Ralph 132–134

Gray, William 133

Great egret: Venice, Fla. **66**

Great Sand Dunes N.M., Colo. **16–17**

Griffin, David 235

Grosvenor, Gilbert H. 24–25, 45, 230

Grosvenor, Gilbert M. 134, 135, 299

Grosvenor, Melville B. 133, 231, 299

Grove, Noel 202, 302–303, 314

Harvey, David Alan 28, 88, 300–302; photos by **8–9**, 29, **100–101**, 302, **326–331**

Hatcher, Bill 136; photos by **137–139**

Havasu, Lake, Ariz.-Calif. **58–59**

Hawaii: endangered species 48, **75**

Hayden, Everett 167

Henshaw, Henry Wetherbee 45

Hercules, Frank 90, 264–265

Highways: Alaska **142–143**; U.S. Route 40 133; U.S. Route 89 133; U.S. Route 93 **14–15**, **123–129**, 130

Hiser, David: photos by **148–149**

Hodgson, Bryan 28, 46–47, 72, 180, 191, 192, 194

Hubbard, Gardiner Greene 24, 223

Hunting club: Clarksdale, Miss. **312–313**

Hurricanes: Andrew (1992) **157–166**; Galveston, Tex. (1900) 167

Hutterites 86, **102–105**

Iceberg Lake, Calif. **148**, 149

Information technology: 1995 NGM article **235–239**

Jackson, Carmault B., Jr. 231, 242

Jaret, Peter 233

Jeffery, David 169–170, 178, 324

Jenkins, Barbara 135, 154

Jenkins, Peter Gorton 134–135, 154; photos by **154–155**

Johns, Chris 29, 48, 128, 130, 216; photos by **14–15**, **74–75**, **123–129**, **216–217**

Johnson, Johnny: photo by **70–71**

Johnston, David 171

Jones, Stuart E. 89

Judge, Joseph 303

Kane, Harnett T. 264, 266

Kasmauski, Karen 25, 28, **32**, 232, **233**, 234; photos by **233**, **240–241**

Keating, Bern 202

Kennedy, John F.: 1964 NGM tribute 299

Kennedy, Thomas R. 25, 86

Kernan, Michael 283

Kihn, Wilfrid Langdon 87

King, Martin Luther, Jr. 264

Kings Canyon N.P., Calif.: star trails over sequoias **36–37**

Klinkenborg, Verlyn 50, 51

Knoebber, John 235

Kobersteen, Kent 25, 28, 164, 167, 196

Kodachrome 264

Kolb, Ellsworth 130

Kolb, Emery 130

LaBastille, Anne 47

Lamb, David 80, 82, 84, 86

Lanker, Brian 90

Las Vegas, Nev. **278–281**

Lechuguilla Cave, N. Mex. 49–50, **68–69**

Lee, Douglas Bennett 214

Leen, Sarah: photos by **72–73**

Leopold, Aldo 322

Lewis and Clark Expedition 133

Lightning **184–185**, **248–249**

Lincoln, Abraham 299, 304

Littlehales, Bates: photo by **324**

Living on the Earth 216

Locke, Justin 264

Long, Michael E. **130–131**, 225, 229–230

Looney, Ralph 88

Los Angeles, Calif. 197, 268; butterfly near airport **64–65**; Sunset Blvd. 268, **269**

Lovell, James A., Jr. 46

Luscombe, Robert: photos by **265**

MacArthur, Douglas 299

MacLeish, Archibald 46

Madden, Robert W. 88, **89**, 171; photos by **89**, **175**

Maddox, Lester 264

Mairson, Alan 25, 74, **91**, 92, 93, 168

Malcolm, Janet 92

Marden, Luis 230, 231

Martin, Charles 196

Massachusetts: 1920 NGM article 197

McCurry, Steve 28, 268; photo by **269**
McDowell, Bart **18**, 29, 87, 115, 291, 292, 296, 298, 318
McGee, W J 167
McGill, Ralph 264
McNally, Joe 229, 230; photos by **223–229**
Menzel, Peter: photos by **184–185, 248–249**
Mermaids: Weeki Wachee Spring, Fla. **214-215**
Meryman, Richard 301, 326
Mexico-U.S. border 86, 131
Miami, Fla.: Biscayne Blvd. **276–277**
Miller, Peter 136, 265, 285, 317
Minnesota: farm **322–323**; lakes 202, **203**
Minor-league baseball **79–85**, 86
Mississippi River and Valley, U.S.: farm near Valmeyer, Ill. **314**; floods 168–169; 1927 flood survivor **315**; raft trip 302–303; rural emigrants 90–91
Mitchell, John G. 50, 54, 66
Mobley, George F. **19**, 32, **201**; photos by **299**
Moize, Elizabeth A. 325
Mongoose: Hawaii **75**
Monterey, Calif.: tide pools **40–41**
Monument Valley, Ariz.-Utah: lizard **39**; monoliths **10–11, 38**
Morris, Willie 303, 308
Moscow, Idaho: newlyweds **53**
Mountain biking: Alaska 136, **137–139**
Muir, John 134
Mules: New Albany, Miss. **308–309**

Nashville, Tenn.: performers **282–283**
National Aeronautics and Space Administration (NASA) 230–232
NATIONAL GEOGRAPHIC magazine: African-American topics 90–91, **106–107**; aviation and space 230–232; biographical stories 296–305; biology and medicine 232–235; Columbus quincentennial issue (1991) **36–43**, 44, 50; disaster reporting **158–166**, 167–170, **171–183**; early wildlife photography **31**, 44, **45**; environmental advocacy 44–46, **47**, 48–50, **51–53, 60–67**, 74; exploration narratives 130–131, 298; goals and policies 24–25, 196; Native American ethnology 87–88, **96–101**; paper 197; publication schedule 167–168; science and technology 229–236; urban reporting 261–268; U.S. Presidents 298–299; U.S. state and regional stories 194, 196–202, 296–305; "Water" issue (1993) **47**
National Geographic School Bulletin 132–133
National Geographic Society: environmental advocacy 44; founding 24; Image Collection 99; N.C. Wyeth paintings 300–301; sequoias 44
National Park Service 131; fire policy 169
Native Americans: Abenaki 50; Apache **320–321**; Blood 298; Cherokee **96–97**; council meeting **98**; Cree 88; Crow 88; Eskimo **110–113**, 201–202; Jívaro 87; Mohave **99**; Mohawk 36–37, 50; Navajo 38, 87–88; Nez Perce 86; Olmec 87;

Paipai **208–209**; pre-Columbian 42, 44; Shoshone Sioux 42–43, **100–101**; Yukon Terr., Canada **144–145**
Nebbia, Thomas 231, 299
Nebraska: 1998 NGM article 200
New Orleans, La. 264, 266–267; cougar in Audubon Park Zoo **76–77**; Mardi Gras 267, **272–273**
New York, N.Y. **21**, 261, **263**; Broadway **253–259**, 261–262; Central Park **270–271**; Chrysler Bldg. **1**; East Harlem **274–275**; Harlem 264–265; Statue of Liberty **21, 22**
Newcott, William R. 184, 249, 279
Newman, Cathy **18**, 89–90, 120, 199, **200**, 206
Niagara Falls, Canada-U.S. **47**
Nicholas, William H. 263–264
Nichols, Michael **19**, 49–50; photos by **68–69, 76–77**
Niezabitowska, Małgorzata 135; photo by **135**
Nilsson, Lennart 233
Norman, Geoffrey 96
North Carolina: 1995 NGM article 199–200, **206–207**
North Dakota **189–195**; economic crisis (1987) 194, 196

Ogallala Aquifer 50
Ohio River, U.S. 22, 24, 132
Okefenokee Swamp, Fla.-Ga.: canoe **5**
Olsenius, Richard 33, 86, 142–143, 198; photos by **142–145, 210–213**
Olson, Randy 54; photo by **56**
Oppenheimer, Robert 233
O'Rear, Charles: photo by **318–319**
Ortiz, Simon 38
Outlaw Trail, U.S. West 299–300
Oxford, Miss. 303–304
Ozark Plateau, Ark.-Miss. 201

Pacific Crest Trail, U.S. **148–149**
Padlock Ranch, Wyo. 86, 87
Paine, Thomas O. 232
Palouse region, Idaho-Wash.: farmer and sons **51**
Parfit, Michael 32, 47, 88, 101, 123, 124, 126, 128, 130
Patterson, Carolyn Bennett 299
Peary, Robert E. 298
Peterson, David: photo by **186–187**
Petty, Richard 199
Philadelphia, Pa.: African Americans **106–107**
Photography: digital manipulation 236, **237**; high-speed 31, **250–251**
Piedmont Plateau, U.S. 200
Pillsbury (agency): photo by **25**
Pinchot, Gifford 44
Pittsburgh, Pa. **12–13**, 265, **284–285**
Pollution 44, 45–46; Cuyahoga River, Ohio 46, **60–61**; *Exxon Valdez* oil spill **180–183**
Poole, Robert M. 33, 168
Powell, John Wesley 130, 317
Powwows **8–9**, 87–88, **96–97**, **100–101**
Prison farm: Parchman, Miss. **6–7**
Project Mercury 231
Psihoyos, Louie **235**, 236; photos by **235-239, 244–247**

Radiation: 1989 NGM article 232, **233, 240–241**
Ranch hands: Modoc County, Calif. **204–205**
Ransome, Frederick Leslie 167
Raymer, Steve 46–47; photos by **171**
Red River Valley, N. Dak.: fields hit by storms **192–193**; sunflowers **190–191**
Redford, Robert 299, **300**
Reed, Roland: photo by **98**
Reynolds, Brad 111
Richardson, Jim **18**, 29, 47, 50, 66, 202; photos by **51–53, 58–59, 67**
Rickman, Rick 47, 197
Roberts, David 320
Rocky Boy Reservation, Mont. 88, **100–101**
Rodriguez, Joseph: photos by **274–275**
Rogers, Martin 22, 132; photo by **132**
Rogers, Will 298
Roosevelt, Theodore 87, 298
Rosenquist, Gary **172–173**, 175
Royte, Elizabeth 48, 75
Russell, Charles M. 291–293, 296, 298

Sacagawea (Shoshone guide) 133
Sacha, Bob 266, **267**; photos by **146–147, 267, 272–273**
Saloons: Ely, Nev. **126**; Magdalena, N. Mex. **118–119**; Miles City, Mont. **73**; Pelican, Alas. **216–217**
San Diego, Calif. 263
San Francisco, Calif. 197, 264; earthquake (1906) 167
Sandburg, Carl 299
Sanford, Ron: photo by **54–55**
Santa Clauses: N.Y.C. subway **260**, 262
Santa Fe Trail, U.S. **150–151**
Sartore, Joel **18**, 29, 32, **33**, 49, 164, **166**, 197–198, 201; photos by **49, 62–65, 157–166, 204–205, 214–215, 218–219, 286–287**
Selfridge, Thomas 230
Shepard, Alan B., Jr. **231, 242, 243**
Shenandoah N.P., Va.: Skyline Drive **57**
Shiloh N.M.P., Tenn. 317
Shiras, George, 3d **30**, 31, 44, **45**; photos by **30–31, 45**
Shor, Franc 131
Showalter, William Joseph 197, 263
Sight, sense of: 1992 NGM article **224–229**, 229–230
Simpich, Frederick 131, 168, 197, 199, 263
Skyscrapers **1, 258**, 266
Smell, sense of: 1986 NGM article **246–247**
Smith, Fred K.: photos by **184–185**
Smith, Thomas R. 134, 299
Souza, Pete 200; photos by **206–207**
Spiegel, Ted 47
Square Butte, Mont. **292–293**
St. Helens, Mount, Wash.: eruption (1980) 170–171, **172–177**
Stanfield, James L. 302; photos by **152–153, 314–315**
Steber, Maggie: photos by **96–97, 276–277**
Stein, Benjamin 268
Steinmetz, George 47
Stenzel, Maria 91–92, 93, 304; photos by

91, 93–95, 278–281, 306–307
Stewart, B. Anthony 299
Stirling, Matthew W. 87
Stolen Season: A Journey Through America and Baseball's Minor Leagues (Lamb) 84
Storm clouds: Gilliland, Tex. **154–155**
Strode, William: photo by **325**
Swerdlow, Joel L. 147, 234, **235**, 237, 271, 304–306

Taft, William Howard 298
Tarpy, Cliff 77
Taub, William: photos by **231, 242**
Testorf, Helga 301, **302**
Texas: 1928 NGM article 198
Tobin, Carl 136
Tomaszewski, Tomasz **135**, 136
Train, Russell E. 46
Twain, Mark 296, 302–303, 314

Van Dyk, Jere 274
Vanishing Breed: Photographs of the Cowboy and the West (Allard) 87
Vanuga, Jeff: photo by **178–179**
Varley, John 170
Vaughn, W. D. "Bill" 299
Vesilind, Paul Eduard: photo by **22**
Vesilind, Priit J. 3, **22**, 24, **29**, 32, **33**, 132, 140, 157, 202, 266, 268, 273, 289
Viruses 233–234
Vosburgh, Frederick G. 45–46, 263

Walker, Howell 132
Ward, Fred 47
Ward, Geoffrey C. 299
Washburn, Barbara 26
Washburn, Bradford **26**; photos by **26–27**
Washington, D.C. 262-264, 304
Weaver, Kenneth F. 232
Webster, Donovan 218
Werth, Roger: photo by **174**
Whitaker, Herman 197
White House, Washington, D.C. 304
Whitman, Walt 304, **305**
Wilburn, Herb 46
Wiley, Gerald L. 133
Williams, Maynard Owen 24
Wisconsin: contour plowing **52**
Wisherd, Edwin L. 196
Wolf: Superior N.F., Minn. **35**
Wolinsky, Cary 299
Woodson, LeRoy, Jr. 90, 264–265
Wray, Fay 266
Wyeth, Andrew 300–301, **302, 330–331**
Wyeth, Henriette 301, **326–327**
Wyeth, Jamie **328**
Wyeth, N. C. (Newell Convers) 300–301
Wyoming: 1993 NGM article 198–199, **210–213**

Yeadon, David 204
Yellowstone National Park, U.S.: fires (1988) 169–170, **178–179**; trout fishing **56**
Yen, Harry S.C. 45
Yosemite N.P., Calif. **25**
Young, Gordon 45, 46, 60

Zahl, Paul A. 45
Zwingle, Erla 50

ACKNOWLEDGMENTS

OUR THANKS TO THE PHOTOGRAPHERS AND WRITERS who came to NATIONAL GEOGRAPHIC with their dreams, kept working when conditions got tough, took countless risks in far-flung places, and shared the results with us. They have enriched us by their example, and their in-depth view of the U.S.A. has made this volume possible.

WE ARE ESPECIALLY GRATEFUL to photographer Sam Abell, who proposed the concept for the project.

THE FOLLOWING PEOPLE went out of their way to help us as this book took shape: David Griffin of the Book Division; Tracey Blanton of Administrative Services; Flora Davis, Susie Riggs, Ricky Sarno, and Jasmin Lofton of Image Collection; Renee Braden, Cathy Hunter, Mark Jenkins, and Andrea Lutov of Records Library; David Findley and Joyce A. Whitehead of National Geographic Photographic and Digital Imaging Lab; Robert Weatherly of National Geographic Interactive; and Tiffany A. Lerch and Holly Legler of the Book Division.

FOR A PROJECT OF THIS MAGNITUDE, we called upon almost all the resources of the Society. We thank the following Society divisions for their generous assistance as we delved into our history: Audiovisual, Distribution Center, Human Resources, Image Collection, Information Systems, Lectures and Public Programs, Map Library, NGM Control Center, NGM Editorial, NGM Legends, NGM Research, NGS Library, News Collection, Photographic, Translations, and Travel Office.